BEHIND APPEARANCE

Behind Appearance

A study of the relations between
painting and the natural sciences
in this century

C. H. WADDINGTON

The MIT Press
Cambridge, Massachusetts

Foreword

This book is a very much expanded version of a series of 'Gregynog Lectures' given at the University of Wales, Aberystwyth, in 1964. I am extremely grateful to that University for the honour they did me in inviting me to deliver these lectures, and for the opportunity they provided for a first 'trial run' of my ideas.

The thoughts I have had on these subjects have arisen in the course of a lifelong interest in paintings, beginning with my friendship, from about 1930 onwards, with the English avant-garde painters of that time: John and Myfanwy Piper were my closest friends, and through them, and the architect Justin Blanco White, whom I married around that date, I came to know Henry Moore, Ben Nicholson, Barbara Hepworth, Ivon Hitchens, Sandy Calder, Moholy-Nagy, Gropius, and a few more — there were not so many of that kind at that time.

In spite of an inveterate habit of gallery-going, whenever — which is not often enough — one can find free time, it would have been quite impossible to provide the background for an extended development of my ideas without easy access to at least the salient items in the enormous literature which has gathered around modern painting. The writing of this book would have been quite impossible without the support of the Rockefeller Foundation made available in the form of grants, which I was free to spend on any books or other materials which I thought would be useful. This was an act of quite exceptional generosity and open-mindedness on their part, for which it is difficult to express my gratitude. But I could not have laid out these funds to best advantage without the expert advice of my friend Bernard Karpel, Librarian at the Museum of Modern Art in New York, who kept finding for me — usually at advantageous prices — books, articles, pamphlets, catalogues, which were just what I needed.

I should like also to acknowledge the generosity and helpfulness of many people within the world of art publishing who have been very ready to give all the assistance they could to an outsider like myself. In particular, M. G. di San Lazzaro, editor of *XXme Siècle*, and Mr Peter Townsend, editor of *Studio International*, have been helpful in a manner more typical of the academic world of learning (and somewhat idealized at that) than of the commercial market-place. If they had not been so generous, the finances of book production would have severely restricted the quantity and quality of the illustrative material which the Edinburgh Press have been able to provide.

Finally, it will be obvious that this book emerges from a whole host of conversations with my friends, from both the scientific and art worlds. I shall not attempt to enumerate and thank them all, but I would feel the weight of undischarged debt if I did not mention one — the biologist Ruth Sager of New York — whose genuineness of response, coupled with a challenging capacity to expose the weaknesses of any argument or line of talk which don't quite make the grade, did more than anything else to force me to find time to put this all down on paper.

C. H. Waddington
Edinburgh — Greenwich Village —
Castagneto Carducci
June 1968

Contents

COLOUR PLATES

BLACK AND WHITE ILLUSTRATIONS

Preface

It is unusual nowadays – some people give the impression that they consider it almost reprehensible – for anyone who is professionally engaged in one field to write a book about some other subject which has its own specialist experts. I am doing just that, but I shall make no apology. Any person who tries to remain alive in all his faculties must be ready for the experiences offered by several, if not all, of the main types of human endeavour, even if his own main work is in only one of them. Scientists in particular, whose daily life is spent in the fascinating but time-consuming activities of the laboratory, have before them the sad fate of Darwin, who confessed that 'formerly pictures gave me considerable, and music very great delight. But now for many years I cannot endure to read a line of poetry. . . . I have also lost any taste for pictures or music.'[1] Works of art are brought into being in order that they can be appreciated by people in general. The writings of specialist experts can, of course, be of great help to outsiders who want to understand what is going on. But new developments in any particular field only become part of the general culture of the world when they enter the experience of people who are not specialists in that area. There is therefore a very definite place for books by 'outsiders'; by scientists about the arts, and certainly by artists about science – how much they might help to bring home to us the glaring and dangerous imbalances in the present distribution of our scientific effort.

This book has, intentionally, dealt with only one particular aspect of the relevance of modern painting to the life of twentieth-century man. It is concerned with the ways in which painters and scientists have seen the character of the material world we inhabit, but hardly at all with how they conceive of human nature, or even with how they envisage the relations between man's emotional life and the landscapes – urban, nowadays, rather than rural – amongst which he shapes his life's path. I have almost entirely omitted, among artists, Matisse, Chagall, Modigliani, Soutine, Nolde, Kirchner, Kokoschka, Moore, Piper, Bacon, the revolutionary Mexicans from Rivera through Siquieros to Tamayo, and many aspects of Picasso, Miro, Klee, and Arp; among scientists, Freud, Gestalt psychology, behaviourism, Sherrington, Muller, Dobzhansky; and a whole spectrum of 'humanists' – Cassirer, Sartre, Mumford, Huxley, Heidegger, Coomaraswamy, Suzuki, and so on. I labour this point to emphasize that this book is not intended to be a general survey of the science-culture chasm which is so often pointed out to us. It is rather a moderately detailed reconnaissance of one of the areas in which the chasm turns out to be quite a narrow and shallow cleft across which it is easy to step.

A further restriction, and a more arbitrary one, is that I have concentrated on painting and almost entirely refrained from discussing sculpture. This limitation was made in order to reduce the bulk of the subject matter, and to keep the book within reasonable bounds. Even for these worthy ends, it would be unreasonable to be completely consistent. There are some movements very relevant to science, such as the Constructivism of the twenties and thirties, which flowered more fully in sculpture than in painting; and later movements, often in part derived from Constructivism, in particular those involving the use of actually moving parts, and of light as a medium, can certainly not be left out, even though they can scarcely be classified as painting in the normal sense.

On the other hand, I have not confined my discussion wholly to the aspects of modern painting which are quite directly related to science. The case I am arguing – that our developing scientific understanding of the nature of our material surroundings has had important effects on the ways in which painters have worked – is strong enough not to call for overstating. It would be quite wrong if the book were to give the impression that many painters have spent most of their time worrying about science; for most of them, their day-to-day preoccupations were of quite a different kind, even though the scientific picture of the world was an important factor in the long-range development of their outlook. Moreover, I hope that this book may appeal to many scientists who are interested in painting but perhaps not very knowledgeable about its recent history. I have therefore included what seems to me the minimum of the general art history of the time, in so far as it serves to 'place' the painters we shall be discussing. Those who are familiar with such books as Herbert Read's *Concise History of Modern Painting* or *Art Now*, the Skira volumes on *Modern Painting* and *Contemporary Trends*, or the many monographs on particular movements such as Cubism, Futurism, Surrealism, Dada, Constructivism, etc., will certainly find many things which they know already. I can only ask their indulgence, and remark that it is not only for them that the book is intended.

The way man sees his material surroundings is by no means irrelevant to the way he sees himself – which is what we mean by 'the humanities'. If we believe that the entire universe is constructed of unequivocal impenetrable atoms, each simply

ix

located at a precisely defined position in an unambiguous framework of space and time – existing, in Whitehead's phrase, in vacuous actuality – this cannot but have repercussions, to any even intermittently consistent mind, on the way we conceive the fundamental nature of ourselves and our friends. Our picture of human nature must be in quite other dimensions if we consider that the basic structure even of the physical world is such that everything is really everywhere, though in some places more than others. Thus the book, which might be subtitled *Modern Art and Natural Philosophy*, is at least a prolegomenon to the more important topic – more often discussed, but rarely with this preliminary step firmly established as a foundation – of *Modern Art and the Image of Man*.

It is perhaps also necessary to point out that this is not primarily a book about aesthetics. I propose no new theories about the nature of aesthetic experience, and make no suggestions how we can decide which painters are 'better' than others. Of course, the mere fact that I find a painter worth considering implies that I think him at least reasonably good and important. But I discuss painters only in so far as their work seems relevant to my main theme – the dialogue between painting and science about the nature of the external world. Possibly some of the points which such a discussion brings out may help to deepen our aesthetic appreciation of the paintings. The aesthetic experience involves many different levels and kinds of reaction to sensory stimuli, and an intellectual understanding of a work's implications for natural philosophy may be one of them. There are many others which, being not relevant to my immediate topic, are neglected here. It follows that the amount of space devoted to different painters is not always a just reflection of their total importance for modern painting as a whole. There are many good monographs on the main schools of recent painting, and a few[2] which survey the field as a whole, and these do attempt some general assessment of a painter's whole work in relation to the general development of painting. This is a dangerous task. The painters we are concerned with are too near to us in time for a just estimation of their ultimate importance. It is salutary to recall the sudden re-evaluation of Kandinsky in connection with Abstract Expressionism, of Stuart Davis as a forerunner of the Pop movement, even of Art Nouveau as a source for the later works of Matisse. In any case I am not competing with those who sit in judgment on the art world. I am sacrificing generality and an all-inclusive judgment for the sake of concentrating on one particular aspect of the modern movement, which has up to now not attracted the attention it deserves.

Je parle de ce qui m'aide à vivre, de ce qui est bien. Je
ne suis pas de ceux qui cherchent à s'égarer, à s'ou-
blier, en n'aimant rien, en réduisant leurs besoins,
leurs goûts, leurs désirs, en conduisant leur vie, c'est-à-dire
la vie, à la répugnante conclusion de leur mort. Je ne tiens
pas à me soumettre le monde par la seule puissance virtuelle
de l'intelligence, je veux que tout me soit sensible, réel,
utile, car ce n'est qu'à partir de là que je conçois mon exis-
tence. L'homme ne peut être que dans sa propre réalité.
Il faut qu'il en ait conscience. Sinon, il n'existe pour les
autres que comme un mort, comme une pierre ou comme du
fumier.

1

The Image
of our
Surroundings

The world around us is not what it was to our grandfathers. Science no longer conceives it as consisting of solid lumps of matter which can be organized into straightforward machines. The matter first thinned out into atoms, then into electrons and protons, and now into – is it waves of probability, whatever that may mean; or is it, alternatively or simultaneously, a set of 37 or 48 (?) elementary particles, which can only be reduced to some sort of sense by means of a Buddhist-sounding doctrine known as the Eightfold Way? And meantime those painters who are not illustrating aspects of scenery, personality, or history no longer offer us recognizable flowers or apples or any other material objects. Among the important artists of the last half-century there are hardly any that one could be tempted to call representational; the retreat from likeness in the theory of painting, as Blanshard[1] called it, has gone so far that many critics seem to consider even the adjective 'figurative' as pejorative.

These two revolts against old-fashioned common sense are most probably connected. Many people have pointed this out already; but there have been few attempts to discuss in detail just what links can actually be found between the explorations, by scientists on the one side and by painters on the other, of what lies behind the world of appearance. This book is a step in that direction.

As Kuhn[2] has noted, at any period in history Man sees the world in terms of a particular 'paradigm', that is simultaneously an apparatus of perception (which brings into particular focus certain aspects of our existence) and a framework by which the many different facets of the universe can be related to each other.

Our general notions about the world – the spectacles through which we see it and the framework into which we try to fit our observations – are, of course, dependent in the main on what we know about it. In the last few centuries, overwhelmingly the most important method of acquiring information about the world has been that complex of activities referred to in a global way as Science.

In his book *The Structure of Scientific Revolutions* Kuhn discusses the historical transitions from one paradigm to another within various fields of post-Renaissance science, such as that from Daltonian to electronic chemistry, or from classical to quantum physics. But there are paradigms of a wider reference than these, and the changes of the world view that have been occurring in the last fifty years are amongst the most far-reaching in the whole history of human thought.

A perspective broad enough to contain them must include also the very beginnings of the scientific analysis of the world. In Athens and Ionia the Greeks invented what may be called *First Science* (cf. Goodall[3]), whose method consisted in the postulation of axioms from which

1. Atomic disintegration

certain theorems could be deduced by the application of a logical system of inference. From the axioms of Euclid one can go, by an indubitably acceptable path, to Pythagoras and his theorem. It was not till nearly a score of centuries later that First Science gave way to *Second Science,* the product of the Renaissance, which systematized the procedure of experimentation. The succession of scientific paradigms discussed by Kuhn all fall within this general pattern of thought, of which they form subsidiary categories. The general characteristic of Second Science is that its basic methods involve the interrogation of nature by means of experiment, and that the questions asked are formulated in terms of entities which are in essence not very dissimilar to things that we encounter in everyday experience: atoms like billiard balls, forces like muscular tensions, masses like weight, and so on. As this enormously successful paradigm was pursued, new kinds of entity came to light, such as electricity, but usually also their discovery was accompanied by new experiences which made it not wholly impossible to form some kind of visual or experiential 'picture' of them.

It is in this century that a whole collection of new developments are becoming powerful enough to break up the Second Science paradigm and to face us with the necessity of formulating a new one – *Third Science,* as Goodall has called it. The first of these developments was the increasing tendency of physics to analyse the basic nature of the material world into entities which seem to be radically different from anything we can experience. The world of billiard ball atoms existing at definite times in simple three-dimensional space dissolved into the esoteric notions of quantum mechanics and relativity, which to the unsophisticated seem most 'unnatural'. Even earlier in origin, though slower to have a general effect, was the conception of biological evolution by natural selection, which has profound implications about the essential importance of time and process, and also introduces the revolutionary idea that chance and indeterminacy are among the fundamental characteristics of reality.

More recently still, several other developments have begun to change radically the Second Science paradigm. The interest of science has tended to move towards the study of such general properties as information or organization. These are not entities in any usual sense but are characteristics of systems. They are becoming a dominant preoccupation of Third Science, not only because of their inherent importance, but because there are now technical means – computers and the like – for dealing with them. Again, the development of quantum mechanics has tended to break down the old distinction between the observer and the observed. The scientist himself, or man in general in his activity as an observer, comes to be incorporated into science in a way which is

2. Element from a fluidic computer

2

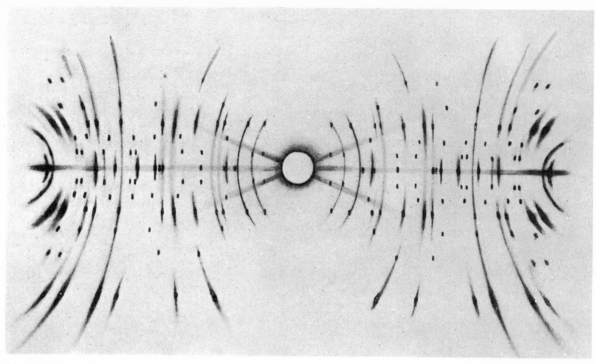

3. X-ray diffraction pattern, tantalum

completely outside the Second Science paradigm. And finally he also becomes involved in science not only as a maker of it but as a subject for its study, not only as an individual with a psychology, but as a member of a set of societies which are themselves examples of organization. Third Science, which is still nascent and has not yet arrived at a definite inclusive paradigm of its own, will certainly have the human and social sciences as very important factors in its make-up.

It is not only within science that there has been, in recent times, a movement away from concepts of self-sufficient isolated entities and towards an engagement with notions of natural relatedness, organization, and the essential importance of system relations. Much of recent thought about social, international, and industrial affairs has been moving in the same direction. To give one example : we are coming to realize that we have to conduct our political and economic life in a world system in which one can no longer make a sharp distinction between producers and consumers ; production only continues in a healthy manner if there are powers of consumption adequate to absorb its output ; it is in the interests of the rich that the poor should become richer.

The relations between painting and the developing Third Science are most interesting and worthy of discussion. For convenience, and also because it seems rather natural in connection with painting, the historical development of our conceptual paradigms during the last half-century has been treated in this book as taking place in two phases. There was first the period from, say, 1910 to 1940,

in which the aspects of science which had the strongest impact on painting were non-Newtonian concepts of space-time, and Freudian ideas about the way in which we formulate concepts and react to symbols. This period is discussed in the first part of the book, in which it is argued that, by the outbreak of the Second World War, both these science-influenced movements in painting had run themselves either into the sand or into a narrow and restricted channel. After the war there was an efflorescence of new varieties of painting, many of which show affinities to various aspects of science which had been of little influence earlier. In particular, a whole complex of ideas deriving from quantum physics, both about the nature of the material world and about the character of our perception of it, began at this time to colour the thoughts of non-scientists in general and painters in particular. Another important set of notions emphasized the functional interrelatedness of the parts of a system — ideas which may be indicated by the engineering terms 'feedback' and 'cybernetics', but which also have deep roots within biology. The many-sided relations between painting and science in this period are discussed in the second part.

We have certainly not yet reached anything that can be considered a well-balanced and harmonious view of man in his relation to nature, which would include all the insights scientific advance has made possible.

It is science's output of verifiable — or, if you prefer, unfalsifiable — statements about the world that provides the motive forces which are driving

3

towards the formulation of the new paradigm of Third Science. But, of course, the great majority of men are not professional scientists. The world view which mankind is now seeking could not be satisfactory so long as it is formulated only in scientific terms. In fact, most professional science is so detailed, and so deeply committed to considering some particular aspect of reality, that a general paradigm emerges in it only by implication and rarely in any explicit form. To find a general picture we have to look to see how the discoveries and new outlooks of science are reflected in the endeavours of non-scientists who are attempting to create works which will be general contributions to civilization. One might look, for instance, at the writings of novelists and poets; or one might look, as I shall attempt to in this book, at the productions of painters.

It might seem at first sight as though the writers would offer the more profitable field to examine. They deal in words, and words are the means by which the human race can most explicitly and precisely express its thoughts. But this use of words, which seems to give writers an advantage over painters, can in fact work in the opposite way. Science also uses words, and uses them with much greater precision than non-scientific writers commonly do. It has invented a large vocabulary for the express purpose of being precise. In fact, in mathematics it has invented not only a new vocabulary but a new syntax. Writers are therefore using the same tools and, if you like, performing on the same stage as scientists. Unless they feel at home with at least the basic elements of the scientific vocabulary, and that means feeling at home with the basic scientific notions to which the words apply, any attempt to express explicitly a world view derived from science would be like a criticism of Shakespeare written by someone whose knowledge of language reached only the level necessary for reading the evening papers. One cannot discuss in words the implication of physical theories of indeterminacy, or of biological theories of genetic determination, without the question being asked whether the writer can understand in words what those theories state. Some literary writers can pass this test, but perhaps an unduly large number of them have attempted to avoid such brash questioning by steering clear of the whole issue of science and its implications. Painters have the advantage that, since words are not the medium in which they work, the adequacy of their verbally expressible understanding of the modern world does not really come into question. When painters do use words — and many of them will be quoted in later chapters — these are to be regarded only as glosses on their actual paintings and drawings. When the Cubists talk about the fourth dimension, we can accept that this term is being used in a much looser and more imprecise way than it would be used by someone for whom words were the tools of his trade.

It is for this reason that any discussion in words of the 'meaning' of painting — such as this book, for example — needs to be conducted in the presence of the paintings themselves, or at least of reproductions of them.

Painting comments on the world not by logical or even visual analysis of it, but by a process of 'showing' similar to that which Wittgenstein claimed was the only way of exposing to view the most profound truths of philosophy. It is perhaps for this reason that painters have been so much bolder than writers in expressing radically new concepts of man and his world in the modern age.

There have been many modern artists, including some of the best, who have been very little concerned to explore the implications of our new knowledge of nature. One might instance Matisse and Modigliani and perhaps, to a somewhat lesser extent, some of the Expressionists such as Kokoschka. Many of these, who have been making new developments within the older traditions of painting, have used the newer freedom of form and colour; but among the conscious aims of the men who first created these freedoms, by breaking with the accepted modes of representational painting, was the intention of producing something concerned with the science of their time.

This was, of course, by no means their sole aim; often not the aim of which they were most immediately conscious. Painting has its own internal logic of development. Although, as I shall spell out in detail in the next chapter, the early Cubists were strongly influenced by rather misty feelings about non-Newtonian space-time which lay about in the back of their minds, probably the intention which was uppermost in their thoughts was to carry forward the innovations of Cézanne in what might be called 'painterly strategy'. These did not concern technical tactics — the nature of the pigments used or the methods of applying them to the canvas — but they were nevertheless basically technical matters, concerned with methods by which concepts may be represented by paints on a picture surface. For those whose life is spent within the world of art — painters, art critics and historians — it is these connections within the family, as it were, which loom largest.

To the cultured world in general they are by no means the only, and usually not even the most important, relations. In just the same way, science has its private history. The discovery of the double helix structure of DNA, the basic determinant of the nature of living systems, can be looked on as a development from the 'old-masterish' crystallographic studies of Astbury on nucleoprotein complexes and Bernal on viruses; one can trace the dualistic wave-particle view of matter from Schrödinger and de Broglie through Rutherford, Bohr, and Thomson to de Fresnel and the early

wave-corpuscular theories of light. But this history, though valid and of intense interest to historians of science, is not the part of the story which is most relevant to the influence of these scientific advances on general cultural life. This is a context in which there is a good deal of truth in the old cliché: the outsider sees most of the game. If people from the world of art or literature wrote about their reactions to science, they would almost certainly omit many historical derivations and influences which scientists would consider crucially important; and this book has certainly omitted, or merely mentioned, many that the art profession would consider to merit extended discussion.

Most art critics and historians, in fact, pay little attention to the particular connections of modern painting which are dealt with in this book. Discussing Chirico, they consider his relations with earlier painters, Boecklin perhaps, or even Ucello or Piero di Cosimo, but scarcely notice that his paintings often depict an allegory of romantic man confronting a world of technology: an egg-head – which may stand for a moron as much as for an intellectual – partly constructed of primitive scientific apparatus, in a setting where a steam engine puffs past the walls of an abandoned building, which may be a warehouse or a palace, behind which there are infinite depths of nostalgia in the clear greenish sky. They are concerned with the derivation of the all-over textures of Pollock and Tobey from Seurat and some of Van Gogh's drawings, but a connection with scientific ideas of the electromagnetic field, or of a continuum of events, does not occur to them. It is in the writings and recorded conversations of artists themselves that one is most likely to discover evidence of the extent to which painters have actually felt the need to assimilate into the springs of their creative activities some apprehension of the world picture which the science of their day provides. One has to delve rather deeply into some of the less well-known publications about modern art to find this material. When one does so, it is impressive to discover how large a proportion of artists have spoken about their relations with science. I have quoted their remarks extensively, both for their intrinsic interest – since I believe that on the whole painters know better than even the best critics what they are trying to do – and to establish the point that the connections I am dealing with are not merely a bee in the bonnet of a scientist who wants to argue that his profession must always be in the centre of every stage, but are matters with which very many painters have felt themselves concerned.

The earliest group of painters who have some claim to be called 'modern', the Impressionists, were strongly influenced by science. It was recent theories of optics and the development of the camera that provoked them to attempt to record visual sensations in their full immediacy. However, the influence of science on the Impressionists,

4. Curve drawn by a computer

although powerful, was at a relatively superficial level of manner and subject. At the deeper level of content, an Impressionist picture reflected science only in so far as science is an activity involving observation. It offered hardly any comment on the character of scientific thought or on the nature of the concepts which science derives from its observations. It is from the time of the Cubists onwards that the most powerful movements in painting have been largely concerned with just these topics. As we shall see, the first few generations of these painters tended to see science as something of a monster, one whose monstrosity seemed to them to arise largely because science presents a one-sided picture of the universe. But, though they saw science as a one-eyed monster, the Cyclops, there were two main streams in the development of painting from 1910 to 1940, and the single eyes that each of these attributed to science were quite different ones: the Cyclops they thought they saw must have been binocular!

But when we look at the sciences themselves, and in particular at the ways in which they have developed in the last half-century, we find that neither are they external monsters, standing outside the pale of humanity, nor do they have only one, or even only two, lines of sight into the world. Scientists have been driven to consider very deeply the extent to which their observations depend on their own nature as well as on that of the external world. They have had drastically to revise the old idea that science is completely 'objective'. The scientist has come to seem almost as involved in his scientific theories as the artist in his paintings; and the artists have responded by acknowledging more openly the extent of their own involvement, and by deepening it to the point where they speak, not of delineating a scene, but of performing an activity in co-operation with their media and tools. Moreover, we have realized that there can never be only one kind of science. All the material world is, we profoundly believe, built of one (or possibly a few) kinds of ultimate stuff; but this is formed into associations of many different grades of

complexity, each of which faces us with problems of its own characteristic kind which demand corresponding types of thinking and conceptualization. The day will never dawn when all scientists are physicists, or chemists, or geneticists, or ecologists. Science is no sort of a Cyclops — monocular or binocular — it is more of an Argus, with a hundred eyes.

Painters, too, have refused all to join one school of Action Painting, neo-Constructivism, Pop, or what you will. There are almost as many different types of painting currently practised as there are specialized branches of science. And, in both types of activity, it is often the coming together of two apparently disparate tendencies that proves most fruitful: hybrid vigour is a very widespread phenomenon.

Modern man is rather consciously 'in search of a soul', as Jung put it. He is looking for a doctrine, a consensus, a unit of thought, feeling, and action, to which he can attach himself, and which gives him the security of whole-hearted commitment that — at least so we like to think — the Catholic Church once provided. Psycho-analysts argue that the basic impulse for such strivings is the desire to find our way back to the good breast from which we were perforce weaned. Perhaps the main conclusion this book will come to is that, at least in the fields of science and painting, there is no one good breast to be discovered or rediscovered. The world has too much to offer for us to take in what Gide called our terrestrial nourishments from any single source. We should be worshippers of the many-breasted Diana of the Ephesians — Diana Polymastigos.

Part 1 The Binocular Cyclops

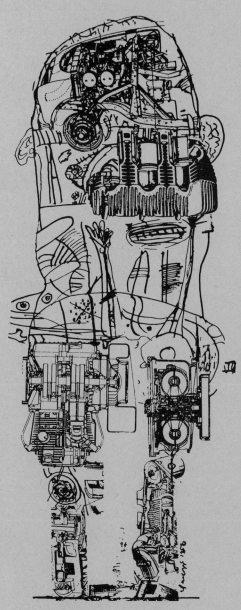

5. Paolozzi

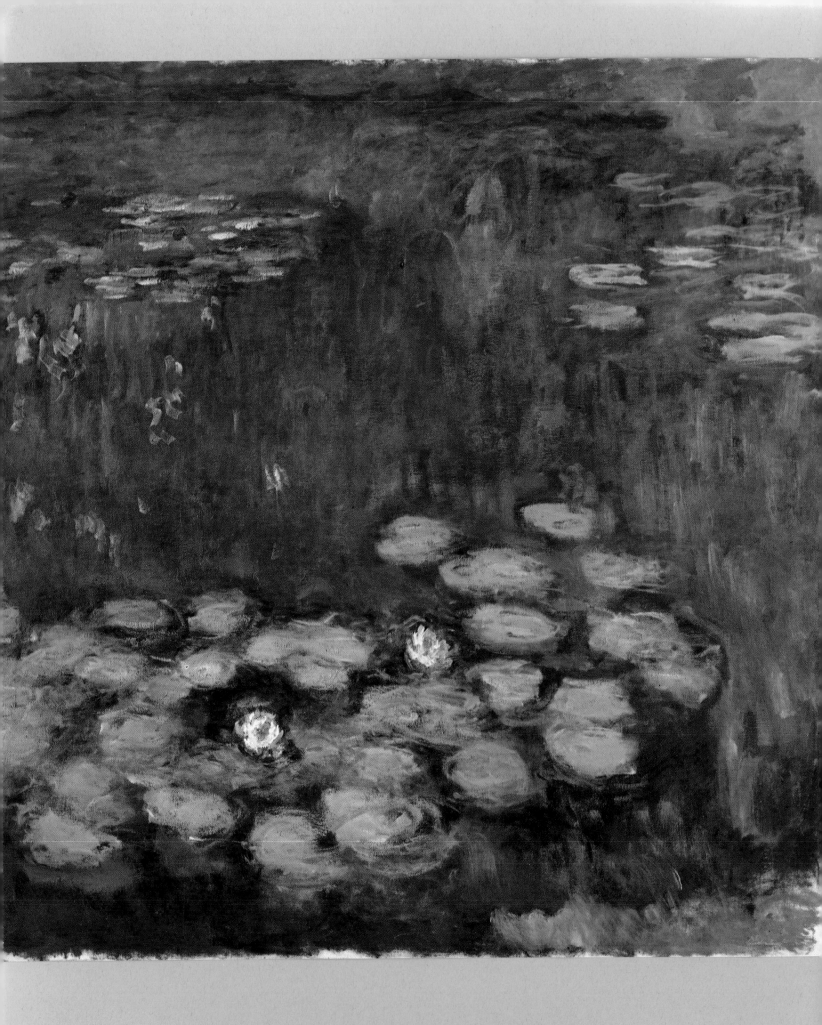

2

The Geometricizers

All, all of a piece without,
Thy chase had a beast in view,
Thy wars brought nothing about,
Thy lovers were all untrue;
'Tis well an old age is out
And time to begin a new.

Dryden

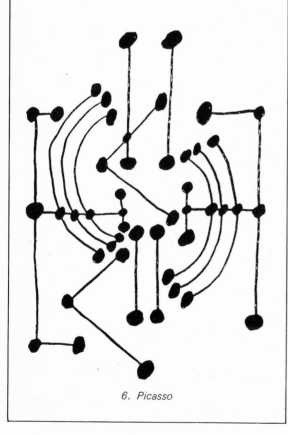

6. Picasso

Cubism: beginnings

It was in the year 1905 that Einstein first postulated the equivalence of mass and energy and proposed, in the Special Theory of Relativity, the amalgamation of space and time into a four-dimensional space-time continuum. It was in the same year that Picasso began the series of drawings and sketches which led in 1907 to a major work, *Les Demoiselles d'Avignon,* which is usually considered as the birth of Cubism.

The coincidence has often been remarked and the question asked, how much more than a coincidence was it? Cubism undoubtedly had very important, and perhaps more immediate, roots within painting itself. The most important of these was Cézanne's lifelong struggle to find a way of painting the structure of objects rather than their mere appearance. This endeavour was in direct opposition to the most advanced painting of the previous few decades, which had been primarily concerned with visual appearances, either reproducing as accurately as possible the immediate fleeting sensation, as most Impressionists tried to do, or giving them the heightened colour and vividness characteristic of Fauve paintings. Only a few Impressionists, such as Seurat, showed much interest in expressing three-dimensional structure; and Cézanne, in his search for an effective way of showing the real world as he apprehended it, adopted much more radically novel methods than any of his contemporaries. He made the famous dictum that all the structures of the real world are variations on the three basic solids, the cube, the sphere, and the cone. His pictures went some way towards exhibiting them under those forms, and this was one of the most important stimuli which emboldened the Cubists to go further. And there were other influences which encouraged them to make a radical break with tradition. In particular, Negro sculpture provided examples of types of art which dispensed almost completely with the systems of perspective and representation which had been conventional in European painting for several centuries, and yet were successful both in having a very powerful emotional effect and in creating structural forms which, although not closely related to the structures of the objects 'represented', had a validity and aesthetic completeness in their own right.

▶There were two other currents in the painting immediately preceding the development of Cubism which are worth noticing not only for what they contributed to that movement in its early phases but, perhaps even more importantly, for their influence on the much later 'second breakthrough' of the Abstract Expressionists of the 1940s and 1950s. The earlier of the two was a late phase of Impressionism, particularly as it was expressed by the paintings of Monet based on views of waterlilies floating on the surface of

semi-transparent water. Plate 1 is a rather more clear representation of such a scene than some that he produced. These paintings emerge as all-over modulations of the picture surface, with, in the more extreme examples, no particular focus of interest, and no natural edges – they might extend indefinitely in all directions. And the space they indicate is one which extends into the depths of water, with every further foot of recession indicated because water is not so trivially transparent as air.

Superficially very different, but with some important basic affinities, were the paintings of the *Fauves*. They were given this nickname (The Wild Beasts) by the critics, primarily because of their violent colour. Several of the painters who took part in the launching of Cubism – Braque in particular – had worked in this style immediately before moving on to Cubism. The paintings, of which Plate 2 is an example, remained representational, without any gross distortion of whatever outlines were accepted for inclusion, but in many areas the edges of natural forms were effectively reduced to insignificance by placing, within regions of officially empty space, brush strokes as definite as those by which solid masses were delineated. Cover the one big boat in Plate 2 with your hand, and the rest appears almost completely abstract and non-representational, and shares with the Monet the characteristics of an all-over, edgeless distribution of interest, and the implication, not of an empty space containing some solid objects, but of a three-dimensional volume with every cubic inch occupied with something or other.

This 'all-overness' and 'everywhere-dense continuum of events' remained as a major ingredient in the first great successful phase of truly modern art, the Analytical Cubism of which Plate 3 is an example – and persisted into the more mature Cubism of Plate 4. After that it tended to be overlaid by other considerations, until it came back strengthened and refreshed in the Abstract Expressionism of the late 1940s – painters such as Guston, and others, like Tworkov and Kyle Morris, not reproduced here, have great affinities with Monet; and Pollock, de Kooning, Brooks, even the quiet and cool Mark Tobey, with the Fauves. It is connected in a very profound way with some of the most important trends of recent scientific thought: the recognition that everything is involved in everything else, that the world is not an assemblage of isolatable and detachable items but is a continuum of interlocking and mutually dependent activities, which have to be handled by logico-mathematical methods quite different from the Newtonian or Cartesian procedures which were conventionally accepted as the only truly 'scientific' modes of thought. But we will leave the discussion of this till later.

Our original question, about the relation of Cubism, not only to its background in the history of painting but with the scientific thought of its time, is an important one. Partly because Cubism was the first major successful break which painters made with the traditions of the representational art of the past, but also because the particular form it took, its emphasis on straight lines, hard edges, and the sort of geometry we learn at school in textbooks of Euclid, laid the basis for one of the dominant vocabularies of form which modern painters have used, while these forms in their turn had a powerful influence in determining what painters took science to mean.

▶ In fact, to the first painters of modern times who tried to come to terms with science, it seemed to look out of a single eye that saw precision, geometry, purity, and the formal logical relations of mathematics. These are, of course, not by any means the only things that science sees. Other painters, such as Kandinsky, only a very few years later, drew quite different conclusions from the same scientific events. But it was Cubism that was first in the field, and it was the far-reaching unorthodoxy of the works it produced that set other painters free to explore their own lines of development quite uninhibited by the traditional values of the past few centuries of European painting.

The actual developers of Cubism, primarily Picasso and Braque, were painters par excellence, neither of them much given to expounding in words what they were trying to do. They were neither of them in any sense mathematicians, and could certainly not have understood Einstein, if indeed they had even heard of him at that time. One must remember, when discussing Cubism, or indeed most of the revolutionary developments of recent painting, that the innovators were quite young men. They were mostly at a stage of their career which would correspond, in terms of our present-day scientific life, to young post-doctorals. Nowadays, at least in America, promising young men at this stage often have 'distinguished investigator career fellowships,' or something equally impressive, and are earnestly thinking about getting a decently elevated place on the sober academic ladder of security. It was quite different for unconventional young painters in Paris fifty to sixty years ago. Picasso, Léger, Braque, Boccioni, and Severini were all in their late twenties, supported by no public grants and expecting no secure appointments. Their non-working lives were spent in cafés, dance halls, and circuses. In the post-World War I generation, jazz – another unbourgeois creative activity – played a considerable part in their lives; even such a dedicated character as Mondrian, who was older than most, about forty-two, when he started 'going modern', named some of his pictures 'Boogie Woogie' after a now defunct jazz style. The effects of developing science on these young artists are important – even serious, if you like – but certainly not solemn. It would be obtuse to

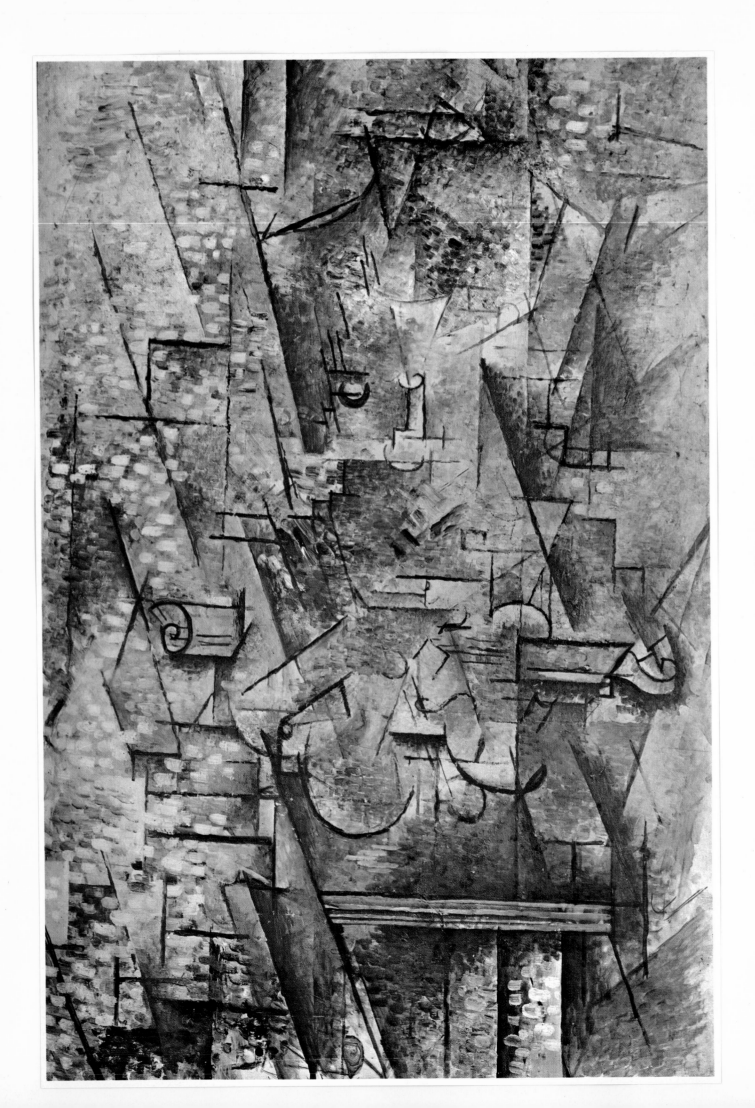

expect these gay and often flippant young men to expound a perfectly consistent and well-thought-out system of thought like a bunch of eminent philosophers. But they were very well able to pick up what seemed exciting to them out of the general talk that went on in the cafés of Paris.[1] It is clear enough that they grasped that science was taking to itself a new boldness in conceiving of things in ways which were radically different from those conventionally accepted. They must have learnt also that some of these new scientific conceptions involved a greater emphasis on process as contrasted with mere static persistence, and that time had also been brought into some new relationship with space, to form a new set of ideas very different from the accepted three-dimensional Newtonian space which painters of the past had expressed through the conventions of academic perspective.

▶ It is worth reminding ourselves what were the new, at that time revolutionary, scientific advances. There is no space, or need, to describe them fully, since they have by now been very widely discussed in non-technical terms (for instance, a good account written not too many years later is Eddington's *The Nature of the Physical World*[2]) ; and they have, partly at least owing to the efforts of the painters we are just going to consider, become almost a part of 'common sense'.

7. *Electron cloud of the hydrogen molecule*

Basically, there were two major novelties to be assimilated during the first decade of this century. The first may be referred to as the dissolution of matter. Common sense had always thought of matter as something whose essence was to be hard, solid, and impenetrable. Older scientific atomic theories agreed. The word 'atom', after all, is merely Greek for 'indivisible'; and the atoms of Democritus, Newton, or Dalton were thought of as hard, unbreakable lumps, which in ordinary matter were packed close together, leaving little if any space between them (except in gases, whose airy character was a consequence of the atoms being

further apart). The newer physics changed the whole of this picture. Radioactivity, discovered just before the turn of the century, was evidence that atoms are not perfectly stable but can break down (i.e., divide) spontaneously. Thomson's discovery of the electron (1897), followed by Rutherford's of the proton (1907), was leading to the view that the atom is anything but solid in any ordinary sense. The most appropriate picture of it at that time was a collection of minute particles of electricity, organized like a solar system, with negative particles orbiting like planets round a positive nucleus; like our solar system, most of it was empty space. Matter, made up of such atoms, no longer had a continuous dense structure, but was mainly empty space containing an assemblage of vast numbers of tiny grains, and even they, consisting of electricity, did not seem over-solid to a more old-fashioned outlook.

The second major novelty, which was perhaps even more influential on painters, was the breakdown of classical ideas of space and time. Fitzgerald and Minkowski had shown that when one material body is moving in relation to a second, its length, as measured from the second body, is altered in a way depending on the relative motion. If we have a number of bodies moving in relation to one another, like the planets or the stars, each one has its own appropriate frame of space, to which its measurements relate. And Einstein, in his Special Theory of Relativity, pointed out that there is no way of determining, indeed no meaning in asking, which of these frames is 'correct'. As Eddington[3] put it : 'We have been confronted with something not contemplated in classical physics — a multiplicity of frames of space, each one as good as any other.' And soon, of course, it became apparent that these frames involved not only space, but also time. The changes in spatial dimensions of moving bodies make it impossible for an observer to determine quite precisely what, in another frame, is simultaneous with his own *now*. There is a certain blurring of what had been thought of as the dimensionless instant. Or, to put it in another way, space, which had been considered timeless, is actually inseparable from motion, which involves time.

The main notions which painters seem to have carried away from the new physics were these : that matter is less solid, more transparent as it were, than it had been thought to be; that motion cannot really be frozen into a timeless instant; that a real body cannot be properly seen from one perspective point, but that there are many spatial frames which can be applied to it, and that all these are of equal validity.

It is, as I have said, very unlikely that they formulated these notions in any clear-cut way. They were at the same time interested, probably more interested, in the way their painting carried forward certain technical experiments of Cézanne.

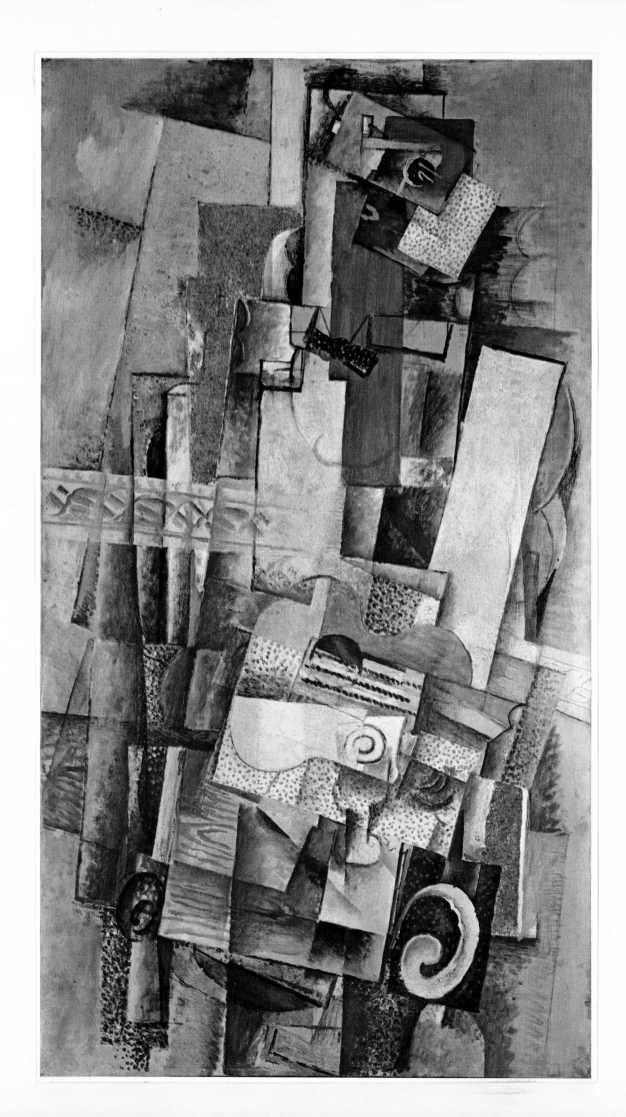

And of course they were not mathematically equipped to grasp Einstein's ideas, at a time long before these had been expounded for non-scientific readers. But we do know that they had some direct connection with a mathematician of a sort. Living in the same house as Picasso, the ramshackle tenement the painters nicknamed the *Bateau Lavoir*, was a certain Maurice Princet, a somewhat derelict figure who seems to have made a living as an actuary, but was known in the group as *Le mathématicien*. He was also a friend of Juan Gris, perhaps the most intellectual of the true Cubists, and of Marcel Duchamp, also very given to ratiocination, but more of a Futurist than a Cubist. André Lhote has given a 'famous and legendary' question said to have been addressed by Princet to Picasso and Braque[4]:

'You represent by means of a trapezoid a table as you see it deformed by perspective, but what would happen if the fancy struck you to express a table as a type? It would be necessary for you to place it on the plane of the canvas, and return from the trapezoid to the true rectangle. If this table is covered with objects equally deformed by perspective, the same rectification ought to operate on each of them. Thus the oval of a glass would become an exact circle. But that is not all: this glass and table considered from another angle are no more than, in the case of the table, a horizontal plane of some few centimetres in thickness, and in the case of the glass, a profile in which the rim and the base are horizontal. Whence is the necessity of another displacement. . . . ?'

▶ The first expositors of Cubism, André Salmon and Guillaume Apollinaire, who were friends of the Cubist painters and wrote only a few years after the first Cubist pictures had been made, were both in no doubt about the determining influence of science and mathematics in shaping the new departure in painting.[5] Salmon wrote that art should take science as its model, 'for is not science the only guide for these seekers, impatient to have us submit ourselves to all the angles of a prism, confusing touch and sight which are the cause of such diversified pleasure?' Picasso, he claims, was trying in the Cubist pictures 'to give us a complete representation of men and things . . . it's that the appearance of these objects is less valuable to us than our own representation; our deformed reflection in the mirror of intelligence.' To do this Picasso had to look at things 'from all sides at once'. 'Picasso', he said, 'also has meditated on geometry.'

Apollinaire went even further in his enthusiasm for half-understood science. Nature, he claimed, is in itself a void with no shape. 'The order which we find in nature . . . is only an effect of art. Without poets, without artists, men would soon weary of nature's monotony. . . . Cubism . . . aims, not at an art of imitation, but at an art of conception, which tends to the heights of creation. . . . Most of the new painters depend a good deal on

mathematics without knowing it; but they have not yet abandoned Nature, which they still question patiently, hoping to learn the right answers raised by life. . . . Until now, the three dimensions of Euclid's geometry were sufficient to the restiveness felt by great artists yearning for the infinite. . . . Today scientists no longer limit themselves to the three dimensions of Euclid. The painters have been led quite naturally, one might say by intuition, to preoccupy themselves with new possibilities of spatial measurement which, in the language of the modern studios, are designated by the term: the Fourth Dimension. . . . Regarded from the plastic point of view, the fourth dimension appears to spring from the three known dimensions: it represents the immensity of space eternalizing itself, the dimensions of the infinite; the fourth dimension endows objects with plasticity.'

This quotation, of course, shows us what is the trouble. Apollinaire starts off by saying that the artists are trying to follow science, but he has not been writing more than a page or two before he comes out with phrases like 'the fourth dimension . . . represents the immensity of space eternalizing itself', which are either incantations of which no precise interpretation is possible, or, if literally interpreted, show that the writer has no grasp of the scientific principles he is referring to. This descent into nonsense is a hazard against which the reader of aesthetic criticism must inure himself. There is surely no other subject in the world about which more absolute gibberish has been thought worthy of committing to paper. The situation, far from improving as the years go by, has been made worse by writers trying to expound the intentions of the most modern painters, who are concerned with conceptions very far removed indeed from those with which our conventional literary vocabulary has been accustomed to deal. Such writings should often be interpreted, not as the carefully formulated exposition of well-defined thoughts, but almost as a nebulous envelope of words, thrown by processes of free association around a half-formulated idea suggested by the paintings. Taken in that way they are, in some cases, illuminating. Meanwhile the painters themselves, when persuaded to speak or write of their work, surely keep their feet closer on the ground, occupied as they are with such very definite questions as where they are going to put their brush down on the canvas next, loaded with what pigment, and for what reason.

It is interesting to see that the Cubist painters themselves — at least several of them who were perhaps slightly lighter-weight as painters but more endowed with verbalizing intellect than Picasso and Braque — admit the important part that science and mathematics played in their early efforts. 'When it began', wrote Juan Gris,[6] 'Cubism was a sort of analysis, which', he went on, 'was no more painting than the description of physical

[4] Braque. L'homme à la guitare (1914)

15

phenomena was physics' (in which he was, the world has decided, quite wrong). And looking back to his early years, Gino Severini remarks[7]:

'At the time of Cubism and Futurism we believed that non-Euclidian geometry was the most convenient way for attaining the reality which was supernatural or super-real by using the concepts of hyper-space and of the fourth dimension. Even today there are artists who believe that, but perhaps they have a pretty imprecise idea just what this famous fourth dimension is. We know today that a non-Euclidian geometry will take us outside our own domain into a region of realities which are possible from a speculative point of view but not possible and not concrete from the point of view of art'.

So it seems that it was science and mathematics, whether they understood it or not, that pushed artists over the brink which separated the orthodox traditions, arising from the Renaissance, from the characteristically modern world. But it was, perhaps, because they did so little understand it that they found such difficulty in deciding what they were really trying to do, and veered so rapidly from one tack to another. Within no more than half a dozen years, from 1909 to 1915, Cubism passed through almost as many different phases, and its leaders, Picasso, Braque, and later Juan Gris, produced a series of pictures, which, while all 'cubist' in some sense, look very different in style and were in fact rather markedly different in intention.

▶The lithograph by Picasso, on the right, is a good example of one of the roots from which Cubism started. The figure is, by classical standards, grossly distorted. But the distortions have been made, mainly under the influence of Negro sculpture, in order to produce a powerful 'image', a visual experience which will live within the memory of the spectator; there is little or nothing here to do with a new sense of the nature of reality – merely a freedom to express a concept of a woman instead of a record of her appearance.

The transition from this to true Cubism can be followed in Braque's landscape of 1909 and the Picasso nudes of the following year. The figure drawings illustrate very clearly the cubist method of building up a picture of the eternal reality of an object by representing it from several points of view simultaneously, so that the purely momentary impression it gives from one viewpoint is overcome. But there was another type of spatial experience which the painters were trying to convey. Braque attempted to describe it by saying (in one version): 'In a still life, it's a matter of a space which is tactile, and even manual, which one can contrast with the space of a landscape, which is visual space. . . . In the tactile space, we measure the distance which separates us from the object, while in visual space, we measure the distance which separates the things between themselves.'

John Golding, in his monograph on Cubism,[8]

8. *Picasso, nude, lithograph*

gives a slightly different version of the same thought, in which tactile space is not so closely linked to the still life and contrasted to the landscape. And he goes on to explain it as follows: 'In front of a still life by Chardin or Courbet, for example, one can say that one object must be separated from another behind it by so many inches, and so on. Braque, on the other hand, wanted to *paint* those distances or spaces, to make them as real and concrete for the spectator as the objects themselves. In order to accomplish this it was necessary to convey the sensation of having walked round his subjects, of having seen or "felt" the spaces between them.' This is clearly something beyond the attempt to transcend the classical picture of an object as an isolated thing seen at one instant from one point of view; Braque wishes also to see it as something interwoven in a network of spatial relations with everything else surrounding it. This is an endeavour which has been very characteristic of many later paintings; its relations with scientific ideas, such as those of permeating electromagnetic or other fields, cybernetic mutual control mechanisms and the like, will be a recurring theme. But, though it did not last long at its

16

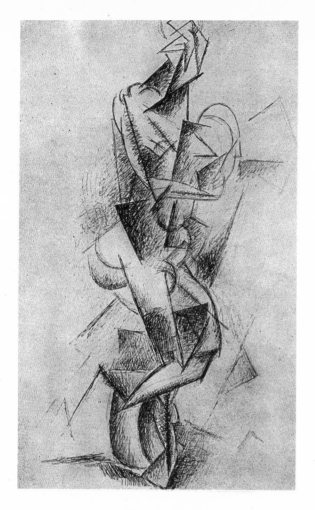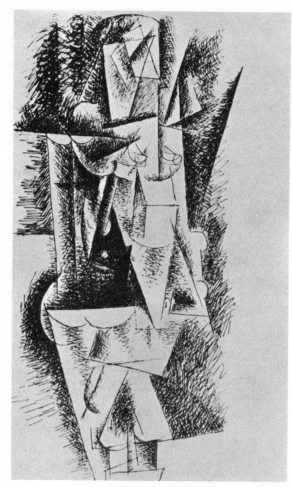

9. *Picasso, two nudes (1910 on left, 1911–12 on right)*

first appearance, it certainly played an important part in the earliest Cubist works, and is, I think, the reason why these paintings, of the so-called Analytical Cubist phase, still seem so very modern and congruent with our tastes nowadays, half a century after they were made.

As John Berger[9] has recently emphasized, Picasso has never been averse to expressing clearly his delight in sexual experience; and it is, perhaps, not unduly flippant to point out that one of the simplest ways to get an idea of what this combination of multiple viewpoints and tactile space amounted to in practice is to 'feel' your way round the bottoms of the nudes on this page. In the drawing of 1910 we see the left buttock and thigh in a three-quarter rear view, while the right buttock is almost in profile; but then, on the right-hand side of the axis of the figure, we see the left thigh again, with the pelvis above it, and the knee bent sharply so as to lift the heel back behind the right leg, and this time from a viewpoint somewhat to the front, which shows up a swelling mons veneris. In the *Standing Figure* of 1911–12, we again have shifting viewpoints; one buttock in profile, with superimposed on it a rear view of the whole bottom in a sitting position, forming a double curve which seems to be attached to a plane, dark at its lower edge and sloping upwards and inwards with various modulations, till it comes to two breasts, seen both from in front and in three-quarter view, which combine to give a doubly curved shape echoing that of the behind. This later figure illustrates, more clearly than the earlier one, the concept of 'tactile space' by which the various features of the whole figure are related to one another and to their surroundings. The back, on the left, and the belly, on the right, are both given in the form of two or three more or less vertical planes, drawn as if they were transparent and intersecting, so that the eye alone cannot place them in any definite relation to one another, though the finger-tips might, if you could feel your way about.

This interpretation of transparent planes seems to be a peculiar way of expressing the kind of tactile space which Braque described. The method arose from a rather different set of considerations. Well before the Cubists, Cézanne had made a valiant lifelong attempt to express the eternal, non-ephemeral existence of objects in the external

17

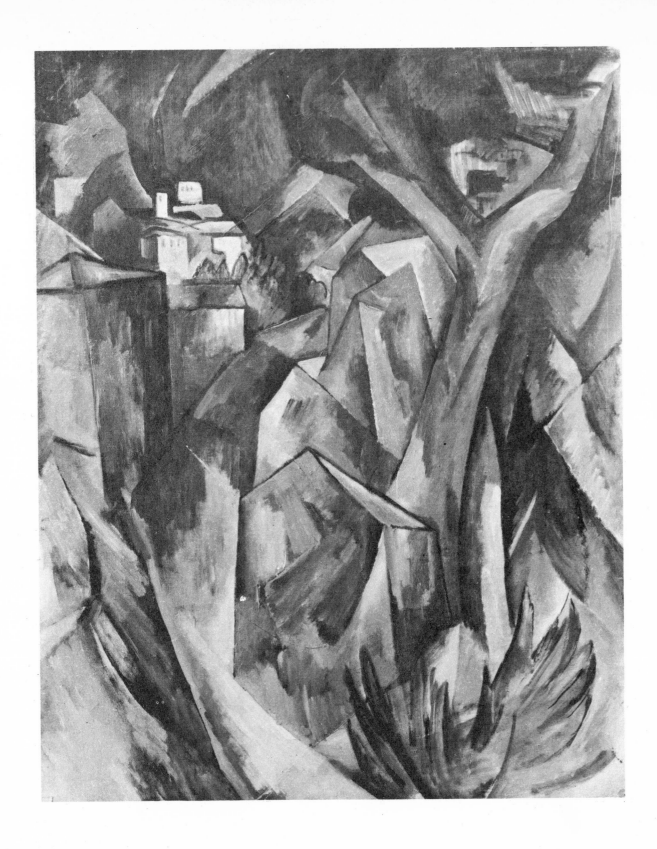

18

world. Like the Cubists, though in a much less extreme way, he had utilized multiple viewpoints. He had also painted many landscapes in which the natural forms of things – rocks, trees or mountains – had been analyzed into large numbers of small planes, like the facets on a crystal; probably in many instances because he studied them in the early morning or late evening, when more or less horizontal lighting emphasized every modulation of the surface. Of all the painters of the European past, Cézanne was the one whom the Cubists felt had most to offer them in their attempt to find a fresh way of depicting external nature, and it was from him that they took over the use of many small plane forms, usually rectangular or triangular.[10]

An early example of this is seen in the landscape by Braque, painted in 1909. A road winds up from the bottom centre, curving to the left and disappearing behind houses in the upper centre. On each side of it are houses, which are drawn not only with 'wrong' perspective, but with a series of planes which are ambiguous – how much of the front plane of the house in the lower centre is wall and how much roof? And the scale is changed violently and arbitrarily, so that the tree on the right has a size which would place it far nearer the observer (and somewhat out of focus), but also seems to fuse with, or arise behind, the central house. As a result of this ambiguity it is impossible to see a scene which recedes commonsensically in depth, way behind the canvas; instead one keeps alternating between feeling that some regions go back into the distance and then seeing nothing but a pattern of painted shapes on the flat of the canvas. This refusal to 'break the picture plane' – to pretend that the picture is not what it really is, pigments on a flat piece of canvas – is one of the most characteristic modern preoccupations of all painters who have been influenced by Cézanne and the Cubists.

▶ In the first great heyday of Cubism, around 1910–11, Picasso and Braque concentrated their efforts almost entirely on the creation of this kind of new and ambiguous space, which enveloped and flowed over and around the objects in the picture. For this purpose they used sets of small, as-it-were transparent, and usually straight-edged planes, and to a large extent they abolished colour, painting in a muted series of greys, off-whites, umbers and blacks. A typical example is Braque's *Composition with violin,* opposite page 13. As this shows, the 'objects' themselves became almost lost; it is difficult enough to discern the violin – horizontally placed, with its scroll to the right and its body on a table whose near edge can be seen in the lower right. Many other pictures, in this period of so-called Analytical Cubism, were even more obscure to read. This seems to have dissatisfied the artists, who felt that they were, or should be, exploring a new way of expressing something about reality. They did not fully realize

that the quality of 'all-overness' and interpenetration of forms which they had achieved, even when used in a completely abstract picture in which no object is recognizable, does serve to convey some concept of what material reality is like. It was only much later, when scientific ideas of this kind gained wider currency, that artists accepted such pictures as sufficient in themselves. Picasso and Braque felt that they had to introduce some more definite reference to normal appearances. They did this in an odd way. They attached to their canvases sometimes actual objects, such as a nail or a piece of string, more often areas – usually more or less rectilinear, like the painted planes – of materials such as newspaper or wallpaper, which carry detailed texture or pattern easily recognized as belonging to the world of commonsensical reality. Having pushed out structure at the level of the construction of solid objects, they brought back everyday appearances at the level of flat areas of texture.

It was a move that was insidious in its consequences. It soon began to lead both to the introduction of stronger colours and to a weakening of the quality of transparency. Picasso's *Violin in the café* of 1913, for example, was painted soon after the introduction of the gummed paper (*papier collé*) technique. There is actually no gummed paper in it, but some of the rectangular planes are painted to resemble things, such as grained wood veneers, which had been stuck on to other pictures; and the planes have become more uniformly rectangular and less often transparent. There is a more definite focal area, and we are beginning to lose the sensation that we are confronted with an indefinitely extended field in which every discernible element is reacting with, or even interpenetrating, every other.

It was in this direction that Cubism actually developed. A new major figure began to exert an influence on its evolution. This was Juan Gris, a Spaniard who for some years had a studio in the same building as Picasso, and began to follow Picasso's lead into the Cubist field in about 1911. He was a considerably more intellectual and theorizing painter than either Picasso or Braque, and seems to have been the one in the circle most closely in touch with 'the mathematician' Princet, mentioned above. From the beginning, Gris's paintings look as though they have a more consciously worked-out system of composition. And, after a few years, he formulated a definite theory of *Synthetic Cubism,* according to which the organization of a picture should be mapped out in the form of an overall plan, which might even be arrived at with the aid of mathematical formulation of relative proportions of areas, etc.; only after this should an attempt be made to find suitable niches within the design to place the more or less representational signs by which the 'subject' could be recognized. He was in fact, one of the

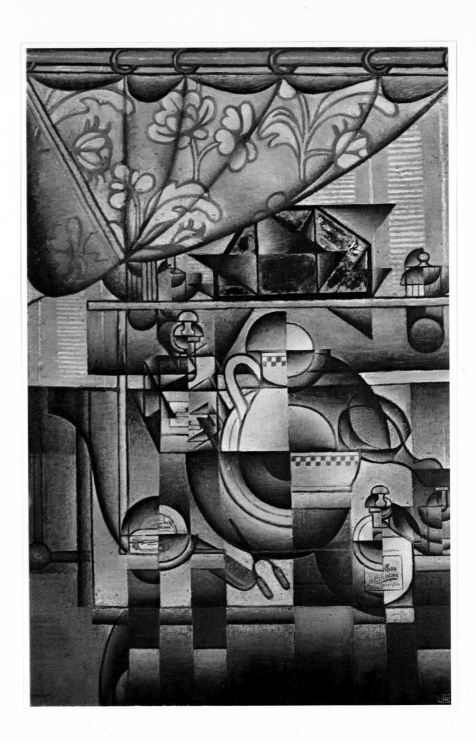

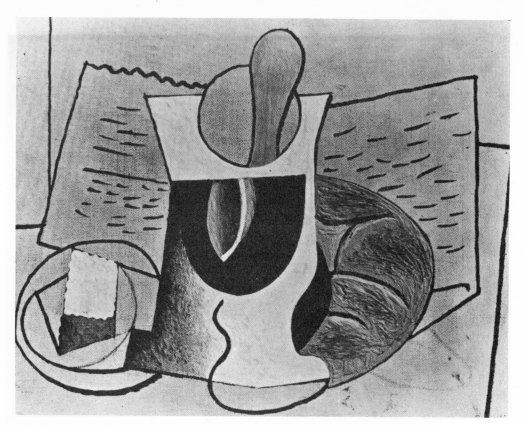

11. *Picasso. Breakfast (1923)*

first of that lineage of painters leading all the way from him to Max Bill (p. 205 ff.) who have attempted to bring intellectual and scientific thought in a fully conscious way into the very beginning of their creative process. He was, at his best, very successful, at least as much so as any of the Constructivist school of later years. But at the same time he was one of the influences, co-operating in the internal development of Cubism that we have described, which combined to bring about a loss of the very profound scientific feeling for the mutual involvement of things that had been expressed in the earlier analytical cubist works of Picasso and Braque, for whom science was not at the beginning of their creations, but was in some way deeply buried within them, at a level *before* creation started.

It is very difficult for a painter to avoid the danger, in being consciously scientific, of becoming only superficially scientific.

Cubism, in the years after about 1913, developed into a movement which produced magnificent paintings, but it ceased to have much direct connection with those aspects of our culture in which science and art find common ground. We shall not, therefore, trace its developments any further. One example, from a fairly early phase in Picasso's evolution, is shown above. We shall see in Chapter 6 (p. 198) that the second major episode of modern painting which emphasized the interpenetration of things – the Abstract Expressionism of around 1945–55 – had among its succes-

sors at least some painters who reacted in a direction not unlike that followed by Picasso.

▶ Very soon after the first Cubists had made the definitive break with the old conventional modes of representation, the new formal freedoms were used by many painters of diverse kinds. There were not only those who formed the 'school' of Cubism, such as Gleizes, Metzinger, Herbin, Marcoussis, Gris, and Villon, but a number of others whose intentions were more or less markedly different from those of the Cubists. For instance, Robert Delaunay and his wife Sonia began about 1912 to paint entirely non-representational pictures, employing mostly circular or rectilinear forms; but the problem in which he was interested was not any type of representation of a three- or four-dimensional space. He was concerned with light and colour, with the utilization of contrasts to intensify the vividness of his colours, or to cause a 'vibration' by giving rise to sensations of induced colour. This lyrical art, which Apollinaire christened *Orphism,* thus owed to the scientific strand in Cubism no more than its licence to be free of conventional shackles. It had great influence on the use of colour by the German expressionist painters of the twenties, perhaps even on Kandinsky, but it contributed little to the more science-conscious types of painting with which we are concerned, although perhaps it lies in the background of the interest in induced colour developed by one of the latest schools of geometricizers, that of Max Bill (see p. 204).

[5] *Gris. Le lavabo*

21

Another artist who was liberated by Cubism in its earliest years, and whose work at first sight appears related to science, was the Parisian Czech, Kupka. Again around 1912, he began producing works built of areas of colours defined by straight or simply curved lines. They have no explicit reference to any external objects, although some, such as a great *Philosophical Architecture* of 1913, could be taken as an abstract landscape of a sky-scraper city, rather like the *City* pictures of Léger. However, as Kupka himself has explained, he was really trying to produce the pictorial equivalent of formally organized music. Indeed, he gives some of his works titles like *Amorpha, fugue in two colours*; and when he calls one *Newton's Rings*, this is not intended to imply that scientific ideas had any important influence on its conception, but only that the areas of colours had been chosen within the limits set by the consideration that they should add up to white light. 'I think', he wrote in 1913, 'that I can find something between sight and hearing and that I can produce a fugue in colours as Bach did in music. In any case, I cannot any longer be content with servile copying . . . a sort of pictorial geometry of thought, the only kind that remains valid, deflects the painter less than a lot of lies.'[11] Kupka was, in fact, a profoundly introspective painter, using superficially cubistic forms for purposes quite unrelated to an exploration of the nature of the real world.

12. Kupka, study in black and white, gouache

[6] Delaunay. Fenêtre (1912)

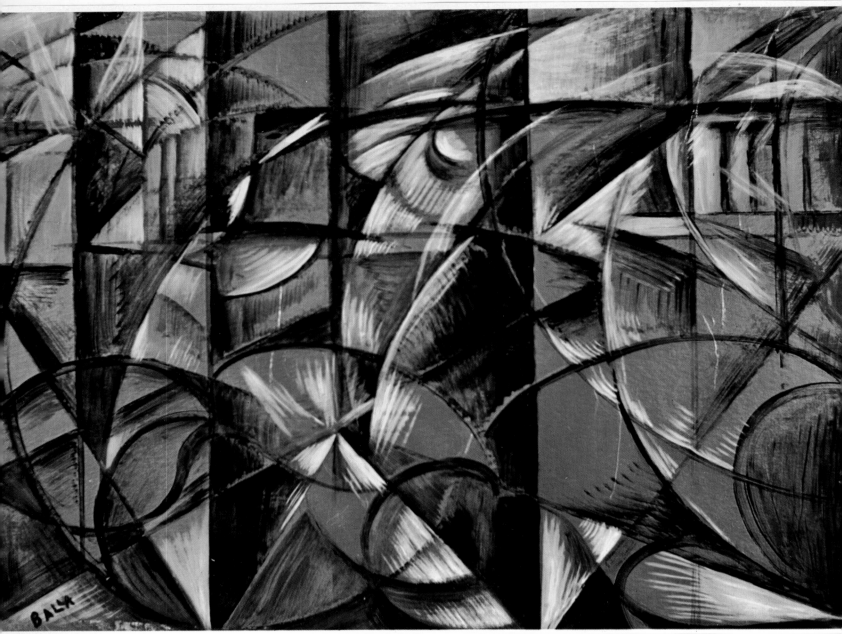

Reactions to the science-based environment

[7] *Balla. Vitesse d'automobile-lumière (1913)*

Most of the artists who used the geometrical ruler-and-compasses vocabulary of forms, and who were, unlike Delaunay and Kupka, interested in the world of science, were attempting something more sophisticated than merely to give their pictures a 'scientific' look. In some cases, however, what they were trying was not very much more than that; there were several groups for whom the visual appearances of scientifically produced objects and constructions was of serious interest.

One such group was that of the Futurists. This was essentially an Italian group, that began producing geometric-looking paintings almost as early as the French Cubists. Indeed, there is still room for argu-

ment whether their leader Marinetti had actually seen any of the Parisian work before he himself produced something rather similar. The Futurists were fascinated, not so much by the nature of scientific activity and the boldness of its intellectual conceptions, but rather by the excitement they felt about the new apparatus which science made possible.

The general character of the movement is well expressed in the *Initial Manifesto of Futurism*[12] (20 February 1909), from which the following paragraphs are taken:

4. We declare that the world's splendour has been enriched by a new beauty; the beauty of speed. A racing motor-car, its frame adorned

24

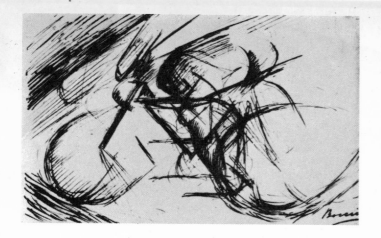

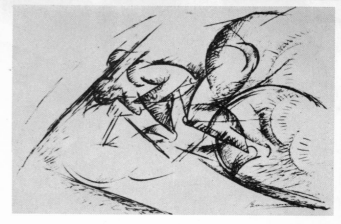

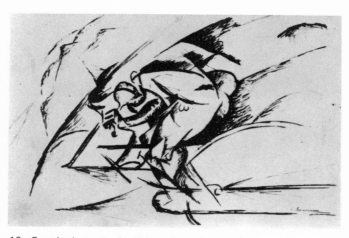

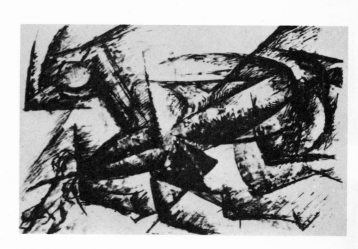

13. Boccioni, studies for 'Dynamism of a cyclist'

with great pipes, like snakes with explosive breath . . . a roaring motor-car, which looks as though running on shrapnel, is more beautiful than the *Victory of Samothrace.*

5. We shall sing of the man at the steering wheel, whose ideal stem transfixes the Earth, rushing over the circuit of her orbit.

6. The poet must give himself with frenzy, with splendour and with lavishness, in order to increase the enthusiastic fervour of the primordial elements.

7. There is no more beauty except in strife. No masterpiece without aggressiveness. Poetry must be a violent onslaught upon the unknown forces, to command them to bow before man.

8. We stand upon the extreme promontory of the centuries ! . . . Why should we look behind us, when we have to break in the mysterious portals of the Impossible ? Time and Space died yesterday. Already we live in the absolute, since we have already created speed, eternal and ever-present.

9. We wish to glorify War — the only health giver of the world — militarism, patriotism, the destructive arm of the Anarchist, the Beautiful Ideas that kill, the contempt for woman.

10. We wish to destroy the museums, the libraries, to fight against moralism, feminism, and all opportunistic and utilitarian meannesses

11. We shall sing of the great crowds in the excitement of labour, pleasure, and rebellion; of the multi-coloured and polyphonic surf of revolutions in modern capital cities; of the nocturnal vibration of the arsenals and work-shops beneath their violent electric moons; of the greedy stations swallowing smoking snakes; of factories suspended from the clouds by their strings of smoke; of bridges leaping like gymnasts over the diabolical cutlery of sun-bathed rivers; of adventurous liners. scenting the horizon; of broad-chested locomotives prancing on the rails, like huge steel horses bridled with long tubes; and of the gliding flight of aeroplanes, the sound of whose screw is like the flapping of flags and the applause of an enthusiastic crowd.

Speed and movement seemed to the Futurists the most important qualities of experience that were truly worthy of being called modern. They were not only fascinated by the shapes of the moving parts of machinery — pistons, cylinders, cranks, cog-wheels, and so on — but they tried a number of

ingenious devices to represent motion on their own necessarily static canvases. These devices in general led to the break-up of the forms of objects into a number of usually angular facets. This produced a superficial resemblance to Cubist pictures, but the intention was quite different. The Cubists were trying to represent an object in an eternal four-dimensional space-time continuum, in which temporal change and motion were no more and no less dynamic than the three dimensions of space but were treated on an equality with it. The Cubist tried to see an object from all directions at once; a Futurist, on the other hand, tried to represent simultaneously the different aspects an object would assume as it changed through time. The Futurist picture was, as it were, a cinema screen on which a length of film was projected in such a way that the earlier frames did not disappear before the later frames were superposed on them. The difference is very obvious if one compares, for instance, Boccioni's *Charge of lancers* with the Braque *Composition with violin* (p. 12), painted in very similar colours only a year or two earlier. But the Futurists were not usually so restrained in colour. A more typical work is Severini's *Dynamic Hieroglyph of the Bal Tabarin* (facing), which is a riot of swirling skirts, high-heeled shoes, girls with ringlets and cupid's bow lips, watched by a gentleman in a top-hat and eyeglass, with a number of little items, like the nude riding a pair of scissors, obviously put in for the hell of it rather than to meet the demands of theory.

▶ In spite of what seems to more northern ears the rather adolescent bombast of their manifestos, some of the Italian Futurist painters and sculptors, particularly Boccioni, Severini, and Balla

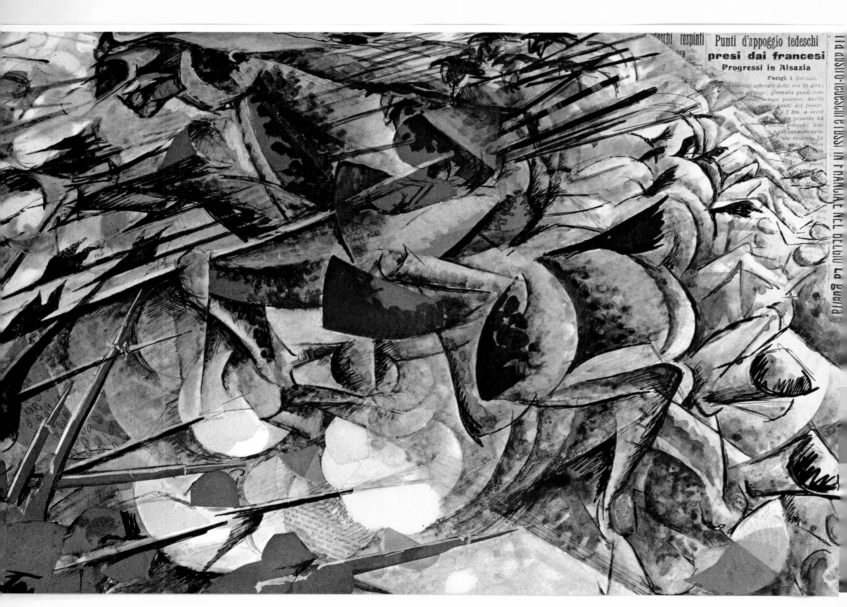

[8] *Boccioni. La charge des lanciers (1912—13)*

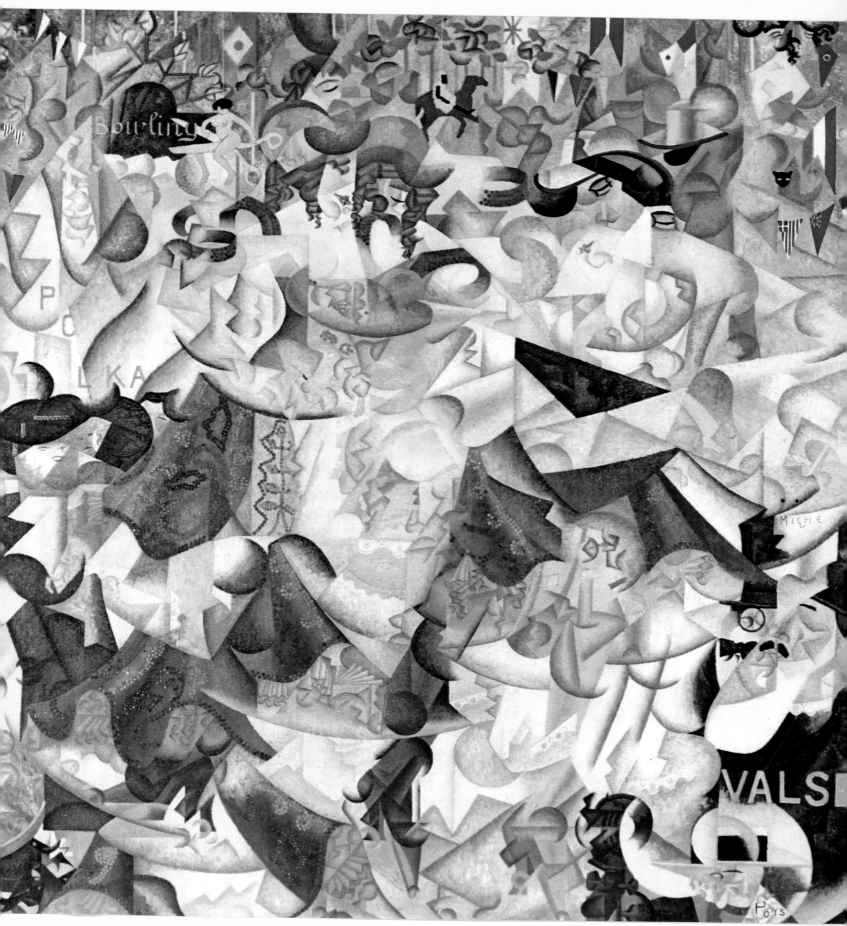

[9] *Severini. Hieroglyphe dynamique du Bal Tabarin (1912)*

produced very fine and impressive work that had a considerable influence in Paris – which at that time, even more than later, considered itself the hub of the art world, and was not very ready to be taught its business by mere provincials. It was in fact a Frenchman who produced what can be considered the masterpiece of painting in the Futurist mode – the *Nude descending a staircase* of Marcel Duchamp. Duchamp has always been expert in surrounding his work with an unusually dense fog of free-associated words, but the *Nude* came early in his career and is a relatively simple work, showing, somewhat geometrified, the successive positions of a nude girl walking down a staircase from top left to bottom right of the picture. From an abstract visual point of view, the picture in itself, as an arrangement of differently coloured and toned areas, is harmonious, striking, and beautiful, and as representation it really conveys a sensation of a graceful movement. It is therefore very successful in what it set out to do.

Duchamp[13] points out that he did the *Nude* independently of the Futurists, in fact beginning it before their first Paris exhibition. He says: 'My aim was a static representation of movement – a static composition of indications of various positions taken by a form in movement – with no attempt to give cinema effects through painting. The reduction of a head in movement to a pure line seemed to me defensible. . . . Reduce, reduce, reduce was my thought.'

Another Parisian artist, Picabia, reduced even further in the representation of movement. He was an eclectic character who tried his hand at many of the experimental styles of the early cubist years – the Orphism of Delaunay before his excursions into Futurism and then Dada. In 1913 he produced a number of paintings of a dancer, Udnie. Dancers were a favourite theme of the Italian Futurists, particularly of Severini. In his works there is always some representation of the physical presence of the dancing girl. In Picabia's *Udnie* a complete abstraction has been made from external reality; the forms and colours suggest a rapid swirling movement, but there is nothing that is, recognizably, a skirt or arms or legs.

But this degree of abstraction was rarely attained by futurists. Their paintings were usually pictorial syntheses based on the superposition of successive poses taken from a sequence of movements. As Duchamp says[14]: 'Chrono-photography was at that time in vogue. Studies of horses in movement and of fencers in different positions as in Muybridge's albums were well known to me. . . . There were discussions at the time of the fourth dimension and of non-Euclidean geometry. But most views of it were amateurish. . . . For all our misunderstandings, through these new ideas we were helped to get away from the conventional way of speaking – from our café and studio platitudes.'

▶The Futurist movement was a short-lived one. In Italy it collapsed primarily because of the involvement of the main painters in the 1914–18 war, in which Boccioni and the architect Sant'Elia died. Marcel Duchamp also did not effectively pursue it; and the manner in which his activity developed, or failed to develop, is interesting and informative about the difficulties that have faced painting which has tried to come to terms with the scientific age. Duchamp was a man of great intellectual powers and penetration. He was not content merely to go on repeating, even with slight developments, his early Futurist attempts to capture motion on canvas. He must, one supposes, have had sufficient intellectual insight to see that this is not much more than a gimmick. The Futurist enthusiasm for industrial machinery, and such technological products as motor cars and aeroplanes, was also not likely to satisfy for long a man of such intelligence. Duchamp painted a number of pictures in which the forms seem to be derived from the retorts, pipes, condensers, of chemical industry (e.g. *The Bride*, p. 30); but by the 1920s, far from showing the naïve enthusiasm of the Futurists for industrial products, he was clearly guying them, adopting an attitude related to that of the Dadaists, whom we shall discuss later. He sent, to exhibitions of sculpture, items such as a mass-produced bottle rack or a ceramic urinal, which he designated *Ready-mades*. This was a manifestation of a completely Nihilist outlook, a total debunking of the development of art by rational intelligent thought. The exhibition of ready-mades implied first of all that what the artists were trying to do, industry (without thought of artistic ends) could do better; while, by his choice of objects, Duchamp seems to have expressed the opinion that what industry produced was pretty sordid stuff as a contribution to man's apparatus for living the good life.

This general attitude of mind, rather common among artists shortly after the First World War, was allied with movements which had much more positive contributions to make, particularly with Surrealism, which involved an emphasis on faculties of the mind which are not intelligent, or at least not verbally intelligent. Duchamp was apparently not able to develop in this direction. On the other hand, he saw through the shallowness of merely producing, or even using, industrial products. A recent Italian artist, Marino Marini, put the point very simply when criticizing the Futurists[15]: 'Machines change their style so rapidly. If one tries to reproduce them in art as realistically as man and horse in classical art, one immediately lapses into a kind of anecdotic or documentary art, like that of old engravings representing fashions for women. A balloon or an automobile will appear, in art, as silly as a bustle. Only the stylization of a painter like Léger could integrate the machine as the subject matter of art.'

[10] *Picabia. Udnie (Young American girl, or the dance) (1913)*

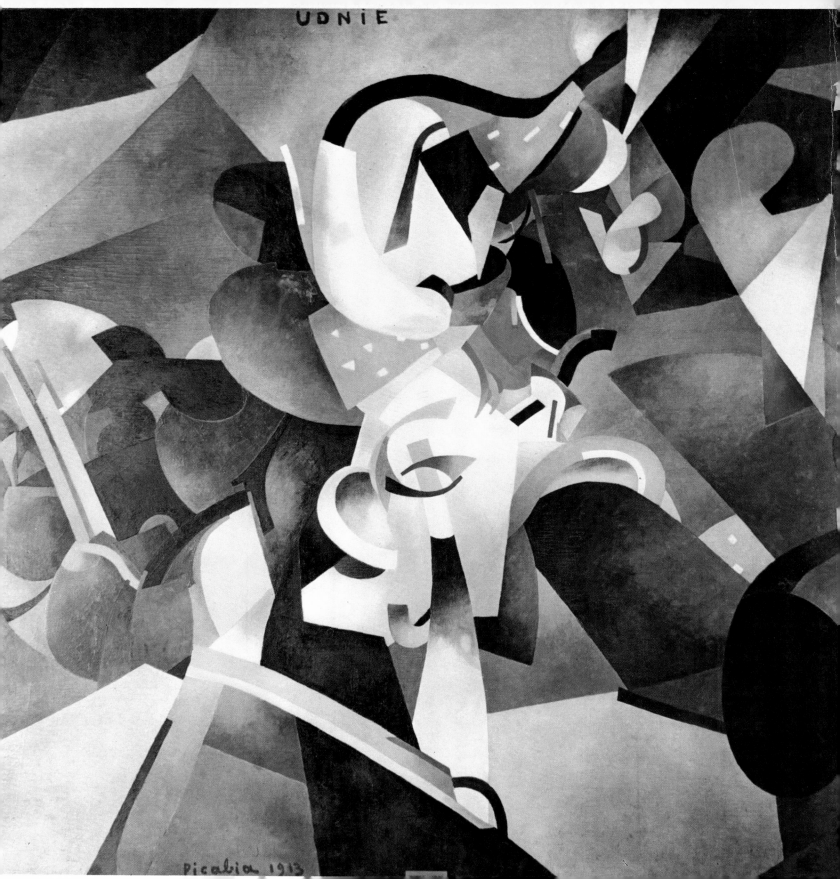

UDNIE

Picabia 1913

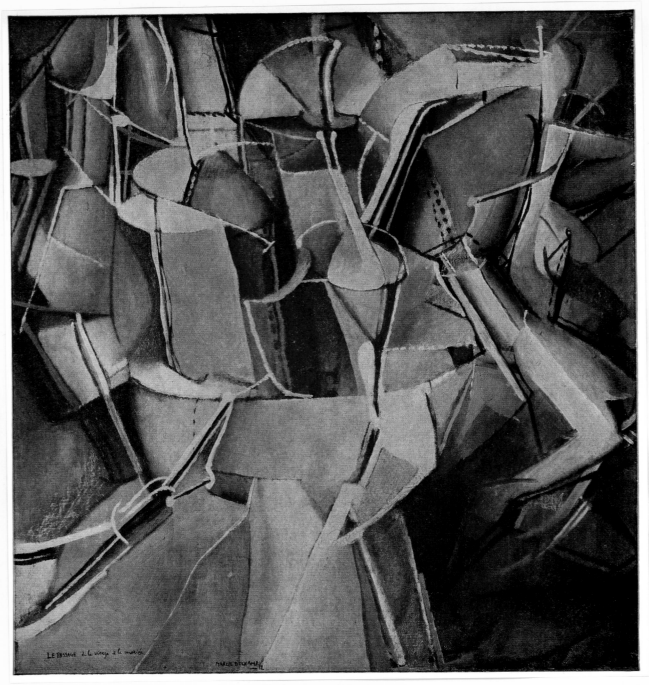

[11] Duchamp. The passage from the virgin to the bride (1912)

Duchamp in effect found it almost impossible to paint anything at all. He seems to have spent most of his life in this quandary. As quite a young man he wrote a series of aphorisms, as short jottings on slips of paper which were kept in a green box, an object which, with his flair for publicity among the avant-garde, he has succeeded in surrounding with an aura of mystery and almost of veneration. Among the notes in it are some which show that he was considerably interested in certain scientific mathematical procedures, such as projective geometry.[16] For instance, 'the *pendue femelle* is the form in ordinary perspective of a *pendue femelle* for which you could perhaps try to discover the true form. This comes from the fact that any form is the perspective of another form according to a certain vanishing point and a certain distance. . . .' Again, he jots down a piece of nonsense which is clearly derived from a reading which embraces both the theory of numbers and the logical analysis of language: 'The search for *prime words* ("divisible" only by themselves and by unity)'. But perhaps most significant is a 'poem' in which he considers how to refer to a picture by

some words which would make it clear that it was not really a picture at all:

DELAY IN GLASS

Use *delay* instead of *picture* or
painting; *picture on glass* becomes
delay in glass — but *delay in
glass* does not mean *picture
on glass* —
Its merely a way
of succeeding in no longer thinking
that the thing in question is
a picture — to make a *delay* of it
is the most general way possible. . . .

In the last forty years — since he is still alive, living in New York — the very few artistic works which he has produced have had as much as possible of this character. Most famous is a great composition, *The Bride stripped bare by her Bachelors even*, painted on glass, which has then been broken and roughly put together again. It is provided with a long and elaborate verbal commentary which purports to describe the various items in the picture in terms of pieces of machinery which, however, it is extremely difficult for the uninitiated observer to relate to what he sees before him. Duchamp is in fact someone who tried, by conscious thought, to relate painting to the world of science, but found himself too clever, and perhaps there was not enough oil paint in his blood, so that the whole enterprise came to a standstill concealed by a certain amount of impenetrable verbiage. He has actually spent most of his time in recent years as a chess master of international reputation.

▶ Besides the Futurists and Marcel Duchamp, there have been others who have tried to develop an art based on the subject matter provided by industrial artefacts. There were, for instance, many Americans around the period from 1915 to 1930 who treated industrial products and urban landscapes in a number of different, though all vaguely Cubist, styles. Some of these approached their material with an enthusiasm and romanticism almost as exaggerated as that of the Italian Futurists. For instance, Stella, painting Brooklyn Bridge in 1917–18, wrote[17]: 'To realize this towering imperative vision I live days of anxiety, torture, and delight alike, trembling all over with emotion. . . . Upon the swarming darkness of the night, I rung all the bells of alarm with a blaze of electricity scattered in lightnings down the oblique cables, the dynamic pillars of my composition, and to render more pungent the mystery of my metallic apparition, through the green and red glare of the signals I excavated here and there caves as subterranean passages to infernal recesses.' Others, such as Demuth, Sheeler, Spencer, and Feininger, produced calm and static arrangements of angular, clean surfaces silhouetted against one another like the facets of a crystal. But in spite of the height-

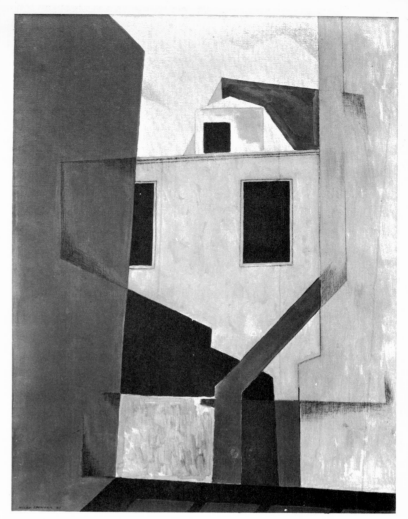

14. *Niles Spencer. City Walls (1921)*

ened emotion or the carefully planned harmonious composition, these pictures were essentially illustrations of a scene.

Before artists could make an important contribution to our comprehension of the industrial world, more was required than a mere reflection or even a reflection involving some comment. There had to be the creation of a pictorially symbolic language related to, but not merely copying, the contours and shapes that industrial processes involve. Of the American industrial school, the most successful in achieving this was Stuart Davis. His shapes and colours were related, not so much to industrial machinery or technological apparatus as to some other characteristics of the machine-age environment, such as the straggling wire-bearing poles, the tatty but bright-coloured hoardings and carpentered domestic architecture, which are such an insistent part of the American edge-of-town landscape. Using stylizations of such features, he painted, during the 1930s and later, a series of works which are attractive and exciting chiefly because of their energetic, uninhibited, and self-confident rhythms. They have many of the qualities of the

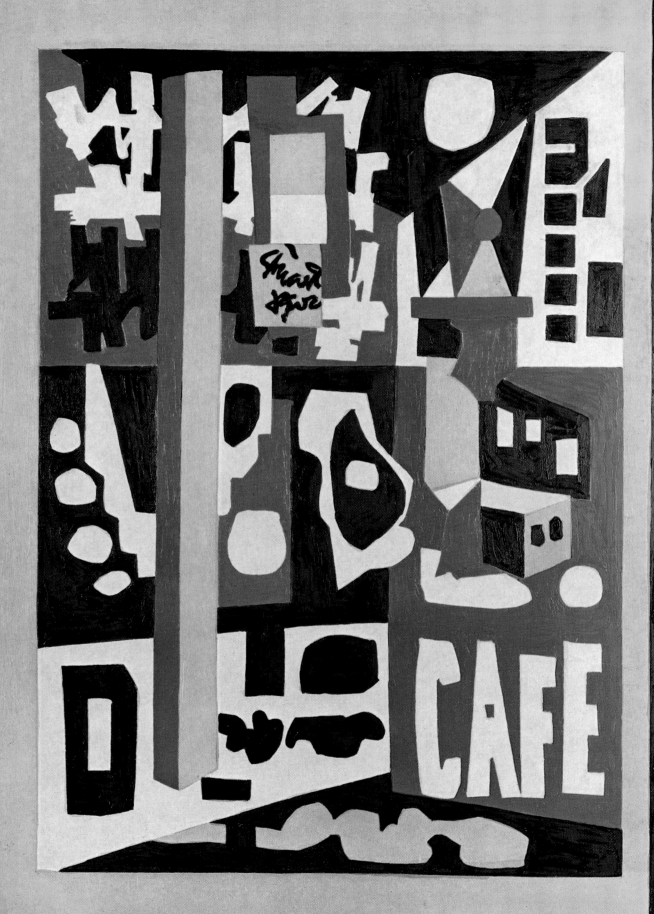

good jazz of the era — not, perhaps, the penetrating lyricism that Louis Armstrong could attain at his best, but with the dash and style of Bix Beiderbecke and the Dorsey brothers; Chicago-style stuff in fact, very good of its kind, but not by a long way the whole story of the impact of science on modern painting.

▶ A more staid, but also more profound — and incidentally earlier — attempt to develop the machine-based vocabulary of painting is that of the Frenchman Fernand Léger.[18] He was associated with Picasso, Braque and Gris in quite early days of Cubism, and his earliest distinctive style, around 1913, had something of the all-over quality of interpenetrating semi-transparent elements which were so characteristic of Analytical Cubism, although in Léger's paintings these elements were usually more or less cylindrical rather than plane surfaces (p. 34). As a French citizen he was swept up into the army at the outbreak of war. In the intervals of his service in the trenches, he produced a number of paintings, fully Cubist in style, whose subject matter was taken directly from his experiences at the Front. After the war he began a long series of works, continued until his death in 1955, devoted to finding a way of painting which would be both contemporary and socially responsible, in the way Léger understood these terms.

He set himself no easy task. His paintings were not only to use shapes and forms clearly related to a mechanical and industrial technology, but were to be of a kind which would give pleasure to simple and unsophisticated working people. The result was a style characterized by great simplicity, precisely delineated boldly modelled forms, usually with a smooth, almost metallic, texture, and with shapes reminiscent of metal pressings and the products of the lathe. This vocabulary was used for works which fall well towards the representative end of the spectrum of modern painting. At first, just after the war, in some of the works that I like best, he kept the early Cubist all-over pattern, for instance in *Wheels and the City* (p. 37). Later he tended to deal with more isolated and easily-identifiable objects. In most of his later work the subject matter — buildings, constructions, people — are instantly recognizable. He has expressed his intentions as follows[19]: 'This people which every day creates objects manufactured in pure colours, in definitive forms, with exact measures, has already discerned the possible real, plastic elements. You will find aeroplane propellers as wall ornaments in a popular dance-hall. Everybody admires them, and these propellers are very close to certain modern sculpture.

'With very little effort these people will feel and understand what is meant by the new realism, which has its origin in modern life itself, in its constant phenomena, in the influence of manufactured and geometrical objects, in a transposition where the imagination and the real meet and over-

15. *Léger, still life (1924)*

lap, but from which all literary and descriptive sentimentalism has been banished, as well as all theatricalism that has its sources in other poetic or bookish directions.' And again : 'What is the representative art that is being forced on these men when they are appealed to every day by the cinema, the radio, enormous photographic cut-outs and advertising? How is it possible to compete with these enormous modern mechanisms which turn out a vulgarized art at high pressure?

'It would be unworthy of their comprehension to attempt to manufacture a popular painting of inferior quality under the pretext that they would understand nothing else. On the contrary, an effort should be made towards quality in a tranquil, interior type of art. We should seek a plane of plastic beauty that is entirely different from the one just described.'

The simplicity of the forms, the boldness of the lines, and the clarity of the colours tend to give

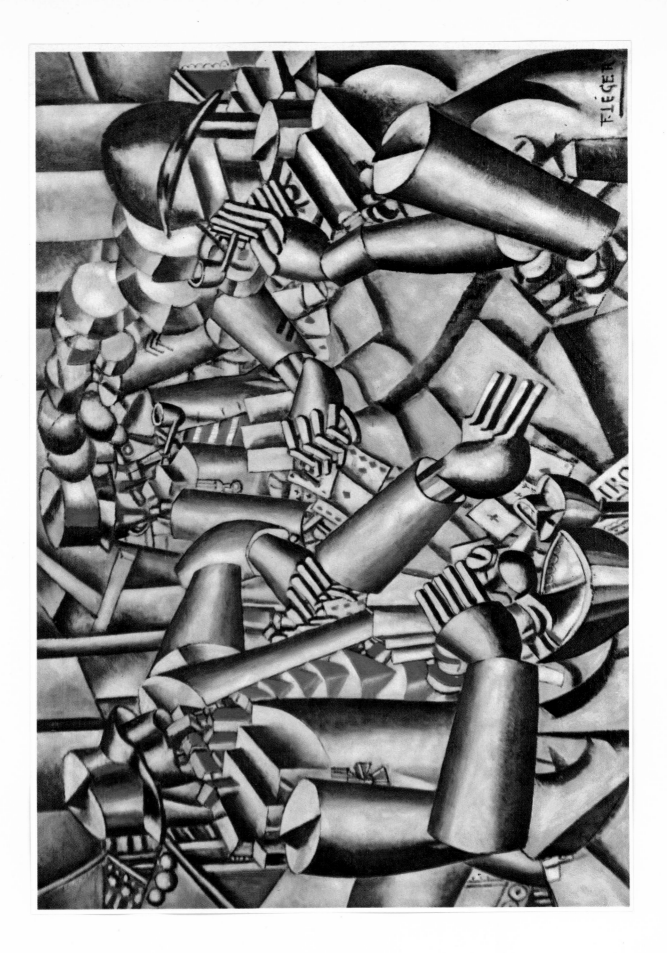

16. Léger, two heads (1920)

17. Léger, woman's head (1939)

most of Léger's productions a powerfully monumental feeling, even when their actual area is relatively small. Many of them indeed are executed on a large scale, since with his ever-present and very respect-worthy sense of the social importance of painting, Léger tended to accept commissions for works which would be exhibited in public rather than in private positions – murals for public exhibitions or other buildings for communal use.

It is an aspect of Léger's later work that seems to be derived from this striving after monumental quality that is perhaps the least satisfactory facet of his achievement. In his early works his forms had sharply defined edges, often outlined; and in still later works these black or dark outlines became one of the most immediately striking elements in the picture. It may be doubted whether they are interesting enough, as lines, to carry that weight. They have none of the ambiguous elegance of Picasso's line, the graceful play of Klee's, the wiry dash or sinuous subtlety of most Chinese and Japanese calligraphy. They have a rather heavy, slightly brutal, possibly flaccid look. Something like this character of line is, it is true, found in some drawings from those Oriental cultures which take line much more seriously than has been usual in the West. But what may be charming in a little Zen scribble, done in a mood of complete relaxation (and probably intoxication), is less so as the dominant element in a large mural. Léger spent much of the Second World War as a refugee in America, meeting there the painters who were developing a style in which the quasi-mechanical

simplicity of his earlier shapes was very out of fashion. His later line was probably an attempt to incorporate some of the values in which they were interested. Even if this attempt was not too successful, and if Léger's later work is in some way just not very endearing, he remains one of the men most worthy of respect and admiration among all those who have tried to express in paint the world of mechanical technology.

Even Léger does not escape Marini's criticism that mechanical shapes have a short fashionable lifetime. Technology changes the metallic machines to plastics, electronics, and atomic energy. The character of the scientific world is not to be caught in any particular set of artefacts.

▶ Still more superficial, though often decorative and attractive enough, have been attempts to embody 'scientific themes' in pictures painted according to the more or less recognized modern canons. The Swiss painter Erni[20] is probably the most impressive exponent of this line. Of no great pictorial originality, he is a very considerable technical virtuoso, even daring to produce etchings which blatantly invite comparison with Picasso – in which they come off second best, but not too

[13] *Léger. La partie de cartes (1917)*

D

ingloriously so. He has made a bold endeavour to incorporate into some of his paintings such scientific items as chemical formulae, portraits of Darwin, representations of crucial experiments, and so on. These are works that can be easily enjoyed; but they present too little challenge, and offer us no new interpretation of the basic character of the scientific world as something which calls forth new developments of the human personality.

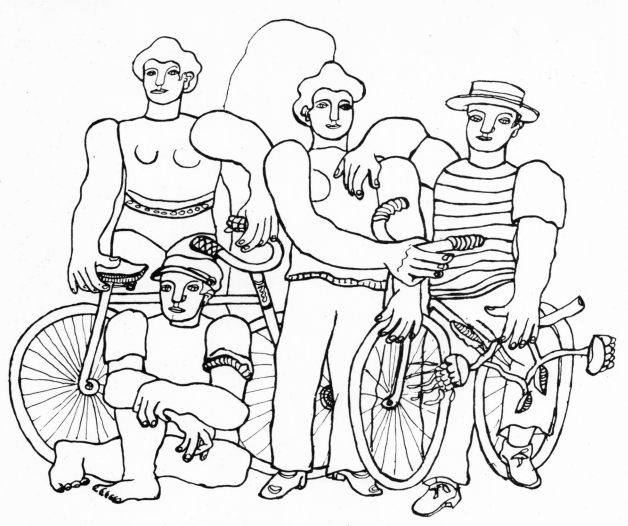

18. *Léger, drawing (1944)*

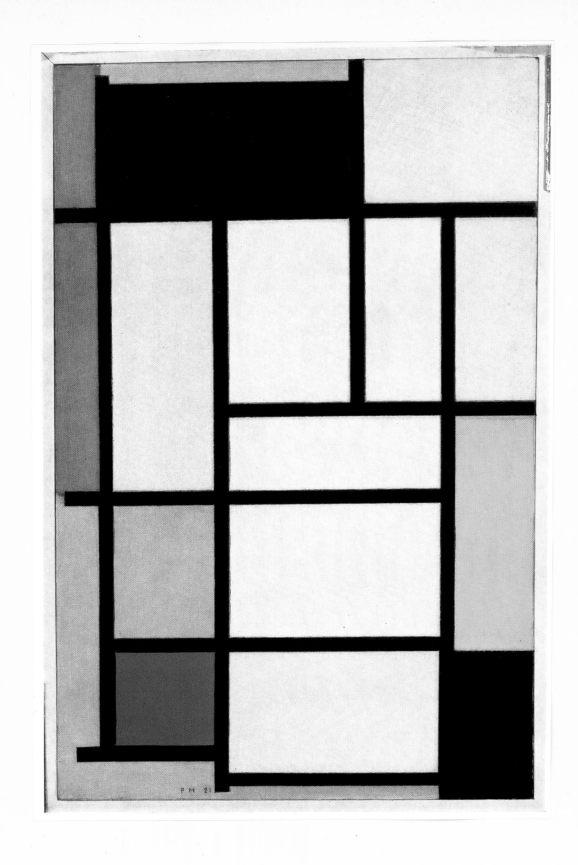

Painting a new reality

More interesting and more influential in recent painting has been the use of a vocabulary of geo-metrical scientific forms, not for the purpose of expressing the visual character of a technological civilization, but in an attempt to discover a form of painting which seemed congruent with the spirit of a scientific age. This is one of the great wide-spread tendencies of modern art. It includes a wide variety of movements which pass under a host of different names, some of the most important of which are the Neo-Plasticist and de Stijl groups in Holland, the Realists and Constructivists in Russia, many of the Bauhaus painters in Germany, and their successors like the Cold Art and Structuralist groups; and from this main line of tradition a great many branches have been put out connecting with other schools of thought.

The character of the whole movement was per-haps most fully represented in its two earliest manifestations – Mondrian in Holland and the Constructivists in Russia. Mondrian went to Paris around 1910, when Cubism was in its beginnings. He was particularly impressed with the work of Picasso and Léger, but he writes [21]: 'Gradually I became aware that Cubism did not accept the logi-cal consequences of its own discoveries, it was not developing abstraction towards its ultimate goal, the expression of pure reality. I felt that this reality can only be established through *pure plas-tics.* In its essential expression, pure plastics is un-conditioned by subjective feeling and conception. It took me a long time to discover that particulari-ties of form and natural colour evoke subjective states of feeling, which obscure *pure reality.* The appearance of natural forms changes, but reality remains constant. To create pure reality plastically, it is necessary to reduce natural forms to the *con-stant elements* of form, and natural colour to *pri-mary colour.* The aim is not to create other particu-lar forms and colours with all their limitations, but to work towards abolishing them in the interests of a larger unity.'

As this quotation makes clear, Mondrian was not trying to do anything so simple-minded as to produce 'scientific' pictures. He was trying to pro-duce pictures which expressed a sense of reality uncontaminated by any personal elements of the recipient, or even any local and contingent charac-teristics arising from things that merely happen to be there.

The notion that there is anything of value in eli-minating from a work of art both the subjectivity of the observer and the characteristic features of a particular scene would seem at first sight a very peculiar one. It had certainly hardly ever been en-tertained before, in anything like such a strong sense as Mondrian gives it, by artists of any kind. In fact, it is only the scientists who would have proclaimed their faith in any similar exclusion of personality and contingency. It was a doctrine of Second Science – which Third Science denies or at least profoundly modifies – that the observer has no place within, and must be kept out of, the picture. The character which Mondrian claims for his 'New Reality' is the character which was claimed by science for its reality, but which was claimed by no one else for theirs. 'It is my convic-tion,' writes Mondrian,[22] 'that humanity, after cen-turies of culture, can accelerate its progress through the acquisition of a truer vision of reality. Plastic art discloses what science has discovered: *that time and subjective vision veil the true reality.*'

It is for this reason, and not because he uses straight lines and right angles, that Mondrian is one of the most 'scientific' of painters. And it is because he based himself on what has turned out *not* to be one of the enduring major factors of science that his effort, although still fascinating in its purity and power, has come to have a pro-nounced flavour of history.

The scientific 'true reality' with which Mondrian was acquainted finds its expression in terms of energy which operates in a bare space-time con-tinuum, from which all trace of personality, or of the 'secondary qualities' revealed in human per-ception, have been banished. Mondrian never seems to have expressed any interest in the con-cept of an Einsteinian space-time as opposed to the conventional three dimensions. However, he combined, in a way which is certainly reminiscent of relativistic ideas, a disregard for particular histo-rical moments of time with a profound interest in the dynamic quality of happenings. Quite early in his career he wrote [23]: 'The problem [of painting] was clarified for me when I realized two things: (a) In plastic art reality can be expressed only through the equilibrium of dynamic movement of form and colour; (b) Pure means afford the most effective way of attaining this. When dynamic movement is established through *contrasts* or oppositions of the expressive means, relationship becomes the chief preoccupation of the artist who is seeking to create equilibrium. I found that the right angle is the only constant relationship, and that, through the proportions of dimension, its constant expression can be given movement, that is, *made living.*' And towards the end of his life he emphasized the point even more strongly [24]: 'It is important to discern two sorts of equilibrium in art: (1) Static balance; (2) Dynamic equilibrium. . . . The great struggle for artists is the annihilation of static equilibrium in their paintings through con-tinuous oppositions (contrasts) among the means of expression. . . . Many appreciate in my former work just what I did not want to express, but which was produced by an incapacity to express what I intended to express – dynamic movement in equilibrium.'

As these quotations make clear, and as a glance at his paintings show, Mondrian felt that he could

only attain the pellucid clarity and freedom from the accidents of the here-and-now that he sought if he restricted his means of expression to a few exceedingly simple forms. He might have echoed the words of Marcel Duchamp[25] : 'Reduce, reduce, reduce, was my thought', but I am not quite sure whether he would have followed Duchamp in the second half of that sentence : 'but at the same time my aim was turning inward, rather than towards externals'.

Mondrian did not merely restrict himself to simple geometrical forms, but at an early stage came to use only one such form, namely the rectangle ; and he was not impressed by one of his followers, van Doesburg, who arranged these rectangles diagonally within the frame of the picture. For Mondrian their edges must lie vertically and horizontally. Thus the pictures of his middle life, which most critics consider to be his best, consist of rectangles of pure colour arranged with vertical and horizontal edges. They have great clarity and simplicity, and the areas give the impression of being knit together into a unity. I think that to most observers this unity appears, as Mondrian complained, to be a static one rather than the dynamic equilibrium which he claims to have been seeking. Often indeed the pictures give the superficial impression of being the expression of some mathematical formula, but it seems to be quite clear that Mondrian did not use any type of mathematical calculation in deciding the proportions of his rectangles. Yet his constructions were certainly not spontaneously and quickly achieved. He kept the pictures in his studios for considerable periods, sticking to them rectangles or strips of paper which he could move about so as to investigate slight changes of proportion.

The final result depended not on calculation but on a choice by the free creative spirit. The pictures are not, as they might appear, 'scientific' in the superficial sense in which the diagrams in a textbook of geometry are scientific. It is significant that in his early life Mondrian was friendly with some of the Dada group, who are, on the surface again, the most obviously opposed of all movements of modern painting to scientific rationalism. In fact, according to a perhaps prejudiced witness it is true, Mondrian stated,[26] that of all the types of modern painters other than his own it was the Dada-Surrealist movement that appealed to him most.

▶ Perhaps it was this strain in his character, which is so easily overlooked when one takes a quick glance at the works of the 'classical' middle period, that led him to be a frequenter of dance-halls and admirer of jazz. They come to expression in another of his illuminating discussions of his intentions. In an interview during the Second World War, when he was living in New York and working on a series of paintings under the general title of *Boogie-Woogie*, he spoke as follows[27] :

'The intention of Cubism – in any case in the beginning – was to express volume. Three-dimensional space – natural space – thus remained. Cubism therefore remained basically a naturalistic expression and was only *an abstraction*, not true abstract art.

'This attitude of the Cubists to the representations of volume in space was contrary to my conception of abstraction, which is based on belief that this very space *has to be destroyed*. As a consequence I came to the destruction of volume by the use of the plane. This I accomplished by means of lines cutting the planes. But still the plane remained too intact. So I came to making only lines and brought the color within the lines. Now the only problem was to destroy these lines also through mutual opposition.

'Perhaps I do not express myself clearly in this, but it may give you some idea why I left the Cubist influence. True Boogie Woogie I conceive as homogeneous in intention with mine in painting : destruction of melody which is the equivalent of destruction of natural appearance ; and construction through the continuous opposition of pure means – dynamic rhythm.

'I think the destructive element is too much neglected in art.'

The last sentence seems surprising when taken in isolation, since Mondrian is pre-eminently one of the few modern artists who have actually succeeded in creating a type of 'new reality', an enterprise which so many have tried with very partial success. What he meant, I suppose, is that the creation of the 'Mondrian world' was only possible on the basis of the destruction of a great deal that had previously existed. For instance, he has written[28] :

'In general, all particularities of the past are as oppressive as darkness. The past has a *tyrannic* influence which is difficult to escape. The worst is that there is always something of the past *within us*. We have memories, dreams – we hear the old carillons ; enter the old museums and churches ; we see old buildings everywhere. Fortunately, we can also enjoy modern construction, marvels of science, technique of all kinds, as well as modern art. We can enjoy real jazz and its dance ; we see the electric lights of luxury and utility ; the window displays. Even the thought of all this is gratifying. Then we feel the great difference between modern times and the past.

'Modern life and art are annihilating the *oppression of the past*. Progress in communication, production, concurrence in trade, the struggle for livelihood have created a lighter environment, even where the inevitable remains of the past dominate. Electric signs, posters, technical constructions of all kinds, compensate for the dearth of new architecture.

'In war many relics of the past are destroyed, among them many beautiful specimens of art.

Obviously it is hard to see beautiful things disappear. But life, as continuous progress, is always right. Eventually another environment nearer to our present mentality will be created. But where? In the same places? In the same countries? It is important to understand that *the new constructions must not be created in the spirit of the past; they should not be repetitions of what has been previously expressed*. It must become clear that everything should be the true expression of modern times.'

As these quotations make clear, Mondrian was profoundly influenced by science, not only, as we saw earlier, in his adoption of an ideal of total objectivity, but also in the emotional content he attached to the artefacts he was creating. His pictures do not record any particular subjective experience, but he implies that they should give rise to a sense of joy or gratification similar to those aroused by the impersonal products of a scientific industrial technology.

▶ The best way to appreciate the character that Mondrian was aiming at in his pictures is by the good old-fashioned biological method of comparative anatomy. One can examine several related specimens to try to determine the common principles underlying their structure; and in this case we can also — which is not so easy in biology — compare them with an artificial specimen from which these principles are lacking. The illustrations overleaf display four versions of a composition painted by Mondrian in 1930 – 31, and

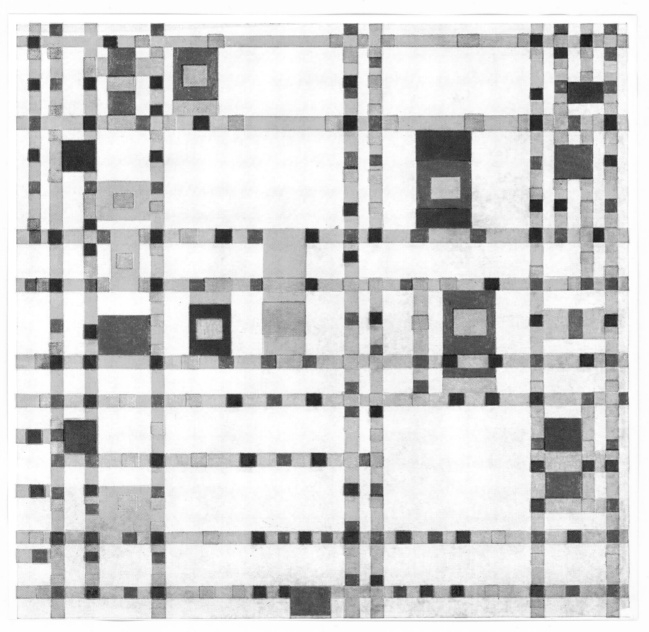

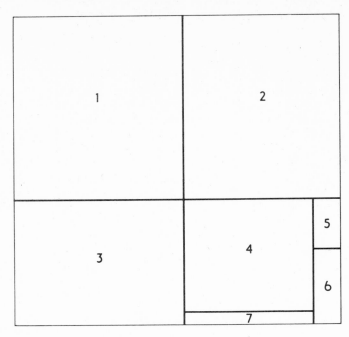

19. Key to Mondrian paintings, opposite

also, in *E*, a 'pseudo-Mondrian' constructed by myself with complete disregard to the principles involved in the others.

The first point to note is the manner in which Mondrian varies the proportions of the areas in a coherent manner over the whole field of each picture. In composition A all the rectangles have a 'squarer' appearance. Area 4 is almost square, while 1 and 2 are equal in width and only slightly taller than wide; 5 is somewhat shorter than 6, but its importance is emphasized, not only by its colour (which is fairly dark in tone), but by the heavier horizontal bar between 5 and 6. The whole picture is a perfect square, and the slight feeling of greater height, stemming from the taller proportions of rectangles 1 and 2, is counteracted by the fact that the main horizontal line, as well as the short bar between 5 and 6, are both heavier than the vertical lines. In compositions B and C there is a more complex interplay between squareness and non-equilinear rectangles. In B, the areas which are emphasized by colour (1 and 5) are markedly higher than wide; but this is counterbalanced by the fact that the large area 4, which strikes the eye because of its bold outlining, is very clearly wider than high; this broadness is played off, not only against the height of areas 1 and 5, but against the fact that the canvas as a whole is taller than wide. The main theme here being the areas, the lines are all of more or less equal thickness, except for the small horizontal boundary between 5 and 6; this, and the shallow depth of area 7, add a certain horizontal emphasis to the 'assistance' of rectangle 4. In composition C we are back again at a rather squarer system, but, in contrast to A, the area 1 is now also emphasized by colour. To balance it, 5

has been enlarged and more strongly coloured, so that 1 and 5 now make two strong elements whose tendency is vertical, though not exaggeratedly so. Since the whole canvas is also exactly a square, this verticality can be held without making area 4 noticeably wider than high, though it is actually very slightly so; and the horizontal lines are also somewhat heavier than the verticals. Since none of the main areas are so unequal-sided as they were in B, area 7 is also higher than it was in that picture. In the version D, the proportions of the main areas are rather similar to those of C, but, since the colour of the large area 1 is much lighter, its vertical effect is reduced; the other coloured vertical area 5, which echoes it, is also lighter, and is not so tall. This playing down of the verticals calls for less emphasis on the horizontal elements, and this has been achieved mainly by a drastic lightening of the main line between the upper and lower halves of the canvas.

As this analysis shows, the Mondrians are controlled by systematic relations between the vertical and horizontal proportions of the rectangles, which affect also the thickness of the lines by which these areas are defined, and the intensity of the colours. Any doubts as to the reality of this organization should be dispelled by a glance at the 'pseudo-Mondrian' in version E. Area 1 is somewhat broader than high, and is no longer echoed by 5, which is still vertical in proportion; area 4 is also slightly vertical, but its effect is rendered equivocal by the heaviness of the lines both on its right vertical side and its lower horizontal edge. The greater width of the main vertical in comparison with the main horizontal has no obvious bearing on anything; and the weakness of the lower edges of 5 is unrelated to the weight of the line under 4. The whole system is obviously disordered — a fact which may make it easier to recognize that the Mondrians all belong within a system of structural order, difficult though it would be to describe the whole system in words.

The principles of organization in Mondrian's pictures are not 'scientific' in the sense that his exclusive reliance on a simple geometry of right angles and straight lines might lead one to expect. The rectangles are only rarely precisely square, and there is usually no simple arithmetical relationship between the lengths of the sides. The kind of 'balance' which was recognized in the analysis in the last few paragraphs is more akin to the type of relationship which the biologist encounters in the overall body-form of a healthy animal than to anything expressible in mathematical terms as simple as the geometry seems to imply. Other painters, at a later date, have made 'Mondrian-like' pictures in which, indeed, the lengths and other quantitative aspects of the structure are derived by the application of simple arithmetical rules. As we shall see in Chapter 6, workers such as Max Bill have been able to extract a particular excitement and interest just

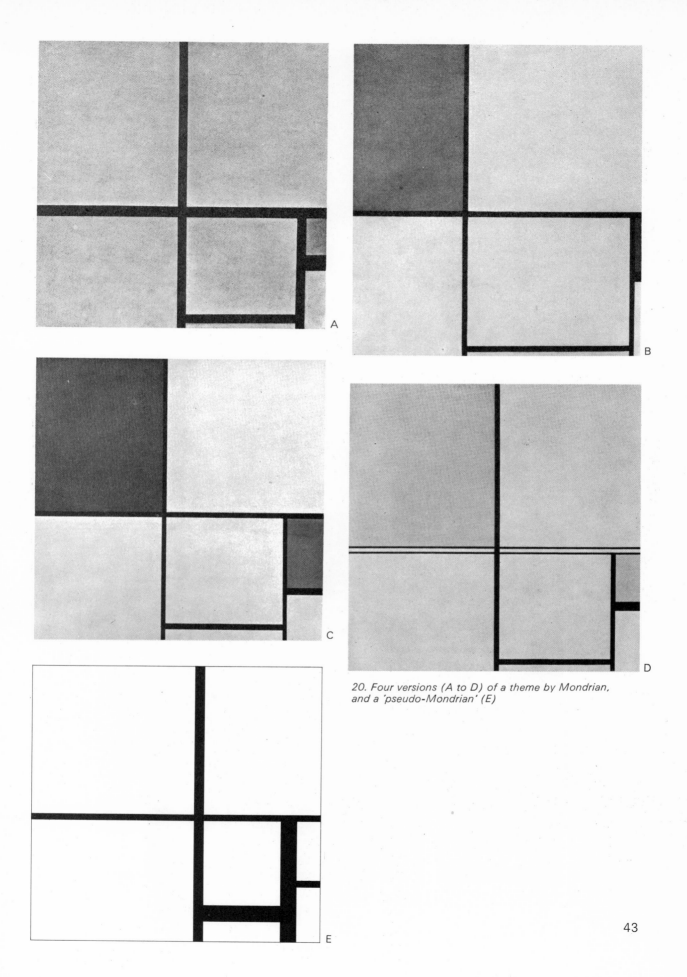

20. Four versions (A to D) of a theme by Mondrian,
and a 'pseudo-Mondrian' (E)

43

from the use of a logical structure which the spectator can grasp (with perhaps a little assistance !).

This was not Mondrian's purpose. One may, in fact, raise the question whether he did not fall between two stools. In the attempt to produce a new 'real world', from which the subjective would be excluded, he first decided that he must use forms only of the most severe and simple geometry, since he seems to have felt that they express the quintessence of the objectivity of science ; and he then places them in relations with one another which are anything but simple and 'scientifically' clear-cut — which can, indeed, hardly escape being called 'subjective'. Now the first conclusion, that science is characterized by dealing with simple precisely defined entities, was already out of date at the time Mondrian reached it. It is a hang-over from the period of over-confident Newtonian physics. The Analytical Cubists, with their transparent interpenetrating planes and their talk about the Fourth Dimension, had already gone beyond such a simple view of objectivity, to realize that science had moved into a phase when its basic concepts have soft edges — like electromagnetic waves, electrons spinning in variable orbits around atomic nuclei, and the other notions of quantum-relativity physics. Modern science tends to be precise, not in the definition of the entities with which it deals, but in its statement of the relations between the entities — exactly the opposite of Mondrian's practice.

Within his own country, Holland, Mondrian's example provided the main guiding principle for a group of artists — of whom the best known are van Doesburg and Vantongerloo — who in the decade from 1916 onwards formed a more or less coherent group known as De Stijl. They worked not only as painters but also in such applied arts as typography, furniture design, and architecture. Their most striking characteristic was the dominance of the straight line, the plane, and the right angle. From our point of view in this book it might be claimed that the group did not go beyond, and usually fell short of, Mondrian's attainment of a state of pure objectivity, and that to some extent they sacrificed this spiritual aim for the particular set of supposedly scientific forms which Mondrian had made fashionable.

21. Van Doesburg. Composition (1916–17)

Constructivism

The last quotation from Mondrian was written in 1941. By that time such enthusiasm for advancing technology had become rather rare. It had been more usual a quarter of a century earlier, when it provided the driving force for the other of the two main sources of modern painting in this structural idiom — the Russian Constructivists. This movement took its origin from contacts around 1910 with the Parisian Cubists and with German Expressionists. It got fully into its stride as a specifically Russian movement in the very first exuberant years of the Revolution. The springs from which it arose, and its character in its early days, can be shown by quoting at some length from the *Realistic Manifesto*, by Naum Gabo and his brother Noton Pevsner, dated 5 August 1920[29] :

'Above the tempests of our weekdays,
Across the ashes and cindered homes of the past,
Before the gates of the vacant future,
We proclaim today to you artists, painters, sculptors, musicians, actors, poets . . . to you people to whom Art is no mere ground for conversation but the source of real exaltation, our word and deed.

'The impasse into which Art has come in the last twenty years must be broken.

'The growth of human knowledge with its powerful penetration into the mysterious laws of the world which started at the dawn of this century.

'The blossoming of a new culture and a new civilization with their unprecedented-in-history surge of the masses towards the possession of the riches of Nature, a surge which binds the people into one union, and last, not least, the war and the revolution (those purifying torrents of the coming epoch), having made us face the fact of new forms of life, already born and active.

'Life does not know rationally abstracted truths as a measure of cognizance, deed is the highest and surest of truths.

'The realization of our perceptions of the world in the forms of space and time is the only aim of our pictorial and plastic art.

1. Thence in painting we renounce colour as a pictorial element, colour is the idealized optical surface of objects; an exterior and superficial impression of them; colour is accidental and it has nothing in common with the innermost essence of a thing.

'We affirm that the tone of a substance, i.e. its light-absorbing material body, is its only pictorial reality.

22. Rodchenko. Line Construction (1920)

2. We renounce in a line, its descriptive value; in real life there are no descriptive lines, description is an accidental trace of a man on things, it is not bound up with the essential life and constant structure of the body. Descriptiveness is an element of graphic illustration and decoration.
'We affirm the line only as a direction of the static forces and their rhythm in objects.

3. We renounce volume as a pictorial and plastic form of space; one cannot measure space in volumes as one cannot measure liquid in yards: look at our space . . . what is it if not one continuous depth?

'We affirm depth as the only pictorial and plastic form of space.'

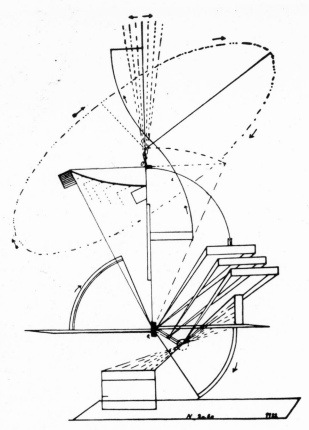

23. *Gabo, drawing for sculpture (1922)*

This does not make it very clear what the actual pictures, sculptures, or buildings of the New Realistics would actually look like. In practice, they had a strongly 'sciency' appearance – they were constructions of metal, glass, or plastic, cut or bent into clearly defined geometrical shapes; or figures moulded by means of an assemblage of planes which cut through the form, leaving it defined by the voids between them. Some time later, after he had left Russia, Gabo expressed much more explicitly the relation between science and his approach to art (which had, in the meantime, come to be called Constructivism rather than New Realism) :[30]

'The artist of today cannot possibly escape the impact science is making on the whole mentality of the human race. In what way then can the artist's work reflect this impact and what may he be able to contribute on his side to the enchantment of the new horizons of the human vision?

'The artist's task is not so straightforward and pragmatic as the scientist's; nevertheless, both the artist and the scientist are prompted by the same creative urge to find a perceptible image of the hidden forces of nature of which they both are aware, yet, it has to be borne in mind, that the means with which they are working and the effects they are striving to achieve are not identical. The

school of Constructive art is known to be the first movement in art which has declared the acceptance of the scientific age and its spirit as a basis for its perceptions of the world outside and inside human life. It was the first ideology in this century which for once rejected the belief that the personality alone and the whim and the mood of the individual artist should be the only value and guide in an artistic creation. It was also the first manifestation in art of a totally new attitude towards the artist's task of what to look for. It has accepted the fact that what we perceive with our five senses is not the only aspect of life and nature to be sung about; that life and nature conceal an infinite variety of forces, depths, and aspects never seen and only faintly felt which have not less but more importance to be expressed and to be made more concretely felt through some kind of an image communicable not only to our reason, but to our immediate everyday perceptions and feelings of life and nature.

'To my mind it is a fallacy to assume that the aspects of life and nature which contemporary science is unfolding are only communicable through science itself or through the material results of inventions which scientific technics bring forth. I rather think that to assume that would be to confine science and scientists to the rôle of a new species of sorcerers, producing miracles which they alone can do and to which the mortal common man has no access unless he is initiated.

'It is, therefore, also a mistake to think that when the Constructive artist uses exact elementary shapes, preferring to draw them with a precision which makes them look like geometry, he is by that fact alone trying to make a scientific communication. He is not and cannot. My striving to the highest precision of a line or a form or a shape is related to the scientific spirit only in so far as it represents to me the highest and most economic utilization of the pictorial and plastic means for the communication of an image.

'I don't ever forget that the scientists do not need me as an artist to help them to say with what they are concerned. But, on the other hand, the scientists, with all their rational knowledge, are primarily only human beings like the rest of us with a psychology and a consciousness common to all, the source of which springs from man's intuitive awareness of his own existence. This alone is the rock bottom of all human creations. . . .

'On the other hand, it would be a relapse into the old naïve naturalism if the contemporary artist should start to reproduce the new forms of nature which the scientist is unfolding, taking for granted the scientist's vision as he, the scientist, is representing them. That would amount to nothing more than a waste of energy and be of no account, since it would only repeat what the scientists have already done. The artist's task consists in bringing forth an image which is in a language of its own,

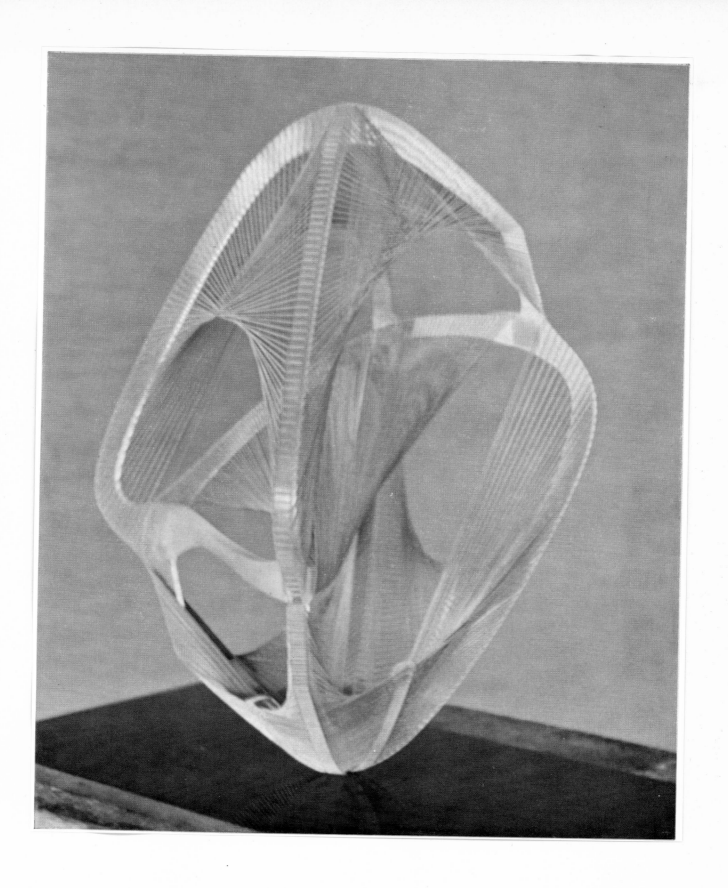

24. Malevitch.
White on white (1918?)

acceptable to all men, and imparting his message without the help of anything other than his own pictorial and plastic means. It is in this way that art always acted on the psychology of man and it is in this way it can and shall still act in our time of ever-widening and ever more inspiring horizons.'

Gabo himself did not carry his Pythagorean search for purity to the extremes of Mondrian. He never reduced his vocabulary of form to anything as simple and uncompromising as a right angle, but continued to produce sculptures and paintings based on curves and surfaces that would be expressible by algebraic formulae of moderate, though by no means great, complexity. Mondrian has the flavour of those extremely sophisticated types of mathematical physics in which the formulae have the appearance of extreme simplicity, just the product of one or two letters equated to a ratio, product or sum of one or two others, but in which the concepts symbolized by these letters are of such complexity and subtlety that only an honours graduate in the subject can grasp them. Gabo, on the other hand, has a quality of elegance and precision, and usually of transparency, dependent on his use of clear plastics or straight strings to define his planes, which reminds one of the grace of the more old-fashioned algebra of infinite series, matrices, and determinants.

▶ Amongst the Russians, the extremist was Malevitch. As early as 1918, he had developed his own variety of Constructivism, which he labelled Suprematism, and his paintings had reached the simplicity — which one might have thought the ultimate one if some recent painters had not gone one better — of a white square on a white background, or a black square or circle on a black canvas. He seems to have been a rather stupid man, notable among his early associates mainly for his ruthlessness in action and cantankerousness in repartee — there is a now old and musty scandal about the way in which he ousted Chagall from the Directorship of the Vitebsk School of Art while Chagall was rash enough to go on a trip to Moscow, leaving Malevitch in charge. His painting seems, by this time, mainly remarkable for his willingness to eschew any trace of compromise, and to push on, as early as anyone else, to a limit of simplification. But it has little of the power and intensity of Mondrian, and Malevitch's most important writing about it, his book *Die Gegenstandlose Welt*, published by the Bauhaus in Germany, is a rather unrewarding exercise in flabby mysticism[31]. It is illustrated with Suprematist compositions, such as a design of black and white half-circles with a band of symbols in the Morse code, entitled *Empfindung des Stromes, Telegraphie*; or

a set of six little crosses on a large white surface, like a line of fighter airplanes in the sky, entitled *Empfindung des Weltraumes*. His Suprematist movement was, in fact, very short-lived. By the end of 1919 he announced that it could go no further and had come to an end, and rather pathetically stated that the cross – which had been one of the forms most used in his painting – 'is my cross'.[32]

The whole Russian modern movement of painting came to an end with the rise of Stalinism. The most important remaining painters – Gabo, Pevsner, Lissitsky, amongst the group we are now concerned with, as well as modernists of other tendencies, like Kandinsky, Chagall, Jabolenski, and others – became dispersed in western parts of Europe. In the present context it is the group that went to Germany, and in the main became settled at the Bauhaus, first at Weimar and then at Dessau, that were the most important.

25. Albers, drawing

The Bauhaus[33]

This remarkable organization was perhaps the most important of all the artistic groups which have, in the last fifty years, made a serious attempt to develop the art appropriate to a scientific world. For a short period, just less than a decade, from 1919 to 1928, its Director, Walter Gropius, brought together, into at least partial integration, both the main strands of modern painting – the 'geometrists,' who are being considered in this chapter, and the 'magicians', who will be discussed in the next chapter and who were represented at the Bauhaus by painters such as Kandinsky and Klee.

The organization was essentially a school, not merely of painting but of the practical and applied arts as well. Again in this sphere it came very near to producing a successful combination of two usually conflicting approaches – the one that depends on technologically advanced manufacturing processes and the other that values craftmanship. The Bauhaus training started from a basis of craftmanship, but it went beyond the traditional crafts which use long-established tools to work on primeval raw materials such as wood and clay and stone. The Bauhaus taught also the craftmanship of the machine tool, and an appreciation of the qualities of the innumerable varieties of glass, plastics, metals, and so on that modern technology has made available. It taught its students that the springiness of a particular type of steel is as interesting and sensuously rewarding as the grain of a particular wood or the texture of a certain type of stone; and, as an extension of this, that there need be no conflict between an appreciation of the playful symbolism of Klee and of the machine-like shapes of Lissitsky or Moholy-Nagy.

The Bauhaus was always quite definitely a teaching institution. Its staff gave regular instruction in their subjects, and produced a good number

of what are essentially textbooks. These are usually set out in a systematic fashion, which leads one to expect that they would prove to be discussions of the relations between painting and the scientific view of nature. However, anyone who opens Klee's *Das bildnerische Denken*[34], or Kandinsky's *Punkt und Linie zu Fläche*, hoping for enlightenment on this topic – the one we are discussing in this book – is due to be disappointed. These books are systematic discussions of painters' tactical technology – how to organize lines or forms within the picture area to produce effects of movement, of ambiguous depth, and so on. They fall rather far outside the topics with which we are dealing. Their value within their own technical field is for professional painters to decide; a few seem to swear by them, but perhaps predominantly those who received the teaching in the flesh and not only from the printed word; it seems in any case to be rather generally agreed that neither Klee nor Kandinsky in their own works followed very closely the advice they formulated in their lectures.

26. Klee. 'A new order, but order'

27. *Schlemmer, drawing*

Both Klee and Kandinsky were among the most important painters of this century. Kandinsky is of central importance to the theme of this book, and is discussed at some length in the next chapter. The position of Klee is less obvious. At first sight, many of his pictures give the impression that he had been profoundly influenced by science, and was reacting in some way towards it, perhaps in a manner connected with the geometricizing tendency. But I do not think that this was in fact the case. The 'abstraction' in his painting and drawings seems not to be related to scientific analysis, but, on the one hand to purely painterly considerations of the arrangements of forms, tones and colours, and on the other to symbolizations, primarily of human beings, their actions and emotions. Quite often, for instance, forms which are broadly geometrical — triangles, rectangles, circles — are found to be provided with little feet or eyes, and turn out to be symbolic people. Klee's painterly innovations, for instance in the exploitation of all-over textures and unfocused compositions, had a great effect on the painters of the late forties and fifties, many of whom are strongly concerned with the nature of the real world, as we shall discuss in Chapter 5; but Klee himself did not, in my opinion, contribute very much in this connection, great painter though he was; and I shall not discuss him further.

▶ Here I want to trace the fate of the geometricizing tendency into the Bauhaus, through it, and out again after the Bauhaus had been disintegrated by Hitler's Germany. None of the major Russian Constructivists, Gabo, Pevsner, or Lissitsky, actually joined the Bauhaus, although they all spent a shorter or longer time in Germany before moving on to Paris or the United States; but ideas which were clearly a development of the Constructivist theme were important ingredients in the Bauhaus brew. The most uncompromising representatives of them were Moholy-Nagy, Albers, and Herbert Bayer. In the Bauhaus all these were associated with workshops exploring modern technology, Moholy-Nagy with photography and metal sculpture, Bayer with typography, Albers with furniture-making, and his wife with weaving. At this stage in their careers they were all, in fact, largely applied artists. Their interests were, to a certain extent, diverted away from consideration of the relations between art and science at a fundamental level to the less basic task of designing the type of artefacts which can be produced by, and which express the character of, scientific technology.

Such endeavours can be looked at in two ways. It might be claimed — as it would be, I think, by the Bauhaus people themselves — that they were attempting to create a new synthesis between art and life, in which the aesthetic discoveries of Mondrian, de Stijl, and the Constructivists were given more weight and body than they had possessed when they were merely studio experiments,

by being made the leading principles for the design of a whole environment for living — just as, at an earlier age, the discoveries of Renaissance painters were incorporated into the works of architects. So Albers, for instance, produced bookshelves and chairs which were clearly derived from the paintings and constructions of de Stijl painters like van Doesburg and Vantongerloo. This view, which is certainly the most sympathetic, is perhaps also the most just estimate of their achievement. But it presupposes that the aesthetic exploration of the rational element in science had already, by that time, reached a stage of culmination in which it was worthy of being made the foundation of a general redesigning of man's apparatus for living, his houses, furniture, carpets, wall hangings, utensils, and so on; and it is clear enough now that this was a very doubtful proposition. The characteristic forms of biology, and even of advanced physics, had hardly yet begun to exert an influence.

Among the geometricizing group within the Bauhaus it was Moholy-Nagy who was the most obviously unsatisfied with 'the present state of the art'. He experimented extensively with new materials and new technical processes: the use of sheets of various types of metals and of plastics, various new types of paints, production of photographic images by throwing shadows or projecting beams of light on to light-sensitive surfaces, the production of cine films showing abstract shapes in motion, and so on. None of this technical expertise satisfied for long his restless mind, which was always trying to push any endeavour he started to its ultimate limit. In 1934, after the Bauhaus had dissolved and he had moved to Chicago, he wrote to a friend as follows [35]:

'You are surprised that I am again arranging a growing number of exhibitions of both my earlier and more recent work. It is true that for a number of years I have ceased to exhibit, or even to paint. I felt that it was senseless to employ means that I could only regard as out of date and insufficient for the new requirements of art, at a time when new technical media were still waiting to be explored.

'Ever since the invention of photography, painting has advanced by logical stages of development "From pigment to light". We have now reached the stage when it should be possible to discard brush and pigment and to "paint by means of light itself". We are ready to replace the old two-dimensional colour patterns by a monumental architecture of light. I have often dreamed of hand-controlled or automatic systems of powerful light generators enabling the artist to flood the air — vast halls, or reflectors, of unusual substances — such as fog, gaseous materials or clouds, with brilliant visions of multi-coloured light.'

Thus, the effect on Constructivist painting of the Bauhaus experiment which brought it into intimate association with modern mechanical and

28. Moholy-Nagy. 'The machine of emotional discharge'

chemical technology was to convince the most enterprising artists that mere painting is not enough; they set out to explore methods which are more rich in potentialities or novelty, such as mobile sculpture, modulation of light, and so on, which we shall discuss later (p. 224). As Giedion has pointed out [36]: 'The emotional values latent in modern industry and in the realities of modern life in general were lost on the townsman in much the same way as the peasant of previous ages was irresponsive to the emotional appeal of the landscape. A steel bridge, an airplane hanger, or the mechanical equipment of a modern factory, is as a rule far more stirring to the imagination of those who do not see such things every day of their lives. It is not surprising, therefore, that most of the pioneers of the new vision hailed from agricultural countries with little industry of their own. Thus the Constructivists came from Russia or Hungary.' Constructivism, in the narrow sense in which it

51

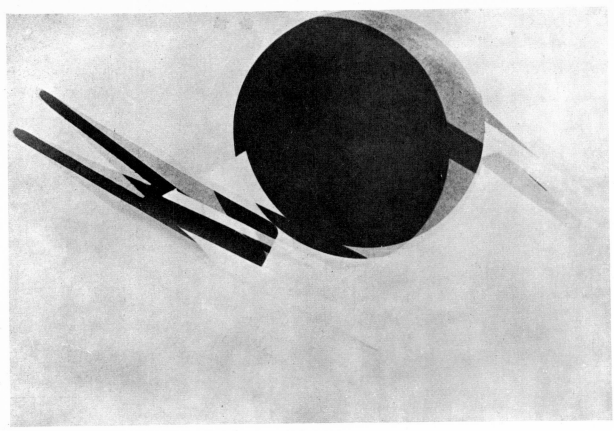

29. *Moholy-Nagy, photogram (1923)*

was defined by its founders, reached a plateau on which it still remains.

Within the field of painting, the Bauhaus also produced a rather vigorous hybrid, in which a constructivist-geometricizing tendency was crossed with the tradition of painterly technology expounded by Klee and Kandinsky. Max Bill, and the other exponents of 'Concrete Art', are the results of this union; we shall discuss them later (Chapter 5).

The work that was accomplished at the Bauhaus during its short lifetime has had an enormous effect on the design of industrial products. This is its most obvious enduring effect, but it also will live in the consciousness of this century as an example of one way, and perhaps the most hopeful there is, in which the scientific and artistic sides of modern man may be brought together. However, it did not survive long enough to do more than indicate the direction towards a synthesis, and could not fully bring this to fruition.

After its disappearance the two main streams of modern painting, which I refer to as the geometricizers and the magicians, were never so successfully brought together again. Its Director, Walter Gropius, turned his attention more exclusively to architecture. Moholy-Nagy, after working for some time in Berlin, Amsterdam, and London, eventually settled in Chicago, where from 1937 until his death in 1946 he directed a School of

Design largely modelled on the Bauhaus. During this period he continued his own explorations of paintings on superimposed sheets of transparent plastic, and on the use of projected beams of coloured light as an artistic medium. Another very important product of the school was a series of books: his own *Vision in Motion*,[37] followed by *The New Landscape* by one of his associates, Gyorgy Kepes, which explored the extraordinarily varied range of fresh images which have actually been laid before men's eyes by a whole battery of modern scientific devices, from the air view of landscape, which is a common place in the normal life of technologically advanced societies, to such recondite but exciting pictures as those produced by the X-ray crystallographer or the electron microscopist.

It was probably these books as much as any others which demonstrated to the world at large, and to the artist in particular, that it is simply old-fashioned to accept the conventional view that the type of image characteristically produced by science has the form of a geometrical diagram or a mathematical model. How very dated is this remark from one of the early manifestos of 'scientific painting'[38]: 'Our senses are accustomed to scenes where geometry reigns; our very spirit, satisfied to find geometry everywhere, has become rebellious against aspects of painting that are inconsistently

geometrical.' But neither, of course, has the iconography of science still the flavour of old-fashioned textbooks of anatomy and comparative morphology, which was exploited, as we shall see, by some of the 'magician artists'. What a modern scientist is likely to see or photograph through his instruments is usually something much more novel and stimulating (pp. 112–27). A good many artists in the last ten years or so have begun to realize this and even to exploit some of these new possibilities.

The use by painters of scientific images, even the most up to date, as things to be represented or copied, is a very minor component of the important modern art. However, to people whose habit of thought is visual rather than verbal — and many if not most painters belong to the psychological division of mankind — a few paintings or diagrams may convey a more intimate sense of the character of a subject than even the most lucid description in words of its logical structure. It is likely that books such as those of Moholy-Nagy and Kepes were among the most important means of conveying to painters some inkling of the changes which were bringing about the development of Second Science into Third Science.

The Bauhaus attempted, and for a few years pulled off, a synthesis – or a tight rope act? – between the pure world of science, technology and aesthetics, and the warm-blooded world of ordinary man and his human cussedness. They were defeated, in the Germany of the thirties, by the febrile pathological development of the least scientific qualities of man. This they well knew – as did the song-writer Bert Brecht and many others – was the Tails of the penny on which they were betting Heads. It came down wrong way up.

30. Bauhaus typography, and Lotte Lenya singing in Brecht's Dreigroschenoper

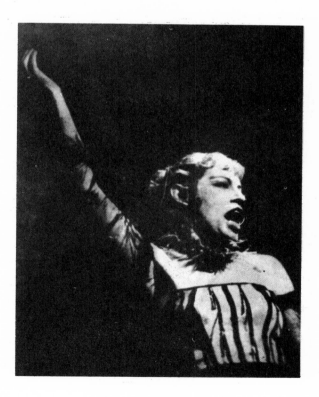

BAUHAUSBÜCHER
11 SCHRIFTLEITUNG:
 WALTER GROPIUS
 L. MOHOLY-NAGY

KASIMIR MALEWITSCH
DIE
GEGENSTANDSLOSE
WELT

Nur dadurch lebt der Mensch, daß er so gründlich Vergessen kann, daß er ein Mensch doch ist.

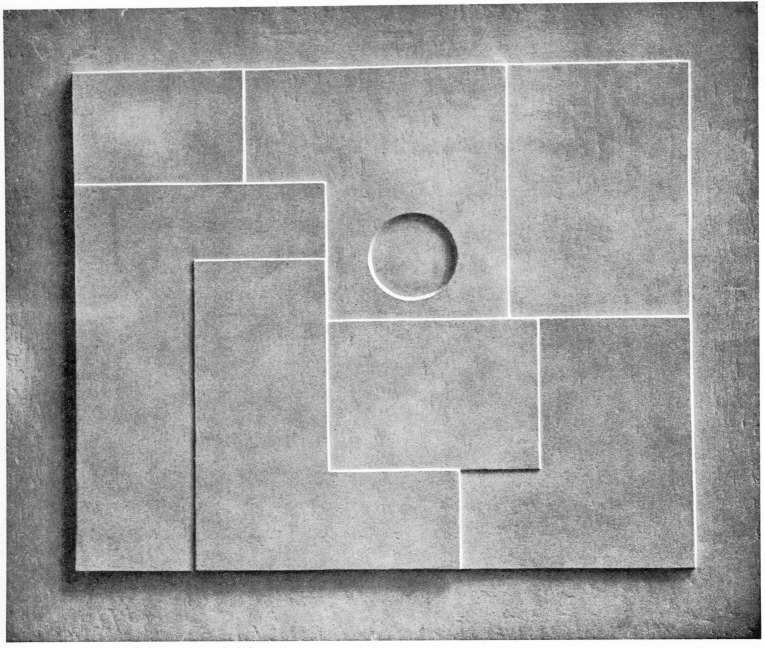

Geometricizing art
outside the Bauhaus

31. Nicholson. White Relief (1936)

Within Europe, the Bauhaus did not find any very immediate successors in the 1930s. At this time Paris was taken up with Surrealism and the movements we shall discuss in the next chapter. The leading art journals, such as *Cahiers d'Art, XXme Siècle, Minotaur*, gave very little space to geometrical painting, and indeed the few painters of this kind who practised these, such as Herbin, Magnelli, and Mortensen, were not successful in producing much more than somewhat diluted Mondrians. It was, oddly enough, in England, usually the least ideological of countries, that the programme of the

geometricizers came to another late, though short-lived, flowering. The paintings, reliefs, and views of these artists are recorded in such documents as the journal *Axis* and the symposium *Circle*.[39]

Although the art-sophisticates of Paris would perhaps dismiss the English artists of the 1930s as a merely provincial school, they were probably the most interesting and profound group with affinities to the geometricizing tradition anywhere in the world at that time. But it is difficult to do justice to them in this book, with its scope focused on the particular topic of the relations of painting and

54

science. Of the four major figures, which, since they are all friends of mine, I will cautiously list in alphabetical order – Barbara Hepworth, Henry Moore, Ben Nicholson, John Piper – the first two were primarily sculptors, excluded by our terms of reference. A more profound reason for treating them here inadequately to their full importance is that the exploration of the nature of the real world, along the lines of the geometricizing insight, was only a part, and indeed a minor part, of their whole creative activity.

The thirties in Britain were, predominantly and inescapably, a political period, coloured at every level of consciousness by the presences of the Slump, Unemployment, the Spanish War, and the coming Nazi War. The geometricizing tradition had originally reached England in its most explicitly socially conscious form, in the paintings of the trenches of the 1914–18 war by Nevinson and the eccentric-Futurist canvases of Wyndham Lewis; and in the twenties a social orientation, akin perhaps to that of Léger, was one of the main characteristics of the most notable 'cubistic' painter, William Roberts. The thirties group was far more abstract than this, and much more concerned with the basic nature of the real world within which man lives his life. They had met Mondrian, Léger, Braque, Arp, and the young Giacometti, and they received, as guests in their own houses, such artists as Gropius and Moholy-Nagy (refugees from the German Bauhaus), Gabo, the Russian constructivist, Helion from Paris, and Calder, the inventor of mobiles. They began their modern periods with an almost programmatic fervour for geometrical-constructivism; and, in line with my whole argument, this led them to a serious interest in science. In one of their major manifestos, *Circle*, one of the articles is by the X-ray crystallographer, Bernal. But this natural-philosophical bent was only one of the strands in what developed into one of the boldest of recent attempts to express visually a comprehensive natural-and-social philosophical synthesis.

For all this English group, the geometricizing tradition was, in fact, more a source of an artistic vocabulary than a main direction of their work. But, almost incidentally, and probably much more under the impulsion of feelings which were political rather than natural-philosophical, they expressed an aspect of the real world which had not previously been brought to the surface, although it was hinted at by Mondrian. Putting it in the broadest way, they saw the external world in terms of equilibria which resolved tensions; and these tensions operated in a world of objects which were refractory, hard, dense, difficult to work, the contrary of ductile, flowing, emollient. The sculptors were puritanical; no effortless modelling in responsive clay, but hard work with a chisel on solid stone; and in these tense hammered forms, the lines of tensions between the masses might be emphasized with thin stretched cords. The painters at first developed an only slightly sweeter idiom. Piper's long vertical rectangular shapes of bold colour impinge on one another with sudden semi-circles and jutting angles; and Ben Nicholson's – although their pure white colour and restriction to the rectangle and the circle often assert a Mondrian-like claim to be superior to any involvement with the merely mundane – sometimes betray the underlying tension in a wiry curve as taut as a drawn bow.

This sense of the real world as an area of interlocking energies, of a line as a path of minimum energy through orderly fields of force, is, of course, an expression of some of the basic notions of modern science; notions, moreover, that were not at all fully expressed in the earlier geometricizing developments, which were either predominantly static, or, as with the Futurists, kinetic, with an emphasis on movement, but hardly at all dynamic, with an emphasis on force. The *Nude Descending a Staircase* is gliding, almost falling, down, with a minimum of muscular tension. Nothing is so effortless in Moore, Hepworth, Piper, or Nicholson; even stillness is poised for the spring, like an ionized atom – one of the most characteristic works in the spirit of this time is the animated abstract film by Len Lye with the title *Free Radicals*.

The involvement of these artists with the human and social situation soon carried most of them out of the field of abstract art into types of work which were rather little concerned with the nature of the non-human external world. Moore's sculpture became devoted more and more to his personal vision of the nature of man, Piper turned to landscape – an unfashionable type of painting in the modern world, but rewarding enough when handled by someone who has been through the discipline of the geometricizing tradition. In recent years his purely abstract works have mostly been carried out in decorative media, such as stained glass or murals, and they have been concerned rather with the expression of mood than the exploration of the nature of the real world. Only Nicholson and Barbara Hepworth have continued to work primarily in their own versions of the geometricizing tendency, their more representational works – figure studies or landscapes – being secondary. Barbara Hepworth has pursued a straight line of development, which has retained almost completely the values and character which she had developed in the heyday of the 'English Thirties'. Nicholson, although continuing well with the geometricizing tradition, soon deviated – I hesitated whether to write 'lapsed' or 'blossomed out', and settled for a more neutral word – from the stark purity of the *Carved White Reliefs* and uniformly, though never primarily, coloured rectangular forms he had used in the late thirties. His earliest paintings combined a generally cubist design with a sensuous appreciation of muted colours and textures

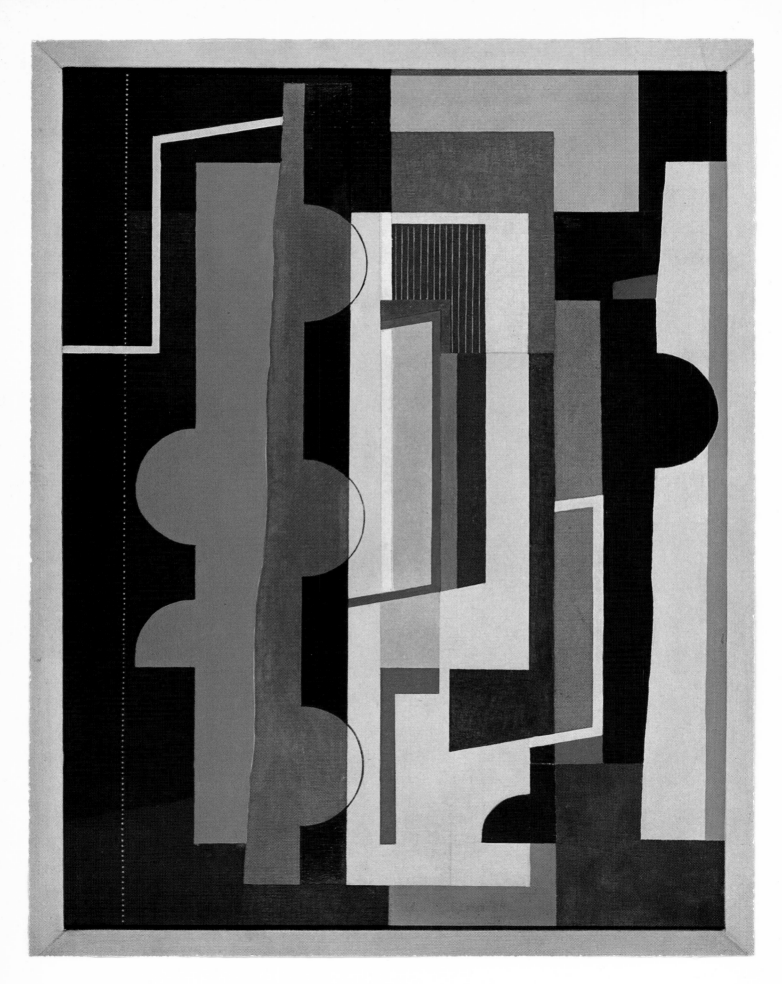

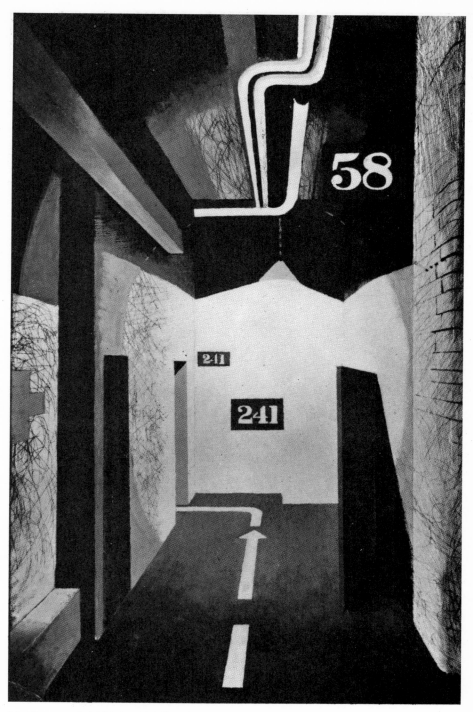

32. Piper. Air Raid Shelter (1942)

which had about them a suggestion of the antique or the homespun; and, after the heroic days of the thirties, it was towards this kind of feeling that he developed. To my eye it is in danger of falling into what I regard as the besetting and apparently ineradicable English vice — nostalgia — cricket under the immemorial elms and the graceful drive guided by subtle wrists between cover and silly mid-off, and so on. The English can take rather more of this than most peoples, though the New Englanders can sometimes run them fairly close; but many of us, and particularly many scientists, reach their saturation limit at a relatively early stage. Whether the later works of Ben Nicholson reached and held a satisfactory blend of neoplastic purity and English aristocratic athletic grace is a matter of personal taste, like the proportion of vermouth in a martini.

[18] Piper. Painting (1935)

Personally, I confess to a preference for the rougher stuff of Piper. His work of just after 1940 was often dismissed by the then-reigning Art Establishment as representational, and therefore renogade in the eyes of purists for abstraction; or denigrated as 'theatrical'. Sir Herbert Read contrived to write the Introduction to the Marlborough Gallery's 1965 retrospective exhibition on 'Art in Britain, 1930–40, centred round *Axis, Circle* and *Unit One*' – *Axis* being a journal edited by Mrs Myfanwy Piper – without once mentioning him. His paintings were indeed tough, with a swagger, and came out with a profusion which entails, as even Picasso has shown us, that not all are as good as the best of them. They leant, not towards the refined aesthetics of the period, but rather to the popular tradition of village churches, country-town domestic architecture and circus decorations. Some of his paintings, incorporating paper lace doilies and similar items, may in fact be called Proto-Pop; and a picture like that on p. 57 has very obvious relations with the Lichtenstein on p. 201, done a quarter of a century later, when Pop imagery was in fashion.

Offshoots and progeny

▶ When Mondrian – that great merciless artist, as Willem de Kooning[40] has called him – reached his heyday about 1930, he seemed to leave open to other painters few avenues of advance into greater refinements of purity and clarity.

In fact, the major strength of the orthodox geometricizing school in later years has been expressed less in true paintings but rather in constructions which are halfway between painting and sculpture. At the beginnings of the movement in Holland, many of the artists belonging to the Stijl group, such as Vantongerloo and van Doesburg, made constructions and even practised architecture and furniture designing. Ever since that time there has been a tradition for the production of 'constructions', usually composed of rectangular blocks or planes, set often at right angles to one another, sometimes coloured in bright hues, and sometimes supplemented by a few simple geometric curved elements. Many of Ben Nicholson's painted reliefs are halfway between such constructions and normal paintings. In the 1930s also, John Piper in Britain, Gorin and Domela in France, and Moholy-Nagy and others at the Bauhaus in Germany, all produced constructions of greater and lesser geometrical purity. The movement has continued to the present day, with the work of Passmore and his followers in Britain, and Biederman, and others, in America. Its longevity is evidence that there is a type of artistic temperament – Archimedean man – for whom geometrical clarity has a profound appeal. The style will probably always remain one of the manners in which artistic creation will continue. To most people, however, the latter-day works of this kind have a rather limited appeal. Even when – it is not always – they have the clarity or the elegance, they lack the strength and almost swaggering impact of Mondrian in his heyday. (There have, however, been developments, ultimately derived from the geometricizing roots, which have broken new ground and brought in new interests; they will be discussed in Chapter 6.)

The geometricizers took what had been one element in the first confused and enthusiastic response of the early cubists to the break-up, by science, of the accepted classical forms. They made a programme of it, and they pushed the programme to a point where they demonstrated that this species of painting exerts an appeal which one can expect to be felt throughout many future generations. It is, in that sense, a deep art. But although deep, and for that reason rewarding, it can scarcely be denied that it is very narrow in the range of human attributes to which it appeals. We have lost all sense of man as an animal, muscular, sexual, and demanding food and drink; or man as a personality and a social being; or as an inhabitant of a world of nature filled with burgeoning plant and animal life, or surrounded by architecture fashioned by human hands; standing on soil, rock or tarmac and roofed over by the sky. He is reduced to an incorporeal intelligence imbued with an emotional reaction to the products of his own conceptualizing thought.

It was mainly in this direction that the geometricizing art of the twenties and thirties tended, and many later artists have done so too. It is a vision valid as far as it goes, but it is only slightly unfair to accuse it of being the conventional caricature of the scientists as the depersonalized researcher in a white coat. Compare a constructivist sculpture with one by Henry Moore. The latter may employ some devices introduced by the cubist-constructivist pioneers, for instance transparent planes indicated by nets of cords; but it also nearly always carries with it some of the enduring presence and richness of Nature, of the human body, and rocks and trees. The power of such works is achieved by focusing on elements in the human situation which are perennial and belong to all periods of history; it misses, perhaps, something of the urgently contemporary. The geometricizers and Constructivists made a sustained attempt to attain this sense of the present day, and were often successful, but nearly always at the cost of sacrificing the links which bind the present to the past, the future, and the timeless. Perhaps only Mondrian largely escapes this criticism. The rest have become specialists. Science is envisaged by the artists that we have been discussing as something which has a penetrating vision, which is illuminating, exciting, and not to be gainsaid; but, as the later developments of this art movement make so clear, it is a partial, a one-eyed, vision. Science is seen as a one-eyed Cyclops.

3

The Magicians

Tie hie! Tie hie!
 He tickles this age who can
Call Tullia's ape a marmosyte
And Leda's goose a swan.
 Anon 16c.

▶ A response to — often taking the form of reaction against — the world of science and technology also played a considerable part in the origin of the other main stream in the first period of modern painting. This stream, which I have referred to as *The Magicians*, became in its heyday of the 1920s and 1930s the movement known as Surrealism. It appealed not only to painters but also to many writers, and was soon equipped with an elaborate and highly articulate body of theory and exegesis. As might be expected of a movement powerful enough to be the centre of fashion in western painting for nearly twenty years, it was complex and arose from a number of different sources.One can perhaps distinguish six main springs, which can be indicated by the names Apollinaire, Lautréamont, Chirico, Kandinsky, Dada, and Freud. Influences from all these six united to form the Paris-centred school of Surrealism. Each of the six had been affected in a more or less important way by the growth of modern science.

The two main streams of modern painting, the geometrical and the mysterious, had their origins simultaneously and together in the few years just before the 1914—18 war, in which the import of modern science first dawned on the consciousness of painters. As we have seen, the first expositor of the Cubists, Apollinaire, pointed out that scientists, by exploring space-time and the interior of the atom, had created concepts which were much more novel and imaginative than anything that had appeared in recent painting. To his mind, and to those of the contemporary painters, these conceptions did not appear nerely as cold, intellectual constructions. They were, on the one hand, precisely defined notions capable of being integrated into explicitly formulated logical theories, but, on the other hand, they contained something mysterious and strange, enabling man to see the world around him as something far more unexpected and less understood than it had seemed to be in the days of Newtonian physics and simple materialism.

It was the clear-cut logical coherence of the new world-view that came most obviously to expression in the work of the constructivists and geometricizing artists, but even they never lost their sense of wonder, of the strangeness — in terms of our traditional concepts — of the new guise in which the world had to be seen. Looking at the simple geometrical forms of a Mondrian, one can hardly avoid the feeling expressed by Valéry : 'Qu'est-ce que c'est de plus mystérieux que la clarté ?' It was this quality of mystery, implicit in the work of the geometrical school of modern painting, which was explicitly developed by the surrealists. The paintings of the two schools came to have extremely different superficial appearances, one non-representational geometric, the other expressing the hallucinatory realism of the dream world. In the 1930s in Paris the two schools were fierce rivals for public

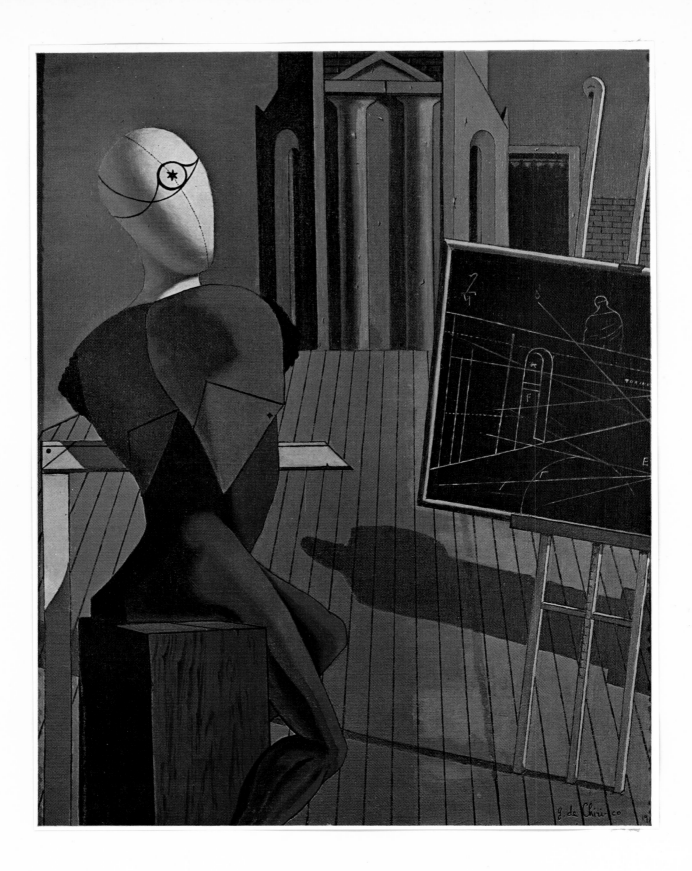

attention, the surrealists in general winning the day in this respect. But it is worth remembering Mondrian's already quoted remark, made towards the end of his life, that in spirit he felt himself closer to the Surrealists than to any others of the painters of our time.[1]

The word *surreal* seems to have been coined by Apollinaire in the preface to his play *Les Mamelles de Tiresias*. He used it to refer to man's ability to create things that are completely novel and are not given in the natural reality into which man finds himself born. He quoted as an example an extremely simple, but profoundly original, human creation — the wheel. Non-human nature does not produce wheels, although it may, of course, produce circles and spheres. The wheel is an entirely man-made invention, a product of the human ability to transcend, by intuition, the previously given real world. Perhaps the whole of the basic criticism which one has to level against the Surrealist movement could be summed up by contrasting Apollinaire's original notion with the fact that at an international exhibition of Surrealism some twenty years later, one of the most admired items was an *oval* wheel — a piece of oversophisticated double-banked allusiveness, good only for a momentary raising of the eyebrow.

Apollinaire realized that in his time the scientists were outdoing the poets in the exercise of the imagination: 'Poetry and creation are one and the same thing; he alone must be called poet who invents and creates, as much as it is given to man to create. . . . One can be a poet in all fields: all that is needed is to be adventurous, to go after discoveries. . . . True glory has forsaken poetry for science, philosophy, acrobatics, philanthropy, sociology, etc. Today all that poets are good for is to take money that they have not earned, since they seldom work. . . . The prizes that are awarded to them rightfully belong to workers, inventors, research men.'[2] And a similar point is made by Ozenfant, another early theorist of Cubism:[3] 'The more science gives us new realities, the further progress true poetry makes. The more science prolongs its sight, the wider do dreams extend their wings and their flight.'

Chirico

One of the first painters in whose works this sense of the mysteriousness of the world became clearly expressed was Giorgio di Chirico. He had, at first, little or no contact with the cubists and art theorists of Paris, and developed the characteristic style of his early paintings entirely from his own resources. His personality was highly complex, and his relations with his father and mother provide a rich field for exploration by psycho-analytically minded art-historians. His paintings are full of symbols, some of which, such as the empty gloves and

elaborately moulded biscuits, which are important elements in many works, remain more or less private to the artist; others, such as the upstanding towers and buildings with dark arcades and empty windows, are common property both as sexual symbols and as reminiscences of all the cities one has inhabited. The other, and from our point of view the most significant, element in his repertoire of forms is a large assemblage of diverse scientific instruments of various kinds — rulers, compasses, T-squares, blackboards covered with geometrical diagrams, frameworks of wood, surgeons' gloves, maps, anatomical charts, and so on. The geometrical forms, which to most of the cubists represented the clarity and lucidity of science, for Chirico had a very different implication: 'Often in the past geometrical figures have been interpreted as portentous symbols of higher reality. In antiquity, for instance, and now in theosophic doctrine, the triangle is considered a mystic and magic symbol, and beyond question it arouses in the beholder, even when he is ignorant of its significance, a feeling of apprehension, perhaps even of fear. (This is why draughtsmen's triangles haunted me in the past and still do; I used to see them rise like mysterious stars beyond each of my pictorial images.)'[4]

Besides these relatively minor paraphernalia, the major subject matter of Chirico's early paintings were urban man-made landscapes. At first these were open-air scenes with no inhabitants visible. Later they began to be peopled by quasi-human figures, which were usually depicted as diagrammatic mannequins, constructed out of geometrically simplified shapes almost as mechanical in nature as those which Léger used a few years later; and finally these mannequins were shown indoors in rooms in which they were surrounded by the peculiar bric-a-brac just described.

The gist of Chirico's message comes mainly from the contrast between the suggestive mysteriousness of the landscape and the mechanico-scientific simplification of the beings that inhabit it. He is painting the poetry of romantic intuitive man constrained to live in a world of which he can understand only the mechanical aspects. The scenery of arcaded buildings and wide, far-reaching piazzas is shown as a stage waiting for something to happen on it — some event which one can realize is impending but about whose nature one can form no conjecture.

Chirico discovered a method of exaggerating perspective, or using several systems of perspective simultaneously in the same picture, which conveys an unavoidable sense of mystery and foreboding. Often there falls across the scene the shadow of some feature — a statue or a tower — which lies just outside the scene depicted; something, we feel, is going on just round the corner — but what? And over all stretches a clear greenish or smoky blue sky, like that of a late summer

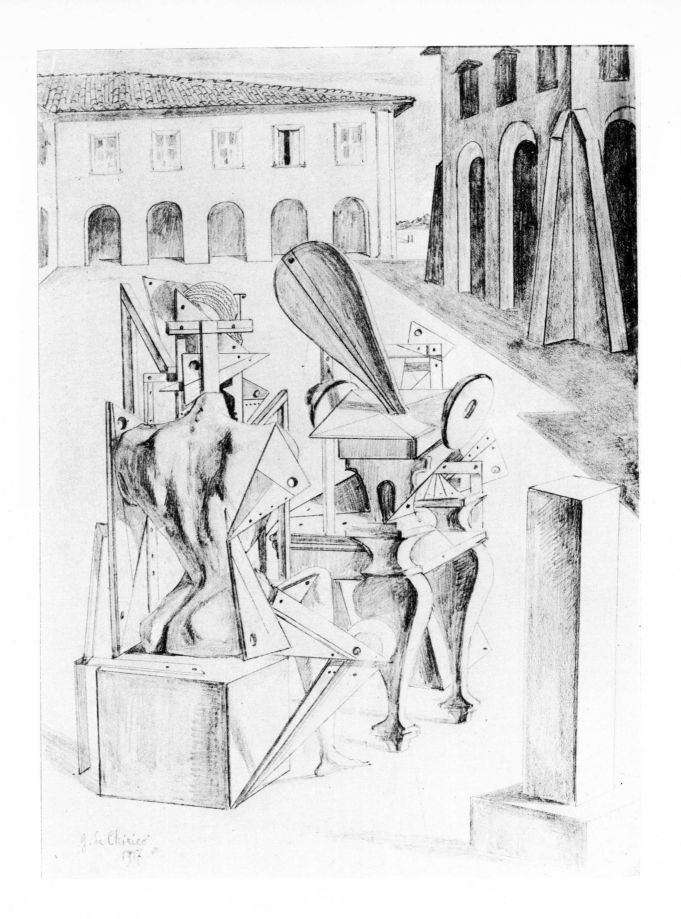

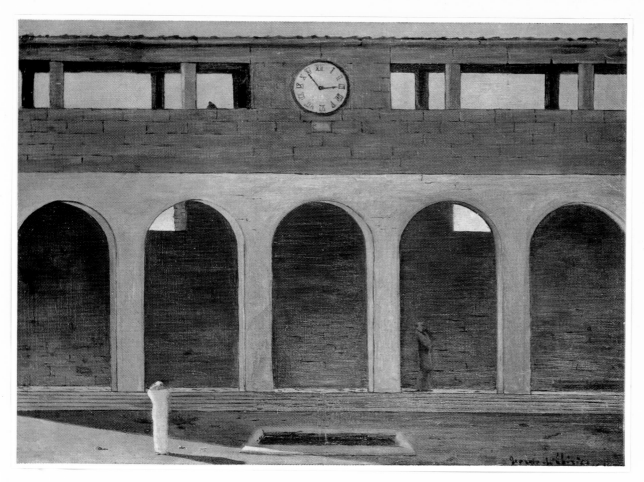

[20] *Chirico. The enigma of the hour (1912)*

afternoon, into the depths of which one could go journeying into the infinite.

The feelings these scenes arouse are of questionings – questions which Chirico himself described in an article he wrote about Giotto [5]: 'The square of the sky seen through the window is a secondary drama that interlocks with the drama of people's imagination. When the eye rests on that blue or greenish expanse held in by the square geometry of stone, many anxious questions come to mind. What might there be over there? Does that sky overlook an empty sea or a crowded city? Or does it stretch over a wide, free, and restless nature, over wooded mountains, dark valleys, plains furrowed by rivers? . . . And the perspective of buildings rise full of mystery and misgiving, corners conceal secrets, the work of art ceases to be a terse episode, a scene limited by the actions of the figures represented, and it all becomes a cosmic and vital drama which envelops men and constricts them within its spirals, where past and future merge, where the enigmas of existence, sanctified by the breath of art, are divested of the entangled fearfulness that man – outside the world of art – imagines, only to assume the eter-

nal, peaceful, consoling aspect of a work of genius.'

It was into such scenes that he introduced his human figures, often apparently over life size but with heads reduced to a blank oval and bodies to an agglomeration of cylinders and metal frameworks. 'The first man', Chirico wrote,[6] 'must have seen auguries everywhere, he must have trembled every step he took.' In Chirico's paintings man is shown as a mechanical construction so overwhelmed by the mysteriousness of the world around him that, while he can strike a defiant pose in the disposition of his body as a whole, his face, which should express an intimate human personality, has become obliterated into the simplicity of an egg-shaped oval which sometimes bears, in place of eyes, the mathematical symbol for infinity. It is one of the most vivid, poetic, and powerful evocations of a feeling which has become, since that day, so widespread as to be almost banal. I quote two sentences from a recent newspaper[7]: 'It is difficult to think rationally about the atom. A force so vast, terrifying, and, to the layman, so incomprehensible, encourages emotion rather than debate.'

The sense of mystery or foreboding which

Chirico expressed so powerfully was one of the main springs from which Surrealism was derived. Unfortunately, few later painters achieved an equally convincing expression of it. They tended to make more use of two other and relatively minor aspects of his genius – the use of Freudian symbolism, and the bringing together into one picture of a number of highly disparate objects, the conjunction of which was, in early Chirico paintings, one of the minor, but in later Surrealist works, one of the major, methods for arousing a sensation of the queer and the dream.

Kandinsky

One of the other painters whose early works, executed just before the First World War, eventually proved of profound importance was Kandinsky. His influence took longer to become effective in a direct way. In fact, it was not until the development of some of the types of Abstract Expressionism in the 1950s that Kandinsky began to be recognized as a major influence in twentieth-century art. In a less immediate way, however, his example has been extremely important for much longer, since he has a considerable claim to be considered the first artist to have produced a completely abstract picture which consciously did not set out to make any reference either to natural appearances or well-known geometrical forms.

It is still a matter of debate, between academic art historians, who can actually claim the priority in this. The fact of the matter is that many artists in different parts of Europe were moving in this direction. However, the main Parisian school deriving from the Cubists was moving towards abstraction through a phase of radical distortion of appearances into disconnected geometrically-defined forms. Kandinsky reached the goal by quite a different route; his early abstract pictures were not at all geometricizing but were made up of freely flowing, even nebulous, shapes with waggly lines, dots, and strokes of pigment.

Kandinsky was an 'intellectual' in the Continental sense, with a much fuller academic training than most artists have had. He was born in Moscow in 1866, and first studied law; for some years he held a position in the Law Faculty of Moscow University. It was not till he was aged thirty that he gave up a legal career and devoted himself to painting. But in spite of these intellectual abilities, there was a considerable element of sheer silliness in the movements of his mind towards abstract art – not that that detracts from the value of what he actually achieved. But it is odd to realize quite how unpromising for important developments was the ground from which the great movement of magical art started. Dada was, as we shall see later, in its beginning an almost pure act of rejection, enlivened by a youthful sense of fun,

while the intellectual basis of Kandinsky's art, one is tempted to say, combined an act of rejection with a simple mistake and an accident. The mistake was to suppose that the science of his time was losing its grasp on nature rather than increasing it, becoming less true rather than more true. The active rejection was to deny the value of the scientific method of arriving at understanding of the world, while the accident, which we will come to shortly, was a quite trivial one, which, however, lit a spark which led to important and splendid consequences.

The 'repudiation' and 'mistake', as I have rather brashly called them, are described in a passage from a book by F. B. Blanshard[8]:
'Another source of information, Kandinsky's own writings, show plainly why he thought representation in art must be rejected. Kandinsky identified representative painting with the dominance of science and materialism to which he was profoundly hostile. He was opposed to men of science as "positivists, recognizing only those things which can be weighed and measured". Even in their own province, scientists cannot be trusted; what they hold true today they may deny tomorrow. Witness their shocking mistake about the atom. This, by definition the ultimately indivisible, they had found in their power to destroy.

"This discovery struck me with terrific impact, comparable to that of the end of the world. In the twinkling of an eye, the mighty arches of science lay shattered before me. All things become flimsy, with no strength or certainty. I would hardly have been surprised if the stones had risen in the air and disappeared. To me, science had been destroyed. In its place – a mere delusion, guesswork by the scientists, who, instead of erecting, stone by stone, a divine and unshakable edifice, had – or so it then seemed to me – gropingly, as if in the dark, fumbled for the scientific verities, often – in their blindness – mistaking one thing for another." '

▶ Before we go on to Kandinsky's accident, it is worth looking a little more closely at some of the ideas that were in the air at the time around 1910, when abstract painting was born. The most important theoretical work to assist at the birth of abstract painting was an essay – actually a doctorate thesis – written by a quite young art historian, Wilhelm Worringer, at that time a student in Munich, the town in which Kandinsky was also living. Worringer's essay, which soon obtained a wide circulation and exerted a great intellectual influence, was one of the first to insist that the value of any work of art can be judged, not by the application of any external and universal criterion, but only in relation to the actual intentions – the 'artistic volition' – of the artist or the society in which he was working. Its title was *Abstraktion und Einfühlung* (translated as *Abstraction and Empathy*)[9] and it first appeared in 1908. In it Worringer envisaged the possibility of a

64

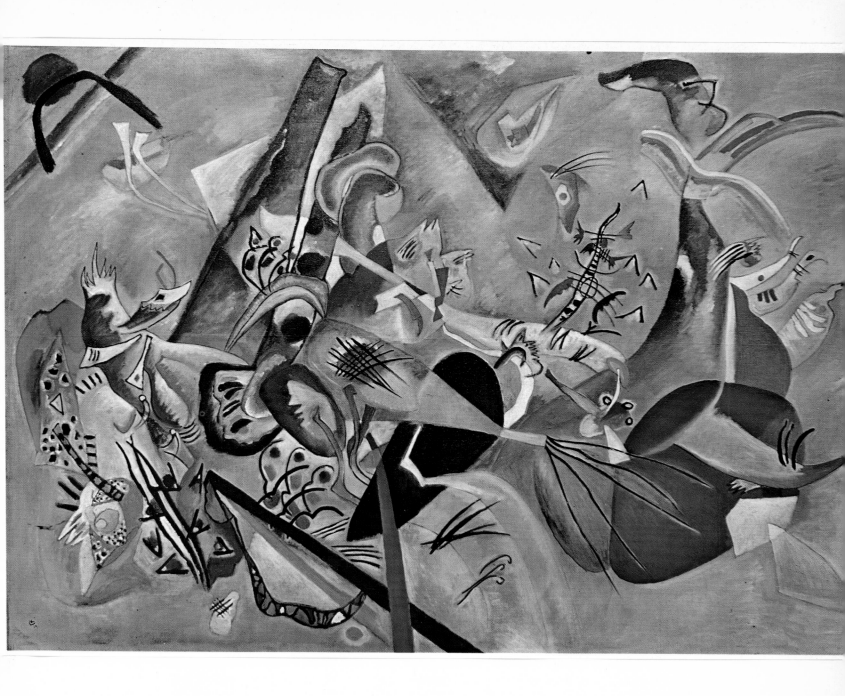

completely abstract, i.e. non-representational, art, although at that time no paintings totally divorced from the representation of nature had been made.

The main argument of the book was to establish a distinction between the two radically different types of art which give expression to two different needs of the human spirit. Worringer argued that all art derives its importance from the fact that it may enable man to deal with feelings of inadequacy of some kind, of 'anguish' or 'Angst', to use the presently fashionable expression. But, he pointed out, there are Angsts of different kinds. The most primitive is a dread of the external world as a whole, as something incomprehended and unpredictable; this is, in Worringer's phrase, 'an agoraphobia against space in general'. If this can once be mastered, man finds himself with a dread or anxiety directed towards his own self.

The dread of the external world leads, in Worringer's view, to what he calls an urge to abstraction in artistic productions: 'Thus all transcendental art sets out with the aim of de-organicizing the organic, i.e. of translating the mutable and conditional into values of unconditional necessity. But such a necessity man is able to feel only in the great world beyond the living, in the world of the inorganic. This led him to rigid lines, to inert crystalline form. He translated everything living into the language of these imperishable and unconditional values.'[10]

Worringer, writing at a time before the palaeolithic cave paintings had become generally familiar, argued that this approach to art was the primitive one, found in people at the beginning of civilization. It was, he thought, only when science understood the world well enough to feel some confidence in itself that man could go on to develop the second type of art, that depending on empathy or imaginative insight. He describes this type of art as follows: 'The simplest formula that expresses this kind of aesthetic experience runs: *aesthetic enjoyment is objectified self-enjoyment.* To enjoy aesthetically means to enjoy myself in a sensuous object diverse from myself, to empathize myself into it. . . . And the new art, which now springs to life, is Classical Art. Its colouring is no longer joyless like the old. . . . Its delight is no longer the rigid regularity of the abstract, but the mild harmony of organic being.'[11]

Looked at from the vantage point of fifty years later, this theory, of course, carries at best very partial conviction. As I hinted before by reference to palaeolithic paintings, primitive forms of art are by no means always geometricizing in character. There was, in fact, shortly before Worringer wrote, a famous controversy between two of the Titans of scientific anthropology on this very subject, A. C. Haddon arguing[12] (in *Evolution in Art,* 1895) that among primitive peoples art progresses from the realistic to the geometrical, while F. Boaz[13] used the history of Alaskan decorated needle-cases to demonstrate that sometimes the movement is in the exactly opposite direction. In the first section of this book we have seen how in recent years the use of geometrical forms has been employed to express the mastery of nature by science rather than as a compensation for the failure to understand the world surrounding us. Again, the Angst about the self has resulted, in the last few decades, not so much in naturalistic or classical art, as Worringer thought it should, but rather in Expressionist paintings (Ensor, Soutine, Redon, Nolde, Beckmann, and others) which depart rather far from the classical as Worringer understood it. But the important points were that Worringer's ideas were those which were influential around 1910, that he clearly indicated the possibility of a completely non-representational or 'abstract' art, and that he argued in his own roundabout fashion that a confidence in the validity of science led to naturalistic art.

There seems little doubt that Kandinsky was influenced by the converse of this last argument. A lack of confidence in science – and as we have seen, this is what his superficial acquaintance with science had produced in him – should lead to an abstract art. According to Worringer it should lead to an abstract geometricizing art. With Kandinsky it did not, or at least not to begin with; his early abstract pictures were the opposite of geometrical.

There is no doubt that he felt not only a distrust of science but an Angst about the external world. In his autobiography, describing his early experience as a student of art taking the usual life classes, he writes: 'The naked body, its lines and movement, sometimes interested me but often merely repelled me. Some poses in particular were repugnant to me, and I had to force myself to copy them. I could really breathe freely only when I was out of the studio door and in the street once again.'[14] His early works were of rather romantic subjects – landscapes, and illustrations to fairy tales or imaginative stories. In most of these paintings he used broad areas of bright glowing colour with little internal modelling, a manner which owed something to Gauguin but more to the traditions of Russian ecclesiastical art. In his autobiography he describes going into a Russian church: 'All over the walls hung peasant prints, telling vividly of battles, of a legendary knight-at-arms, of a song, rendered in colours. One corner was rich with dark gleaming ikons, in front of which, devoutly and whisperingly humble, yet proud, mysterious, and star-like, warmly glimmered a hanging image lamp. When I finally crossed the threshold, it was like entering into a painting and becoming a part of it.'[15]

As this style developed, his colours became richer and the representation of natural objects more simplified, while his attention became concentrated more and more on the integration of the painted colours and shapes into a unity existing

within the picture and more or less independent of the scene that had provoked it. The transition from these abstracted naturalistic pictures to fully non-representational abstraction seems to have depended quite largely on an accident which he describes as follows:

been used by Mondrian and the Constructivists. He proceeded in the next few years to produce a series of paintings in which irregular shaped areas of bright colour are placed, usually against a white background, with a few contrasting fluid black lines. Nothing as free, both from the limitations of

34. Kandinsky, drawing

'Using the tendency of a painted object to lose much of its form and identity to the general composition of a picture, I gradually acquired the gift of no longer noticing the given object, or, at least, of overlooking it. Much later, in Munich, I was once deeply enchanted by an unexpected sight that met my eye on returning to the studio. Twilight was drawing in. I was returning, immersed in thought, from my sketching, when, on opening the studio door, I was suddenly confronted by a picture of indescribable and incandescent loveliness. Bewildered, I stopped; staring at it. The painting lacked all subject, depicted no identifiable object and was entirely composed of bright color-patches. Finally I approached closer, and only then, recognized it for what it really was – my own painting, standing on its side on the easel.'[16]

It seems to have been this experience which set Kandinsky off on the exploration of freely shaped forms rather than the geometrical ones which had

representation or of geometry, had appeared before in western painting (with the possible exception of some of the works which Monet produced towards the end of his life, and those contained some representational element, since they were conjured out of his vision of the intangible scene presented by water-lilies floating on the ruffled surface of a transparent pond). Kandinsky's painting, however, explicitly made no attempt to represent anything, and when it happened that some of the shapes suggested a meaning – for instance, what might be taken for two cannons being fired in the bottom right-hand corner of one of his better-known pictures of this time – Kandinsky stated that it was no part of his intention to produce anything of the kind.

▶ In his most important writing, the book *Concerning the Spiritual in Art*, he insisted that the essential point for a picture is that it should arise from *inner necessity* – and by this he meant not

67

F

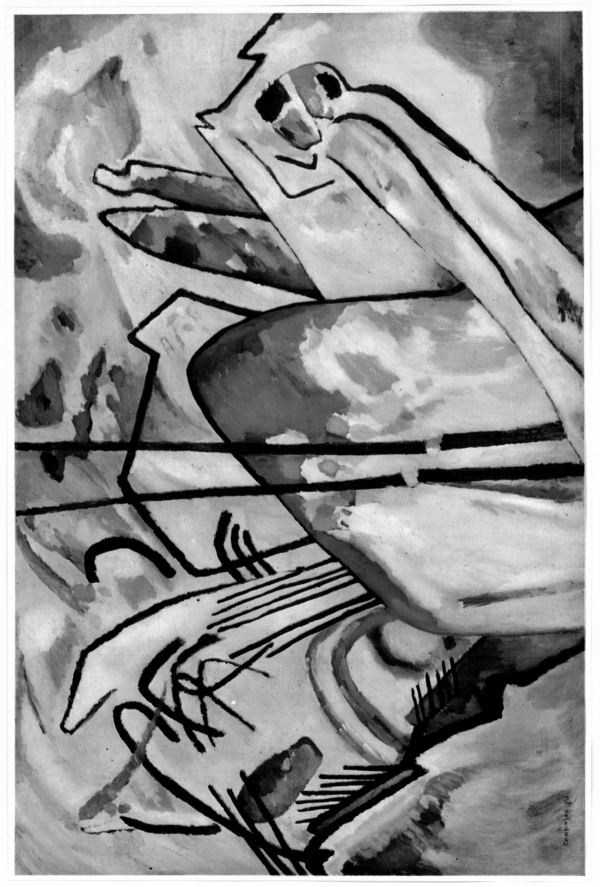

merely a necessity interior to the picture itself but, much more, one which arose from the innermost being of the artist as a man. 'It is evident that form harmony must rest only on the purposive vibration of the human soul. This principle has been designated here as the principle of internal necessity.'[17]

He points out[18] that: 'Inner necessity originates from three elements. (1) Every artist, as a creator, has something in him which demands expression (this is the element of personality). (2) Every artist, as the child of his time, is impelled to express the spirit of his age (this is the element of style) — dictated by the period and particular country to which the artist belongs (it is doubtful how long the latter distinction will continue). (3) Every artist, as a servant of art, has to help the cause of art (this is the quintessence of art, which is constant in all ages and among all nationalities).

'These three mystical necessities are the constituent elements of a work of art, which interpenetrate and constitute unity of the work. Nevertheless, the first two elements include what belongs to time and space, while in the pure and eternal artistry, which is beyond time and space, this forms a relatively non-transparent shell. The process in the development in art consists of the separation of its quintessence from the style of the time and the element of personality. Thus, these two elements are not only a co-operative, but also a hindering, force. The personality and the style of the time create in every epoch many precise forms, which in spite of apparent major differences are so organically related that they can be designated as one single form: their inner sound is finally but one major chord. These two elements are of a subjective nature. The entire epoch desires to reflect itself, to express artistically its life. Likewise, the artist wishes to express himself and chooses only forms which are sympathetic to his inner self. Thus, gradually is formed the style of an epoch, i.e. a certain external and subjective form. The pure and eternal art is, however, the objective element which becomes comprehensible with the help of the subjective.

'The inevitable desire for expression of the *objective* is the impulse here defined as 'internal necessity'. This impulse is the lever or spring driving the artist forward. Because the spirit progresses, today's internal laws of harmony are tomorrow's external laws, which in their further application live only through this necessity which has become external. It is clear, therefore, that the inner spirit of art uses the external form of any particular period as a stepping-stone to further development.'

Thus Kandinsky's philosophy was a thoroughgoing mysticism. It is surprising to find that, in the final version of his *Concerning the spiritual in art*, published in America after his death, he finds support for his views in a comparison with the revolutionary advances in science, which he had earlier found so unsettling[19]: '. . . work is going on which boldly criticizes the pillars men have set up. There we find other professional men of learning who test matter again and again, who tremble before no problem, and who finally cast doubt on that very *matter* which was yesterday the foundation of everything, so that the whole universe rocks. The theory of the electrons, that is, of waves in motion, designed to replace matter completely, finds at the moment bold champions who overstep here and there the limits of caution and perish in the conquest of the new scientific fortress. They are like self-sacrificing soldiers making a desperate attack. But "no fort is unconquerable". Thus facts are being established which the science of yesterday dubbed frauds. Even newspapers, which are the most obsequious servants of worldly success and of the masses, which trim their sails to every wind, find themselves compelled to modify their ironical judgments on the "marvels" of science, and even abandon them.'

But he expresses himself in a less equivocal way about his sympathy with the Theosophism of Madame Blavatsky[20]: 'In that moment [of Madame Blavatsky's work] rose one of the most important spiritual movements.... Sceptical though we may be regarding the tendency of the theosophists toward theorizing and their excessive anticipation of definite answers in lieu of immense question-marks, it remains a fundamentally spiritual movement. This movement represents a strong agent in the general atmosphere, presaging deliverance to oppressed and gloomy hearts.'

However, Kandinsky himself was, as he said every artist must be, 'impelled to express the spirit of his age' by the development of a style that somehow grew out of his surroundings. After a fairly few years the free unconstrained shapes of his early abstracts had disappeared, and their place was taken by circles, rectangles, and slightly more complex but still 'hard-edged' forms, little removed from those of geometry. As a later abstract artist, S. W. Hayter, pointed out[21] in his Introduction to Kandinsky's book: '. . . it is interesting that Kandinsky states in his autobiography that he was never able to overcome the initial difficulties of mathematics; perhaps as a consequence, like many non-mathematical people, he regards mathematics with too great respect as a determining factor in certain forms. To refer as he does to the triangle, square, circle, as geometrical forms to the exclusion of such less obvious forms as ellipse, parabola, hyperbola, lemniscate, or cardioid, is too narrow a view of geometry. Obviously a mathematical expression can be devised for any curve, surface, or solid, although the expression becomes impossibly cumbersome when a sufficient degree of irregularity exists in the form to be described. He fails to realize the very superficial order of the commentary that mathematics furnishes on visual phenomena, but he arrives, just the same, at a

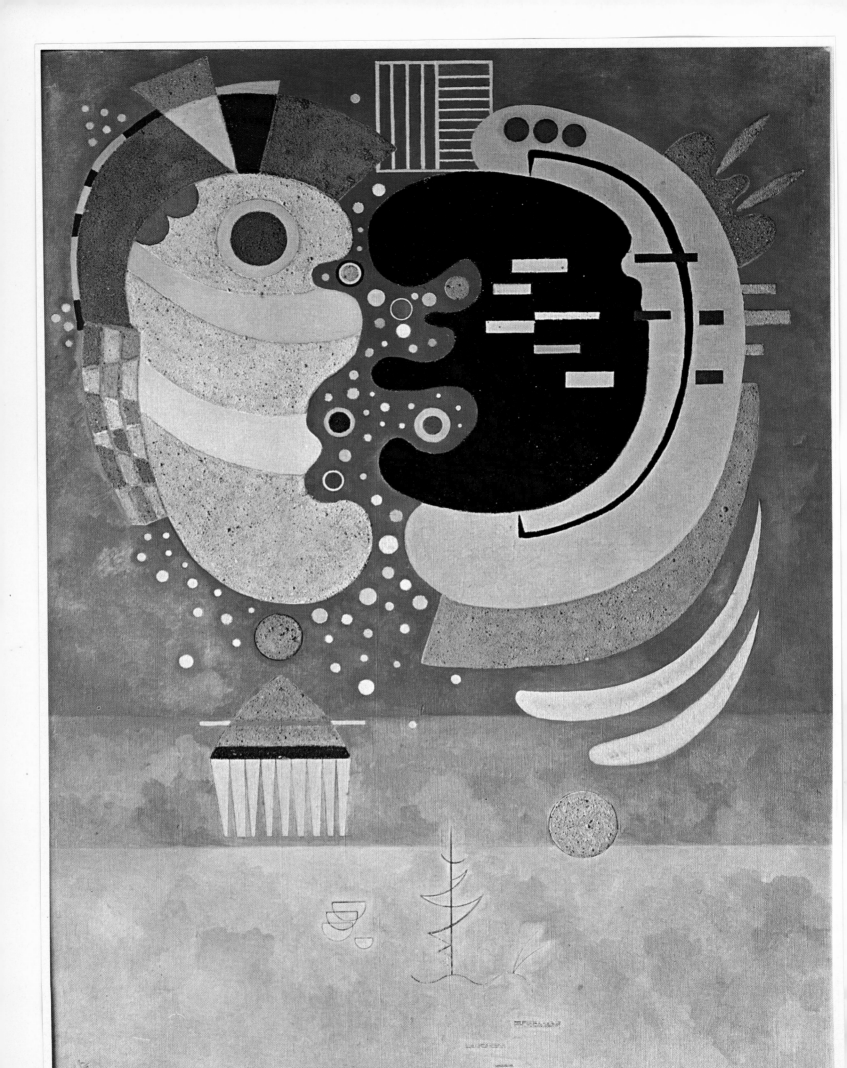

distrust of mathematical meanings in the projection of graphic material.'

Possibly one influence in the reduction of the forms in Kandinsky's later paintings to those of simple geometry was the fact that he had by now joined the Bauhaus, where he was in contact with such abstract constructivists as Moholy-Nagy, in an atmosphere full of highly intellectualized argumentation about the characteristics of a scientific age. Kandinsky also produced a quite elaborate and clearly formulated exposition of his ideas on formal relations in painting, which he published in his book *Punkt und Linie zu Fläche*.

This conceptualizing of his method of working, and indeed the adoption of clear-cut geometrical forms, seems to me to have sat rather uneasily on his essential creative personality. His greatest gift to the future was in neither of these nor in the rather vague mystical theories he had expounded at an earlier stage of his development . . . 'a sort of Middle European Buddhism, – at any rate too theosophical for me', as de Kooning called them;[22]

it was in his demonstration that an artist can be completely free to use what shapes, forms, and colours he pleases and to allow them to suggest a space of any character that he can imagine. The geometrical abstracts of Mondrian and the constructivists always appear to be located somewhere on the earth's surface, subject to the force of gravity. Mondrian with his insistence that lines must be either vertical or horizontal was, in fact, insisting on the implicit existence of the ground we stand on. Most of Kandinsky's abstracts, on the other hand – not surprisingly if we remember their origin in a picture turned on its side – imply no outside frame of reference at all, gravitational or other. His forms might be floating in outer space. Whether such rootlessness is a valuable quality or not is perhaps a matter of personal taste. In these days of an obsession with space travel it is at least fashionable. But the important thing was that Kandinsky set painters free to disregard gravity if they felt like it.

35. Kandinsky, sketch for 'Intimate Message' (1926)

[23] *Kandinsky. Entre deux (1934)*

71

36. *Picabia. La sainte vierge (1920)*

Dada

Kandinsky was only one of the springs from which the *intuitionist* stream of modern art arose. Another was the movement known as *Dada*. This arose in the middle years of the 1914—18 war. It was produced by a loosely knit group of young people whose whole being was outraged by the regimented and conventional, but at the same time obviously demented, character of the war society in which they found themselves. A few of them were in Berlin; some had got out to the still neutral New York. Perhaps the most important group were those who had succeeded in making their way to Zürich. They were mostly penniless and had only just, if at all, ceased to be teenagers. But,

in a world in which nearly all their contemporaries were being drafted into the trenches, where their mean expectation of life was measured at best in months, if not weeks, these young people looked deep into themselves to discover what they really wanted to do while they could still do anything. Several of them have since grown up into relatively solid citizens, one at least (Arp) into a really important artist, and some of them have given very illuminating accounts of what was making them tick so feverishly in their wild and disturbed youth.

One of the most vivid, clearly formulated and least hackneyed accounts is provided by the German, Richard Huelsenbeck, who later became a psychiatrist in New York.[23] In a talk on the B.B.C. Third Programme, recorded in June 1959 (for which I am grateful to the producer, Leonie Cohn),

he first tells a rather characteristic story of how the name Dada came into use. A group of war refugees in Zürich — himself, Hugo Ball, with his wife Emmie Hennings from Germany, Hans Arp from Alsace, Tristan Tzara from Roumania, and a few others — were trying to earn enough to eat by the expedient of renting a café — the Café Voltaire — now destroyed but venerated in some quarters at least as one of the birthplaces of an important strand in modern thought, like the Bun Shop in Cambridge, where the logical framework of so much of the biology of the 1950s was being licked into shape during the late 1930s.

In this café they put on a cabaret performed by themselves. It was not wildly successful amongst the burghers of Zürich. As Huelsenbeck tells it, 'Anyhow, our cabaret was bankrupt after two weeks, and the owner came and said "Dear friends, I'm sorry but you will have to quit the place unless you bring in some money." So we had to hire a real performer who could sing. Ball played the piano but the public wanted to hear some songs, and we had a Swiss girl. Her name was rather complicated, and we wanted to give her a stage name and so I — a few days before she was supposed to come to the cabaret, I went with him through the Larousse *Encyclopaedia,* and there I found the word "Dada", so I said to Ball, "Why not Dada?", and he said, "Dada". Dada is wooden horse, or toy, in French. This girl that I was talking about never showed up in the cabaret and therefore we told the whole story to our friends. The word Dada had a kind of magical attraction and from now on we called many of our activities Dada. There is a development, which deserves a certain description — from Dada to Dadaism. Dada was something different from Dadaism. Dadaism already has a certain intent, at least, to explain attitudes by theories, though we frowned very much about any theoretical attitude.'

He then goes on to explain what Dada was all about. '. . . But it was mostly experience, here is the interesting thing that people — we were all very young, I was twenty years old — we felt that something had to be done and our urge to act on something that we didn't know was the real mood that we felt ourselves in. What we wanted to act upon, or what we wanted to act against, we didn't know exactly, so I had been — since I founded Dada together with Arp and Tzara and Ball and the others — I always was in the state of slight uncertainty about the definition of Dada. Until finally I decided that just this kind of uncertainty was the characteristic of Dada.

'We had a great deal of hostility which is always, in my opinion — according to my psychiatric opinion — a part of irrationality. We didn't know exactly against whom we should turn, but it was very important for us to find a target for our resentment. Now I believe that all creative people have a great resentment either against the country they live in or against the civilization in the period of history that they live in.'

The pure spontaneity of primeval Dada is difficult enough to attain, and impossible to sustain over any length of time. Man is too ineradicably a rationalizing animal. He can only live up to the Rabelaisian injunction 'Fait ce que vous voudrez' either in the dream world of a Utopian *Abbey of Thelema,* or by settling for behaviour which is Rabelaisian in the other meaning of that adjective. The young men and women of the original Dada group were by no means wholly averse to the latter course. The wife of one of the Dadaists has described[24] how in 1915 they went from Paris to New York, and 'no sooner had we arrived than we became part of a motley international band which turned night into day, conscientious objectors of all nationalities and walks of life living in an inconceivable orgy of sexuality, jazz, and alcohol'. And you are likely, when scanning the literature, to keep coming across the arcane rubric LHOOQ, a cult expression like Dada, which seems very importantly mysterious till you learn that it is to be pronounced letter by letter in the French fashion, when it comes out as 'Elle a chaud au cul' — *she's got hot pants.* What could be simpler, less sophisticated, and after all not very exclusively avant-garde? Not, of course, that this need weigh heavily against the Dadaists in the eyes of active scientists. What could be a better symbol of sexual love than the double helix of DNA? And the most far-reaching notion of modern molecular biology, that of an 'allosteric' compound — action at one sensitive site causes another sensitive site on the same body to change its properties — might have been directly derived from erotic experience. And the sheer lunacy of Dada finds a worthy rival in the 'eight-fold way'[25] of nuclear physicists.

A more insidious temptation was towards a rational exposition of some attitude. In 1918 Tristan Tzara published a manifesto[26]: 'I write a manifesto and I want nothing, yet I say certain things, and in principle I am against principles, as I am also against manifestos. . . . We are a furious wind, tearing the dirty linen of clouds and prayers, preparing the great spectacle of disaster, fire, decomposition. . . . If I cry out:

Ideal, ideal, ideal

Knowledge, knowledge, knowledge

Boom, boom, boom

I have given a pretty faithful version of progress, law, morality and all other fine qualities that various highly intelligent men have discussed in so many books.'

But Dada could not fully resist the transition into Dadaism. This is what Huelsenbeck said in his Third Programme talk:

'I fought rather for the original status of Dada, which was the status of continual change. I fought for the irrationality which is in Dada — the original creative element in Dadaism out of which came

37. *Arp, drawing (1919)*

many aspects in many movements of Dada; I wanted to avoid to bring Dada into a definite rationalistic scheme. Therefore, I was, all my life, I had a certain hostility or enmity against Surrealism, which is a definite direct rationalistic outcome of Dadaism, and interestingly enough, it has many conventional rationalistic elements.

'If you develop Dada into Dadaism then it disappears, because there you have a kind of philosophy which contains elements of hostility against representational art, and other things. You can write about it. But if you — as I always try to do — adhere to or prefer chaotic, irrational, and creative elements of life to anything, including art, then you understand what I mean by anti-art attitude. To prefer life as such at all times, the basic creative forces of life, to any human activity — or in other words if you put it negatively — I had the feeling that the creative element of life, which in psychoanalytical terms has something to do with the problem of personality or individuation, that the creative forces of life were imperilled by certain forms of conventionalism, mechanization, technology. So that the creative forces of life were the main thing that had to be saved.

'Dada in a way did not fulfil itself. This was its very nature. It was a kind of a stimulant in a great

sense. But here something comes in which develops this whole movement into something new. In order to understand that one has to understand the problem of what is called ''la réalité nouvelle'', the new reality. I think that in our circle Arp was the only one who developed to the point to be able to create new reality which can be accepted.

'There are two major currents in modern art where this new reality is very visible, or two psychological elements which express this striving: the structural element and the expressionist element. And these two are represented in the history of modern art through Kandinsky and Mondrian. You see here how Surrealism falls flat. Surrealism was really only a kind of mixture of romantic originalism and didn't show a new reality in this sense. It indicates, it points towards the uncanniness of life, in the pictures of Delvaux, Max Ernst, Chirico, especially. But it doesn't create that new reality. The new reality is created by the two big movements in art, by the structuralists and by the expressionists.'

▶ In the early days of Dada, Arp expressed a destructiveness as aggressive as any of the rest of the group. 'We must destroy in order that the lousy materialists may in the ruins recognize what is essential. . . . Dada wanted to destroy the rationalist swindle for man, and to incorporate him again humbly in nature.'[27] But he very soon made it clear that there was a great deal more behind his creative impulse than mere destructiveness. He could start off saying[28]: 'Philosophies have less value for Dada than an old abandoned toothbrush, and Dada abandons them to the great world leaders. Dada denounces the infernal ruses of the official vocabulary of wisdom.' But he goes on: 'Dada is for the senseless, which does not mean nonsense. Dada is senseless like nature. Dada is for nature and against art. Dada is direct like nature. Dada is for infinite sense and definite means.' He speaks of the world of nature and the world of art which we wished to create as 'a pious, senseless world without reason'.[29]

It is this sort of world that he did actually create. His works, particularly his sculpture, exhibit, perhaps more profoundly than those of any other modern artist, a sense of an immanent inherent orderliness arising within nature, not imposed on it by any human rationality or conceptualization. It is the type of orderliness with which a biologist is confronted; that of a bone rather than of a crystal. Arp might in fact almost be called a biological constructivist, one who uses the shapes not of elementary geometry, but the more subtly modulated forms of living things. 'Art', he wrote, 'is a fruit that grows out of man like the fruit out of a plant or the child out of its mother. But whereas the fruit of a plant acquires completely independent forms and never resembles a balloon or a president in a cutaway suit, the artistic fruit of man generally

38. Arp, woodcut (1949)

shows a ridiculous resemblance to the appearance of other things.'[30]

His own art is sometimes criticized as being too fruit-like. He wanted 'to inject into the vain and bestial world and its retinue, the machine, something peaceful and vegetative' and sometimes he may have verged somewhat too much towards the vegetable rather than the vegetative. But his best works, although in general serene and pastoral, arouse a feeling of quiet nobility and contained strength, far removed from the lax placidity we associate with a vegetable and more like that of a muscular animal body in repose. These sculptures have been one of the sources from which there has flowed much of what is most valuable in modern sculpture. Henry Moore, who is one of the greatest humanistic sculptors of the time, derived many of his forms from Arp, as did Barbara Hepworth, who has remained more completely within the tradition of abstract, non-representational, work.

Even when Arp appears at first sight to be at his most nonsensical, it appears that in his own view what he was doing was an attempt to come in contact with an underlying order — though a non-human, non-rational order — which he held to be inherent in the universe. He was probably the first artist to make conscious use of chance processes in a considerable way. Duchamp may have occasionally done so earlier. In his Green Box, containing notes written between 1911 and 1915, one runs[31]:

'The Idea of Fabrication

If a horizontal straight thread one metre long falls from a height of one metre on to a horizontal plane twisting as it pleases and creates a new image of the unity of length . . .'

but there is no record that he made more than a few

experiments. Arp for some time used such methods persistently; for instance, by allowing torn scraps of paper to be blown off his desk on to a canvas, or a piece of rope to fall on to it from a certain height, and then fixing them where they fell. 'I declare that these works, like nature, were ordered "according to the law of chance", chance being for me merely a limited part of an unfathomable raison d'être, of an order inaccessible in its totality'.[32] It is the same feeling that led him to write 'For in nature a broken twig is equal to the stars in beauty and importance, and it is men who decree what is beautiful and what is ugly.'[33]

39. Arp, woodcut (1957)

This sense, that the nature around us has an orderliness of its own, of a quite non-human kind, although man can attempt to understand it and adapt himself to it and has no need to regard it as inherently inimical, is, of course, perhaps the most important guiding principle of science. Before the rise of science men thought of the order of nature as something imposed on it by the will of its creator. Medieval man did not see this will as necessarily rational in the human sense; eighteenth-century man did, or at least nearly brought himself to believe that God is a reasonable being. But both saw the order of nature itself as something imposed on it, not something which arose out of it and which therefore entailed no essential reference to human values, so that a broken twig is equal to the stars. This is essentially a scientific climate of thinking and feeling.

Arp's intuition that stochastic or chance processes are one of the fundamental aspects of

75

40. Arp, woodcut

natural processes could scarcely have arisen before. Darwin and the quantum physicist between them had loosened up the framework of strict determinism into which man had previously tried to force the universe around him. His was essentially a one-hit, or at most two- or three-hit, stochasticism. His strings were allowed to fall once from a height on to the canvas, and were then stuck down. His painted papers might be torn at random, and then the pieces assembled 'according to the laws of chance'. But his method of working does not seem to have involved any long-continued sequence of steps in which chance processes alternate or intermingle with more consciously controlled states. It was not until the last decade or so, in the period after the last war, that such complete marriages between chance and control became a regular and important feature in the creative procedures of many painters.

▶ Not many of the early members of the Dada group shared the elegiac temperament of Arp. In most of the others, the aggressive iconoclasm of the movement was more savage and distracted. In the group of Dadaists who were active in Berlin shortly after 1918 the movement had, in general, a rather explicitly political character, although Kurt Schwitters, who was probably the most important of them, was also something of an exception in being comparatively non-political. He made pictures and sculptural constructions out of the discarded rubbish which is such an abundant product of modern civilized life. He referred to them by the word Merz, which seems to be a hybrid between the French and German words for solid excreta (in point of historical fact, it is part of the phrase 'Privat und Kommerz Bank', which Schwitters had cut up for one of his collages; but why did he choose just that syllable?).

The pictures were abstract arrangements of such items as torn bus tickets, bills, letterheads, scraps

76

of packaging materials, and so on, while the constructions incorporated broken pieces of turned wood, such as balustrade railings, wheels, handles, wire nets, and various odd fragments of mechanisms. At the time they were first produced the impression they made was one of derisory contempt for the products of civilization and the machine age. This was certainly amongst the elements that went to their production, but it was by no means the only one. When one looks at these pictures now, one is struck first of all by their charm. The colours are soft, and blend with one another to give an overall impression one can only describe as sweet. This impression has probably been reinforced by the fact that most of the constructions and pictures were made of very ephemeral material, which has faded and acquired the patina of age in the comparatively few decades since they were first made.

But again this is not all the story. Behind the embitteredness engendered in him by the war, Schwitters seems to have had a taste for prettiness and charm. Huelsenbeck, who knew him well, said [34] : 'I think Schwitters was a great artist, but I have an ineradicable hostility toward German petty bourgeois. . . . I felt and I smelt in him a form of petty bourgeois romanticism which I disliked.'

▶ Another artist, Edouardo Paolozzi, who is very sympathetic to this type of art, and in fact has often worked in a rather similar way himself, has written [35] : 'Only a few of the *objets trouvés* and readymades of the heyday of Dada and Surrealism have withstood the ravages of time, if only as materials. They soon fade or rust, and they tend to disintegrate like cheap artificial flowers left out in the wind and the rain on a grey French cemetery. Besides, most of these works of the early Dadaists, and of Kurt Schwitters too, seem to me to be too loud, sometimes even too infantile or silly, in their protest against serious craftsmanship and against all art. It is all a bit hysterical, like a spoiled child's tantrum of anti-art.'

But Paolozzi also expresses very well a strand of feeling which was present in the Dadaists, and which he has himself carried a good deal further. In a conversation with Roditi, Paolozzi said :

'I suppose I am interested, above all, in investigating the golden ability of the artist to achieve a metamorphosis of quite ordinary things into something wonderful and extraordinary that is neither nonsensical nor morally edifying.'

Roditi 'Would you then agree that your own conception of the fantastic sublime tries to avoid both the portentous and the grotesque ?'

Paolozzi 'Yes, It is the sublime of everyday life. I seek to stress all that is wonderful or ambiguous in the most ordinary objects, in fact often in objects that nobody stops to look at or to admire. Besides, I try to subject these objects, which are the basic materials of my sculptures, to more than one metamorphosis. Generally, I am conscious, as I

41. Schwitters. Merz 22 (1920), collage

work, of seeking to achieve two or at most three such changes in my materials, but sometimes I then discover that I have unconsciously achieved a fourth or even a fifth metamorphosis too. . . .

'That is why I first build up my model by cementing my salvaged *objets trouvés* together with clay, after which I make, with my assistant, a plaster cast of them, and in this cast a wax mould that is finally sent to be cast in bronze. This is what imposes, in addition to a formal metamorphosis, a material metamorphosis on all my materials. In the finished casting, the original *objets trouvés* are no longer present at all, as they are in the Dada and Surrealist compositions of this kind. They survive in my sculptures only as ghosts of forms that still haunt the bronze, details of its surface or its actual structure.'

The Dada collages of gummed paper and assemblages of bits and pieces loosely joined together

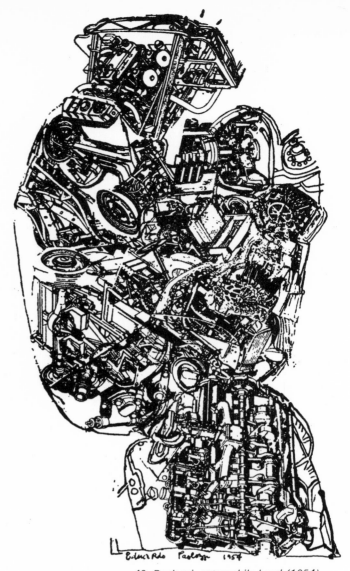

42. Paolozzi, automobile head (1954)

were intended to be 'multi-evocative images', suggesting simultaneously a number of different, often at first sight contradictory, associations. In a great many, probably the majority, of them, some of the associations are with the products of technology and often with science itself. Thus, in recent times, Paolozzi builds up images of human figures which incorporate into their structures pieces of quite elaborate mechanism, such as parts of typewriters, gearboxes, crankshafts, and so on. And, again in recent years, artists like Chamberlain, Stankiewicz, César, Seley, and others have made sculptures out of pieces of car engines, automobile bodies and bumpers.

Most recent workers have used such materials when they have been reduced to scrap, and the engines are broken and rusty, and the car bodies often after they have been compressed ready for shipment to the scrap merchant. In the early days of Dada artists were less insistent on seeing the technological world as merely a rubbish heap. For instance, Picabia and Max Ernst made many drawings and pictures involving more or less imaginary machinery of a relatively simple type involving cranks, pistons, levers, and so on. To some extent, of course, they were guying the scientific world of machinery. They often gave their pictures titles of a romantic, if often nonsensical, character. For instance, Picabia entitled *Flamenca*, a drawing which was a more or less accurate engineering diagram of a push valve, but which also carried some suggestion of a dancer holding both her arms above her head; while Max Ernst made a painting, the main feature of which seems to be a diagram of a gas-refining plant, which he calls *Winter Landscape*. Besides the element of irony — the implication that it is to such cold, inefficient, and ridiculous mechanisms that science has reduced the romance of the world — there is also in these pictures some feeling of an

almost boyish attraction for mechanisms as such, something of whatever it is that leads so many people to find happiness in tinkering with machinery.

This romanticizing was applied almost exclusively to scientific images which were already out of date at the time the artist used them. The machines of Picabia and Ernst are definitely old-fashioned contraptions which would operate — if they could work at all — by the simple mechanical principles known to Watt and Stephenson. The scientific pictures used in the collages were taken from old textbooks of such well-established subjects as comparative anatomy. There was no attempt to make use of a vocabulary of images that was up to date. The affinity between Surrealism and modern science is not at all at that level, but lies in the Surrealists' interest in the psychology of the unconscious mind and the processes of imaginative creation.

▶ The characteristic Dada attitude to science and to science-based products is a strand of some importance in the complex network of inter-relations between science and painting in our time, if only because it began so early and has continued right up to the present day. Although its heyday was in the period just after the First World War, when its most important exponents were Dadaists like Picabia and Surrealists like Max Ernst, it began perhaps with Alfred Jarry at the very beginning of the century. It is still an important force in Paolozzi and some of the Pop artists and has even been given a definite organizational form incorporated in the *Collège de Pataphysique*, whose headquarters can be found in one of the little streets off the Rue de Seine in Paris. It is a highly complex attitude containing a lot of high-spirited but essentially trivial nonsense, buried in amongst which there are a few rather disjointed insights of considerable importance.

On the surface — and in my opinion quite a long way down into the depths of the movement — it was no more than a simple adolescent guying of the stuffy 'I'm-more-efficient-than-you' aspects of science. Picabia and Ernst drew pictures of machines which clearly didn't work or didn't do anything in particular. More recently artists like Tinguely have actually made them, constructing them in such a way that their operation either ridicules the whole purpose of mechanism by resulting in a totally unpredictable instead of a precisely defined end result, or by an even more radical *reductio ad absurdum* which actually succeeds in causing the whole mechanism to fall to pieces and disintegrate. At first glance — and first glances are not without importance, whatever may follow — this is no more than a piece of good clean fun on the level of the spoof modern art exhibitions — there is a story, but I'm afraid I cannot lay hands on documentary proof of it at the moment, that even such an eminent scientist as Lord Adrian, O.M.,

43. Picabia. Flamenca (1917)

formerly Master of Trinity College, Cambridge, took part in one when he was young — in which scientists have guyed contemporary painters by throwing a lot of paint on canvas and exhibiting it as the latest thing.

But, we have to ask, is this the only or the most important level? The Dadaists get at us, sometimes in not quite fair ways, to persuade us that their work contains implications which are not merely more important, but even of an ultimate importance. Alfred Jarry, who began the whole of this movement when he invented a pseudo-scientific character, Dr Faustroll, as a mouthpiece to preach the doctrine of Pataphysics, so far refused to have anything to do with ordinary common sense that he consciously drank himself to death — and, the argument goes, who are we, in the face of consciously courted death, to deny him the status of a character whose contributions to human culture must be taken seriously? In the relatively gentle Georgian era before the First World War the

point was rather devastating. In the more brutal and lunatic world of the 1960s we are perforce developing a more impervious shell against the impact of human eccentricities. Buddhist monks soak themselves in petrol and burn themselves to death in protest against the atrocities committed by Viet Cong at a time when the most conventionally progressive people have worked up a great movement of protest against the atrocities committed by the American enemies of the Viet Cong. Personally I confess to a very 'square' conviction that lunacy is not an argument but is an occasion for treatment by the Mental Health Authorities, and to a strong antipathy to being morally blackmailed by masochism. The fact that Jarry — and the hopped-up Beats who are his rather pallid modern counterparts — were very unhappy characters does not in itself persuade me that they had anything noticeable to contribute. To decide that, one must look at what they actually said and produced.

When one does so, one finds, I think, that there is a genuine germ of valuable feeling hidden amongst the mixture of jolly fun and games and bitter chip-on-shoulder nihilism. This germ is, to put it in unduly simplified and black-and-white terms, an insistence on man's most non-rational but inescapable characteristic, the experience of free will. We build machines to do particular things, but we can always decide that we didn't really want to do those things after all. We can understand some natural process as a sequence of cause and effect — a machine — but perhaps the only reason we can do this is because we have invented the terms in which the problem is stated at the beginning, the way in which the result is to be formulated at the end, and the whole series of cogs, levers, and other connections by which the process is carried on. The nugget of gold in the Jarry-Dada Pataphysical Science — the sixpence you may be lucky to find within the rich and indigestible plum pudding — is a key to open the door to the unconscious realm of non-rational mental happenings, a step or two removed from our conceptually formulated but partial insight into the real world. As it has been expressed by Shattuck, the expositor-in-chief of the Collège de Pataphysique[36]: 'Pataphysics is the science of the particular, of laws governing exceptions. . . . Pataphysics is the science of imaginary solutions.' It is the statement that whenever we have a system, there remains something outside the system — a point formulated with complete logical rigour in Gödel's theorem, which we shall meet again on page 106.

There is, then, something lurking behind these pseudo-machines from Picabia to Paolozzi, but now let us return to a more mundane level.

It was not only the romance of machinery that appealed to the Dadaists. Max Ernst has related[37] how 'one rainy day in 1919, finding myself in a village on the Rhine, I was struck by the obsession which held under my gaze the pages of an illustra-

ted catalogue showing objects designed for anthropologic, microscopic, psychologic, mineralogic and palaeontologic, demonstrations'. He soon started making pictures in which parts of drawings from illustrated catalogues and textbooks of biology and anatomy were combined by cutting out and gumming them together into collages to form multi-evocative images, in which the scientific content of the original drawings lingers only as a general flavour behind a whole series of layers of other associations and intimations.

Surrealism

The shadowy presence of these scientific artefacts was certainly not by any means the main factor in these productions, for Max Ernst. The collages which he made just after the end of the 1914 – 1918 war can perhaps be regarded as the beginnings of what became a well-defined school of painting, which took the name Surrealism, borrowed from a closely related literary development. Besides the sense of wonder in scientific discoveries, which had been expressed by Apollinaire, the paradox of romantic man in a mechanical world, which had given rise to Chirico's most evocative pictures, and the aggressive nihilism of Dada, they incorporate also two other of the main strands of Surrealism's multiple parenthood. By this time Freud's discovery of the unconscious, and the development of a scientific — or at least would-be scientific — theory of psycho-analysis was

44. Max Ernst. L'unique et sa propriété

80

becoming well known. The possibility of utilizing the symbols recognized by the unconscious, and of appealing to subliminal processes of association, was a major preoccupation of Max Ernst and the other surrealist painters and poets of the time, such as Dali, Magritte, Delvaux, Miro, and others.

The exploration of this area of shady and nebulous concepts and relations followed two main directions: the bringing together of incongruous elements in unlikely circumstances and the exploitation of various techniques of 'automatic' (i.e. unconscious) production. The former of these had been used in an extreme and easily recognizable form by the nineteenth-century French poet, Lautréamont. His book *Les chants de Maldoror* became almost a Surrealist bible, particularly to the poets attached to the movement.

Lautréamont was writing just at the time when Darwin's theory of evolution was first becoming known in France. He studied in the Paris *École Polytechnique*, and his work is full of scientific allusions and mention of technical instruments, advances in physiology, zoology, etc. As Balakian says[38]: 'In *Les chants de Maldoror* the primary concern of the author is the reorganization of the living world, biologically integrated and by the same token bereft of the moral supremacy of man. . . . Finding himself a descendant of the ape and a brother to the leech, man can no longer believe himself created in the image of God. Lautréamont did not come to this notion serenely . . . it was a bitter disappointment for him to discover the extent of man's limitations. Maldoror, the half-man, half-beast, hero of his work, wanders day and night without rest or respite, troubled by horrible nightmares and by phantoms that hover about his bed and trouble his sleep . . . the analogies between man and beast form the core of his imagery in his *Les chants de Maldoror* . . . human eyes are like the sea hog's, circular like a night bird's. When man stretches his neck it looks like a snail's; his legs remind Lautréamont of a toad's hind limbs. Man's facial expressions are those of a duck or a goat, his baldness that of a tortoiseshell, his nakedness that of a worm.'

What mainly interested the surrealists was the lengths to which Lautréamont went in his search for vivid and far-fetched analogies provoked by this earlier shock administered by scientific discoveries to accepted beliefs. 'A vulture of the lambs, beautiful as the law of the arrest of the development of the chest in adults whose tendency to growth is not in relation to the quantity of molecules that the whole organism assimilates, vanished into the high reaches of the atmosphere.'

Theorists of surrealism, such as André Breton, have cited this last effort as the perfect surrealist image. It was effects of this kind that Max Ernst was striving for in most of his collages. 'What is the mechanism of collage?', he writes.[39] 'I think I would say that it amounts to the *exploitation of*

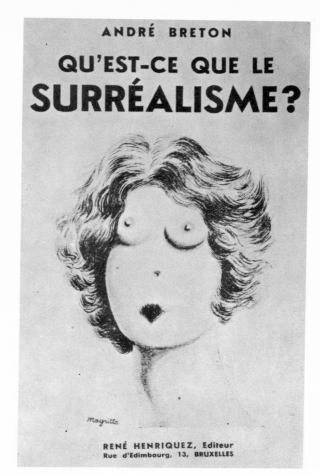

45. Magritte, book cover

the chance meeting on a non-suitable plane of two mutually distant realities (a paraphrase and generalization of the well-known quotation from Lautréamont "*Beautiful as the chance meeting upon a dissecting table of a sewing machine and an umbrella*").

'A complete, real thing, with a simple function apparently fixed once and for all (an umbrella), coming suddenly into the presence of another real thing, very different and no less incongruous (a sewing machine), in surroundings where both must feel out of place (on a dissecting table), escapes by this very fact from its simple function and its own identity; through a new relationship its false absolute will be transformed into a different absolute, at once true and poetic; the umbrella and the sewing machine will make love.'

When it succeeds, this technique of juxtaposing two apparently unrelated objects may provoke the mind, particularly at unconscious levels, to go riding off into a fantasy more free and unfettered than its everyday mode of progression. The surrealists were insisting on, and trying to exploit, the fact that the drawing of analogies is an activity, not a mere passive reflection. As a recent surrealist, Jean Brun, has put it,[40] 'The capital fact of the entire history of the mind lies perhaps in this

discovery of surrealism: the word *comme* is a *verb* which does not signify *telque.*'

For the more thoughtful and articulate Surrealists, this amounted to nothing less than a very radical theory of epistemology. Man does not, they argued, apprehend the objects by which he is surrounded in any sort of direct manner. On the contrary, they wished to invert the commonsense outlook, which believes that we usually perceive the ordinary chairs, tables, and other items among which we live in a way which does not too blatantly distort their real nature, although occasionally we may be deceived by illusions or hallucinations. The Surrealist claim was that a kitchen chair is no more 'real' than a vision which our imagination conjures out of a chance configuration of light and shade, or an image in a dream; both are perceived by the selfsame process, which depends not on mere receptivity of sense organs, but on a creative act of the imagination. This is a point of view which has some similarities with the outlook of those physicists who claim that in his investigation of nature 'man confronts himself alone' (which we shall discuss on p. 108). But it goes very much further in this solipsistic direction than even the most idealistic physicists; and, of course, it entirely fails to take account of the feet-on-the-ground biological point that natural selection will have seen to it that what we perceive is at any rate something which it pays off to perceive – an argument which is discussed more fully in connection with the physicists' theories (p. 116).

It is noteworthy that Max Ernst's collages, like Lautréamont's verbal analogies, contain a great number of references to scientific objects or technological mechanisms. The conflict between man the conceptualizing scientist, and man the

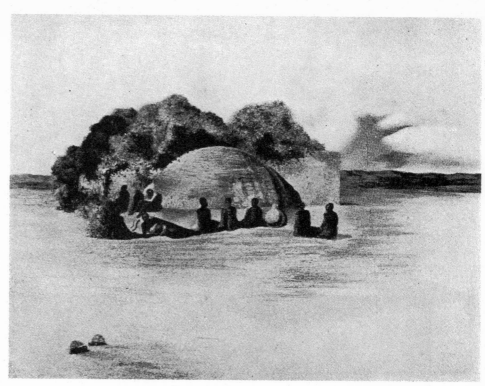

46. Molinier, portrait of Joyce Mansour

47. Dali. Visage paranoïque (1935)

emotionalizing sensualist, was one of the main forces impelling the surrealists into their exploration of the uncharted potentialities of unconscious processes. They pursued other methods than that of the confrontation of incongruous objects in a collage. They explored the images that arise in dreams, or in that half-dreaming state that precedes full sleep or occurs at the moment of awakening. They went in for automatic writing or automatic drawing, when the attention of the conscious intellect is withdrawn and the hand allowed to move under 'its own' impulsion. But this phase was relatively short-lived. As was pointed out by one of them, Marcel Jean, in his book, the *History of Surrealist Painting,* which is one of the best accounts of the whole movement, 'Living flowers fade and wither away, beach pebbles, so attractive when gathered during the holidays, soon turn into sad little stones – the brilliance of the scenes and speeches perceived in dreams often evaporate in the light of day. In addition, their unconscious origin in no way frees these representations from the grip of habit which is inevitably bound up with any automatic operation.... Monotony and disillusionment are, then, the two hazards of automatic activity.... André Breton went so far as to say, in *The Automatic Message,* that "The history of automatic writing in surrealism has turned out to be a constant misfortune" [41]'.

▶ A more fruitful technique was the production by some automatic technique of an expanse of varied texture which provoked the mind to conjure up fantastic images inherent in it. Max Ernst has described one of his methods as follows.[42]

'It all started on August 10, 1925, by my recalling an incident of my childhood when the sight of an imitation mahogany panel opposite my bed had induced one of those dreams between sleeping and waking. And happening to be at a seaside inn in wet weather I was struck by the way the floor, its grain accentuated by many scrubbings, obsessed my nervously excited gaze. So I decided to explore the symbolism of the obsession, and to encourage my powers of meditation and hallucination I took a series of drawings from the floorboards by dropping pieces of paper on them at random and then rubbing the paper with blacklead. As I looked carefully at the drawings that I got in this way – some dark, others smudgily dim – I was surprised by the sudden heightening of my visionary powers, and by the dream-like succession of contradictory images that came on top of another with the persistence and rapidity peculiar to memories of love.

'And so the *frottage* process simply depends on intensifying the mind's capacity for nervous excitement, using the appropriate technical means, excluding all conscious directing of the mind (towards reason, taste, or morals) and reducing to a minimum the part played by him formerly known as the "author" of the work.'

As he said in another place [43]: 'You can see that this amounts to putting into practice the celebrated lesson of Leonardo da Vinci, who advised

[24] *Max Ernst. Oedipus Rex (1921)*

48. Max Ernst, collage from 'La semaine de bonté' (1934)

his disciples to let themselves contemplate stains on walls, the ashes in a fireplace, clouds, streams. He promised them very remarkable discoveries which which their painter's genius could take as a basis to compose battles of animals and men, landscapes, or monsters, devils, and other fantastic affairs' (see p. 165).

In practice, Ernst used his frottages mainly to make landscapes — mysterious cities perched on a hilltop under the moonlight, threatening impenetrable regiments of tree-trunks crowded around a forest clearing. In his *Histoire naturelle*, he employed rubbings, made from a variety of natural surfaces, to construct portraits of imaginary or outlandish animals and plants, in drawings of great simplicity and childish charm. He opens the preface of the book with Eluard's phrase, 'plu-

sieurs enfants font un vieillard'; and closes it with some sentences which may be translated thus: 'Let's have no fear of falling into the infancy of art. We will not upset those blind ones who dance, at night, on the roofs of our towns and countryside. They, who are more amorous for life than are the living, try only to live — they do not try to see. Let us honour the seas that rise, and the moons also.'[44]

This is a typical specimen of what was, perhaps, the Surrealists' most successful achievement, a free-flowing, allusive, mysterious, and lyrical poetry — not painting at all. Surely no one in our time has written better love poetry than the surrealist Eluard; and some of the novels and stories produced by writers associated with the movement seem likely to outlast most of the paintings. Modern philosophers of the analytical school may

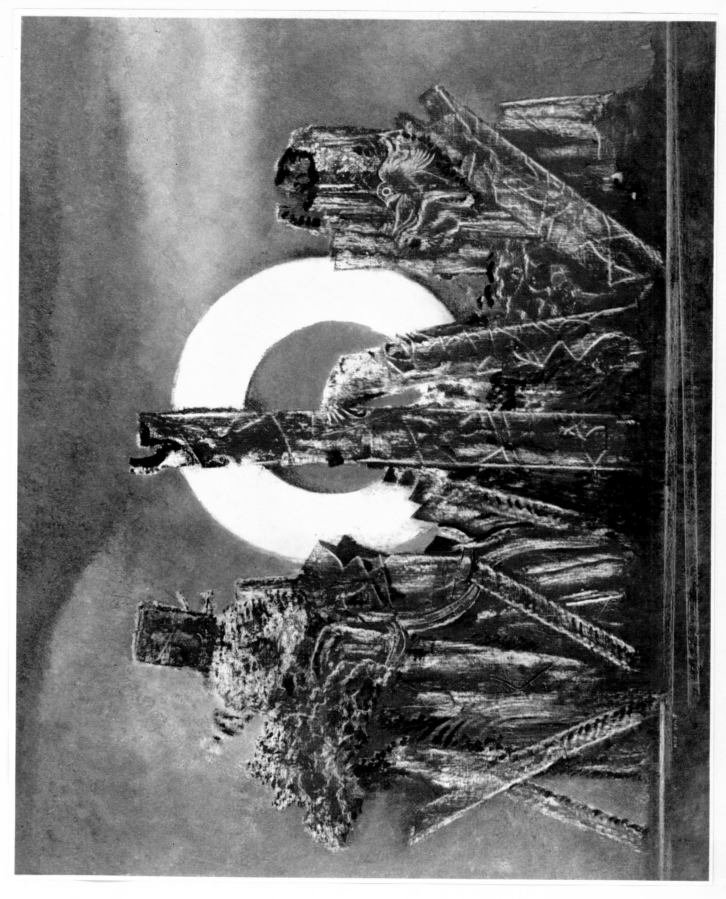

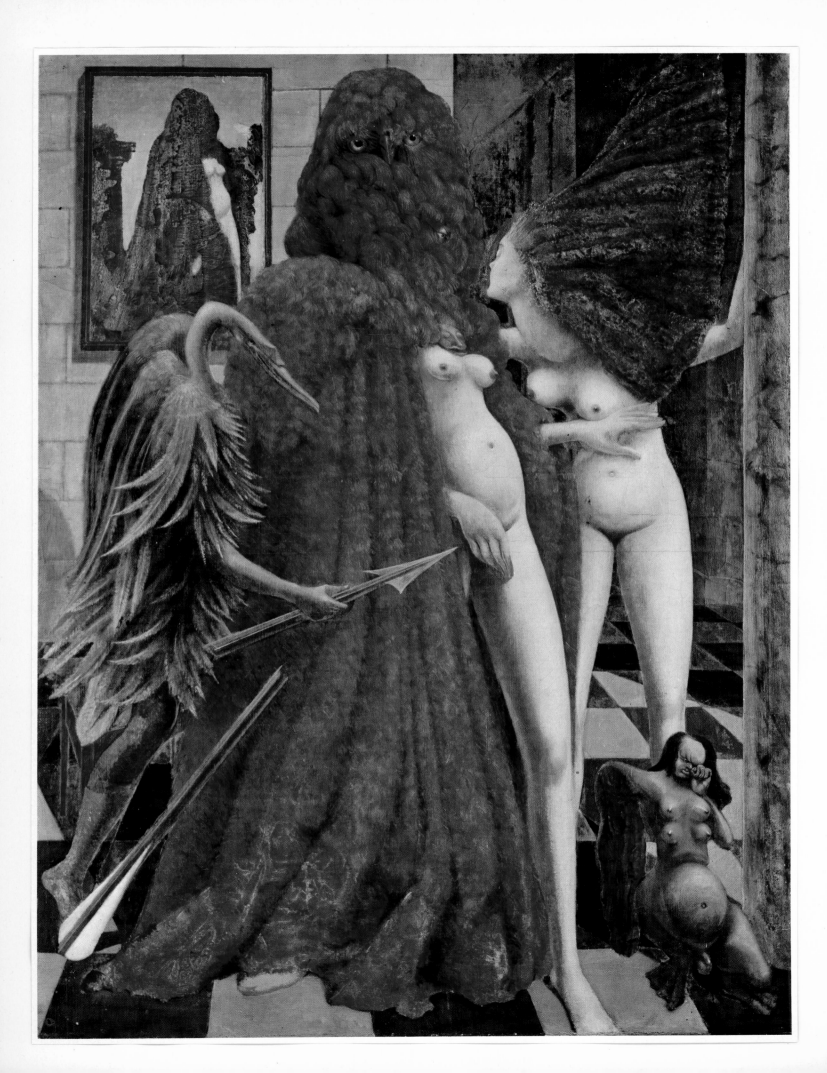

49.

try to convince us that words or statements are precise instruments which can be subjected to an algebraical calculus of manipulation, but in fact it seems to turn out that a verbal phrase carries with it a field of far more widely ramifying over- and undertones than any 'mysterious' texture elicited by making a rubbing on a worn plank. The allusive capacities of the mind, which the surrealists set themselves to exploit, proved easier to tap through words than through pictures.

However, the fact that image-suggestions have a real effect on our minds – if you prefer, on the operations of our neurological apparatus – has become a scientifically respectable field of research; and it has been shown that they are effective at quite a deep level in the strata of pre-conscious mental events which the surrealists were trying to tap. To give one example. Eagle, Wolitzky and Klein have published a report[45] on an experiment in which one group of people was shown the drawing on the left (above), while another group was shown that on the right. Both groups were then asked to try to let their minds wander, and to write down the first images or associative ideas that came to them. Most people's images were concerned with nature in some form – trees, streams, and so on. But a considerably higher proportion of those who had been shown the figure on the right came up with something which, in a preliminary experiment, had been shown to be associated with *ducks*; though almost no one in this group (or in the other) expressed any conscious awareness that there was anything to do with a duck in what they had seen. It is not only that what you know you have seen calls up associations of quite other meanings – but even things you don't know you have seen may have similar causal consequences, which you don't recognize. The surrealists were only too

right in their insistence that the mind is Funny Business; the main criticism of them is that they tried to oversell a good point.

▶ In painting, the greatest successes of Surrealism were achieved by painters who were on the periphery of the movement, and in whose work surrealism was only one, and not even a dominant, influence. Miro and Klee are both painters who were not mainly concerned with reflecting any views about the nature of physical reality; their interests were primarily in aesthetic creation itself, and secondarily in people and mood. They, therefore, are among the many fine modern painters whom it would be inappropriate to discuss at length in this book. But there are two points which it is important, for our purposes, to make about them. One, in the immediate present context, is that both of them were to some extent 'surrealist' in their use of free association, allusive symbolism and appeal to the subliminal mind – which they used also in their method of working. The other is that many of their technical advances – particularly the all-over non-focused patterns so common with Klee and used also, more seldom, by Miro – had an important influence on developments in the next phase of painting, in the late forties and fifties.

Meanwhile, Surrealism rapidly developed into a definite 'school', with its own orthodoxy. Dali, one of the most technically facile, and originally one of the most provocative – perhaps because also one of the craziest – of them, was 'expelled' for deviations, of an esoteric kind which nowadays only the most erudite would bother to comprehend. But the more strictly orthodox school – Magritte, Masson, Delvaux, Paalen, Tanguy, Brauner, Lam – produced very little that Max Ernst had not already adumbrated about the way in which man experiences his material surroundings; although Magritte, in particular, thought up some

[26] *Max Ernst. L'habillement de la mariée (1940)*

87

50. Masson. La Martinique (1941)

ingenious visual sledgehammers for driving home the point that the real is conceptual, and *vice versa*. For the most part, they tended to turn away from exploring the intrusion of man's emotional and intuitive being into the very act of perceiving the outside world, and developed instead the new powers which the Dada-Surrealist movement had offered to another of painting's main preoccupations, the endeavour to express feelings and states of mind in visual terms. It was along this line of evolution that, in what geneticists' jargon would call the second filial generation, Matta and Arshile Gorky transmitted a great liberating freedom from dogma and symbolism to the initiators of the New Start which we shall consider in a later chapter.

But the first filial generation had Freud in the forefront rather than the background of their minds, and most of them soon found that their free associations led them inexorably to the more or less run-of-the-mill anatomy of their girl-friends. In a conversation with Georges Charbonnier on the French radio,[46] André Masson, who was one of the best painters, and later one of the most influential, associated with the surrealists, began by saying: 'I believe that what surrealism wanted to do was this: to show men that they have poetic resources which they neglect.' But he soon became more explicit:

'I will tell you what I have already said many times: I have always been cold in front of the abstraction which I call geometrical. For me, it is often nothing more than elementary cubism. Naturally, I consider the extremism of Mondrian as a very respectable thing, but what I want to say is, that I am never elevated by this type of art. I have often been extremely violent in my remarks against this type of painting, but when I see young painters going towards what I call lyrical abstraction, I am delighted. There is an old painter, Bonnard, who thinks the same. Painting can devilish well start from there, even figurative painting. Why not? Painting of lyrical abstraction contains all the phantasms in a latent state, phantasms of desire, phantasms of a more beautiful life, intimacy with nature. As I said before, I — I would like to paint the private parts of nature, which is a very surrealist idea, without a doubt. I would like to paint nature's vulva, that's it. And well, I think that if I said that to the young lyrical abstraction painters, it wouldn't offend them at all. They'd find it jolly good.'

[27] *Miro. Tête de femme et oiseau par une belle journée bleue (1963)*

51. Meret Oppenheim, surrealist object (1936)

52. Man Ray, portrait of Meret Oppenheim (érotique voilée) (1933)

He certainly tried his best, but do the genitalia he so realistically depicted belong to Nature, or even to one of those remarkable women – Marilyn, Brigitte, Christine – on to which western man has off-loaded his sexual feelings as on to some hybrid between a living Venus and a scapegoat – or merely to a very ordinary landlady's daughter?

So Surrealism, as an explicitly formulated philosophy and an organized school of painting, ran itself into the ground almost as irrevocably as did the geometricizers. It produced some of the most haunting poetry of our time; and some of the finest artists – Picasso, Miro, Klee, Arp – allowed themselves to come into relations with it close enough to be considered compromising. But too many of the true-blue, 100% surrealist paintings have acquired, a quarter of a century later, an ineradically gimmicky look. The standard response to them nowadays was expressed by Charles Madge in a recent newspaper article[47]: 'Of all the theories of artistic creation which have held sway during the present century, perhaps the bravest and most all-embracing was the theory of Surrealism, with its programme for the total reconstruction of human spiritual activity based on Marx and Freud. But of all the rooms at the Tate Gallery, for example, the one which seems to hold least for us in 1963 is the surrealist room, with its emptily programmatic canvases, its hallucinations which were never hallucinated, its dreams that were never dreamt. Just as the Neo-Impressionists demonstrated that painting could not be based on physics, so the Surrealists have proved that it could not be derived from psycho-analysis. Positivism in art is a form of hubris, a splendid ambition which is doomed to failure.'

This is, I think, to throw the baby out with the bathwater. Even within the strict surrealist canon, some of the best works still have a good deal to offer. Max Ernst's collages, and particularly his collage 'novels', *La femme cent têtes*, and *Semaine de bonté*, which are like a cross between Wilkie Collins and parts of James Joyce's *Ulysses*; some of Masson's eroticized landscapes; or Yves Tanguy's views into the depths of the sky over an infinite plain of pebbles, which hint at both the soil close-ups of Dubuffet and Rothko's areas of effulgent light; these cannot be so summarily dismissed. And, most explicitly, in its literary manifestations, Surrealism lent its aid to one of the most vital, but one of the most struggling and most in-need-of-aid, endeavours of man in this age of statistical assemblages – what Auden spoke of as 'fleeing the short-haired mad executives'. What Surrealism opposed to the lunacy of accepted common sense was, admittedly, an ultimately even less satisfying crankiness – but at least it opposed and thereby let in light. I quote from one of its more endearing works, André Breton's account of his mad girl-friend Nadja.[48] 'And after this, let no one speak to me of work – I mean the moral

[28] Brauner. Détermination d'un espace (1962)

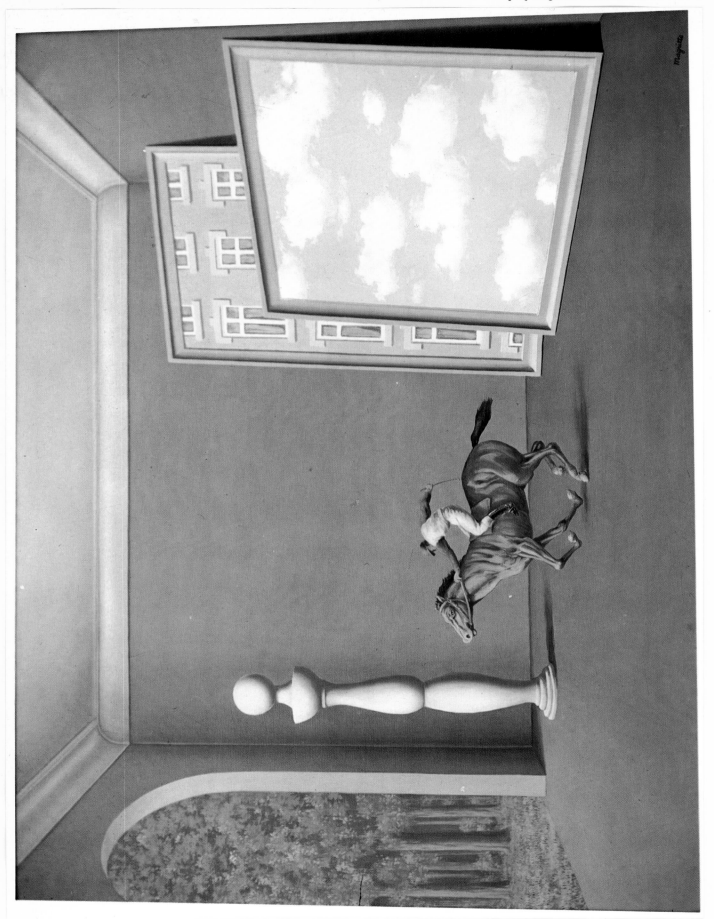

value of work. I am forced to accept the notion of work as a material necessity, and in this regard I strongly favour its better, that is, its fairer, division. I admit that life's grim obligations make it a necessity, but never that I should believe in its value, revere my own or that of other men's. I prefer, once again, walking by night to believing myself a man who walks by daylight. There is no use being alive if one must work. The event from which each of us is entitled to expect the revelation of his life's meaning — that event which I may not yet have found, but on whose path I seek myself — *is not earned by work*.'

Perhaps the most satisfying of all the works of the school are those in which Surrealist artists collaborated with the poets who were their friends to produce books. A page from one example, *Facile* by Paul Eluard, illustrated with photographs by Man Ray, is reproduced on page 96. Few love poems of such simple beauty have been created in this century.

But, making all allowances we can, it remains that the Magicians, who took their origin in so many diverse reactions to the eruption of modern science into the rational Newtonian world, yet finish up by seeing science as a Cyclops, a monster whose one eye sees only mystery, nostalgia, foreboding, and tends to become fixed in a stare at that orifice through which we enter the world and in which we find either the most fitting socket in which to plug in to what is going on, or, alternatively or simultaneously, the most seductive avenue down which to escape from the day-to-day toing and froing. The Magicians began by using many different sorts of abracadabra, but finished up firmly riding along a set of rails that led to a dead end.

53. Masson, from the 'Nocturnal Notebook' (1944)

54. Max Ernst. Paramyths (1949)

Overleaf: 55. Miro. Légende du Minotaure (1934). [30] Magritte. Philosophie dans le boudoir 93

Tu te lèves l'eau se déplie
Tu te couches l'eau s'épanouit

Tu es l'eau détournée de ses abîmes
Tu es la terre qui prend racine
Et sur laquelle tout s'établit

Tu fais des bulles de silence dans le désert des bruits
Tu chantes des hymnes nocturnes sur les cordes de l'arc-en-ciel
Tu es partout tu abolis toutes les routes

Tu sacrifies le temps
A l'éternelle jeunesse de la flamme exacte
Qui voile la nature en la reproduisant

Femme tu mets au monde un corps toujours pareil
Le tien

Tu es la ressemblance.

56. Poem by Paul Eluard, photography by Man Ray, from 'Facile' (1935)

Part 2 The Hybrid Argus

57. *Max Ernst, from 'Troisième Poème Visible' (1934)*

Part 2 The Hybrid Argus

4

The Scientists

Man in the world is like a caterpillar weaving its cocoon. The cocoon is made of threads extruded by the caterpillar itself, and is woven to a shape in which the caterpillar fits comfortably. But it also has to be fitted to the thorny twigs – the external world – which supports it. A puppy going to sleep on a stony beach – a 'joggle-fit', the puppy wriggles some stones out of the way, and curves himself in between those too heavy to shift – that is the operational method of the scientist, as he tries, with his blunt instruments – intellectual and experimental – to come to grips with the stubborn and unexpected world.

Science and society

The science which provoked artists into the revolutionary activities which gave rise to what we know as modern art was that of half a century ago. Such artists were influenced by the first stirrings of the movements which are leading to the overthrow of centuries-old Second Science by the nascent Third Science. The theoreticians of early Cubism, such as Apollinaire, realized that the scientific world picture was being changed out of all recognition by systems of ideas which not only had an immediately attractive elegance of logical coherence, but which had been arrived at by an audacity of imagination bold enough to formulate concepts far outside the range of conventional common sense. The geometricizing movement in painting developed mainly the feeling for elegance and precision, although, as we have seen, it never quite lost its sense of the mysterious – expressed by Mondrian when he said he felt himself close to the Surrealists. The other main movement, which I have labelled the Magicians, made the sense of mystery and the reliance on intuition the centre of its interest; but it, in turn, retained some interest in the more factual aspects of science – as illustrated in Max Ernst's collages. Each of these movements produced some magnificent works, but it is probably fair to conclude that none of the artists who had tried to produce a form of art congruent with man's new ways of looking at the universe had succeeded in synthetizing, in symbolic form, the whole gamut of new insights which science was yielding.

In the late 1940s a new chapter in modern painting was opened. Perhaps the most impressive and certainly the most publicized of these new movements took place in a country which had previously played little part in advanced painting – the United States. But the movement was not at all a local one. Important new beginnings had been made in most European countries – France, Great Britain, Spain, and Italy – before the artists in those countries had much contact with the American developments, which, when they became known on this side of the Atlantic – and on the other side of the Pacific – immediately evoked enthusiastic responses from European and Japanese artists. Before we consider these new movements in painting, and in particular their relation to the understanding of the existing world, which science offers, it is necessary to say something about the developments which had been taking place within science itself.

Science had, of course, been advancing at an almost explosive rate in the forty years between the beginnings of Cubism and of the newer styles of painting, which began in America. This advance of science has taken place on many levels. The most obvious in everyday life is the technological.

The years between the beginning of the First World War and the end of the Second were a period in which many devices — like automobiles, aeroplanes, telephones, refrigerators, and the entire apparatus of modern medicine — which previously affected the lives of only a few, were multiplied and made available to all, so that they now provide western man with a tool-box of whose capabilities not even the most impecunious and bohemian artist can remain unaware. An even more important development has been the increasing dominance of technology over politics in the old sense. This was dramatized by the development of the atomic bomb. The production of this weapon of cataclysmic power was, of course, carried out not by scientists working as members of the community of natural scientists, whose aim is to understand the world, but by scientists who had placed their services as technical experts at the disposal of the political governments of their countries. The almost equally important, although (so far) less obtrusive, results of the application of medical and biological sciences, which have led to the population explosion, were also produced by scientists acting as technical experts in carrying out the behests of the ruling powers of society. These two developments, and the continuing and accelerating increase in the efficiency of technical industry, have brought about a situation in which the most urgent and pressing problems in the social life of man are worldwide rather than intranational in scope, and are as much, if not more, technological as political.

There have, of course, always been painters deeply engaged in the political and social issues of their time. For instance, in the early part of our period, there were the Mexican muralists, the Russian socialist realists, and politically oriented western European artists — such as Grosz, Beckmann, and others in Germany, Guttoso in Italy, and many more. There is no space to consider them in this book, which is concerned not with modern painting as a whole, but with the more limited subject of the relation between modern painting and science.

Similarly, we shall have largely to ignore the more recent artists whose work has been mainly concerned to express the situation of man faced with an Atomic Age. Beginning perhaps with Picasso's *Guernica*, this has been an important movement in the painting of the last twenty years, containing such names as Giacometti, Francis Bacon, Leonard Baskin, Rico Lebrun, Germaine Richier, Paolozzi, Zadkine, and a number of others. Their outlook was almost uniformly pessimistic. They have responded to the horror of the atom bomb but hardly at all to the contemporaneous doubling of the life span of the populations of the previously backward parts of the world. They tend to picture man either as a terrified and agonized individual caught in a cage of his own making, or

as a partially disintegrated being, crumbling away into shreds and tatters of refuse. Goya, after the Napoleonic wars in Spain, painted a vision almost as black, but the present-day artists take steps to show that the savagery confronting mankind nowadays is universal in scope and not confined to individual instances in isolated battles.

It is, however, only a minority of artists that has mainly concerned itself with such themes; although these lurk at the background in the work of many others who are primarily concerned with other matters. The technological character of the world we live in has to be kept in mind throughout our discussion of the bearing of post-war painting on our view of the nature of reality, to which we must now return.

Measurable facts or intuitive understanding?

During the last fifty years, science has become a much more self-conscious activity; or at least the criticism of its methods and modes of operation, which scientists have always made since the days of Sir Francis Bacon, has been carried out much more thoroughly and in ways which have brought it to public attention. Writers such as Bertrand Russell and Eddington, who were largely concerned with such questions, in their time almost reached the ranks of best-sellers. Artists who dabbled in such writings — and painters seem, much more often than poets and literary men, to be admirably exploratory in their reading, uninhibited by a fear that the details of the subject will be beyond them — have found themselves coming up against two rather radically contrasted views of what science is about. One suggests that science deals only with certain formal relations between the entities making up the world, which it investigates by measuring certain quantities, while it omits from its consideration the greater part of the qualities which give things their feel and colour; while the other claims that science has, by an act of intuitive imagination, to seize on some new aspect of just these qualitative characters before it can decide what is worth measuring.

The opposition between these two points of view runs through a great deal of the recent history of thinking about the nature of scientific activity. It is worth considering them first in the form they took in the inter-war period. Again I will go to original sources and quote, first, from Eddington, who puts very clearly the argument in favour of the idea that science must necessarily omit most of the phenomena of existence in order to be able to handle the logically coherent remainder. In *The Nature of the Physical World*, he writes as follows[1]:

'. . . We are drawing near to the great question

whether there is any domain of activity — of life, of consciousness, of deity — which will not be engulfed by the advance of exact science; and our apprehension is not directed against the particular entities of physics, but against all entities of the category to which exact science can apply. For exact science invokes, or has seemed to invoke, a type of law inevitable and soulless against which the human spirit rebels. If science finally declares that man is no more than a fortuitous concourse of atoms, the blow will not be softened by the explanation that the atoms in question are the Mendelian unit characters and not the material atoms of the chemist.

'Let us then examine the kind of knowledge which is handled by exact science. If we search the examination papers in physics and natural philosophy for the more intelligible questions we may come across one beginning something like this: "An elephant slides down a grassy hillside. . . ." The experienced candidate knows that he need not pay much attention to this; it is only put in to give an impression of realism. He reads on: "The mass of the elephant is two tons." Now we are getting down to business: the elephant fades out of the problem and a mass of two tons takes its place. What exactly is this two tons, the real subject matter of the problem? It refers to some property or condition which we vaguely describe as "ponderosity" occurring in a particular region of the external world. But we shall not get much further that way; the nature of the external world is inscrutable, and we shall only plunge in to a quagmire of indescribables. Never mind what two tons *refers* to; what *is* it? How has it actually entered in so definite a way into our experience? Two tons *is* the reading of the pointer when the elephant was placed on a weighing-machine. Let us pass on. "The slope of the hill is 60°." Now the hillside fades out of the problem and an angle of 60° takes its place. What is 60°? There is no need to struggle with mystical conceptions of direction; 60° *is* the reading of a plumb-line against the divisions of a protractor.'

Eddington goes on to put the matter in a nutshell: 'The whole subject of exact science consists of pointer readings and similar indications.'

Anyone who looks into the professional scientific literature can have no doubt that Eddington's words express something that at least plays a very large part in scientific work. For instance, in a number of *Nature* that appeared while I was writing this there are thirty-three 'Letters to the Editor' communicating results of scientific work. Of these, twenty-one have as their main point a set of measurements, recorded as a table of figures or a graph, and of the other eleven, a considerable number would fall within the scope of Eddington's rubric 'similar indications'. One can easily find extreme examples of the lengths to which scientists will go to try to force their experimental

material into a framework in which something can be measured. Here is an example, which has already been quoted in an article by S. A. Barnett.[2] It is from a study of the 'smiling response' in infants. 'Each infant' (we are told) 'was placed on a schedule of social deprivation during the entire experimental period . . . minimized social and body contact between the infant and any other person, excluding E (the experimenter). This meant elimination of all social and body contacts that were not absolutely necessary for S's (the subject's) well-being.' And the conclusion was this: 'Results confirmed the expectation that intermittent reinforcement is superior in maintaining continued performance of a response during extinction. Further, a negative correlation was found between rates of emission of protest and smiling responses. . . . It was proposed that rate of acquisition and extinction is not only a function of reinforcement schedule but also of initial discrepancy in habit strength between competing responses.'

Turning the last part of this into ordinary loose English it appears that the experimenters found that if you keep a baby isolated and then do something that makes it smile, it will go on smiling longer if this stimulus is repeated at intervals rather than being present all the time; that the more often it cries the less often it smiles; and that the frequency with which it smiles or stops smiling is not only a question of what stimuli are presented to it but also depends on whether it was feeling like smiling or crying when the experiment began.

It is easy to smile in a superior way at science of this kind, but we shall see that some modern painters — or at least their apologists — have adopted a rather similar attitude about their subject, arguing that the whole point of the proceeding lies simply in the manner in which the pigment is put on to the canvas. But before going on to that we must notice the complementary strand in recent thinking about science, which emphasizes the importance of the 'leap into the dark' by which a creative scientist arrives at a new concept. These new concepts do not, of course, spring out of the blue. Mendel did not invent the concept of the hereditary factor, which we now call the gene, or Dalton the chemical atom, or Thomson the electron, as free constructs of an unengaged imagination that could then go round looking for phenomena to justify them. The notions arose as solutions to puzzles. Facts were known which could not be explained, or phenomena were encountered which could not be fitted into the existing frameworks of thought; and the great scientific inventions are either of new entities which make it possible to explain what is going on, or new ways of thinking about phenomena which show how to ask revealing questions about them.

▶ It is worth considering an actual example. One of the most impressive feats of scientific intuition in recent years has been that of Watson and Crick

in proposing a double-helical structure for the molecule of a compound with the awe-inspiring name of deoxyribonucleic acid (usually contracted to DNA). The puzzle they were facing was this. It was known that the hereditary factors, or genes, which a living creature inherits from its parents, and which determine all the potentialities with which it starts its life, are carried by minute bodies known as chromosomes. These bodies are made of DNA and of protein, the two substances being assembled together to make up long, thin threads. It was known that the proteins are substances made up of long chains of relatively small chemical groupings known as amino acids, joined one to another to form a linear sequence like the letters spelling out a long word. Much less was known about the DNA, but it was clear that it also is made up by joining together a number of other small chemical groupings, known as nucleotides, and it was not unreasonable to suppose that they also were assembled end to end, again forming long, string-like assemblages which might well lie side by side with the protein chains.

Two further important things had been discovered about the hereditary material. It was also known to be a line-like assemblage of different entities following one after another like a column of soldiers marching in single file. But the only proof of this linear arrangement dealt with entities — the individual hereditary factors — which are a thousand or more times as big as the unit chemical groupings assembled into the DNA or proteins. People guessed that the large-scale linear arrangement of the hereditary materials was simply a picture, seen by the crude and inefficient eyes of the then-existing experimental methods, of a fine-scale linear ordering of the chemical groupings in proteins and nucleic acids, but they were only just beginning to get any real evidence for this suspicion. The second main fact about the hereditary material is that it can identically reduplicate itself; that is to say, the cells of the body grow, and when they reach a certain size divide in two; and we find then that each of the two new cells contains a complete set of hereditary factors. Each hereditary factor in the parent cell has made an identical duplicate of itself, so that there is one available for each of the two daughter cells.

Now nobody knew with any certainty whether the essential part of the hereditary material is the DNA or the protein, or whether, in fact, both of them are essential. Nobody knew how the identical duplication is carried out, and nobody knew just how small chemical groupings of nucleotides are assembled to make the long-thread-like DNA. The facts about the assemblage of these nucleotides were just beginning to be produced by x-ray crystallography, but it was not at all clear how these facts could be interpreted. A lot of people were trying to see a clear path through this jungle. The intellectual situation was one which White-

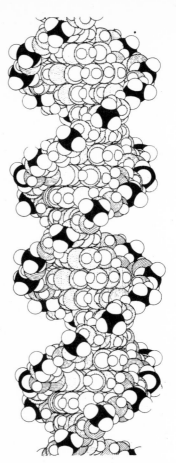

59. Structure of the DNA molecule

head has vividly described with the phrase imaginative muddled suspense'.

Crick and Watson came up with a notion which solved the whole complex puzzle at a single stroke. They suggested that the DNA is made, not just of one assemblage of nucleotides joined end to end, but of two such threads which are complementary in the sense that if, at any particular position, there is one nucleotide on one of the two threads, then there can only be the complementary nucleotide on the other thread. Such a scheme immediately explains the identical duplication of the hereditary material. The two threads, A and B, fall apart, and thread A can do nothing other than become complemented by a new thread B, since each unit nucleotide in thread A has only one other nucleotide that it can 'go with'; and similarly for thread B. But the crux of the matter was that they showed that if the two strands A and B are twisted round one another like the two parts of a stick of barley sugar, then the chemical groupings of the nucleotides would exactly fit together in the way they suggested, and the resulting substance would give just about the results which x-ray crystallography was beginning to reveal. It was, more than anything else, the beauty and elegance of this

102

three-dimensional structural analysis — a piece, if you like, of abstract sculpture, whose freedom was constricted by having to use building blocks of a known size — which first convinced the scientific world that the notion had to be taken seriously. Of course, it had terrific consequences. It led to the conclusion that the essential part of the hereditary material is the DNA and not the protein. Some evidence suggesting this was already around. More has since been accumulated. It led also to the conclusion that the particular order in which the nucleotides are arranged in sequence in the DNA should determine the order in which the other molecular groupings, the amino acids, become arranged in the proteins which the hereditary factors cause the cells to produce. Again, much recent work stimulated by the Watson-Crick hypothesis has produced a great mass of confirmatory evidence.

What I want to insist on here is the nature of the original act of creative imagination. It was suddenly 'seeing' a solution to a complex, many-faceted problem, like seeing a word that will fit into a crossword puzzle and, although it may call for the alteration of a number of things one has already tentatively put down, will allow a whole area of the puzzle to fall into place. This is one, and perhaps the most striking, of the kinds of scientific discovery. I have chosen this particular example of it, not only because it is almost contemporary and still has a certain news interest, but because it happened that the type of insight which it required was visual or structural, and therefore closely related to the experiences on which the plastic arts are based.

▶ There is another kind of scientific discovery, a somewhat more nebulous sort of activity, which is called for when one can't see quite in what terms a whole range of phenomena should be considered. A classical example of this is perhaps Darwin's advocacy of the theory of evolution. How should one consider the relation between the somewhat different forms of life which are obviously related in some way? Darwin persuaded the world that the right framework in which to see such phenomena is that provided by the theory of evolution. He succeeded in making this convincing mainly because he suggested a mechanism by which evolution might occur; that is, the theory of natural selection. The point I want to make is that he realized that evolution of some kind or other — whatever the mechanism by which it operates — is the right framework of thought.

Quite a large number of scientists have described their mental processes when they are groping for the solution of puzzles or the formulation of new concepts. The classical work on this subject is the book by the French mathematician Hadamard, *The Psychology of Invention in the Mathematical Field*.[3] I will quote a few passages from this. Some of these use rather intimidating technical terms,

but there is no need for the lay reader to understand what these mean. We are not concerned with exactly what the problem is, or what its solution turns out to be, but only with the processes by which the solution is arrived at, and with the parallelism between these processes and the kind of mental activity that is involved in artistic creation.

First, a story about the French mathematician Poincaré.[4] It involves a complex mathematical notion, Fuchsian functions, but there is no need to understand just what these are. At first, Poincaré attacked the subject vainly for a fortnight, attempting to prove that there could not be any such functions — an idea which was going to prove to be a false one.

Indeed, during a night of sleeplessness and under conditions to which we shall come back, he builds up one first class of those functions. Then he wishes to find an expression for them:

'I wanted to represent these functions by the quotient of two series; this idea was perfectly conscious and deliberate; the analogy with elliptic functions guided me. I asked myself what properties these series must have if they existed, and succeeded without difficulty in forming the series I have called the Fuchsian.

'Just at this time, I left Caen, where I was living, to go on a geologic excursion under the auspices of the School of Mines. The incidents of the travel made me forget my mathematical work. Having reached Coutances, we entered an omnibus to go to some place or other. At the moment when I put my foot on the step, the idea came to me, without anything in my former thoughts seeming to have paved the way for it, that the transformations I had used to define the Fuchsian functions were identical with those of non-Euclidean geometry. I did not verify the idea; I should not have had time, as, upon taking my seat in the omnibus, I went on with a conversation already commenced, but I felt a perfect certainty. On my return to Caen, for conscience's sake, I verified the result at my leisure.

'Then I turned my attention to the study of some arithmetical questions apparently without much success and without a suspicion of any connection with my preceding researches. Disgusted with my failure, I went to spend a few days at the seaside and thought of something else. One morning, walking on the bluff, the idea came to me, with just the same characteristics of brevity, suddenness, and immediate certainty, that the arithmetic transformations of indefinite ternary quadratic forms were identical with those of non-Euclidean geometry.'

Here is an account by the British biologist, Francis Galton[5]:

'When I am engaged in trying to think anything out, the process of doing so appears to me to be this: The ideas that lie at any moment within my full consciousness seem to attract, of their own

accord, the most appropriate out of a number of other ideas that are lying close at hand, but imperfectly within the range of my consciousness. There seems to be a presence-chamber in my mind where full consciousness holds court, and where two or three ideas are at the same time in audience, and an antechamber full of more or less allied ideas, which is situated just beyond the full ken of consciousness. Out of this antechamber the ideas most nearly allied to those in the presence-chamber appear to be summoned in a mechanically logical way, and to have their turn of audience.'

Finally, it is interesting to consider some remarks by Einstein[6] in reply to questions about his methods of thought:

'The words of the language, as they are written or spoken, do not seem to play any rôle in my mechanism of thought. The psychical entities which seem to serve as elements in thought are certain signs and more or less clear images which can be "voluntarily" reproduced and combined.

'The above-mentioned elements are, in my case, of visual and some of muscular type. Conventional words or other signs have to be sought for laboriously only in a secondary stage, when the mentioned associative play is sufficiently established and can be reproduced at will.'

The layman, including the artist, who reads books such as those of Eddington and Hadamard might well wonder what is the nature of scientific activity, what the character of its practitioners. Are scientists merely soulless men in white coats, good at recording pointer readings? Or are they some peculiar form of poet, whose unconscious mind throws up to them from time to time some unforeseeable but penetrating notion about the nature of existing things? Perhaps it was not too difficult, in the face of these earlier discussions, to come to the conclusion that science demands contributions from men of both kinds, or perhaps that most scientists can act at some times in one way, at other times in the other. But as science went on developing through the 1930s and 1940s, somewhat similar contrasts of opinion about the nature of science appear again in subtler and more profound forms. They appeared particularly in the writings of physicists, and were peculiarly challenging because they arose in connection with what was obviously the most important and profound discovery of physics in the first third of this century – the discovery of quantum physics and the principle of indeterminacy.

The new physics:
quanta and indeterminacy

These developments in physics really involved three main interlocking discoveries. The first was that energy cannot be indefinitely subdivided into

60. Bubble chamber photo of nuclear particles (sigma minus decay)

smaller and smaller amounts, but that it comes in separate packets, each packet being a *quantum.* The quantity of energy in each packet is, of course, exceedingly small. It is not always the same (actually, in radiant energy it varies with the wavelength) but is always too small to be appreciated by our normal senses in everyday life. However, this discovery revealed the unexpected and surprising fact that energy – or, to put it more loosely but vividly, we could say activity – does not vary continuously, but goes by jumps.

The next major allied discovery was of the equivalence of waves and particles; that is to say, each of the minute particles that make up the basic material of the universe can be considered either as a particle or as a set of waves. For instance, the electrons that we learnt about at school as minute and negatively charged particles rotating round the nucleus of atoms, or rushing along a wire carrying an electric current, can also be regarded as sets of waves; and looking at them in this novel

104

way has had important practical consequences, for instance, in the development of the electron microscope, which uses electron waves instead of the light waves used in previous microscopes. Since the electron waves are much shorter in length they make it possible to photograph a magnified image of things which are so small that the larger light waves simply wriggle past without noticing them, like a long snake threading its way through the stems of a wheat field. So both ways of looking at an electron are equally valid. It is both a particle and a train of waves, and one can choose whichever way of regarding it is most convenient for the purpose in hand.

The third discovery was even more disconcerting to common sense. It is usually known as the principle of indeterminacy. According to it there is, as it were, a screw loose somewhere in the basic workings of nature. Events in the incredibly minute world of the fundamental particles, such as quanta, electrons, and so on, do not follow each other in strictly determined causal sequences. In normal life, of course, the things we deal with always contain many myriads of these elementary entities, and the events we see really express averages taken over such enormous numbers that the irregularities of the individual behaviour of single particles are smoothed out. But when we come down to studying the ultimate structure of nature, we find that it is made up of entities which individually do not follow the normal rules. There are various ways in which their irregularity can be expressed. A fairly common way of describing the situation is to state that one cannot measure both the position and the velocity of a fundamental particle with complete accuracy. If we measure the position absolutely precisely, then our measure of velocity cannot be completely accurate, and we have to accept a considerable margin of error in it, or *vice versa*. Another and, as it turns out, equivalent way of expressing the same situation is to point out that if we are dealing with two or more particles they do not necessarily retain their identities. For instance, if particles A and B collide and then ricochet off one another, we cannot say for certain which of the two particles which separate after the collision was derived from A and which from B.

Physicists can give certain rules about what goes on in these minute but fundamental events. It is not the case that the behaviour of the particles is completely indeterminate so that anything is equally likely to happen. The point is that the rules applying to such processes do not absolutely determine what will happen, as do the laws of physics for larger entities, but instead only set certain limits to what is to be expected, leaving a degree of imprecision. But just such a degree of imprecision, of uncertainty, in the very basic mechanisms of the universe is obviously something most unexpected and challenging.

▶ There have been two main controversies among scientists about the interpretation and understanding of the indeterminacy principle. One was about the question whether we really have to accept uncertainty as a basic fact in the structure of nature, or whether we can hope, with further advance of science, to find some way of coming back to a rigidly deterministic scheme of causation. The other was about the even more profound problem: do our scientific theories give us knowledge about exterior nature uninfluenced by man, or do they, on the other hand, merely show us the way in which the human mind happens to work in its interaction with the rest of the universe?

The orthodox view is the one which holds that the newer developments have really shown us that the natural world is not as we had previously thought. This interpretation is summed up in two main principles: Niels Bohr's *Principle of Complementarity*, which states that the fundamental entities in the world are of such a kind that they can be seen in two complementary distinct ways simultaneously, for instance, as particles and as waves, and that there is no sense in looking for a way of finding some single unitary conception which will be appropriate in all circumstances; and Heisenberg's *Principle of Uncertainty*, which states that there is an essential element of indeterminacy in the fundamental processes. The laws governing this indeterminacy were expressed in a famous equation by Schrödinger, which dealt with waves of a special kind referred to as *psi-waves*. These equations were interpreted by Max Born as referring to probabilities and, following him, the usual interpretation of the Heisenberg Uncertainty Principle is that the outcome of elementary processes is not certain but that one can specify the probability of the various possible results.

These interpretations, however, are not by any means universally accepted. Even some thirty or more years after the problems were first formulated, several of the older generation of physicists, such as Einstein and Max Planck (who can perhaps be regarded as the originator of quantum theory in general), were never quite content with the views given in the last paragraph, which are often known as the *Copenhagen Interpretation*, since that was the city in which Niels Bohr worked. Of those more closely associated with the elaboration of the 'uncertainty phenomena', perhaps the two most important dissidents are Schrödinger and De Broglie. Both of these seem to feel that we have not yet seen the full development of appropriate concepts in this area, and that we can look forward to a time when some new theory will be produced which will provide a strictly deterministic and causal account of these processes. For instance, it may be that the particles which we now think of as fundamental are themselves made up of still smaller and still more basic entities and that, if

we understood enough about this substructure, we would find that the uncertainties in the behaviour of our present fundamental particles would disappear. No 'lower level theory' has, however, yet gained general acceptance, and there are arguments, produced by adherents of the Copenhagen school, intended to show that in general principle no such theories are possible.

These are, of course, highly technical matters on which no one except a very highly qualified theoretical physicist can have an opinion. From the point of view of the generally cultured person of today, the crucial fact has been that the physicists — the scientists who study the simplest basic materials out of which the natural world is constructed — have had to confess that they find it incomprehensible in the terms of our normal modes of thinking. The impact of this admission is enormous. Whether the failure of understanding arises from an inherent indeterminacy in the basic principles of nature, or from a merely temporary failure to formulate any system of thought which can conjure away the uncertainty that seems to be there, in either case we are confronted with the situation that nature — even the simple dead matter that we thought we understood fairly well — has turned out to be much more mysterious than we had given it credit for.

Man's mind, so it seemed, was a good deal less all-conquering than we had hoped, and another major intellectual achievement of this time reinforced the same conclusion. The mathematician Gödel succeeded in 1931 in proving that it is impossible, in principle, to set up a system of mathematical logical relations which does not imply some relations which the system is unable either to prove or disprove. That sounds a rather technical statement, but it means that no complete watertight system of mathematics will ever be possible.

The sort of impact that these scientific developments had on literary thinkers may be illustrated by two quotations from William Barrett's *Irrational Man: A Study in Existential Philosophy*[7] :
'Heisenberg's principle of indeterminacy shows that there are essential limits to our ability to know and predict physical states of affairs, and opens up to us a glimpse of a nature that may at bottom be irrational and chaotic — at any rate, our knowledge of it is limited so that we cannot know that this is not the case. This finding marks an end to the old dream of physicists who, motivated by a thoroughly rational prejudice, thought that reality must be predictable through and through. . . Gödel's findings seem to have even more far-reaching consequences, when one considers that in the western tradition, from the Pythagoreans and Plato onwards, mathematics as the very model of intelligibility has been the central citadel of rationalism. Now it turns out that even in his most precise science — in the province where reason had seemed omnipotent — man cannot escape his essential finitude; every system of mathematics that he constructs is doomed to incompleteness. . . . What emerges from these separate strands of history is an image of man himself that bears a new, stark, more nearly naked, and more questionable aspect.'

We shall consider later whether this conclusion is fully justified. It is drawn from considering exclusively the developments in physics and mathematics. Although these — along with astronomy, which also easily reinforces the opinion that human achievements are not to be rated very high in the universe as a whole — have been the sciences with the greatest glamour in the public eye they are certainly not the whole of science; if we bring biology into the picture the human situation appears in a rather different light.

Chance, creation, and biology

The physical sciences are concerned mainly with repetitive processes. They observe and analyse how the wheels go round; rather rarely, and only to a minor extent, are they confronted by systems which can be said to build up or develop. Thus for the physicists chance appears merely as a degree of uncertainty in processes which he would like to be able to consider as precisely repeatable; it is a disturbing element. The biologist finds that his material presents to him some processes of rather different type. He watches an egg developing and differentiating into an adult organism. This can hardly be regarded as a mere succession of repeating processes; something or other has definitely undergone changes which can be referred to as 'development' or even 'progress'; the system has become more complicated, what were at first only potentialities have become realized; or, more concretely, the genes which the egg contained have actually controlled the production of the various different proteins corresponding to them. Moreover, not all potentialities have been realized equally all over the developing body; in one place a group of genes has guided the formation of the assortment of proteins which make a cell into a muscle cell, in another place another group of genes have caused the cell to become a nerve cell. It is as though we were watching the development, from a set of axioms like those of Euclid, of a number of elaborated theorems — first, that the square on the longest side of a right-angled triangle is equal to the sum of the squares on the other two, and then that the tangent to a circle is perpendicular to the radius to the point of contact, and so on and so on.

The characteristic of processes of this kind is that the information originally contained in the system is becoming expounded into significant expanded complexes. Physical theory has hardly had to deal with such matters. In biology this kind

of behaviour in a system is referred to as 'developmental', or, to avoid the use of the word 'development' which has been extensively confused by thinkers primarily interested in physics, as 'epigenetic'.

There is no reason in principle why epigenetic processes should not be completely deterministic, or why chance should play any rôle in them. In fact, it is doubtful if it does play any important part in most biological epigenetic systems, such as those presented by developing eggs. Its fundamental rôle in biology is in connection with another type of 'building-up' process with which biologists have to deal, namely evolution.

Evolution is something which happens to populations of animals or plants which reproduce and persist through many generations. Now, first, it is as well to remember that in any such population there will be, scattered about among the numerous individuals, a vast number of different hereditary potentialities, determined by separate genes. These genes can be brought together in all sorts of combinations, by crossing of the animals containing them; and if the conditions of life are such that some individuals leave more offspring than others, then the frequency of the different genes can be altered from one generation to the next (this is called Natural Selection). It is therefore possible for a population to undergo a great deal of change, as the generations pass, without anything new coming into it, but simply because it starts as a complex mixture from which many different things can be sorted out. This would be a kind of evolutionary process essentially similar to the epigenetic processes of embryonic development, in that whatever 'build-up' occurred would be based entirely on what was present in the system at the beginning.

But in fact this is not all that happens in evolution. Man has not been evolved from something like an amoeba simply by sorting out potentialities which were present in the original population of amoebae. We know that another process is involved, namely the appearance of new hereditary potentialities. A new potentiality arises by a change in an old one. The process of change, which is called 'mutation', takes place spontaneously and without any clearly assignable cause. It is, in fact, a chance happening. And it is in this connection that chance plays a much more fundamental role in biology than in the physical sciences. For the latter it is merely a confusing complication; for biology it is the source of real novelty. It makes it possible for an evolving population to change into forms for which even the potentiality was not present at the beginning of the process.

This does not mean that the mere occurrence of chance processes is in itself sufficient to justify the claim that something creative has happened. We speak of 'creation' only when something worth while has been brought into existence. It is in

contrast both to the preservation of the unchanged *status quo*, and to the production of new things which are chaotic, incomplete, or otherwise unsatisfactory. The idea of 'creation' presupposes the notion that some new things are more valuable than others. This applies, of course, as much when we speak of creation in the arts as when we use the word in any other connections.

The idea of value has always caused difficulties to philosophers; so much so that professional students of that subject nowadays urge us to give up the idea altogether. There are a few painters, doctrinaire Dadaists, who allege, in words, that they accept this advice; though it may be doubted whether they do so at all completely in their actual works. But to most artists it is one of the major facts of their existence that some pictures are better than others, and that pictures they are working on can be improved or spoiled.

To biologists who look at their material with unprejudiced eyes, the notion of improvement — which implies value — is equally inescapable. As has been said above, it is most obvious during embryonic development, and almost equally so during the course of evolution. These examples bring out an important point about the biologists' idea of value — one which applies equally to the ideas of modern painters. In order to recognize that something worthy of being called 'improvement' has occurred while a rabbit's egg is developing into an adult rabbit, we do not need to apply any *a priori* notion of what an animal ought to be like, or any yardstick external to the developing system itself. An adult rabbit is just more of rabbit than a rabbit's egg is. The system defines its own criterion, and it is by this inherent criterion that it is judged to have improved. Similarly, if you look at the animal kingdom in general — the whole system engaged in evolution — it defines its own criterion, by which it is clear that animals like lions, horses — and men — are improvements on worms or cockles.

In an essentially similar way, most painters today judge the progress of a painting on which they are working, not by some external standard such as whether it is becoming a better copy of nature, but by a criterion which arises from the painting itself.

To the biologist, then, and to the painter, improvement is a perfectly valid notion, proof against any attacks philosophers may make on it. (It is, of course, another question whether *society* has actually improved in the last few hundred years or so — but we are not concerned with this at the moment.) And the point I want to make is that in the biological process of evolution, chance processes are among the essentials on which improvement depends. They are not the only essential. The other main one is the occurrence of selection; some of the novelties produced by chance are preserved, others are rejected and allowed to disappear. Even those that are retained are usually altered considerably by being combined with the

61. X-ray photo of the molecule of hexamethylbenzol

most appropriate factors already available in the population. This does not alter the essential point that, although mere chance is not in itself creative, no evolutionary creation is possible except on the basis of chance happenings.

The continuation of evolution requires that there should be a succession of chance mutations of hereditary factors as time passes. Processes characterized by a succession of chance events are called 'stochastic' processes. It is one of the most characteristic features of much recent painting, as we shall see in more detail in the next chapter, that the artists have used stochastic processes of creation, making first some mark which has certain features left to chance, then modifying the result with another mark also with a chance element, and so on. Such methods of working have much more in common with the biological processes of evolution than with the indeterminacy of subatomic events studied by physicists.

The theory of biological evolution leads to the conclusion that the intrusion of chance into the world of man's understanding is not such damaging evidence of failure as Barrett suggested in the quotation on p. 106. And the practice of modern painters shows that they have accepted chance as a potentially valuable component of the creative process.

Physicists, and our knowledge of the external world

There is a further controversy among physicists which could hardly fail to come to the attention of anyone reading popular science writings. Most of those who believe in the 'Copenhagen' interpretation of quantum phenomena also believe that our scientific knowledge is not nearly as objective

as had previously been thought. The argument can start from the conclusion that any means used to observe the position of an elementary particle, such as a ray of light reflected from it, is bound to interfere with its motion, and thus make it impossible simultaneously to determine precisely its velocity. This is one of the forms in which the uncertainty principle is expressed. Heisenberg argues [8]:

'If we wish to form a picture of the nature of these elementary particles, we can no longer ignore the physical processes through which we obtain our knowledge of them. . . . Thus, the objective reality of the elementary particles has been strangely dispersed, not into the fog of some new ill-defined or still unexplained conception of reality, but into the transparent clarity of a mathematics that no longer describes the behaviour of the elementary particles but only our knowledge of this behaviour. The atomic physicist has had to resign himself to the fact that his science is but a link in the infinite chain of man's argument with nature, *and that it cannot simply speak of nature "in itself"*. Science always pre-supposes the existence of man and, as Bohr has said, we must become conscious of the fact that we are not really observers but also actors on the stage of life . . . If, starting from the condition of modern science, we try to find out where the bases have started to shift, we get the impression that it would not be too crude an oversimplification to say that *for the first time in the course of history modern man on this earth now confronts himself alone, and that he no longer has partners or opponents*. . . . Even in science, *the object of research is no longer nature itself, but man's investigation of nature.*'

Heisenberg goes on to quote a passage from Eddington, written in his characteristically academic purple style: 'We have found that where science has progressed the farthest, the mind has but regained from nature that which mind has put into nature. We have found a strange footprint on the shores of the unknown. We have devised profound theories, one after another, to account for its origin. At last, we have succeeded in reconstructing the creature that made the footprint. And lo! It is our own.'

Again, Schrödinger voices the opposition view. In one place [9] he remarks rather acidly: 'The argument for whose sake I have inserted this brief report would be reinforced by mentioning the "pulling down of the frontier between observer and observed" which many consider an even more momentous revolution of thought, while to my mind it seems a much overrated provisional aspect, without profound significance.' In fact, Schrödinger does not believe that the observer ever has been or should be mixed up with the observed in scientific research; he thinks that it is only because of a temporary failure to reach a full scientific understanding of quantum phenomena

that he seems to have got into this anomalous situation at present. His belief is[10]: 'That a moderately satisfying picture of the world has only been reached at the high price of taking ourselves out of the picture, stepping back into the rôle of a non-concerned observer.' He describes how we have found ourselves faced by 'two most blatant antimonies due to our unawareness of this fact. . . . The first of these antimonies is the astonishment of finding our world picture "colourless, cold, mute". Colour and sound, hot and cold, are our immediate sensations; small wonder that they are lacking in a world model from which we have removed our mental person. The second is our fruitless quest for the place where mind acts on matter or vice versa, so well known from Sir Charles Sherrington's search, magnificently expounded in *Man on his Nature*. The material world has only been constructed at the price of taking the self, that is, mind, out of it, removing it; mind is not part of it. It therefore can neither act on it nor be acted on by any of its parts.'

Schrödinger's view was, as I have said, not the fashionable or dominant one among physicists. But it was not far removed from that implicit in the first few lines of the most influential treatise on philosophy of the thirties, Wittgenstein's *Tractatus Logico-Philosophicus*.[11] This book is mainly concerned with the nature of language and its relation to the things it refers to. It is written in a series of detached sentences, each of which is numbered in a system which expresses their place within the logical system of the whole argument. And it begins boldly:

'1. The world is everything that is the case'

(As though we knew what *that* is! The life's work of most scientists is dedicated to trying to find out what is the case in some minute area of the world's affairs.)

Wittgenstein goes on with the appealing point, which we shall return to later in the fuller exposition of it given by Whitehead:

'1.1. The world is the totality of facts, not of things.' and proceeds through a number of arguments till he reaches a point where he joins forces with Schroedinger:

'1.2. The world divides into facts

. . .

2. What is the case, the fact, is the existence of atomic facts

2.01. An atomic fact is a combination of objects (entities, things).

. . .

2.0232. Roughly speaking, objects are colourless.'

The writings of the leading scientific theoreticians – physicists, be it noted – have therefore offered to the general public a number of at first sight diametrically opposed views about the nature of man, or reality, and of science. In comparison with the more subtle and more profound dilemmas just described, the contrast between Eddington's picture of the scientist as a reader of pointers and Hadamard's account of him as a potentially imaginative being appears relatively simple. We now have to find a way of surmounting two further difficulties. The first concerns the nature of scientific knowledge. We have, on the one hand, Heisenberg arguing for what amounts to a communal solipsism, claiming that 'the object of research is no longer nature itself, but man's investigation of nature. . . . Man confronts himself alone'. In complete contradiction, Schrödinger presents what almost amounts to a revival of simple materialism – that we arrive at a valid scientific knowledge of nature only by leaving ourselves completely out of account. Then, over and above this conflict of views, we have to assimilate the fact that the system of deterministic causation on which we based the whole of our daily conduct cannot be applied to the most ultimate units into which we can analyse existing things.

The dominant view among physicists has, in fact, been that we should reconcile ourselves to giving up any attempt to apply it to the basic constituents of the world and, as Bohr argued, simply accept 'indeterminacy' as a fact. Even if we feel inclined to accept the more conventional view of Schrödinger, that one day in the future we will find some way of envisaging these ultimate constituents in a manner which renders their behaviour once more deterministic, we have to recognize that any such revision would involve a surrender of some other of our basic notions about the world, which would be little, if any, less deeply engrained than the idea of causation. Whichever way we choose to look at it, common sense has taken a terrific beating. But there is another equally far-reaching reorganization of thought still to be considered, and here again biology helps to rescue us from the worst of the dilemmas which the physicists see before us.

Whitehead and organization

During the last few decades the physics of fundamental particles has not, of course, been the only branch of science which has been making revolutionary advances. In particular, biology has been gradually developing towards an understanding of living processes which is firmly enough based, and reaches down far enough into the depths of its subject matter, to merit being called fundamental. The advance of biology has gradually brought to the fore a system of ideas which has at least as much relevance as those of the physicists to the general way in which civilized man nowadays should regard the world he inhabits. Even within science these ideas are not confined to biology, but are closely related to similar notions developing in fields such as general systems theory, communications engineering, and so on. I shall not

62. *Paolozzi, from the Wittgenstein series. These kaleidoscopic jumbles are about as far from the early Wittgenstein of the* Tractatus *as it is possible to get. W. was trying to be superlogical at that stage. It is, however, a valid transposition of the late W., after he had realised that words are not precise and that everything overlaps with everything else*

engage in the rather profitless undertaking of discussing who thought of them first, but I shall discuss them largely in relation to biology, the context in which I know them best.

As a matter of fact, it will be more convenient to start with someone who was not a biologist, but a mathematician who later turned into a philosopher. A. N. Whitehead made his first major impact on the world of thought when he collaborated with Bertrand Russell in a large and elaborate work — *Principia Mathematica* — which tried to develop the whole basis of fundamental mathematics as a coherent system of logic. This was an enterprise which, according to the theory of Gödel which we mentioned above, is doomed in the last analysis to failure. However, Whitehead and Russell's work was extremely influential, partly for what it seemed, at the time it appeared (1923), to have achieved, and partly because of its method. It applied to a very general problem, which had previously always been held to fall in the field of philosophy, a technical equipment involving the formulation of logical arguments in algebraic symbols. This rendered the whole argument totally incomprehensible to anyone who was not prepared to spend a considerable length of time mastering the technical expertise. It was one of the most powerful influences in converting philosophy from a subject in which all educated people were interested, and felt justified in arriving at at least a tentative opinion, into a strictly professional matter. From Plato to Hume, with perhaps an interlude in the time of the Schoolmen, philosophers had addressed their contemporaries in general. Later the great German metaphysicians had certainly demanded of their readers a pretty thoroughgoing devotion to the subject; but it is only since the Whitehead-Russell *Principia* that there has been a strong tendency for philosophers to write exclusively for other philosophers, and to express surprise if anyone outside the profession opens their works, and disdain if, after doing so, they dare to open their mouths to comment.

Whitehead himself, however, became a professional philosopher of a rather different kind. After the *Principia* he did not continue to express his philosophical ideas in the involved jargon of symbolic logic. His professionalism took a different form. After writing a primarily mathematical work on relativity, he produced a number of books on general philosophical problems, written in normal English prose, which did not abandon conventional vocabulary and syntax for the amalgam of letters printed upside down, brackets of three or four varieties, italic, roman, and clarendon letters, which make the pages of symbolic logic so unusual to the eye. It was, at first sight, remarkable mainly for the astonishing epigrammatic vividness of some of the phrases. However, it soon dawned on the reader that Whitehead had an ingrained habit of using quite normal words in quite abnormal senses. He had an exaggeratedly Humpty-Dumpty attitude to words. For him they meant what he intended them to mean; and this was, not merely sometimes but usually, not what they had meant before to other people. It requires, in fact, not much less application, and a great deal more imagination and insight, to grasp what Whitehead's prose is intended to convey than it does to master the language of symbolic logic — a task at which computers are as good as, if not better than, human minds.

However, in my opinion, a great deal of what Whitehead had to say is well worth the effort to understand it. He seems to me one of the great underestimated figures of the first third of this century. His best works are no more 'difficult' than James Joyce's *Ulysses* and fundamentally more rewarding. But, like James Joyce, he did not know where to stop. After having written profoundly revealing but somewhat incoherent works, such as *The Concept of Nature, Science and the Modern World*, and *Symbolism: Its Meaning and Effect*, he persisted in the attempt to work these insights into a total comprehensive system. This he expounded — or let us say laid down on paper for his readers to make the best of it — in a *magnum opus, Process and Reality*, a work as daunting as *Finnigan's Wake* and, like it, providing a number of attractive mouthfuls but leading almost inevitably to indigestion when tackled as a whole without a prolonged course of preliminary training.

63. Solid state electronic circuits for a computer

Whitehead began by arguing — he was one of the first to do so — that the theory of relativity had made it impossible to go on accepting the conventional view of the world as consisting essentially of an assemblage of material 'things', which exist in space but endure through time. The theory of relativity shows that simultaneity, or instantaneousness, can only be defined with reference to some particular spatial frame of reference, and that two occurrences which may be simultaneous in one frame may happen at times which, in another frame, are different. This is the scientific reason why time and space cannot be completely dissociated from one another. And Whitehead goes on to point out that in our experience, also, the notion of a durationless instant — a point in time — is an abstract idea which we never experience: 'the present is the fringe of memory tinged with anticipation'.

The exploration of this point by painters began with Cubism, and has continued in many later movements. 'The fundamental concept of realistic representation', writes Marcel Jean in his *History of Surrealist Painting*,[12] 'is that the real is formed of objects. But the object has disappeared from modern physics, which sees a whole range of energies and an interplay of continuous happenings as the motivating force of a complex and many-faceted reality.'

The importance of Whitehead lies in the way in which he encourages us to regard 'facts', which are obviously highly complicated affairs. Wittgenstein emphasized the possibility of dividing any ordinary fact into simpler part-facts, until one comes eventually to a class of 'atomic facts', which consist simply of 'a combination of objects (entities, things)'; and the existence of a particular atomic fact is asserted by an 'elementary proposition', which 'consists of names. It is a connexion, a concatenation, of names'. Here again, of course, we are confronted by a philosopher who is using ordinary language to mean something other than its normal usage would suggest. Take an everyday 'elementary proposition' describing a combination of objects: The Cat sat on the Mat. Does not one immediately feel, lurking in the background of that mere 'concatenation of names', and seeping in round the edges of the isolated 'atomic fact', some shadowy picture of a fairly complex situation — nursery tea, with buttered toast, in front of the fire, a wet night outside the windows? Wittgenstein, in proposing to study facts by considering how we use language to describe them, found himself confronted with the terribly difficult question of the relation between ordinary language and the idealized logical language which he envisaged and which he described in terms of 'elementary propositions', 'names', and so on, using these words in highly specialized and technical senses. In fact, he spent the rest of his life wrestling with these difficulties; and he carried most professional

philosophers along with him into this arcane and murky territory.

It has, perhaps, not proved very rewarding territory to anybody, and certainly it is very far from the two interests with which we are concerned. Painters employ means other than words; and scientists, although they may be willing to grant a moderate importance to considering the technical linguistic requirements of clarity of expression, are much more concerned with stating new truths or insights for which, by the definition of 'new', the existing language is inadequate. To J. J. Thomson the word 'atom' meant something different from what it meant to Dalton, and its meaning had changed again for Niels Bohr, and it does and will continue to change. But the changes will not be arbitrary. Science does not use language either as a watertight logical system, as the early Wittgenstein claimed, or as a collection of 'language games', as he later came to think. Possibly his followers, the so-called 'linguistic philosophers', can dredge up something important from this line of thought. Scientists and painters can wish them luck, while looking elsewhere for thoughts more relevant to their own problems.

One of the great points about Whitehead is that he did not rule anything out. The word he used for what Wittgenstein called 'facts' was 'events' — which emphasizes the point that they involve a lapse of time as well as an extension in space. And he proceeds to argue that any given event is impossible to grasp, conceptually, in its totality. The human mind can see some things, possibly many things, in it; but it can never see everything that is in it. If it could, mere mental activity — thinking — could create existing things. This is the same point that worried Wittgenstein in his discussions of how a word — something that could be present in the mind — could 'refer' to an object obviously and basically other than the mind, such as a stone he held in his hand. But Whitehead, taking it as read that the word 'stone' does so refer, went on to state that the piece of existent stuff he had hold of contains everything that you can find in it; and that, try as you will, you will never exhaust what it contains. You may find in it a fossil, and that is an item in which the whole pageant of organic life on earth is focused; you may find in it calcium carbonate, and in that resides the whole of chemistry; you will find a colour, shape, and texture, and you have the whole of painting and sculpture on your hands; it might be a sling-shot, and David and Goliath are beside you; it is full of atomic events which you can only describe in the fumbling language of Heisenberg's Indeterminacy and Bohr's Complementarity; and so on and so on.

As one of the more articulate of modern artists (Naum Gabo) has put it[13]: 'Nature is not a chessboard, and we are not pieces moving on it in strictly defined order within strictly prescribed co-ordinates. The patterns of Nature can be as

many as our consciousness is capable of drawing on it.'

Every event, for Whitehead, contains some reference to every other event in the universe. In fact, he argued that its character is determined entirely and completely by the way in which it relates to everything else. Every time-extended occurrence to which we give a name, every stone, or table, or person, is, as it were, a knot in an indefinitely complex four-dimensional network of relations, like one of the junction points in a spider's web that stretches off in all directions.

Perhaps some visual equivalent of this kind of concept is offered by Figure 65. This really represents a number of trains of earthquake waves which are being used to explore hidden underground geological structures. A small explosion is made; the waves originating from this travel in all directions, some of them penetrating downwards, where they may be reflected back again towards the surface by any sudden change in the structure or consistency of the rocks. The reflected waves are detected at a number of points spaced out along a line and recorded as the undulating lines seen in the diagram. The three more or less definite lines which run across the middle of the picture sloping slightly upwards from left to right record the presence of a particular discontinuity in the rocks. In this picture the discontinuity has no individual existence of its own; it simply emerges as the overall resultant of the whole series of wave traces, that is to say of the relations between the geological discontinuity and each of the stations at which the waves have been recorded. Whitehead suggested that the entities in the real world should also be thought of as originating from such interaction with other things, just as these lines have emerged within the confines of the picture.

The language which Whitehead used to express this point of view was necessarily — some people say, unnecessarily — complex. Obviously, although a stone you have in your hand may involve some tenuous reference to, say, the beating of the heart ('my landlord has a heart of stone'), it has much more to do with, for instance, geology. We need some way of talking about the particular manner in which a given event is related to other events. In inventing a language for this purpose Whitehead was bold enough to take on, face to face, the most difficult of all intellectual problems — the fact that each one of us has a conscious experience, whereas in science we try to account for the behaviour of things by means of concepts or entities — atoms, waves, fundamental particles, and so on — whose definition does not contain any reference to consciousness. Whitehead argued that this is not good enough: you have either got to have consciousness, or at least something of that general kind, everywhere; or nowhere; and since it is obviously in us, and cannot be nowhere, it must

therefore be everywhere, presumably mostly in very rudimentary form. Therefore, when he wanted a word to refer to the way in which a stone relates to geology, evolution, and the story of David and Goliath, he said that each relation was a 'feeling', whose intensity and character was determined by the 'Subjective Aim' of the stone. The stone drew all the other events together into its own being by processes of 'prehension' — a word which has overtones of what we try to attain in 'comprehension'.

I do not want, in the present connection, to pursue the very difficult questions of the illumination or obfuscation which come from such metaphorical usages. As an aside, one may remark that the way in which some recent symbolizing painters have seen the relation between the various signs-for-entities which they have put on to canvas — say, the breasts and face of one of de Kooning's paintings of *Woman* — reminds me much more of the prehension of feelings than of geometrical theorems. Certainly many painters are quite consciously and intellectually aware that what they are doing involves leaving out many of the interconnections which exist in real situations, and that these interconnections — at least, the kinds important to them as artists, if not all of them, as Whitehead argued — are of the nature of feelings. As Robert Motherwell has said[14]: 'One might truthfully say that abstract art is stripped bare of other things in order to intensify it, its rhythms, spatial intervals, and color structure. Abstraction is a process of emphasis, and emphasis vivifies life, as A. N. Whitehead said. . . . The need is for felt experience — intense, immediate, direct, subtle, unified, warm, vivid, rhythmic.'

Whitehead's account of the way we perceive the world around us is also very relevant both to the actions of recent painters and to the points about the validity of our perceptions discussed in the last section. Every act of perception, he maintained, involves two modes: perception by 'presentational immediacy' and by 'causal efficacy'. By 'presentational immediacy' he referred to what we have been trained to think of as the immediate data presented to us by our senses — patches of colour seen with the eyes, noises of a certain pitch and intensity, sensations of hard, rough, or soft surfaces, and so on. These are the 'sense-data' of more old-fashioned philosophers, and were formerly regarded as the basic elementary facts of experience. But Whitehead claims that a more primitive element in perception is awareness, not of sheer sensations, but rather of entities which are perceived as having some potential effectiveness in the world. He argues that it is more elementary to perceive causally efficacious things, such as a chair (something suitable for sitting in) or a table (something to put things down on), and that it is a relatively sophisticated business to 'see' such things as mere coloured patches or other

65. *Geological exploration by explosion waves*

pure sensations; in fact, it takes training — which some artists, such as the impressionists, have willingly undertaken — to be able to do so.

It is characteristic of post-impressionist painting in general that it lays emphasis on something akin to Whitehead's 'causal efficacy' rather than on presentational immediacy. It has often been pointed out that Cubism is a 'conceptual' art, concerned with ideas (i.e. with the causally efficacious) more than with simple appearances; and so certainly is Surrealism. Again we may quote Naum Gabo[15]: 'We have to distinguish between two faculties which are in action when we see things: the physiological faculty of sight and the conscious faculty of vision. Sight is only a vehicle by means of which we receive the visual signals. Vision, however, is what our consciousness makes of these sight-signals.' Here Gabo's 'vision' is something very like Whitehead's 'perception by causal efficacy'.

Whitehead did not, so far as I know, discuss the biological origin of 'perception by causal efficacy'. It is clear enough that it must be a faculty which has been produced and refined by evolution; for the simplest organisms, which are receptive merely to light or darkness, or to the intensity of various other types of stimuli, it is impossible to make any distinction between the two modes of perception.

It is only with a considerable elaboration, both of the sense organs and of the neural networks in the brain by which the crude nerve-impulses coming from organs are processed, that it becomes possible to imagine that a complex train of light waves can be perceived as signalling the presence of a definite entity which has causal efficacy. But. of course, as soon as we start talking about evolution, we automatically must be invoking the action of natural selection. A perceptive apparatus — like every other element in the make-up of an organism — will evolve into a form which is of selective value, which is in some way useful. Perceptive apparatus, including our own, must have been moulded by evolution in such a way that it is at least reasonably effective in perceiving things that it pays off to perceive. If we perceive things as chairs and tables rather than as mere patches of colour and tone, this is because, living in the sort of world we inhabit, and struggling throughout the ages of evolution, to be 'fittest' in dealing with it, natural selection

115

has tailored our perceptive equipment to correspond to those characteristics of that world which importantly affect us. The same arguments must apply to our modes of thinking and arguing about what we perceive. We think with the kind of logic that comes naturally to us — one in which, for instance, A times B is the same as B times A — because our brains have been shaped during evolution by the necessity to deal with phenomena which actually work in that way. There can be no question either of 'man confronting himself alone', as Heisenberg put it, or of man leaving himself completely out of the picture of nature, as Schrödinger would have it. Man is a product of evolution, that is to say, a part of nature, in essence inseparable from the rest of it; there can be no Heisenbergian man with no nature, or Schrödingian nature with no man. And we need not be surprised that when we try to deal with a world which we have never met before during the whole course of evolution — such as that of sub-atomic physics — we find the greatest difficulty in a logic, or system of thought, which corresponds to the peculiar rules by which it operates.

In the painting of the last twenty years there has been a tendency to assign more equal importance to both perceptive modes; but the presentational immediacy that has been insisted on is the immediacy of the actual material presence of the painting itself, its coloured and textured pigments; while the causal efficacy has been in the more or less deeply buried symbolic and emotional reverberation of these same physical materials, and little if at all in references to such conceptualized objects as people, places, or things.

In Whitehead's thought the individual character of every event, including the percipient (or perceiving event), is created by its interaction with everything else. In an act of perception, the person involved is neither a merely passive reflector nor a dominating actor who imposes his preconceived scheme of things on to his surroundings, but is instead a knot or focus in a network of to-and-fro influences. This point of view has strong affinities with the attitude taken by many recent painters to their work. They start on a painting without knowing exactly where they want to get to with it, and they allow the painting itself, as it develops, to suggest what the next step should be. This has been very clearly stated by Motherwell[16]: 'I begin somewhat by chance but then work by logical sequence — by internal relations, in the Hegelian sense — according to strictly held values. . . . A picture is a collaboration between artist and canvas. "Bad" painting is when an artist enforces his will without regard for the sensibilities of the canvas.'

Since this attitude to painting is very far from the traditional — even from the 'Traditional Modern' of the thirties — it may be as well to illustrate it further. Here are statements by William Baziotes, James

Brooks, and Philip Guston, all leading painters of the post-war New York school.[17]

Baziotes describes quite simply the way he sets to work. 'There is no particular system I follow when I begin a painting. Each painting has its own way of evolving. One may start with a few colour areas on the canvas; another with a myriad lines; and perhaps another with a profusion of colours. Each beginning suggests something. Once I sense the suggestion, I begin to paint intuitively. A suggestion then becomes a phantom that must be caught and made real. As I work, or when the painting is finished, the subject reveals itself. As for the subject matter in my painting, when I am observing something that may be the theme for a painting, it is very often an incidental thing in the background, elusive and unclear, that really stirred me, rather than the thing before me.'

Brooks is more concerned to emphasize the unexpectedness of what may emerge. 'The painting surface has always been the rendezvous of what the painter knows with the unknown, which appears on it for the first time. An engrossment in the process of changing formal relations is the painter's method of relieving his self-consciousness as he approaches the mystery he hopes for. Any conscious involvements (even thinking of a battle or standing before a still life) is good if it permits the unknown to enter the painting almost unnoticed. Then the painter must hold this strange thing, and sometimes he can, for his whole life has been a preparation for recognizing and resolving it.'

Guston's description of the interactions between the shapes of his half-complete canvas is in terms extraordinarily reminiscent of Whitehead's emotionally charged vocabulary. 'The resistance of forms against losing their identities, with, however, their desire to partake of each other, leads finally to a show-down, as they shed their minor relations and confront one another more nakedly.'

It is not likely, of course, that this movement towards what might be called a state of mutual participation in the painting was at all directly derived from a knowledge of Whitehead's thought, although he is referred to several times by Motherwell, one of the most 'intellectual' of the early group of New York painters. But similar ideas certainly got into the post-war American air from other sources. A vivid description of this general attitude of mind has been given in a lecture by the musician John Cage,[18] who was a friend of many of the New York painters. He seems to have derived this type of idea from Suzuki, the expositor of Japanese Zen Buddhism; and he draws explicitly some far-reaching ethical and philosophical conclusions, which, although perhaps somewhat personal to Cage, are probably not far behind the surface of the thought of many of the post-war American painters.

'In a lecture last winter at Columbia, Suzuki said

116

[31] *Guston. 4N 1955*

that there was a difference between Oriental think-
ing and European thinking, that in European think-
ing things are seen as causing one another and
having effects, whereas in Oriental thinking this
seeing of cause and effect is not emphasized, but
instead one makes an identification with what is
here and now. He then spoke of two qualities:
unimpededness and interpenetration. Now this

unimpededness is seeing that in all of space each
thing and each human being is at the center and
furthermore that each one being at the center is the
most honored one of all. Interpenetration means
that each one of these most honored ones of all is
moving out in all directions penetrating and being
penetrated by every other one no matter what the
time or what the space. So that when one says

117

66. Magnesium-tin alloy

that there is no cause or effect, what one means is that there is an incalculable infinity of causes and effects, that in fact each and every thing in all of space and time is related to each and every other thing in all of space and time. This being so, there is no need to cautiously proceed in dualistic terms of success and failure or the beautiful and the ugly or good and evil, but rather simply to walk on "not wondering", to quote Meister Eckhart, "am I right or doing something worse"'. And in another lecture[19] he goes on: 'It may be objected that from this point of view anything goes. Actually, anything does go, but only when nothing is taken as the basis. The thing to do is to keep the head alert but empty. Things come to pass, arising and disappearing. There can be no consideration of error. Things are always going wrong.'

I will return to this aspect of modern painting in the next chapter. Meanwhile, there is another facet of Whitehead's thought, and of modern science, which should be considered. Whitehead insisted that an event is not merely an assemblage of numerous relations between many different things thrown together into a disorderly heap. On the contrary, the various 'feelings' of one thing for others are *organized* into something with a specific and individual character. The concept of organization has become of focal importance in science, not only in biology but in such branches of physics as deal with the quantum mechanics of molecules, communications theory, and so on. It implies something more than merely reciprocal mutual relationships between the sub-units of the organized entity. There are, of course, mutual spatial interrelations between the five diamonds on a playing card, but no one would refer to such a card as geometrically organized; the diamonds form a mere pattern. Organization occurs when the relations are of such a kind that they tend to stabilize the general pattern against influences which might disturb it. That is to say, the organization confers on the entity an enduring individuality which a mere assemblage lacks.

Organization of this kind is very obvious in the living world studied by biology. A warm-blooded animal – such as ourselves – contains a series of parts: heart, lungs, blood-vessels, muscles, brain,

and so on, which are related in such a way that they interact to stabilize the internal conditions. If the muscles work hard and generate extra heat and carbon dioxide, the heart beats faster, the lungs pant, and the situation is brought back to normal. This has been known for a long time, but it is only recently that biologists are realizing fully how universal organization is. When a fertilized egg is gradually developing into an adult animal, it is, we find, not sufficient to regard it – though many biologists are still tempted to do so – as a mere collection of processes by which new substances become manufactured according to the instructions laid down in the hereditary constitution. There is something more than this. The processes lock together in an organized way, so that the whole system tends to produce end results which have complex but individually definite characters – brain, liver, kidney, muscle, and so on. Again, until a few years ago it was usual to describe the theory of evolution in terms of large numbers of quite separate hereditary factors, which might vary and cause the appearance of new 'unit characters' of the organism; and these factors and characters were then supposed to be individually preserved for future generations, or rejected, according to the pressures of natural selection. But now we realize that the factors, the characters, and the natural selection are not all quite separate things, without influence on one another. In fact, they all form parts of an organized system that influences the kind of character-alterations which a given factor-change will produce, and also the kind of natural selection which will occur.[20]

Organization is a major factor in all aspects of life processes – in day-to-day physiological functioning, in development from egg to adult, in the long-term processes of evolution. One of the most striking developments in the recent history of science has been the increasing awareness of its importance. Under somewhat different names – for instance, 'feedback control', 'end-product inhibition', 'error-correcting networks', and the like – very similar ideas have been growing in importance in the physical as well as the biological sciences. Very recently the most fundamental of all the physical sciences – that which deals with the structure of the atomic nucleus – has developed a system of thought, referred to by its practitioners as 'bootstrap dynamics', one of whose basic notions is that of organization. The nucleus should not be regarded, as it has been, as something composed of fundamental particles held together by forces; it seems rather as though, when the nucleus is intact, the particles and the forces are in some way parts of the same thing, only appearing in these two different guises when the nucleus has been disrupted and its organization broken down.

Science in the past did not take organization as a central topic of study, perhaps partly because the importance of organization was not fully realized

but also because it had no methods for dealing with anything but the simplest kinds of organization. It is mainly the advent of computers which has overcome these technical difficulties, and with the aid of these instruments science can handle extremely complicated and unobvious patterns. From the visual point of view this has the result that the shapes of the things with which scientists deal have a quite different character in the new Third Science from what they had in Second Science. It is worth while looking at some examples – not, as I said before, because these have been in any direct way models for recent painters (except perhaps in a very few cases), but in the first place because they do constitute a new 'landscape of thought', a new climate of form; and secondly, perhaps more importantly, because to those of a visualizing turn of mind they may convey the character of Third Science better than many pages of verbal discussion.

Before showing any scientific images, I should like to say something about the relevance, as I see it, of such materials to modern painting. I think it is a fact that if shown any abstract painting one could find, in some scientific journal or other, some photograph or diagram which offered a more less close visual parallel to it. The *locus classicus* for such comparisons in recent years is probably the exhibition on *Kunst und Naturform*[21] held in 1958 at Basel, while General Motors of USA offers a prepackaged exhibition of art in nature in the advertisement pages of the *Scientific American*. The Basel exhibition was remarkable in offering precise detailed comparisons between particular pictures by modern painters and photographs of objects as they are seen by scientific equipment. Poliakoff was married off with a coloured polarized light photograph of a section of granite, Wols with a thick section of nerve cells, Jackson Pollock with a section of the lining of the human brain, and so on.

Now, I should be willing to concede that many modern artists have seen pictures of this kind in more or less popular journals or in advertisement, and a few of them may even have looked through some of the files of technical scientific publications in libraries available to them. They may well have been struck by the visual qualities of such scientific images, and found them exciting raw material to be worked up; as I have pointed out, some of the Bauhaus people, such as Moholy-Nagy and Kepes, produced books[22] aimed at bringing this type of visual experience to the notice of painters. But the point I want to insist on is that no artist would – or should – have dreamt of using them unless he was convinced that these images had meaning. There has never been, and I doubt if there ever could be, an Impressionism of the scientific image. No one has painted a section of tissue or a bubble chamber photo from the same point of view that Monet painted his immediate

67. Field of ultra-sound, made visible by a photographic method

visual experiences in front of a cathedral. The scientific images were never taken solely as images: they were taken always as symbols. It is only because painters have tumbled to it that these types of visual experience could be meaningful in science that they realized that they could be meaningful in art also. Most of the scientific parallels which were discovered in the Basel exhibition for modern paintings could in fact have been produced in 1890 (even when electron microscope pictures were used one could have found visually equivalent photographs taken with the ordinary microscope at a lower magnification). The artists of the 1890s made no use of such images, just because they saw no reason to believe that images of this kind could be meaningful.

What convinced the artists of our day – some fifty years later – that images of this kind are worthy of aesthetic attention was not that the scientific pictures suddenly became more figurative representations of some particular appearance in the world that science examined. The crucial fact was that they came to realize that hard scientific *analysis* – from which conclusions could be drawn, on which effective technologies could be based – led to images of the same general kind. The coloured areas in a painting by Poliakoff, which impinge on each other with boundaries which curve subtly away from the rectilinear, should be compared not to the contiguous grains of minerals in a rock, which mean nothing in particular, but to phase diagrams which give essential information about the properties of complex mixtures; and so for the rest of them. The happenstance down the microscope only becomes worthy of attention if, in some other much more analytical and meaningful context, the general point has

119

been made that forms of this kind can carry significance. The impact of scientific images on painting is first through what Whitehead called the mode of causal efficacy and only secondarily through presentational immediacy.

It is for this reason that, when offering some images to indicate the character of Third Science, I shall show few photographs of appearances taken through scientific instruments, but shall present a number of diagrams which exhibit the underlying causal structure of events, or recordings of characteristics which are more causally efficacious than mere appearance.

For instance, in the days of classical Newtonian science a molecule of carbon was pictured as consisting of two solid billiard-ball-like atoms joined together. Nowadays, in so far as it can be visualized at all, it appears as a soft-edged cloud of electrons, in the middle of which there nestle two atomic nuclei. The cloud is thinner in density near the surface and thickens towards the centre. A map of it, showing contours of density, is shown in the drawing below. But even this gives only a hint of the extent to which solidity and firm boundaries have vanished from the picture; the overall density in the actual structure is the summation of five different electron clouds of different types and different shapes, two of which are shown separately in the drawings on the right. Note also the soft outlines of the atomic groups in Figure 61.

Figure 70 is an example of the direct images yielded by one of our newer methods of 'perceiving' the world around us. They are obtained from crystals in which large molecules are organized into patterns which are regular but extremely complex. When these images are interpreted (by the aid of a computer) into terms of 'causal efficacy' or 'real structure', we get first a picture like Figure 69, showing only part of an organized cloud of particles in the form of a contour map which indicates their density at any point. This is a much more complex example of the same sort of picture as that shown in Figure 68. From such a contour map we can make a diagram, in three

dimensions, of the whole pattern, now representing the densest parts of the cloud by solid lumps connected with wires; and we find that we are dealing with a pattern as complex as that shown in Figure 71. Guston's picture on p. 117 could be a portrait of such a structured cloud of electric charges.

We do not need to go to such lengths of complexity to find examples of typically Third Science shapes. Figure 72 is a diagram (worked out by a computer) of the structure of the weather system over the northern hemisphere which would result if certain assumptions are used in connection with a particular theory about meteorological phenomena. The pattern is not very complex, but it is very subtle and irregular, in ways which would make it impossible to handle by conventional algebra and geometry. Even such forms as those in Figure 4 (p. 5) make an instructive contrast to the 'cubes, spheres, and cones' to which Cézanne felt the world could be reduced.

A number of electronic devices make it comparatively simple nowadays to convert experiences which originate in some other mode of perception (say sound) into visual images. This often makes it easier to recognize the characteristics of their organization, but the visual images produced are usually of the subtle, fluid, non-Euclidean type characteristic of Third Science. Figure 75 is a visualization of the word 'you', recorded by the Bell Telephone Laboratories and used by them in an advertisement in a popular journal, *The Scientific American*. Perhaps Kandinsky or Arp might have come to something like this when they thought they were being least scientific, but it has

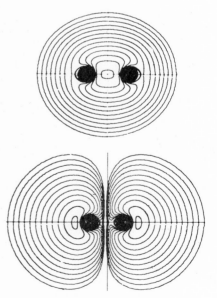

68. *Electron orbits of the carbon molecule. The left figure shows the total electron density contours; the two figures above show the contours for two particular types of electrons*

69. Electron density contours for part of the myoglobin crystal

70. X-ray diffraction photo of myoglobin crystal

71. Wire model showing main structural features of the myoglobin molecule

more affinity with drawings of much more recent artists, such as Dubuffet. Figure 74 is a record of some varieties of bird song, again very far from what is conventionally considered to be the typical scientific shape but quite reminiscent of drawings by Michaux or some other abstract expressionists. Figures 66, 67 and 73 are a few other examples of the types of form which are likely to strike the eye of anyone glancing through popular scientific literature of the present time. Note, in particular, the change in character between an old-fashioned graph, made by drawing a line through a small number of points, and the type of curve produced by modern continuous-read-out apparatus (Figure 76).

Many modern scientific techniques produce pictures which have two characteristics. One is that the image spreads all over the whole picture area without any particular focus and often with no very obvious edges; this is what in the next chapter I shall refer to as 'all-overness'. The other is that the picture records the interaction of two or more intersecting patterns. The simplest examples of such intersecting systems produce what are known as moiré patterns. For instance, if two systems of lines intersect at an angle they seem to

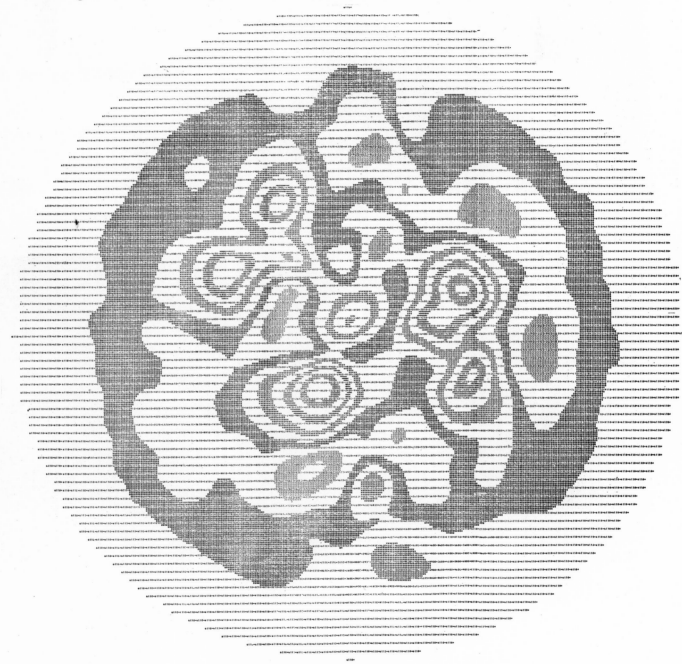

72. *Weather map of the Northern Hemisphere calculated by computer from theoretical equations supplied to it*

73. Computer simulation of turbulent flow

74. Two spectrographs of bird song

75. Sound spectra of you spoken by three people

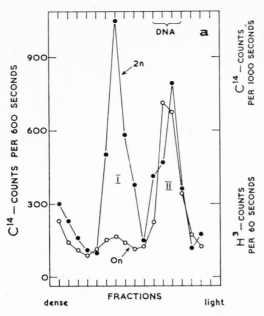

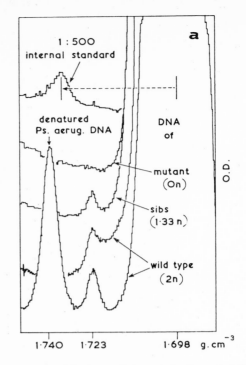

76. *Curves based on a few measurements,* left, *and on continuous readings,* right

give rise to new shapes. Figure 77 shows two of the moiré patterns which can be produced by superimposing two systems of concentric circles on each other. Some very recent artists of the so-called 'Op' school have been sufficiently fascinated by such effects to make them into the subject of pictures. However, I introduce them here not as themselves worthy of imitation but merely as a very simple example of one of the kinds of phenomena with which Third Science is concerned; a system which is itself produced by the interaction of two sub-systems.

A more interesting example is shown in Figure 78. In this the background is an all-over field which contains a certain amount of order, which is, however, not very easy to see or to describe. If an

even grid of parallel straight lines is laid over this, the moiré pattern changes as the grid is rotated, and, when it has the best orientation in relation to the background, the element of pattern in the background becomes revealed.

As another rather typically Third Science type of image it is worth considering a method of recording a scene on a photograph in such a way that one really does succeed in achieving the old goal of the Cubists — to make an image which records simultaneously the appearance of an object when seen from several different points of view. This is a method first invented about twenty years ago by Gabor in England, but which has only recently become practicable in a developed form following the invention of lasers. Lasers are a variety of lamp

77. *Moiré patterns from two sets of circles*

124

which produce light all of one wavelength and with all the waves very precisely in phase, that is to say with their peaks and troughs coinciding.

The method uses a principle rather similar to that of moiré patterns. If the light emerging from a lamp is as orderly and well behaved as laser light, the tops of the waves can be pictured as forming a set of concentric circles (in normal light there is a mixture of wavelengths, and the waves are out of phase, so that we should get a misty blur rather than precise separated circles). As Figure 77 demonstrates, if we have two lamps placed some distance apart, the waves will intersect and give rise to a moiré pattern, which in this case is known as a set of interference fringes. Even if we have an intersection between one source of light which is quite orderly and another which is rather disorderly, we shall still get some pattern formed in their interaction, as Figure 78 shows. In the system of recording an image which we are considering, known as 'wave front analysis', an object is illuminated with light from a laser beam and, of course, reflects this light from its surface in all directions. Some of the reflected light is allowed to fall on a photographic plate which is also illuminated directly by the laser beam. The photograph then records the interaction between the direct laser light, which is very orderly, and the reflected light, which has been made disorderly in ways which correspond exactly to the surface from which it was reflected. All we have to do now with this photograph is to cancel out the direct laser light, and we should be left with a record of the light reflected from the object. It is not very difficult to do this: it corresponds to laying, on top of the series of parallel lines in Figure 78, another complementary series in which white has been replaced by black and *vice versa.*

This may at first sight seem a long way round to get an ordinary photograph. But in fact the photograph is by no means ordinary. The light reflected by the object was not brought through any lens to a focus before being recorded. In fact, it has not been recorded as though we were looking at the object only through one eye, placed at a definite

78. Regular grid placed over an irregular background

79. Four prints from the same hologram

spot, but we have captured *all* the light reflected by the object on to the whole area of the photographic plate, which can be quite large. This means, in the first place, that any part of the photographic plate has got the whole image on it. Even if we cut the plate up into halves or quarters, we can reconstruct the entire scene, although if the fragment of the plate is too small the amount of detail becomes considerably reduced. Another and perhaps even more remarkable property is that if the photograph is tilted slightly while being printed we get a series of images on the object as though it were seen first from one edge of the plate, then through the middle, and finally from the other edge. With a fairly large plate we are coming quite near to having captured both the full face and profile of views at once (Figure 79).

In the 'wave front' photographs we have in fact recorded much more information about the object than is included in any photograph or drawing made from only one position. Now what does our image, so rich in content, actually look like ? Figure 80 shows an enlarged part of such a photograph, or 'hologram', as they are called. It is really, as we have said, an extremely complicated moiré pattern, and it has the characteristic modern all-overness which to eyes not yet attuned to the modern idiom often seems merely chaotic and meaningless. This is a case in which such an all-over pattern is certainly by no means meaningless — contains in fact more meaning than a conventional photograph. It leaves one quite ready to believe that there may be some meaning, though, of course, of quite a different kind, in the somewhat similar-looking productions of many modern painters.

The multiplicity of sciences

The recognition of the importance of organization produces a profound change in our attitude to the structure of science. It is an obvious and generally accepted fact that there are a great many different branches of science. Indeed, in universities and technical colleges new departments devoted to some specialized variety of science are being set up every day. But until recently it was usually thought that there was, or should be, an ideal Unity of Science to which we should aspire. The hope was that eventually all the separate branches of science would be seen as merely convenient sections within a framework of theory which applied uniformly to the whole range of natural phenomena. We realize now that this ideal is largely based on a misapprehension, and although it has still some relevance in certain connections, cannot be so widely and generally applied as previously hoped.

80. *A hologram at high magnification*, above; *and low magnification*, below

126

It remains valid in connection with the basic material stuff of which the natural world is made. Everything is constructed from the same atoms, and those from the same fundamental particles. But when these units are associated together in an organized way, the resulting complex may exhibit properties which cannot be expressed by the units in isolation. It is just this that is meant by organization. As soon as it is recognized as a fact, and a very important one, it becomes clear that the science which deals with properties of one type of organized entity may, and probably will, be very different in character from that which deals with a different kind of organization. Moreover, since it is difficult — perhaps even theoretically impossible — ever to comprehend exhaustively the entire content of any class of natural phenomena, we cannot hope that the different sciences will, in general, merge with one another again. Of course, many links will be made between them, and partial mergers. For instance, it has recently been possible to treat a large section of the study of heredity as a special sort of biochemistry concerned with the molecular structure of nucleic acids. But that leaves out other enormous aspects of genetics, such as those dealing with cell structures, the many different types of hereditary mechanism, evolution, and so on. The evolution of man from some species of ape involved many processes of a kind quite different from those studied by chemists. Any attempt to discuss, in chemical terms, such factors as a change from a forest to an open grassland habitat, the use of the hand for manipulation rather than as an aid to climbing, the adoption of an erect posture, and so on, would be so impractical as to be merely silly.

Further, it is not only that the subject matters of the different sciences cannot all be described in the same terms. The types of thinking required to deal with the behaviours of the various types of entity may be considerably unlike. There are, perhaps, not so very many different types of thought, and it may one day be possible to bring them all together into one enormous system of mathematical logic — though it looks as if that day is still distant, since mathematics still keeps on opening up some new types of logical structure for exploration. But even if we had a complete system of thought, in which all types of logical process were included, it would still remain true that each science would call for a particular selection of methods, an intellectual pattern appropriate to the behaviour of its subject matter. Biologists who deal with cells in which many hundreds of chemical processes are proceeding simultaneously will always have to use different intellectual procedures from those of students of, say, fundamental particles, who handle situations in which only a few different kinds of entity are involved.

The immediate relevance of this point to our present theme is obvious. If there is no one all-embracing Science, we cannot expect artists to incorporate its point of view into their own outlook. We should not be surprised or disappointed if we find that there are many highly diverse kinds of painters, and that those who are influenced by science respond to many different aspects of it. And this, as we shall see in the next chapter, is just what we do find.

81. *Electron density contours of the myoglobin molecule*

5

The New Start

Meaning what it seems to mean
But feeling the way it does.
Kenneth Fearing

Since the Second World War, *avant-garde* painting has taken on a New Look – in fact, a look so radically new that many new names have been suggested for it: *Action Painting, Informal Art, Tachisme, Abstract Expressionism, American-style Painting* – all implying a more or less total break with the past. As the first shock of novelty wears off, it becomes clear that the discontinuity is not after all as complete as originally appeared. The change has nevertheless been rapid and profound enough to amount to a real mutation. And, as the name 'American style' indicates, one of the remarkable features has been the sudden emergence of the United States, and particularly New York, into the position of the world centre of advanced painting. This position had for generations been held by Paris. Cubism was invented there; Paris remained, at least until 1940, the undisputed capital of the central tradition, with which we have been little concerned in this book. Even exploratory movements, some of whose sources were elsewhere – the Futurism of Italy, the geometricizing art of Holland, Russia, and later Germany, the Dada of Switzerland and Germany – all tended to flow back and become concentrated again in the Parisian art world. It was, however, quite clearly in New York, not in Paris, that the most far-reaching new developments took place during the 1940s; it has been primarily, though of course not exclusively, these American movements which have set the pace in recent painting; and it was, predominantly, American artists who opened the doors into new regions.

There is no one single New Style. The plethora of names which has been used for post-war painting reflects a genuine fact. There are many New Styles, extremely different one from another. What they have in common is perhaps little more than that, in one way or another, they transcend the rather narrow categories – of geometrical abstract or figurative surrealist – into which the exploratory art of the thirties was becoming canalized.

Painting is not as diversified a subject as the whole of science, but is certainly as diversified as any of the major *branches* of science, such as biology. We are used to the exponential increase in the subject-matter of science, and we do not expect post-war biology to have a uniformity of character. There is a continuity of development of some of the classical fields – nerve-muscle physiology, metabolic biochemistry, animal behaviour, plant growth hormones, endocrinology, genetic analysis – and also a lush crop of new, less easily foreseeable, advances – molecular biology, cellular ultrastructure, applications of information theory to brain functioning, virus genetics, cybernetic evolution theory, and many others. It is a sign of its liveliness and vigour that post-war painting shows an almost equal range of types of activity. The material to be discussed in this chapter is, then, extremely varied and extensive. I shall attempt to

82. *Pollock, drawing (1950). The width of the drawing is five feet*

129

83. Matta, drawing

organize it as follows. After a summary account of the initiation of the 'modern-modern' movement — the 'break-through' — I shall describe a number of main sub-currents in the stream; and then their relation to scientific developments, and in particular the parallels, if any, between the efforts of painters and scientists to produce syntheses of broad scope, since the attempt to bring things together into complex unities is recognised by both painters and scientists as a major goal of their endeavours.

Forerunners

Begin, then, in New York, during the war. American painters, in the Depression years, had mostly been engaged in the Federal Art Project of the WPA, an official outfit which had paid them enough to keep alive, and had used them to provide decorations, either as murals or easel pictures or sculptures, for a variety of public buildings. Its policy was rather surprisingly liberal and unrestrictive, but even so the general tendency was towards a somewhat politically conscious or even committed art; vaguely 'social-realist', not of course in the

Stalinist canon, but influenced rather by Mexican muralists such as Diego Rivera and Orozco. By the outbreak of war, however, a considerable number of up-to-date European painters had taken refuge in America. There were 'geometricizers' — Moholy-Nagy had opened a new Bauhaus near Chicago, Mondrian was living in New York, Gabo in New England — and also various vintages of 'magicians' — Marcel Duchamp, one of the Dada-like ancestors, and Max Ernst, Masson, Dali, André Breton of the Surrealist heyday. In the build-up to the breakthrough which we are now considering the geometricizers played little part; they had their own offspring in the sculptors and constructionists like Lippold, Biedermann, and others. In laying the trail which sparked off the New York eruption, the two most important of the refugee artists seem to have been Ernst and Masson.

Their influence did not derive directly from their Surrealism. Max Ernst was in the centre of the Surrealist tradition, a conscious exploiter of unexpected allusion, and expert in injecting jolts of adrenalin into the imagination. Masson was more obviously sexy but less orthodox — 'I am not enough of a surrealist for the Surrealists', he said, 'and too much for others.'[1] But the importance of both was that they were daring technical innovators. Masson, a master craftsman in the highly professional Parisian school, could use unconventional materials like sand with a totally confident manual skill; Ernst, somewhat more slapdash, had an extraordinarily fertile technical imagination, which led him to experiment with all sorts of semi-automatic processes, collages, blotting liquid drops of pigment, raking it over the surface with forks or combs, making rubbings on rough surfaces, and a whole host of other trick methods — in fact, in a painting with the suggestive title *Homme intrigué par le vol d'une mouche non-euclidienne*, he invented the technique of guiding dripped fluid paint into flowing curves, which later became the mainstay of the most famous period of Jackson Pollock's development.

Another surrealist in New York at the same time was Matta, a Chilean who had lived for some years in Paris. At a first glance, he was one of the most 'scientific' of the surrealists, his paintings usually showing a scene which seems to be taking place in free space, a rendezvous between astronauts or space-ships, in a void illuminated by some unearthly radiance or fluorescence; rather as one might imagine it would be in the middle of the aurora borealis. His basic importance is probably not very great. His 'scientificness' is mainly a matter of using quasi-scientific props; and he might perhaps be called a 'science-fiction Léger', without Léger's solid peasant feet on the ground. But he played a part in stimulating the first potentially world-ranking achievement of the New York painters, the work of Arshile Gorky, an Armenian, who had spent most of his life in America. He was

130

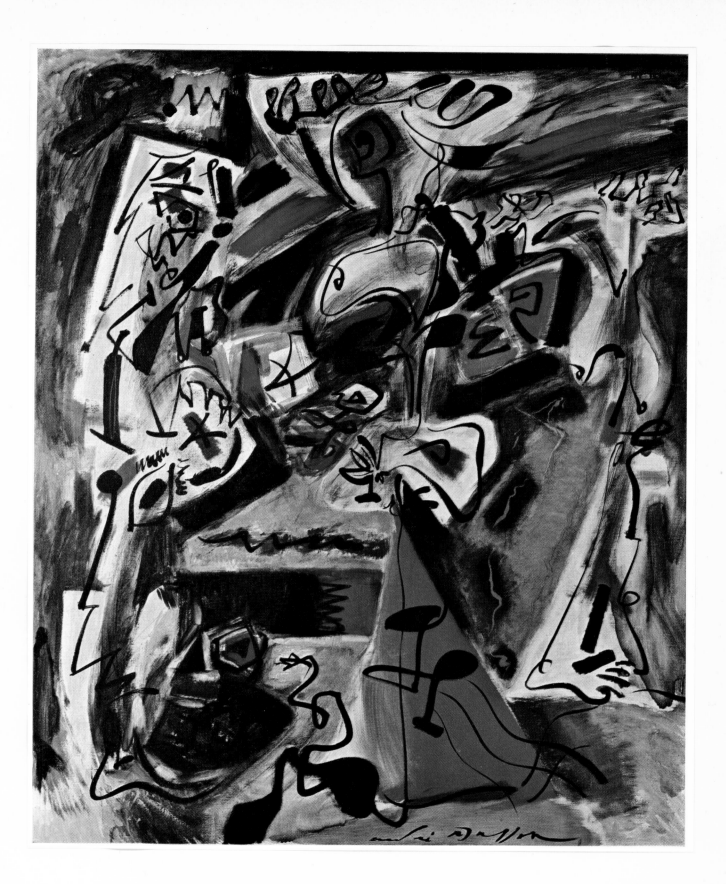

a 'late Surrealist', whose pictures succeed in expressing the Surrealist atmosphere, of hinted-at emotion and mysterious goings-on somewhere round the corner, while using only abstract shapes in which no 'things' or people are clearly recognizable. Part of Gorky's reputation probably derived as much from his gifts as a talker and romantic Bohemian (or Greenwich Villager) as from the paintings themselves. In any case, true to the romantic image, he died, by his own hand, at an early stage in his development; and he remains,

therefore, an enigmatic forerunner, a John the Baptist figure.

There was another of these scurries of air to presage the storm which would soon break. Hans Hoffman was born in Germany as long ago as 1890. He was in Paris, and at the right cafés in Paris, when Cubism was born. In 1930 he went to California, and in the later thirties he ran an art school in New York and in the capital of its summer sea-coast of Bohemia, Provincetown, Mass. His influence as a teacher was profound in two

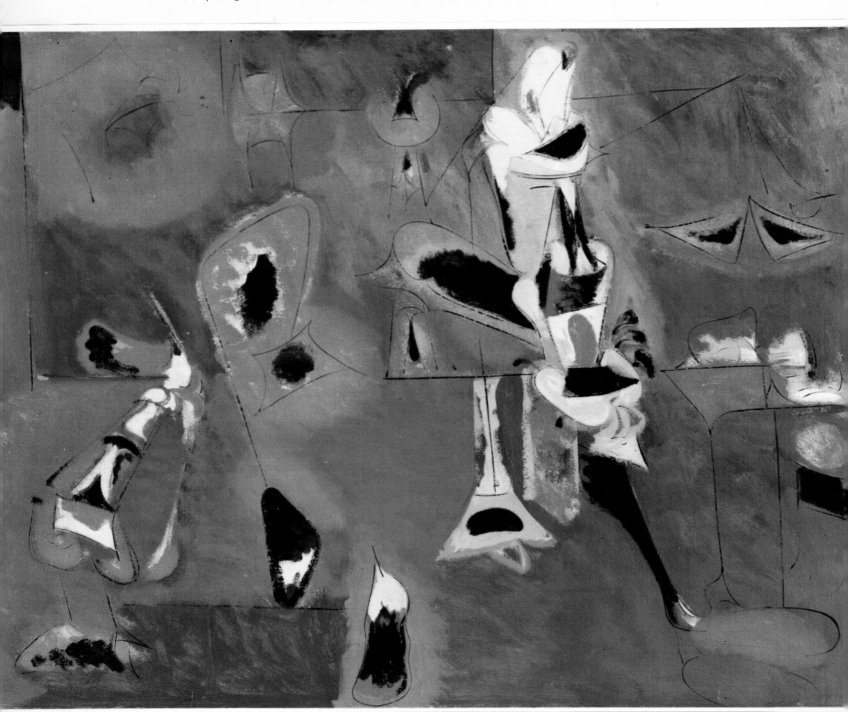

particular respects.[2] He insisted on one of the germinal ambiguities which have vivified modern painting: that there must be no compromising the fact that a painting consists of a set of material pigments laid on to a solid plane surface, that of the canvas; but that, simultaneously, the spectator, who is never allowed to forget this piece of banal materialism, is wooed into an illusion of seeing one shape behind or in front of another. And Hoffmann carried this to a second level of ambiguity in his theory of 'push-and-pull'. Every patch or stroke of pigment, by its colour, texture, or shape, at once pushes itself into the background, and, at the next glance, pulls itself into the front. The surface of a painting, therefore – regarded purely abstractly, without any reference to anything it may 'represent' – pulsates in space, sometimes the reds sticking out towards you, sometimes the blues. It is a transposition, into colourful painterly terms, of the spatial ambiguity which was exploited, in black and white geometrical language, by late constructivists such as Albers. This ambivalence of near and far, this 'movement of the surface', has remained one of the characteristic features of much of the newer painting.

Hoffmann was one of the main originators of another of the most characteristic features of the New York school. He was the first really noisy painter. He slapped the stuff around by the trowelful, almost by the bucketful, though Pollock was to go one better. Parisians, even immigrant Spaniards like Picasso and Miro, remained professional craftsmen with high standards of technical expertise, even when they were being as revolutionary as possible in what these technical means were being used for. This professionalism was preserved by the European innovators in the postwar world such as Wols, Dubuffet, and Mathieu. America is the country which – in pre-Status-Seeker days, anyhow – believed in 'get it done; you say how'. Bed-in a telegraph pole by standing it up on a (precisely suitable) charge of dynamite which, when exploded, will dig just the right-sized hole for it to sink into – not the method laid down by the age-long tradition of our ancestors, but effective enough, in people who really have the feel of material, and particularly of new materials. This is one of the directions in which America has gone furthest beyond the traditional craftsman's knowhow of Europe. At the end of a ten-year apprenticeship our craftsmen may perhaps know more about the traditional uses of wood, clay, and bronze; but for an instinctive feeling for what you can, if you try, do with these materials, or with glass, plastics, casein paints, new metal alloys – or, for the matter of that, with such laboratory materials as cellulose acetate electrophoresis strips, caesium chloride density gradients or chromatography columns of various peculiar substances – the 'materialism' of American culture seems to pay off. It produces a quite excep-

tional empathy with what the stuff will or won't do.

Hoffman was the first to bring this aspect of the specifically American genius into the forefront of painting. He started, around 1938, to demonstrate that oil paint has a considerable interest simply as a substance. It is not, to my mind, actually a very *nice* substance; too buttery, emollient, not enough bite. It is improved by making it more gritty, by adding sand, for instance; or making it more fluid, as Pollock did. I am surprised no one seems to have tried making it more fibrous, perhaps by mixing hair with it. But, whatever one may think of its character, Hoffman, though of no great importance as a painter, is a key figure not only as a teacher, but in getting across the point that paint has a character; and this has remained one of the flavoursome ingredients in the 'modern-modern' witches brew.

The breakthrough

The real breakthrough to the characteristically post-war type of painting came with the work of Willem de Kooning and Jackson Pollock. Both of these men worked in New York and made the

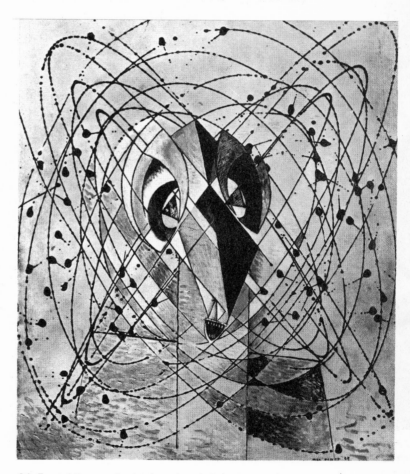

84. Ernst. L'homme intrigué par le vol d'une mouche non-euclidienne (1947)

[33] Gorky. Agonie (1947)

133

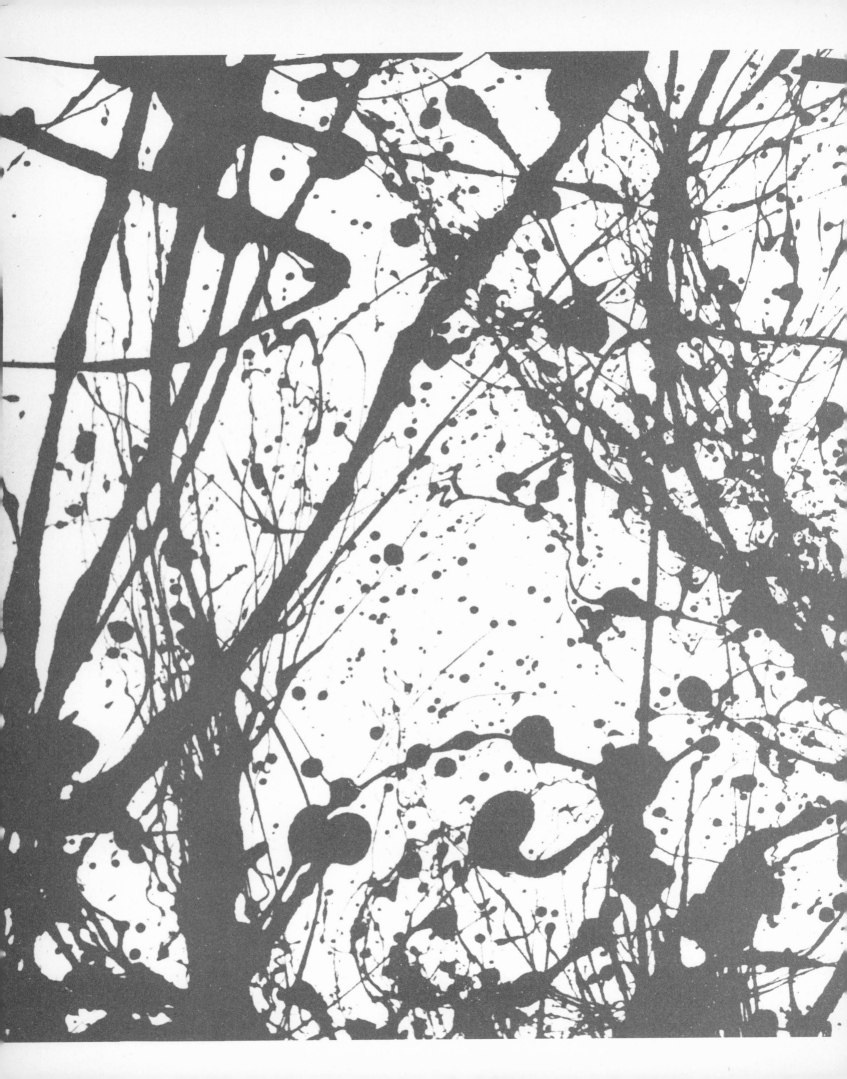

decisive advances in the middle 1940s. At about the same time, Mark Tobey (on the Pacific coast of America), and one or two painters in Europe, such as Wols and de Staël, were developing in somewhat similar ways. Their productions were, however, less aggressive and uncompromising than those of de Kooning and Pollock, and it was the two New Yorkers who swept the rest of the painting world into their train and over the frontiers into new territory.

The most influential effect produced by the work of all these painters was to provide a demonstration that painting can dispense with anything resembling an image. It cannot merely do without the representation, in however symbolic a form, of any recognizable object or thing, such as those which have haunted the Surrealist's pictures, but can even fail to depict any geometrically coherent abstract shape. The first abstracts of Kandinsky had been almost equally inchoate, but in the intervening thirty years very few pictures had been produced which were free of either geometricizing or figuration. The demonstration that painting is possible without either of these two elements acted as the opening of a door into an enormous area of freedom into which painters had not previously ventured.

This abolition of the image is comparable to the abolition in science both of the object and of logical form. In earlier times the object had certainly been dispensed with in mathematics and much of logic; and in some branches such as topology, the logical form of the entities considered had been attenuated almost to a vestige. But as we have seen, one of the main characteristics of recent science is the development of subjects such as systems theory or information theory, in which the topics studied are not material and do not have precisely definable form. Scientific thought operates in a freer medium, with a less rigid framework, than before. The newer paintings belong to the same world as this kind of science, and this community of 'level of discourse' is one of the main reasons for their appeal to many scientists.

In fact, freedom, the refusal to be bound by previously accepted dogmas, was one of the dominant characteristics of the new movement. Neither de Kooning nor Pollock, for instance, were in the slightest inhibited against mixing freely together the traditions of abstract and representational art, either in different phases of their development or even on the same canvas. The many different currents of interest which had gradually become funnelled into the two narrow channels of surrealism and geometrical abstract art were taken apart again and then mixed together once more, in different combinations and proportions with, as well, a number of new developments added.

Both de Kooning and Pollock started their careers in more or less conventional schools. De Kooning received a thorough art training in Hol-

land, where advanced painting was still largely dominated by the influence of Mondrian, before he emigrated and settled in the United States in 1926, at the age of 22. His earliest fine-art paintings — for some years he kept himself going by working as a house painter — were in a fairly straightforward surrealist manner, with Picasso influences. He soon passed on, however, to a phase of abstract painting, largely in black and white, characterized by a calligraphic style of drawing, done at great speed though subject to a long-continued process of correction and overpainting which often led to the building up of thick slabs of pigment. In these paintings there is scarcely any reference to objects in the external world, although one can sometimes spot an odd item of recognizable content here or there. In general, however, the shapes are quite free, neither geometric nor representational. They usually appear as though in violent motion, colliding and interpenetrating with a powerful sense of muscular or even inorganic energy, while in their space relationships there is an ambiguity somewhat like that exploited by Hoffman.

Violence, energy, and ambiguity were to remain dominant characteristics of de Kooning's work. They were very obvious in a series of paintings of women which he produced in the early 1950s. These paintings were by no means wholly or even mainly abstract and were at least as representational as many late Picassos or some Surrealist works. However, the type of distortion used by de Kooning was in some ways cruder and more brash than anything since the heyday of Dada. The colours were bold, even garish, though showing an extraordinarily sensitive colour sense. Organs — a mouth, a nose, a hand — might be displaced or reversed in position, and sometimes a sheet of paper with a drawing of the part in question had been simply attached to the canvas surface. Many of these individual items are also represented in a peculiarly ambiguous manner, so that a certain part might be both the woman's leg and a part of a bicycle, or another both a smile and a necklace. One effect of this manner of painting was, as it were, to fill the picture frame to overflowing. The forms continued right up to the edge and seemed as though they might be going on beyond it, while there was no well-defined central focus that brings the eye back to the middle of the painting. This was an early example of the 'all-overness' which, as we shall see, has been one of the characteristics of recent painting.

De Kooning's women, even when given names like Marilyn Monroe, showed little signs of the nymph-like charm which is the recognized fashionable form of sex appeal. They were as buxom as the women of Rubens and Maillol, and with a good deal more of the peroxided barmaid in their appearance (though barmaids are not a feature of the American scene). Many critics read into

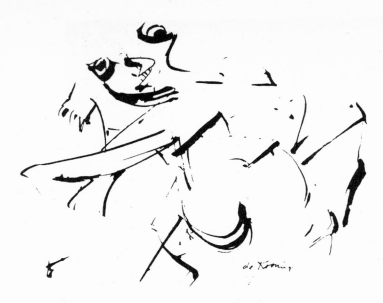

86. De Kooning, drawing (1962)

this an aggressive and destructive attitude towards the female sex, and indeed de Kooning has been regarded by some as primarily an iconoclast, out to smash all convention and to express nothing but horror and desperation at the character of the world in which he lives. Aggressive revolt against the forms of the society which had led the world into a great war was certainly an important factor in the feelings of all these artists working in the late 1940s and early 1950s. De Kooning[3] has explained that he does not find painting a calming activity. 'Art never seems to make me peaceful or pure. I always seem to be wrapped in the melodrama of vulgarity. . . . Some painters, including myself, do not care what chair they are sitting on. It does not even have to be a comfortable one. They're too nervous to find out where they ought to sit. . . . Those artists do not want to conform. They only want to be inspired. . . .' But that is not the same thing as saying 'they do not want to conform, they only want to destroy' as the early Dada artists might have done. De Kooning, in common with nearly all the other first-rate painters even in the agitated decade of the 1950s, was more interested in painting than in politics. His paintings of women seem to me not so much destructive but rather productions which might be compared, both in their female but unglamorous subjects and the ambiguity and concertinaed multiple-reference technique, to the characters in James Joyce's *Anna Livia Plurabelle*[4] :

'First she let her hair fell down it flussed to her feet its teviot winding coils. Then, mothernaked, she shampooed herself with galawater and fragrant pistania mud, wupper, and lauar, from crown to sole. Next she greased the groove of her keel, warthes and wears and mole and itcher, with antifouling butterscotch and turfentide and serpenthyme and with leafmould she ushered round prun-

ella isles and islets dun quincecunct all over her little mary. Peeld gold of waxwork her jellybelly and her grains of incense anguille bronze. And after that she wove a garland for her hair. She pleated it. She plaited it. Of meadowgrass and riverflags, the bullrush and the waterweed, and of fallen griefs of weeping willow.'

De Kooning's later work was mostly much more abstract than the series of paintings of women. The forms are quite free from any clear-cut geometry. In fact they often consist of single strokes with the brush or palette knife. The quality of these marks as calligraphy contributes a large part of their interest. They are often spoken of as 'gestures', as free muscular movements dictated only by the particular style of movement inherent in the painter's body, rather as the lines of a signature carry the impress of the particular person who has signed his name. This is the aspect emphasized by the critic Rosenberg, who coined the name 'action painting' by which this style of abstract art is often referred to.

'A gesture on the canvas', he writes,[5] was a 'gesture of liberation, from value — political, aesthetic, moral.' But the gesture is, of course, not a free and uncommitted one. It is a movement made while transferring, from brush or palette knife to canvas, a quantity of paint of a certain viscosity, plasticity, and so on. The material quality of the substance involved is as much part of the painting as the muscular movement of the artist. Rosenberg is on sounder ground when he writes: 'The big moment came when it was decided to paint . . . just to PAINT.'

He went on to argue that the most important characteristic of the new movement was that it regarded painting simply as an act, something that the artist did, just as he might perform some other complex physical action, such as dancing, cooking a meal, or cleaning out his room. 'A painting that is an act is inseparable from the biography of the artist. The painting itself is a "moment" in the adulterated mixture of his life. . . . The act — painting — is of the same metaphysical substance as the artist's existence. The new painting has broken down every distinction between art and life. . . . The critic who goes on judging in terms of schools, style, form . . . is bound to seem a stranger. Some painters take advantage of this stranger. Having insisted that their painting is an act, they can claim admiration for the act as art.'

This peculiar view of what modern painting was all about became rather fashionable for a time; probably it was so difficult to formulate any meaningful verbal comments on the new style of visual abstract art that the first critic who put up an even faintly plausible smoke screen of words tend to be happily accepted as an excuse for giving up the hard work of trying to think out something more adequate. Even many of the painters themselves seem to have been willing, when called on

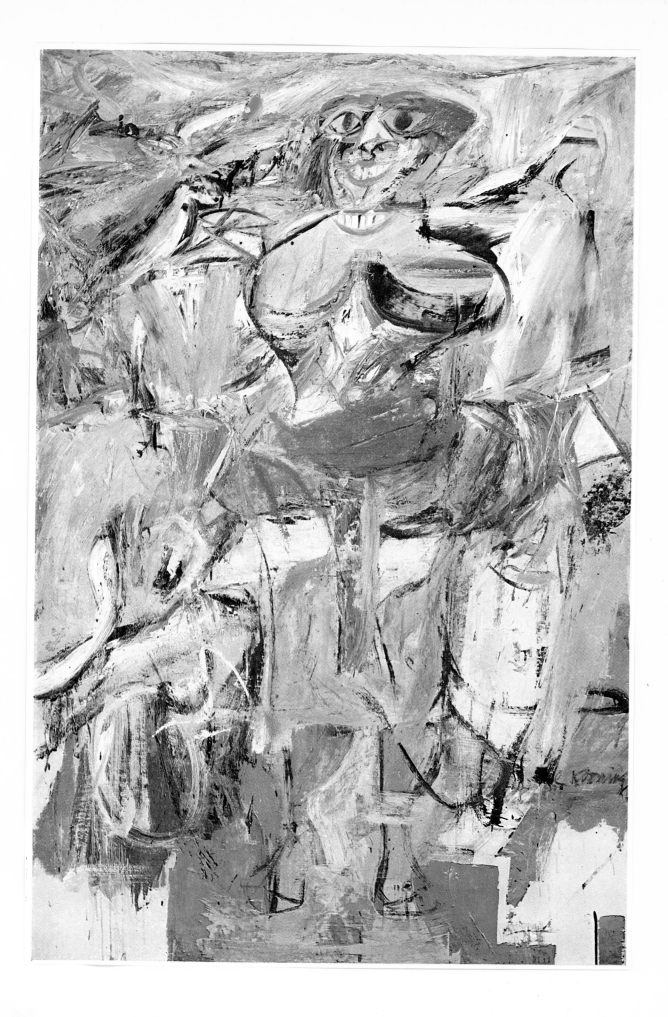

to expound their aims, to give an explanation along Rosenberg's lines.

However, it has become fairly clear that Rosenberg was exaggerating. None of the painters have regarded their paintings as nothing more than actions. They have always been concerned to *produce* something, and have hoped that what they produced would be a vehicle for some sort of communication or expression. There is an acrimonious exchange of articles between Rosenberg and another New York critic, Greenberg, on the subject in *Encounter*, December 1962 and May 1963, from which the amateur of art criticism may derive some amusement. However, as early as 1958 Lawrence Alloway[6] was writing 'Although "action" was a good word to stress the importance of the creative action of the artist, it has been mistaken as a full description of the art, instead of recognized for what it is, a polemical melodramatic label. . . . Action was not the end result, but a process in the discovery of aesthetic order.' Such validity as Rosenberg's emphasis on 'Action' possesses comes from the fact of seeking aesthetic order by rather new methods, which involved both what I have referred to as 'participation', that is, the breakdown of the sharp distinction between the percipient and what is perceived, and also a use of calligraphic gestures in the application of the material substance — paint or whatever — that was being used.

De Kooning is very far from being a mere acrobat of gesture. In fact the marks of his brush or knife more often give the impression not of a smoothly flowing, a practised or even a completed movement — as for instance do those of Matthieu or the classical schools of Oriental calligraphy — but rather of something vigorous but hesitant, becoming almost clumsy in its determination not to be slick. He is one of the first great exponents of the 'unpainterly' — a sort of uncouthness and refusal to be competent which is one of the ways in which modern painting escapes from the orthodox into freshness; this is sometimes successfully pulled off both by painters who have never been through the art school routine and by a few who, having done their technological training, succeed in getting their hands to unlearn the craftsman's knowhow. It has some affinities with the 'Academic' style of Chinese painting, which also involved a reaction against a professionalism which was in danger of becoming too slick.

De Kooning's paintings seem to me basically concerned with the way things interpenetrate one another, which he feels almost in terms of bodily sensation and in a way closer to Whitehead's concept of a prehension of feelings than to perspective or any other form of geometry, or even to the impersonal causal connection of 'objective' science. He once said[7] 'That space of science — the space of the physicist — I am truly bored with it by now. Their lenses are so thick that seen through

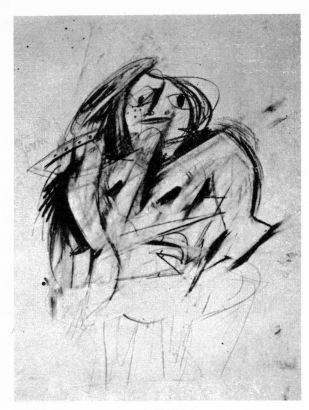

87. De Kooning. Woman (1953)

them, the space gets more and more melancholy. There seems to be no end to the misery of the scientist's space. All that it contains is billions and billions of hunks of matter, hot or cold, floating around in darkness or into a great design of aimlessness.

'The stars I think about, if I could fly, I could reach in a few old-fashioned days. But the physicist's stars are used as buttons, buttoning-up curtains of emptiness. If I stretch my arms next to the rest of myself and wonder where my fingers are — that is all the space I need as a painter.'

▶ Jackson Pollock, like de Kooning, came eventually to the new type of abstract painting after a beginning in more conventional modes. Part of his art student training was in the school of one of America's more reactionary representational artists, Thomas Benton, who attempted not very successfully to develop a style which would recall the regional characteristics of the people and places of the United States, particularly the Middle West. Pollock then, like many American painters in the late 1930s, worked in the Federal Arts Project, doing a number of murals and other public works which sufficed to keep him going during the years of the Depression.

During this period he was considerably influenced by the Mexican muralists such as Rivera, Orozco, and Siqueiros. These were painters who dealt mainly with very large works suitable for the walls of public buildings, and who expressed left-wing social ideas with great dramatic fervour.

[35] *De Kooning. Door to the river*

88. Pollock. Autumn Rhythm (1950)

They must have provided a vitalizing contrast to the traditionalism and narrow regionalism of Benton. A little later Pollock was deeply influenced by some of the late semi-surrealist works of Picasso.

In many of these, Picasso was exploring the significance, for a world threatened or engulfed in war, of a range of symbolic figures concerned with the conflict between human and bestial nature. The bullfight is one such theme; another, which Picasso has explored in many contexts, is the Minotaur, the bull-headed creature in which man and animal contend with one another as parts of a single being. In Jackson Pollock's first important period of work he was also deeply concerned with myths of man and beast. Several of his paintings deal with the wolf which suckled Romulus and Remus. One of the best known of this period is entitled *Pasiphae*, the Minoan queen whose lustfulness led her to accept copulation with a bull, from which union the Minotaur was the offspring. Pollock's pictures show the scenes in an idiom which is far from naturalistic but contains elements derived not only from Picasso but also from expressionists, such as perhaps Soutine, and from the Red Indian art of totem poles.

These pictures are full of wild, surging energy, expressed not only in the brushstrokes, but in the symbolism of the forms used; the total subject of many of the pictures is a myth of murder or lust, and the detailed small elements frequently also have strong sexual suggestions. The parts of the main forms are scattered around as though by an explosion, or heaped together in a milling mass, like arms, thighs, breasts, buttocks, of people engaged in a writhing, wrestling-match copulation. Pollock is often accused – or praised – as the incarnation of the destructiveness of modern civilization. His own activities and way of living encouraged such judgments; he was notorious for his readiness, when drunk (which was not seldom), to pick fights with all and sundry, or to tear down bits of interior decoration, chandeliers for choice, and hurl them into the street. But these were after-hours acts: of rebellion, certainly, but also, more simply, loosening-up work-outs for an abundance of energy which, the pictures suggest, was ridden on a much tighter rein in the studio. Mere anarchic destructiveness, such as some of the Dadaists had advocated, is not the main impression made even by these early Pollocks; it is because the violence is held tense within some sort of order, spontaneously generated and unformalized yet forceful enough to contain it, that they give off their great sense of power and virility.

In this period one might say that Pollock had a dominant general 'subject'; a world in which humanity is in danger of being swamped by barbarism. His expression of this has close links with the work of Picasso before him; and he has had important followers, such as Alan Davie. These social references of painting are not being followed up in this book. However, the pictures, as visual entities, already contained many of the features which were to become dominant in the abstracts to which Pollock soon proceeded; and these are very relevant to our theme. There was, for instance, already an insistence on the quality of paint as a material. It was often laid on thickly with a granulated or otherwise interesting surface texture, or brushed

[36] Pollock. Painting (1945)

141

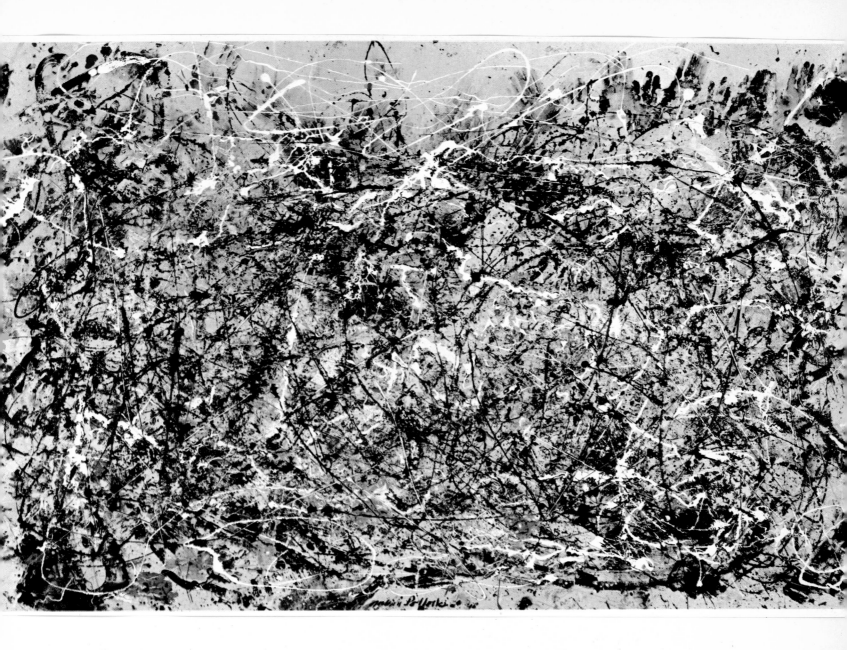

on in curved or looped lines which hold one's attention by their calligraphic quality. Again, the forms tend to fill up the whole picture frame instead of being grouped into a number of entities standing out against a background.

About 1946 Pollock began a period in which figurative elements disappeared completely – or nearly so. At first sight the interest of Pollock's new paintings lies wholly in the paint itself and the manner in which it is put on to the canvas, which it covers from corner to corner with a complicated dazzling network of lines and scrawls forming not so much pictures as painted surfaces, many of which could be given the title used for one of them,

'Shimmering substance'. After working for a few months with only brush and knife, Pollock adopted a method of dribbling fluid paint from a can with a hole in it, swinging this so as to get swirling lines and curves on a canvas laid on the floor. By this method he was able to achieve a special and very enticing type of free gesture. There was also a strong element of chance involved, since the precise rate at which the paint flowed, and the exact positions it came to, could not be controlled in full detail – or at least Pollock did not wish so to control it. However, there were, of course, many other factors which remained entirely at his discretion; for instance, the order in which the skeins of lines

89. Pollock. Number 7, 1952

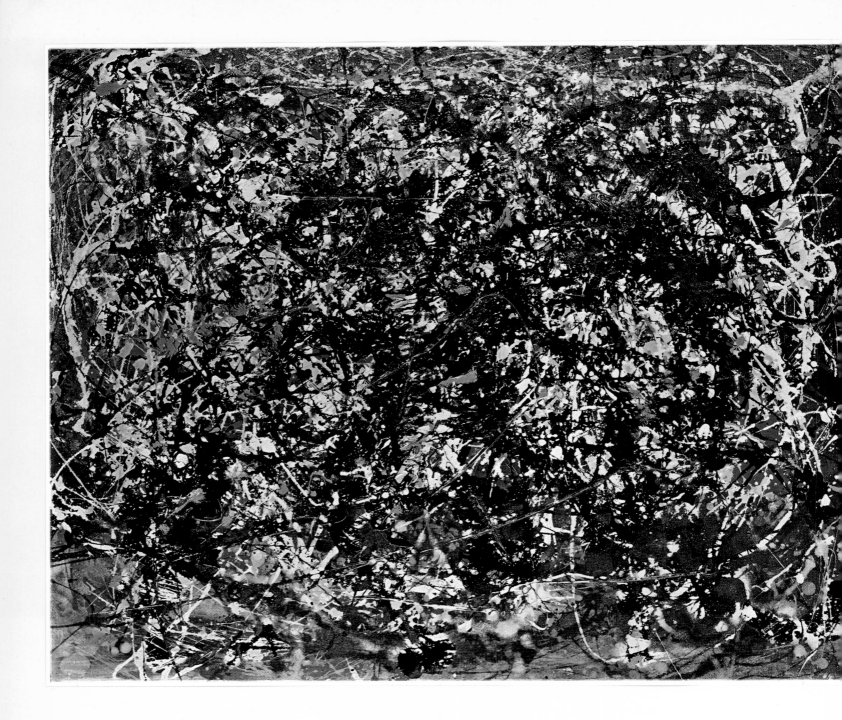

of various colour were applied, the general character and rhythm of the sweeping forms in the different parts of the canvas, the disposition of large blobs, smudges, and area of paint, and so on.

The works were usually very large in size, and when first exhibited seem to have created the impression of uncontrolled violence, like the scribblings one might imagine being performed by a cosmic madman. This impression, like the similar one produced by the early Dada works, appears now to be highly superficial. The paintings, when one sees them today, seem indeed to be strong, with a powerful muscular energy, but, far from being merely aggressive and destructive, they give an impression of poetry and tragedy. The close network of swirling lines seems to create depths of space between them, into which one could wander in many different directions. They are paintings to be looked at, not with a single glance but over a period of time. They can be 'taken' in many senses and in many scales; for instance, 'Autumn rhythm' of 1950 is not only the winter twigs of a forest against the sky, it is not only the veins of a heap of dead leaves whose substance has vanished; it could be the electrons buzzing round the atomic nuclei of a complex molecule, or the stars slithering along their orbits in the galaxy. You can see in it a macrocosm or a microcosm: the landscape of withered grass stems you would see if you lay flat on a winter meadow and looked through the eyes of an ant, the hair of the Virgin Mary falling over the crib of the infant Jesus, the whips of the Fates scourging man through the universe, the smoke billowing from a bonfire of autumn leaves, the interconnection of everything with everything else, the flickering surface of evanescent thoughts just below the threshold of consciousness. You can explore it in a search for whatever you may bring with you to find.

These paintings by Pollock are unlike anything that had been seen before. In some ways perhaps the nearest forerunners of them were the analytical Cubist pictures produced by Picasso and Braque in about 1910 or 1911, but in those, in spite of the multiple facets which crowded one another all over the picture area, there is a ghost, and sometimes something more, of a represented figure; and the lines are usually straight or segments of circles, and lack the flowing melody of Pollock's handiwork. This novelty was the most immediately effective aspect of Pollock's new style. Joined with de Kooning's almost equally radical and in some ways even more shocking innovations, it burst open, for good and all, the fences which were threatening to herd painters into the two camps of the Geometricizers and the Surrealists. It was in these years, from 1945 to 1950, that the new style – or rather a whole series of new styles – of painting found their feet and their self-confidence.

90. De Staël. Drawing (1945–8)

The new look in Europe

In the years during and immediately after the war, movements of a somewhat similar but rather less radical kind had also been taking place in Europe. One of the most influential of the new European painters was a German who worked under the name of Wols (born Schultze). In the early 1930s he spent a period at the Bauhaus but then moved to Paris, where for some time he worked largely as a photographer. He became a friend of Sartre and was profoundly influenced by existentialist philosophy, which advocates the identity of being and becoming, and of existence and activity. These are somewhat Whiteheadian notions but, in continental existential philosophy, are usually put forward with little reference to the scientific world picture. They tend to lead to an insistence on the fundamental importance of an act performed by the whole man in his reaction to the whole cosmos which he experiences. From such a point of view mere visual experiences appear as relatively trivial factors in a total experience, the major part of which is felt as arising spontaneously within the thinking and feeling psyche of the person concerned. Following lines of thought of this general character, Wols was led to produce works which, although consisting of paint applied to canvas, were not intended to be taken merely as visual data. They are rather the record of an activity of pushing paint around. The forms into which the paint is manipulated are certainly not intended to

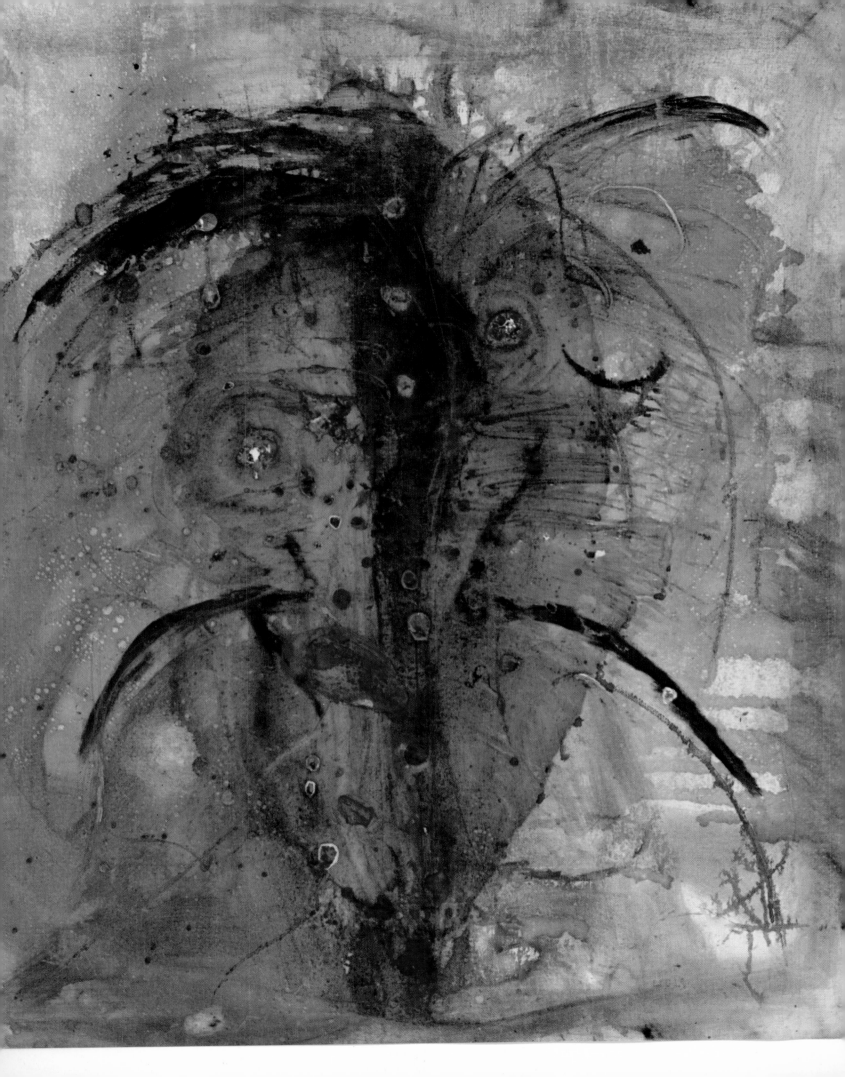

represent anything, or even to appeal by association to images latent within the unconscious mind. They have been decided by a spontaneous and essentially non-referential impulse which arose within the painter at the time he was doing it. Thus Wols, by a rather different route of thought, came to a type of art-work very similar in its essential motivation to that of Jackson Pollock. He also completely 'destroyed the image', being unconcerned with making a picture of anything, but involved instead in carrying out an activity.

The European art of this character is often referred to as Lyrical Abstraction or 'Other Art' (Art Autre[8]). It is often quite appealing, but lacks the characteristics of vigour, power, and confidence of the best American work. Whereas Jackson Pollock's poetic feeling rises to tragedy, that of Wols tends to become muted in alienation and despair. However, Wols must be considered as one of the innovators who liberated European painting to begin the exploration of new territory.

Another important European influence in the late 1940s was Nicolas de Staël. He did not contribute so much to the destruction of the image; in fact most of his works, except for a few years in the middle of his life, were rather straightforwardly figurative, containing representations of immediately recognizable scenes, such as footballers, landscapes, and even such conventional subject matter as nudes. His importance was mainly that his manner of work redirected attention to the interest of paint as a substance. He frequently built up, with one layer over another, thick blocks and areas of solid pigment, often finished off with a stroke of the knife which brings out very strikingly the characteristic oil pigment texture. Again, this European development was more delicate, well mannered, and civilized, and therefore less iconoclastic and renovating, than the corresponding American movements by Hoffmann and de Kooning. But it was a step in the same direction.

Characteristics of the new painting

The spread throughout the world of the new look in painting took place with astonishing rapidity. Within a few years there were groups of painters in all countries, not only of western Europe but in Japan, South America, and even in communist-dominated Poland, whose work clearly belonged in the new rather than the older fashions. The movement did not consist of one single definable school, and it is unprofitable to lump it all together under any of the names that have been suggested. Almost the only thing the painters had in common was freedom from the restrictions of the two major schools of Geometricizers and Surrealists in the immediately preceding years. They used this freedom in very different ways, but there are a number of characteristics, one or other (or in many cases,

several) of which the different painters have developed in a variety of combinations and with many differences of emphasis. Probably the best way to discuss this confused richness of creative activity, and to enquire concerning its relations to scientific culture, is to consider these characteristics in turn, taking appropriate opportunities to discuss the works of particular painters who synthesize many facets of the movement. I find I shall have to consider no fewer than eleven separate characteristics, and some of these under a number of sub-headings.

1. Participation

One of the most widespread and important characteristics of the modern style is the participation of the painter in (or, if you like, with) his painting. He gets 'into' it, working in a sequence of steps, the next being determined in the light of what has been done already. I have already quoted, in Chapter 4 (p. 116), a number of statements by painters on this theme. Here is another one, from Jackson Pollock[9]: 'When I am in my painting, I am not aware of what I am doing. It is only after a sort of "get acquainted" period that I see what I have been about. I have no fears about making changes, destroying the image, etc., because the painting has a life of its own. I try to let it come through. It is only when I lose contact with the painting that the result is a mess. Otherwise there is pure harmony, and easy give and take, and the painting comes out well.'

This participation is a general feature of much recent painting, but it is perhaps not universal. It is doubtful how far one could claim that it is expressed in the work of painters such as Rothko, Morris Louis, or Noland, and it is certainly not relevant to the work of the Pop artists and the others discussed in the next chapter.

As we have already pointed out, this characteristic is fundamentally allied to the Whiteheadian or biological synthesis between the opposing physicists' views about perception, represented on the one side by Heisenberg (in science man confronts himself alone) and on the other by Schrödinger (science attains a reasonably successful world view only because man and mind are totally excluded). This is a major and pervasive way in which recent painting is congruent with the most advanced scientific outlook of today.

2. Integrity

Recent painting at its best is not out to provide kicks. The painter participating in his painting is doing something much more profound than keeping his eyes open for effects which can be developed into the shocking, the chic, or the merely clever. As Motherwell wrote[10]: 'I believe that painters' judgments of painting are first ethical, then aesthetic, aesthetic judgments flowing from an ethical content. . . . Venturesomeness is only

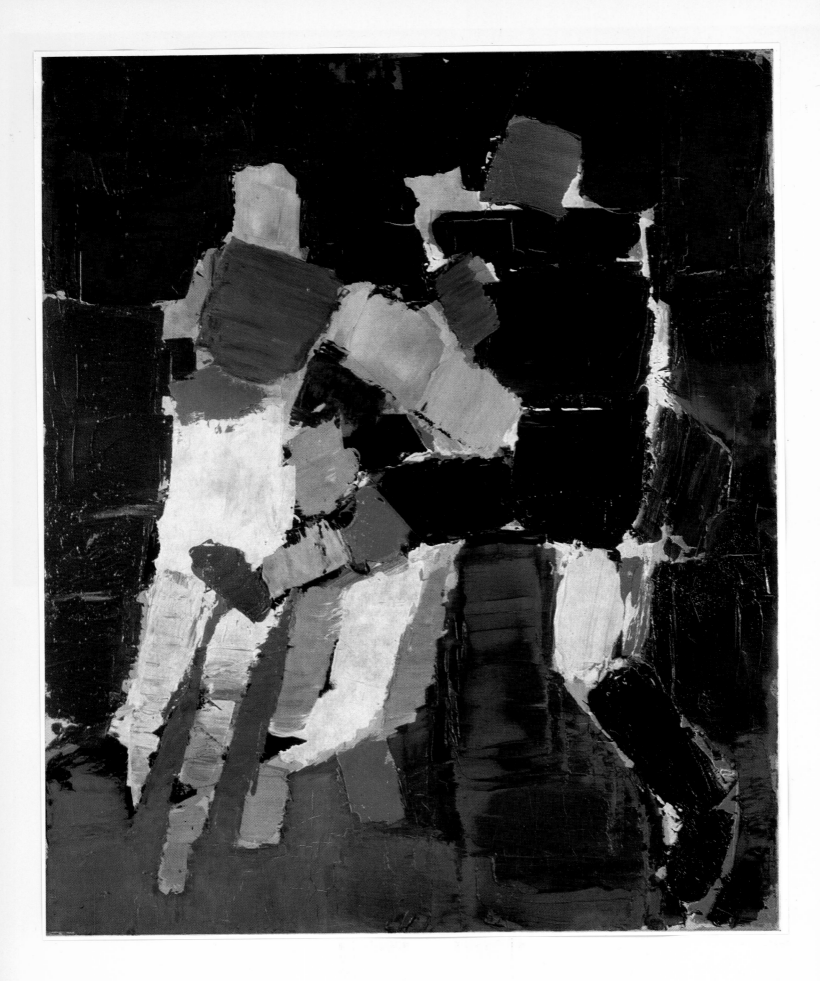

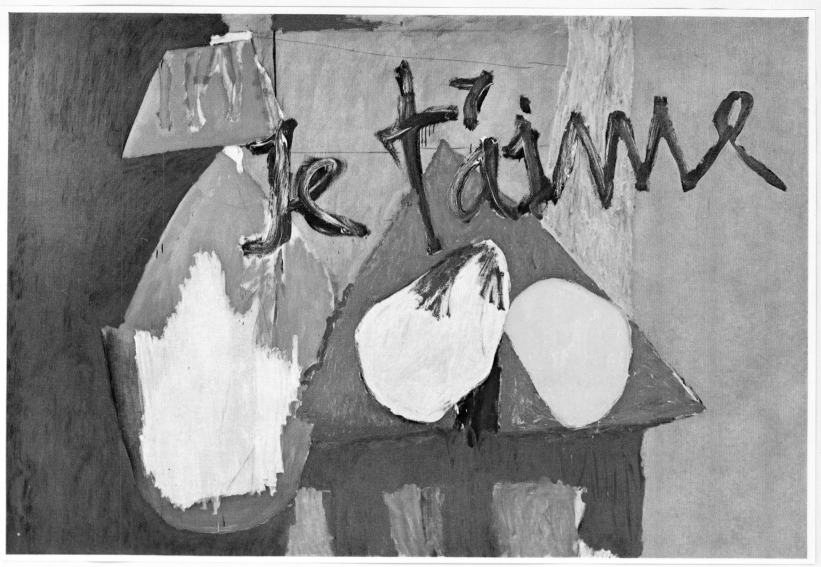

[41] Motherwell. Je t'aime IV (1955/7)

one of the ethical values respected by modern painters. There are many others, integrity, sensuality, sensitivity, knowingness, passion, dedication, sincerity, and so on, which taken all together represent the ethical background of judgment in relation to any given work of modern art.'

It is, to a considerable extent, this 'phobia for the phoney' that leads the majority of modern painters to have a profound mistrust of anything that can be considered figurative. The point has been well put by a British painter, Frank Avray Wilson[11]: 'To build up this kind of highly energetic structure a great verve is essential, and must be maintained and even increased as the work goes on, and this is why continuous destruction is as important as creation, to prevent the crystallization of the image, and it is because of this that the big work is the real test and challenge. . . . The difficulty of keeping up this verve is so great that one finds artists reacting to the cooling in a variety of hysterical, angered ways, but in spite of this, if the drive is not genuine and integrating, there are all the risks of fall-back into some sort of static figuration, either derived from nature or from within the mind, archetypal, anthropomorphic. One finds both these things happening in a painter like de Kooning, in Appel, in Dubuffet, in Jorn, and the very many painters who do not quite make the grade to a synthetic figuration. De Staël reached a near autonomy, but fell back to a weak figuration shortly before his death.'

This is an opinion, one might say, from towards the left end of the spectrum. Not all the leading modern artists would rule out figuration so drastically, but the tendency is undoubtedly in that direction, and largely on the grounds that any recognizable allusion to natural appearances becomes only too easily a way of avoiding the difficult task of performing with complete personal integrity. The painter's attitude is rather like that which would be taken towards the 'prostituting' of mathematics to solve engineering problems by

[40] De Staël. Footballers (1952)

really purist mathematicians such as G. H. Hardy, who wrote[12]: '. . . The point which is important to us now is this, that there is one thing at any rate of which pure geometries are *not* pictures, and that is the spatio-temporal reality of the physical world. . . . There is no mathematician so pure that he feels no interest at all in the physical world; but, in so far as he succumbs to this temptation, he will be abandoning his purely mathematical position. . . . It is the dull and elementary parts of applied mathematics, as it is the dull and elementary parts of pure mathematics, that work for good or ill. . . . There are then two mathematics. There is the real mathematics of the real mathematicians, and there is what I will call the "trivial" mathematics, for want of a better word. The trivial mathematics would appeal to Hogben, or other writers of his school, but there is no defence for the real mathematics, which must be justified as art if it can be justified at all.' Substitute 'painting' for 'mathematics' in Hardy's remarks and you have a fairly good summary of this particular tonality of feeling among modern artists.

3. The whole man in depth

The participation which the modern painter aims at is not merely one which operates at the level of the conscious mind. On the other hand, the novelty has worn off the idea of the official unconscious as propounded by doctrinaire Freudian psycho-analysis. Recent painters have outgrown any exaggerated respect for purely automatic techniques 'arising from the depths of the Freudian (or Jungian) unconscious', and train a rather cold eye on such gimmicky notions as the 'paranoic-critical' method which Salvador Dali had some difficulty in having taken seriously even in the heyday of Surrealist enthusiasm. But they do certainly realize that the consciously realizable, let alone the verbally expressible, facets of the human personality are only, to use the standard cliché, the parts of the iceberg that stick into the air. Below the surface there is not only the whole throng of myths, symbols, dream figures, and so on, to which Freud and Jung drew attention, but there is also a large and mainly unexplored range of neurological and muscular co-ordinating mechanisms which are quite crucial for the way the brush or knife actually transfers the pigment to the canvas, and, as the Op school emphasize, for the way in which the eye and brain perceive the result.

The modern artist is not at all a doctrinaire psycho-analyst, as the Surrealist tended to be, but he definitely feels himself as something much more heterogeneous and complex than a disembodied conscious intelligence. There is an interesting statement which expresses this rather well by Jack Tworkov[13]: 'I didn't want my statement, that I don't think when I paint, somehow or other to be taken as a kind of pose or to signify a kind of mindlessness when I am painting. I simply mean that when you are involved in doing, you are not at that moment involved in thought processes. And we all know that we can't make a painting by thinking any more than you can skate by first thinking it out and then doing it. But I am a sort of a thinking artist. I am not for the mindless artist.'

The artist is in fact trying to summon to the aid of his painting personality the forces and tendencies lying below the threshold of consciousness, of which the scientists quoted by Hadamard speak (see p. 103). They are inviting us to discover, in looking at a painting, a record of an act of creation which has the same character, though a very different end result, as a piece of creative scientific imagination.

4. Gesture and calligraphy

One of the important methods for ensuring participation by the whole man has been the development of techniques emphasizing the laying on of pigment by means of broadly executed gestures rather than in small spots and flecks. 'The line', as Avray Wilson has said,[14] 'is never used to define shape and form as in traditional painting and drawing. It now symbolizes energy, and is entirely calligraphic.' To some extent indeed this factor in modern painting derives from a recrudescence of interest in oriental art, where for centuries an artist's handwriting in producing the relatively complicated ideographs of Chinese and Japanese script has been an important method of expression.

One of the first recent Western artists to develop a calligraphic style was Mark Tobey, who lived on the Pacific coast of the United States and had some contact with oriental painters. However, the influence of Asian modes of painting and thought is perhaps not so direct on Tobey as might be thought at first sight. Tobey is a highly intellectual painter with a consciously held philosophy, but originally his philosophical beliefs were derived from the Middle Eastern doctrines of Baha'i and it was only later that he came to take an interest in Zen Buddhism. Tobey once said[15]: 'Baha'i found me and later I found Zen.'

The basic belief of Baha'i is an ultimate unity underlying the appearances of the immediate world. William C. Seitz[16] has written: 'The belief in an ultimate unity — visualized as a central focus or enclosing sphere, conceived as a common underlying substance as in early Greek monism or modern physics, known through an irrefutable experience as in mystical religion, or derived from a universal principle as in Buddhism — underlines a great body of human speculation. Few religions however, have given the concept of *oneness* such pointed emphasis, and a few modern artists have dealt with it as explicitly as has Tobey.'

One of the methods which Tobey used in his early paintings to emphasize the interpenetration and interconnection of things was the employment of white or light-coloured meandering lines,

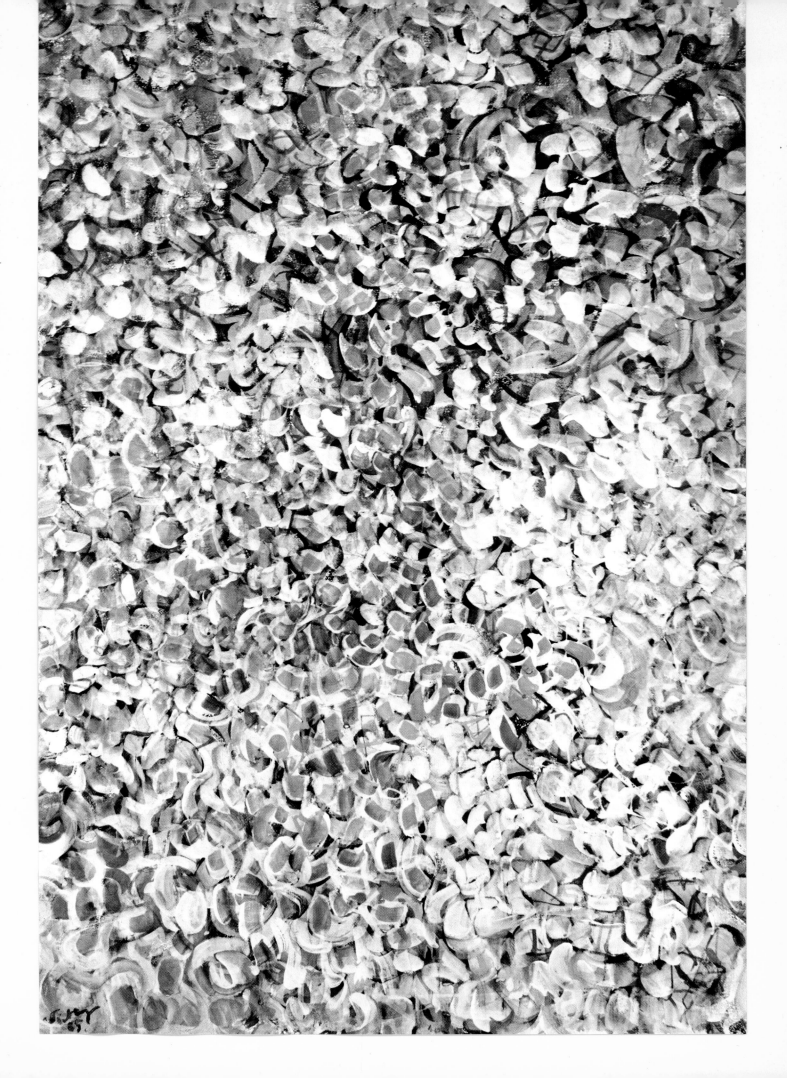

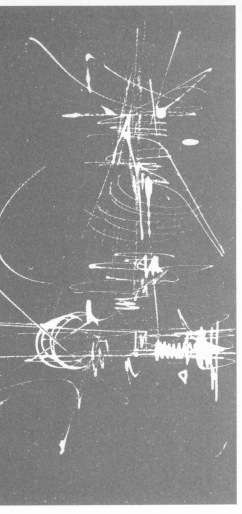

91. *Mathieu, painting*

which carry a suggestion of rays of light penetrating into the recesses of structure, such as streets or buildings, which at that time were sometimes represented rather directly on Tobey's canvases. He had therefore developed something of a linear style before coming into direct contact with Oriental calligraphy. However, there is no doubt that later on the Oriental influence was strong, not only on Tobey but on many other painters. Another influence was that of Klee, who developed a dancing, symbolizing, highly personal linear style in the 1930s.

Pollock's method of dripped paint was also one depending on gesture – the gesture of swinging a can from which the paint was flowing. Of later painters, perhaps the most extreme exponents of linear calligraphic styles have been some in France, such as Mathieu, Degottex, Hartung and some others. Mathieu, in particular, has emphasized that one of the main aims of his style is to enable him to paint in a way in which action is completely unimpeded by second thoughts or hesitations while it is being performed. Oriental

152

a

b

calligraphers have developed methods, depending either on long periods of meditation or a somewhat more simple-minded reliance on alcohol, to get themselves into a frame of mind in which paint strokes flow out of them without hindrance. Most of the Western painters rely on speed, after a period of germination which may amount almost to a meditative exercise comparable to that of the Oriental mystics. They carry out the actual painting so fast – or at least each individual stroke is performed so fast – that second thoughts do not have time to arise. Mathieu has listed what seem to him the three characteristic features of this painting[17]: '1, First and foremost, speed in execution. 2, Absence of premeditation, either in form or movement. 3, The necessity for a subliminal state of concentration.' The last of these he characterizes further as 'a concentration of psychic images at the same time as a state of utter vacuity'. This is like Cage's remark, 'Keep the head alert but empty.'

Mathieu's characteristic line is thin and wiry, with a look of the 'scientific age' in its reminiscences of spring steel, or of orbits or trajectories defined by the dynamic equilibrium of powerful forces. It is very attractive at first sight, but perhaps appears a little thin or overdramatized after a longer acquaintance. There are other painters, equally or more in contact with science, who use calligraphic marks of quite a different kind. One of the most interesting is that remarkable person, Alcopley. He is not only an artist 'of good standing' – one of the founder members of 'The Club', which was the rendezvous of the breakthrough New York painters, a friend of Jackson Pollock, de Kooning and the rest, and critically discussed by such pundits as Will Grohmann – but also, and simultaneously, Dr A. L. Copley, a physiologist and expert on capillary blood flow, of international reputation in the scientific world. His artistic productions are quite diverse. Some are paintings, usually done with large flowing brush-strokes, and sometimes reminiscent of such laboratory artefacts as chromatograms. He is also very prolific in producing abstract drawings in black and white, using dancing, sensitive brush-drawn lines on absorbent paper.

As one of the very few people who can claim considerable standing as an executor in the fields of both painting and science, his views on the relations between these two types of activity are bound to be interesting, although I am not fully in agreement with them.

In his few writings about his work, Alcopley emphasizes both the distinctness and the connectedness of science and art. 'My reasons for separating my artistic from my scientific activities are that I am fully aware of their separateness as intellectual disciplines, and of their entirely different approaches to the world, the former relating to the metaphysical, while the latter deals with physical matters. . . . To me, a scientific truth, irrespective

of how well it may be established, is alterable, not infinite, and is derived from processes of uncovering phenomena of nature and from attempts to explain them. The artistic truth appears unalterable and belongs to the world of the absolute.'[18] But he also says: 'Emphatically, I say yes to science, and yes to art. . . Actually, that some connection of these two worlds is conceivable, can only be true to me in the realm of my own experience.' And elsewhere[19] he explains how his scientific experience forms a deeply buried bedrock from which some of his artistic experiences grow: 'The drawings entitled "Structures of Signs" . . . are composed by using lines which, in their course, are assembled to signs. I suppose they spring from my personal experience of nature and the special phenomena with which I am concerned in my scientific work. For more than three decades I have

92. (On facing page and below) *Alcopley, drawings*

c

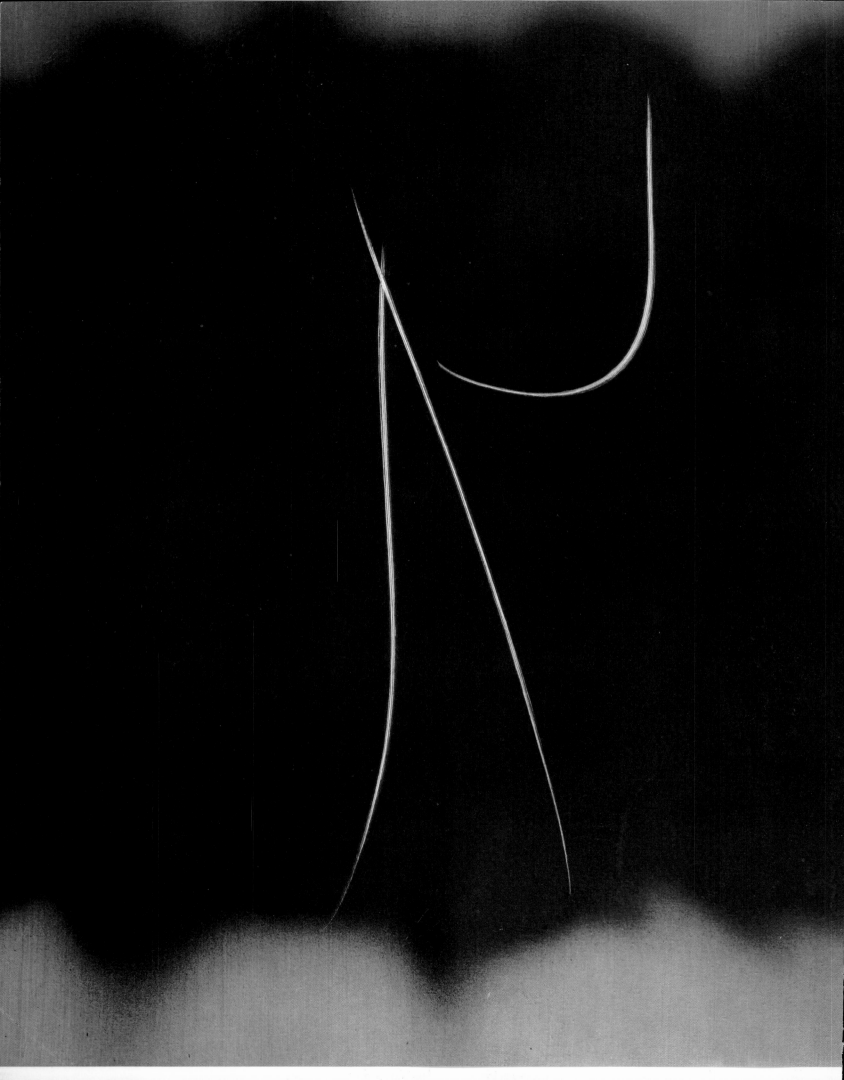

been an experimental biologist and therefore have lived in a world of the smallest natural phenomena.' For the benefit of non-biologists, one may interpolate that there is, in Figure 92c, a suggestion of the building up of a metaphase plate on a spindle, and in 92a some hint at an information-carrying DNA helix and the condensation of lampbrush chromosomes. 'At the same time I have tried, by the continuous practice of drawing, to catch some of their aesthetic and expressive values until finally the setting of lines crystallized into signs. They correspond to certain thoughts which I can only express in the movements of these lines. I included the . . . "structures of signs" in this volume to express the kinds of ideas for which, I suppose, only poets and thinkers could find adequate words.'

A very similar point of view was expressed by the French calligraphic painter Hans Hartung. In an interview with Georges Charbonnier[20] the latter pointed out that on looking at Hartung's pictures one thinks immediately of such things as trajectories of particles, Brownian movement, hyperbolas, etc.; and he asked whether Hartung felt himself particularly influenced by such notions.

Hartung replied : 'I believe that, in a very general fashion, we are today much more influenced by certain theories of physics than we were in the past. We have learnt so much about the atom, in the last ten years. No one can escape. . . . But I have a horror of people who try to depict astronomical or physical facts, that's a new kind of representation which hasn't any sense. If these things penetrate into your spirit, if they take part in the formation of your thought, well and good. But if anyone sets himself to paint the microbes he sees down the microscope — he would do better to paint the pretty girls in Montparnasse or Montmartre.'

This is, of course, just what I have been arguing in this book. The scientist does not go to the painter for a representation of scientific objects, but for the enrichment and deepening of his consciousness, which comes when he finds a painter in whom the climate of scientific thought has penetrated into the spirit, leading to the production of works in which some of the deeper, less easily expressible, features of the scientific outlook are 'shown forth'.

93. Kline. White forms (1953)

155

[43] Hartung. Peinture (1963)

One of the most important American calligraphic painters, indeed one who has some claim to be amongst the original pioneering group of modern painting, is Franz Kline. His pictures are large, often reduced to black and white, the black being laid on in broad, bold, more or less straight strokes, which show the traces of the brush or other implement by which it was applied. Elaine de Kooning has written of these paintings [21]: 'The tough masculine thrust present in every scraped surface and bruising brush stroke reveals nothing of theory or dogma. . . . Stark and instantaneous in effect, Kline's compositions are not at rest, their balance is not classically internal. Each picture directs its energy outward, but never explosively. . . . One feels in the spreading black shapes a curious sense of threat. Forthrightness seems carried to the point of brutality. . . . The artist himself however sees these

94. Kline. Cardinal (1953)

[44] Soulages. Peinture (1963)

structures as personages – not menacing ones but playful or gentle or lost – and his interpretations are as logical as anyone's.'

It is interesting to compare the works of Kline with those of a European painter who also works primarily in broad strokes of black – Soulages. Soulages' compositions are as forthright – that is to say uncomplicated by afterthoughts – as Kline's but their structure is much more balanced and harmonious. They remind one more of a classical period of Chinese calligraphy than the wilder styles of Japanese handwriting. They are strong but lack the violent energy of the American.

There is a whole other style of calligraphic painting in which the individual strokes are relatively small and there are many of them scattered over the whole area of the canvas. Mark Tobey is only one of a considerable group of artists who use squiggly, totally non-geometrical calligraphic signs to cover the whole surface of a painting or drawing. One of the most striking of these is Michaux, a poet who has made an extensive series of drawings, though fewer paintings. Michaux has explored the psychological effects of some of the hallucinogenic drugs, such as mescalin. Some, but by no means all, of his drawings have been done under the influence of this drug. Rather surprisingly, the mescalin drawings seem, on the whole, rather less free and uninhibited than some done without artificial aids towards a state of trance. Many of them, in fact, resemble somewhat imaginative sketches of invertebrate animals, such as polychaete worms, centipedes, and so on; some others, and more of those produced without drugs, approach the portrayals of the 'surface of the unconscious' which we shall discuss later.

There is a peculiar affinity, but also an important difference, between the experimental scientist and the painter in their experience of coaxing parts of the material world – paint, canvas, stone, or ultramicrotomes, bubble-chambers or simple hypochondriac embryos – to do what they want them to do. Painters and laboratory scientists have to recognize and respect the 'green-finger' ability of some people to pull things off when others just make a mess. The difference between the can-do's and the can't-do's is hardly at all affected by the introduction into the lab of a whole range of automated processing equipment, with data-read-out in digitalized form on magnetic tape, and what have you; or turning over in the studio from linseed oil, turps and oil paints to Duco, acrylics, and silk-screen processes. In the literary world there are, it may be conceded, somewhat similar differences in hitting it off; as Auden wrote[22]:

> Time that is intolerant
> Of the brave and innocent,
> And indifferent in a week
> To a beautiful physique,

> Worships language and forgives
> Everyone by whom it lives;
> Pardons cowardice, conceit,
> Lays its honours at their feet.

> Time with this strange excuse
> Pardoned Kipling and his views,
> And will pardon Paul Claudel,
> Pardons him for writing well.

But the affinity between technical mastery in painting and in laboratory work is much closer than between either of them and 'writing well'. All three, including writing like an angel, depend mainly on non-conscious mental processes; but outstanding execution in scientific experimentation and painting have in common a dependance on ability – probably ultimately muscular – to handle the physical stuff of the world in a way which is not at all demanded by literary composition. The values which some modern painters see in calligraphy are already part of the scientific ethos, but have little connection with the living experience of European writers, especially if they have abandoned the pen for the typewriter or dictaphone.

In science, the ability which corresponds to calligraphic excellence in painting is never regarded as sufficient in itself. It is not enough to be able to carry out some difficult measurement with impressive precision and repeatability, if what is measured is inherently of no particular interest. 'Time that is intolerant' of this and that, as Auden said, does not just pardon the superb experimentalist and his views, because he does it well. A scientist cannot get away with only the non-conscious, mindless ability to perform excellently; he, or at least the scientific community of which he is a part, has also to think out, by hard intellectual cogitation, which problems are worth tackling.

5. The rôle of chance

The gestures of calligraphic painting are not consciously determined actions, but they do not usually allow much of a rôle for purely chance happenings, any more than does the action of serving the ball at tennis or making a turn in skiing. The introduction of chance events into the production of a painting involves something more than the suspension of conscious thought processes in deciding what should be done next. It requires that the painter takes some technical step which makes the occurrence of chance processes likely. He may, for instance, paint with the very liquid paint which is allowed to trickle down the surface of the canvas or to soak into its substance in uncontrolled ways. He may apply the paint by throwing or flicking it so that it splashes, or he may blot it, or squash lumps of it on to the surface. A whole variety of techniques are possible, the essential feature being that the result produced cannot be precisely foretold or controlled.

A great many modern painters make use of methods of this kind. The impulse to do so is clearly connected with a view that the structure of the universe is not so fundamentally deterministic as had previously been thought. This view, in turn, clearly derives from the new indeterministic quantum-mechanical theories of physics, and the recognition of the importance of random processes in biology. The tendency has been reinforced by an interest in other cultures which have also considered the world to be non-deterministic and have also employed chance elements in their painting. The most influential of these has been Zen Buddhism. It seems fairly clear, however, that unless the older European sense of determinism had been undermined by the advances of science in the first few decades of this century, the non-deterministic currents of oriental thought would scarcely have made the appeal to Western intellectuals that they have come to have in the last few years.

The first painters in recent Western history to use chance processes were early Dadaists such as Arp and Picabia. Arp had certainly already arrived at the notion that the fundamental structure of the material universe involves an element of chance (see p. 75), but he, to some extent (and the other Dadaists probably much more), were also intending to express a derisory contempt for conventional rationality. When Picabia produces a drawing consisting of a splash of ink and gives it the title *La sainte vierge* (p. 72), this is not a serious comment on the nature of fundamental causal processes but a squirt of a water-pistol in the face of orthodoxy. (It is interesting to note that several rejected alternatives of this work exist[23] — just any ink-splash wouldn't do). But it is essentially only in the post-war period that the use of stochastic processes in the production of paintings has been accepted as an element in a perfectly serious and not at all flippant technique. It is one of the clearest and most far-reaching influences of recent scientific thought on the practice of art.

It hardly needs saying that chance processes alone are never sufficient to produce a work more profound than any of the imprecisely determined natural appearances by which we are surrounded — stains, blots, areas of fading, dried-up puddles, and so on. Even the exertion of great quantities of what painters refer to as 'post-creative selection' cannot salvage from purely chance productions more than a few happy accidents. Chance is primarily valuable as one component of a painting technique which also involves elements of control.

It is not clear how far painters realize the connection between their practice in employing stochastic procedures and the outlook of biology on the rôle of chance. As we have seen (p. 107), the chance process of mutation is an essential ingredient in the major biological process, that of evolution. It is the only source from which true novelty

can be derived, and without it evolution could be no more than a series of reshufflings. But in evolution chance mutation is subject to control of at least two kinds. In the first place, the developmental system of the organism in which the mutation occurs will limit to some extent the degree and manner in which the new hereditary potentiality is expressed. Then, and more importantly, the general conditions of life will influence the number of offspring left by the bearer of the mutation, and thus the extent to which its occurrence affects later generations. One might compare the developmental control to the conditions of the painter's technique: does he use very runny paint, which can trickle freely and far, or thicker paste, not so likely to spread? The natural selective control is like that which the painter exercises in the later stages of the painting. Does he obliterate some or all of the drippings and splashes, or does he accept them as indications of what might be done next to utilize

95. Michaux, drawing

159

them? To a painter, they are of course only one of the factors in creation, the main other one being his own voluntary actions; in biological evolution chance processes are the *only* source of novelty. This is a difference; but there is the great similarity that both in biology and in painting chance is to a greater or less extent a creative element, not a mere source of uncertainty and confusion. And it is precisely 'the connection between probability and the logic of relations which', Goodall[24] has said, 'may be regarded as the one central theme of Third Science'.

6. All-overness

One of the features of recent painting, which is likely to seem particularly striking to those used to the older traditions, is that forms and colours are often spread more or less evenly over the whole picture surface, filling it up right to the edges, with little grouping into special foci of interest standing out against a background. This, though not an absolutely universal feature is a very general one. It is also relatively new, although it has some older roots. Possibly its origins are to be found in one of the first influences of scientific technology on painting — the influence of the photograph. In the later part of the nineteenth century painters such as Degas began using compositions in which the picture-frame isolated what was clearly part of a larger scene, cutting off for instance one arm of a figure or one part of an item of furniture in a manner immediately reminiscent of amateur snapshots. This both suggested that the picture could extend indefinitely on all sides of the part of the scene which happened to be within the frame; and it also began the liberation of the composition from the previously conventional dependence on a particular focus.

There are also more closely connected historical roots, particularly in works carried out towards the end of the last century (or even by Turner considerably earlier). The later paintings of Monet, such as his series of Cathedrals and Waterlilies, consist of un-outlined patches, wisps, and flecks of paint, spread over the whole canvas and not building up to any particular focus. Seurat, and others of the pointillist school, used a technique of small separate spots of colour which got rid of any definite outlines. Although Monet and Seurat were attempting something quite different from the intentions of the recent painters — they were exploring sensations of the colour and space of external nature — their canvases and the paint on them are very clearly related to the works of painters such as Guston, Pollock, and Tobey.

In the intermediate period some of the landscape drawings of van Gogh, of gardens or cornfields, have almost the same all-over quality and add to it the calligraphic element in a form very like that of Tobey; and Klee is another obvious contributor. But, as has been pointed out, the purpose of this book is not to discuss historical derivations within the world of painting, but to try to discern what connections there are between recent paintings and contemporary science.

It is the two characteristics, of an even, all-over distribution of interest and a sense of potential extension outside the frame, that make up the 'all-overness' which has become so important in recent years. In fact, the extension beyond the frame has developed even more thoroughly, since, in many recent pictures of this kind, one almost loses the notion of there being a frame at all other than as a mere material device for making it possible to hang the object on the wall. The effect can be produced even in quite small works, such as the drawings of Michaux. A special method of emphasizing the effect has been used particularly by American painters. This is to produce canvases of enormous area, the size of a wall of a good-sized room, and to ensure that they are looked at from fairly close. The spectator is then, as it were, engulfed into the work of art. He cannot see the whole of it simultaneously in sharp focus, and much of it is only apparent to his peripheral vision, which does not recognize a sharp outer boundary. It is a method which, considered as a sheer technical device, is probably influenced by wide-screen cinemascope movie-projection methods. It has, however, a more than technical significance, as one of the aspects of the general factor of all-overness.

This factor is not at all a simple one. It has implications of many different kinds, several of them quite closely related to scientific thought. It will therefore be considered under five sub-heads:

(a) *The everywhere-dense continuum of events.* In one of its aspects all-overness is a recognition that something — Whiteheadian events, electromagnetic vibrations — is going on everywhere all the time. Tobey is quite specific about this.[25] 'Scientists say that . . . there is no such thing as empty space. It's all loaded with life. We know it to be teeming with electrical energy, potential sights, and silent sounds, spores, seeds, and God knows what all.' Thus, when he entitles a picture *Universal Field*, he means by 'field' something not at all far away from what a physicist might mean by that word.

All-overness is in fact the painter's recognition of the final breakdown of 'billiard ball' atomic theories and his recognition of the wave mechanical picture. The point can be illustrated quite specifically in the words of a practising painter, Avray Wilson[26]: 'If one were to teach painting to a scientist of the old order, a biologist dealing with organs or a physicist believing in eternal chunks of matter, one would have recourse to traditional technique. To paint a cluster of bones, of organs, of crystals, one would adopt much the same approach and technique as in painting a bowl of apples, for one is still dealing with a concrete world, a realm of fixed and static quantities and shapes. Even in the

[45] Tobey. Electric dimensions (1960)

penetrations of the electron microscope, one finds shadows cast which are identical with the shadows cast by objects in the ordinary world of visual experience. But as soon as one passes to the dynamic happenings of the new physics, of the new chemistry and biology, one is faced with a movement and pulsation, with a perpetual alteration and precariousness, for the portrayal of which the traditional techniques of painting are quite useless. Indeed, as one strives to catch such phenomena by the traditional approaches of observation and exact rendering, one misses their essen- tial quality, and to use various illusional devices to give the impression of movement and pulsation, like the strokes of movement along a racing car, is a subtle form of traditional trickery and cheating. The only way to illustrate such dynamic pheno- mena is, in fact, to have recourse to the quite new techniques of painting, mostly learnt from the action painters and abstract expressionists and the practitioners of the other valid imageries. For instance, action paintings can naturally resemble the exciting photographs of particle tracks and smashed atomic nuclei, the fields of force made

162

97. Crippa. Simbolismo vibrato (1951)

evident in paracrystalline structures, the throbbing microstructures within cells, and so on. If a scientist was taught painting to serve his own fields of observation and experience it would be with such techniques, and from this the doors to a truly modern art would be as naturally opened.'

Avray Wilson is not the only one of those intimately concerned with modern painting who refer to new developments in physics and mathematics. Mathieu[27] has published quite a long discussion of recent developments in scientific thought, reaching the conclusion that 'the definitive bankruptcy of Aristotelian rationality has thus spread to mathematics, physics, and biology'. In another article he refers to a number of mathematicians, physicists, and philosophers, but says that, although there is definitely a connection between his painting and modern scientific theory, this ari-

ses simply because he lives in the Atomic Age. He claims that the fact that he is interested in, and knows a little about, some technical fields of science has no direct influence on his work. In view of its extremely calligraphic character, Mathieu's painting is, in fact, probably little affected by his scientific reading.

The French critic Tapié, who quotes exactly the same mathematicians as Mathieu, has written somewhat grandiosely and vaguely[28] of painters exploring rhythms based on transfinite and hypercomplex numbers and the topological concept of neighbourhoods. This is setting rather high sights for the painter's understanding of modern mathematics, but is perhaps not without some trace of justification. Modern painters have, in fact, shown themselves considerably more interested in three-dimensional than in linear two-dimensional

163

rhythms. Moreover, they appear relatively uninterested in the analytically simple curves, symmetries, and periodicities employed by the geometricizers in the 1930s, and more attracted to the irregular or asymmetrical forms which tend to be generated by 'non-linear' equations. Scientists, perhaps particularly biologists, have known for a long time that many of the most interesting processes must be expressed in mathematical forms of this kind, but it is only with the advent of computers that such systems have become possible to handle and the curves they generate explored. In this rather general sense, of a vague awareness of the character of Third Science, and almost certainly not in the sense of a conscious use of mathematical refinements like complex numbers and topological neighbourhoods, there is a recognizable relationship between some of the characteristics of modern forms and recent scientific thought.

(b) *Chaos*. All-overness may also be a way of expressing a sense of chaotic disorder and therefore a means of protest against a world which has gone haywire. This implication is, however, not usually very strong. It was certainly present in Jackson Pollock and some of the other American painters who wished to protest passionately and violently against the orthodox conventions of the society in which they lived, as did the Dadaists before them. In Pollock also this sense of chaos was reinforced by his deep feeling of tragedy. This arose partly from the times in which he was working – the period when the first atom bombs burst on the world and were followed by the Cold War. I shall not attempt to follow here all the effects of the threat of annihilation on painting, since this book is concerned with the relation between art and our picture of the material world, not with its involvement with society in general. Pollock's sense of tragedy, however, seems to go much deeper than a reaction to a particular bad patch in history. It is a response to the human predicament in general rather than to the Cold War in particular.

(c) *Order arising out of chaos*. The use of all-over irregular patterns and textures can be regarded as following Leonardo's advice[29]: 'I shall not refrain from including among these precepts a new and speculative idea, which although it may seem trivial and almost laughable, is none the less of great value in quickening the spirit of invention. It is this: that you should look at certain walls stained with damp or at stones of uneven colour. If you have to invent some setting you will be able to see in these the likeness of divine landscapes, adorned with mountains, ruins, rocks, woods, great plains, hills, and valleys in great variety; and then again you will see there battles and strange figures in violent action, expressions of faces and clothes and an infinity of things which you will be able to reduce to their complete and proper forms. In such walls the same thing happens as in the sound of bells, in whose strokes you may find every named word which you can imagine.'

The most recent painters, however, do not attempt to draw out of the original visual mess any clear and defined image. They leave their painting in the form of 'a wall stained with damp' rather than seizing on some suggestion and 'reducing it to its complete and proper form'. This is, as we have seen, at least partly for the sake of preserving an unsullied integrity. Those painters who do conjure recognizable forms out of a haphazard background, such as Dubuffet, are ones who are strongly affected by others of the many factors involved in modern painting (see p. 169).

(d) *Portrait of the subliminal*. Although these painters show little interest in the faces, figures, or other images that one can see in a confused mass of colours and lines, many of them tend to be fascinated by a somewhat allied topic – the processes by which defined ideas may 'jell' out of the turmoil of the unconscious mind. Many of Tobey's all-over paintings, for instance, suggest what one might call, in rather mixed metaphors, a seething mass of rays of light, or in other cases a buzzing galaxy of differently coloured meteors or stars, and from out of or within this assemblage of small strokes and dots of pigment vague suggestions of ghostly forms sometimes build themselves up for the observing eye and as quickly vanish again. In his picture 'Universal City', for instance, one can from time to time almost, but never quite, catch a glimpse of the canyon of a New York street, reminiscent of those which he had depicted more realistically some years before in his painting 'Broadway'. These adumbrations of forms are evanescent almost to the point of non-existence. The point is certainly not simply to start with a mess and make something of it. It is much more to convey something of the character which is felt to belong to the helter-skelter of mental events that are going on just below the level of our consciousness.

One of the painters in which this aspect of modern painting has been most fully developed is Sam Francis, an American living in Paris. His paintings, usually rather large in area, frequently consist of a large number of closely packed, roughly round or ovoid patches, predominantly of one colour. The pigment is put on very wet, and allowed to dribble down the surface of the canvas so that the separate blocks of colour, each of which has a soft, rather blurry edge, are also united with one another in a network of thin trickles of paint. The pictures offer very little suggestion of recognizable objects. Their beauty is in their colour, but they have no more form than a gently stirring cloud. Herbert Read[30] applies to them an expression from a fourteenth-century mystical treatise, *The Cloud of Unknowing*, and quotes Shelley, who says that the poet draws his inspiration from a shifting cosmic panorama, from a 'boundless element' through which forms voyage 'cloud-like and unpent'.

[46] Tobey. Capricorne (1957)

165

M

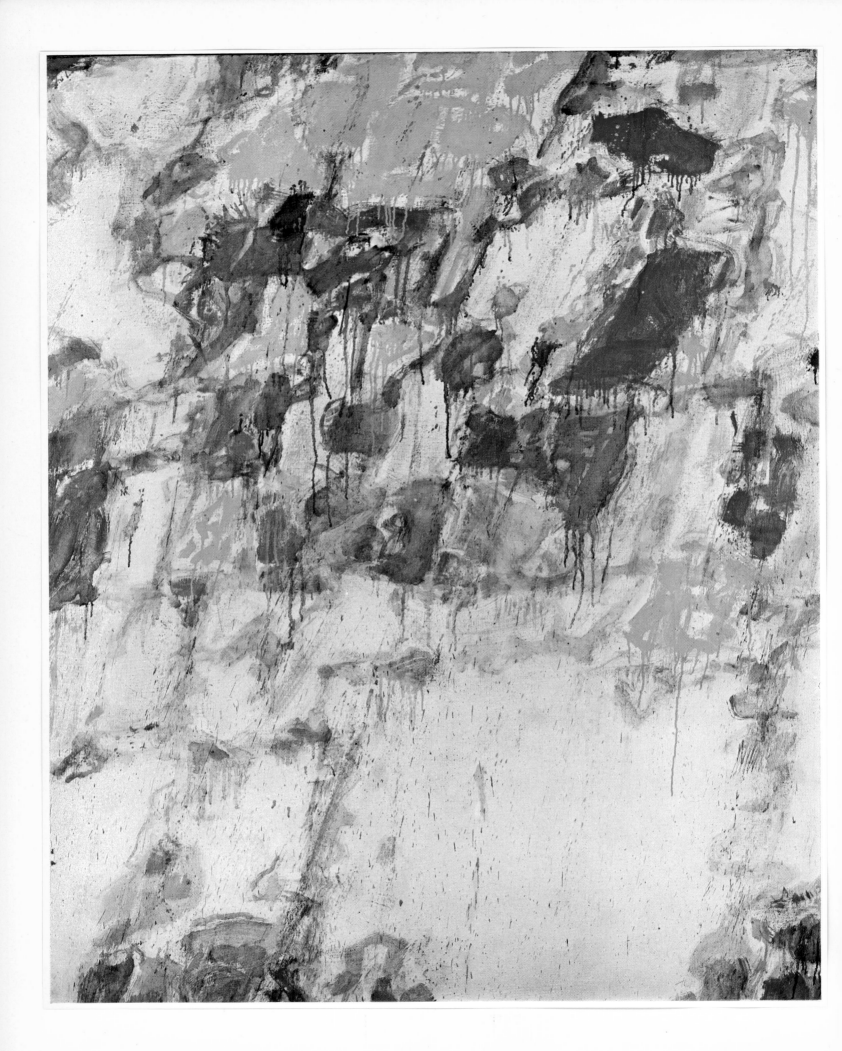

Sam Francis's paintings can be regarded, if we wish, as portraits of the surface of the unconscious mind. Sam Francis himself has written about them[31] : 'What we want is to make something that fills utterly the sight, and can't be used to make life only bearable; if painting till now was a way of making bearable the sight of the unbearable, the visible sumptuous, then let's now strip away all that.' But his more positive comments on what is achieved after this stripping are cryptic and given in a poetic language in which one is free to see many meanings. 'Do you still lie dreaming under that huge canvas? Complete vision abandons the three-times divided soul and its neighbours; it is the cloud come over the inland sea. You can't interpret the dream of the canvas, for this dream is at the end of the Hunt on the Heavenly Mountain — where nothing remains but the Phoenix caught in the midst of lovely Blueness.' According to Herbert Read, Francis himself does not consider that he is exploring a world within himself but rather his 'awareness is directed not inwardly, towards the self, but outwardly, towards a source from which proceeds the primary substances of light and colour, the formless forms of a sensuous reality in a state of becoming.'[32]

Whether we interpret it as inside or outside the self, the world which Francis is painting reflects some sort of mystic continuum out of which no definite presences have yet emerged. To a biologist like myself they carry another, much more everyday suggestion which, however, is not entirely incongruent with a more mystical interpretation of them. They remind one strongly of what one sees down a microscope when controlling the staining of a histological section. In many staining procedures, which are carried out in order to make more visible the details of the structure of a preparation, one first overstains the slide with a mixture of brilliantly coloured dyes — safranin, gentian violet, and so on — and then washes out the excess dye with alcohol or some other solvent. Watching the process so as to stop it at the precise moment, when just enough of the various colours is left to differentiate as fully as possible the different structures of the cells, one sees the image of the final preparation gradually clarifying and becoming firmer as the excessive obliterating colouration is washed

98. *Dubuffet, lithograph in black*

167

[47] *Sam Francis. Composition (1957)*

99. Dubuffet. Paysage au chien mort (1952)

away, flowing off the slide in trickles and streaks; it is, on a microscopic scale, extremely reminiscent of one of Francis's paintings.

Another artist who has produced many 'pictures of the unconscious' is Jean Dubuffet. He arrived at them as a development from a series of landscapes. These were carried out in an unusual technique, consisting of a high relief, composed of thick paint to which various substances such as clay, sand, and so on had been added, and the whole surface worked on, incised, squeezed into prominences, or grooved and hollowed out. Dubuffet first explains[33] that he intends these landscapes to be ambiguous in scale, since 'the forms living matter has a liking for are everywhere the same, whether it is a question of quite tiny objects or great geographical formations. In this spirit I liked, in these landscapes, to scramble the scale, in such a manner that it would be uncertain whether the picture represents a vast range of mountains or a minute parcel of earth.'

He goes on to say[34] that another ambiguity be-

gan appearing in the pictures. The experiments (very numerous) which I made in connection with these paintings sometimes led to bizarre effects, in which the false was mixed up with the true, and the landscape took on an absurd appearance, suggesting, more than any real place or true natural material, some sort of aborted or incomplete creation, such as might have been produced by a magician suffering from fatigue. Thus the very strange was combined in the same canvas with the very real and concrete, and many forms appeared whose character was ambiguous; they could in fact strike someone looking at the pictures either as representing the surface relief or accidental features of the earth, or as suggesting the presence, leaping and whirling all over the surface, of living beings (living a peculiar life, halfway between existence and non-existence, between the real and the imaginary, halfway between the features of the places actually represented in the picture and of those belonging only to the mental world of the painter). The effect obtained by this play of

168

100. Dubuffet. *Paysage avec 4 personnages (1961)*

ambiguity and this marriage of the very real with the very anti-real seems to me to be – at least it works in this way for me – to reinforce very strongly in the picture the influence of these two realms. . . . Following this, I got the idea that there may be shared rhythms, identical systems of movement, between the forms and appearances which physical matter presents to our eyes and the mental dances which set themselves going in the human mind. I had the impression, at any rate, that some of these paintings tended to become representations which could appear to the mind as a transposition, into visual terms, of the functioning of the mental machinery, as a kind of kinetics of thought processes in general, and that is why I called them *Mental Landscapes*.'

It is interesting to compare the different characters which the mental world has for two separate individuals – Sam Francis and Jean Dubuffet. The former represents it as unstructured but calm; one sees the appropriateness of his own phrase, 'the cloud over the inland sea'. For Dubuffet it is more agitated, though again not violent; the surface has the rugosity of fractured stone, or the solidified viscous appearance of cold toffee or tar, sometimes a hint of the metallic or suggestion of the mercurial; again, the artist's own phrase, about half-living beings cavorting and whirling all over the surface, hits the nail plumb on the head. These pictures are indeed self-portraits of a peculiarly penetrating kind.

(*e*) *Painting as an object of contemplation.* Very closely allied to, but still distinct from, the concept of a painting as a portrait of the surface of the unconscious mind is the intention that it shall serve as an object to be looked at while the mind is contemplating. One might, to employ a rather crude metaphor, say that the painting is functioning as an artificial navel. It is not intended to suggest the character of the unconscious mind, nor certainly to serve as a source in which symbolic or representational forms are to be searched for. It is simply something to be looked at while the mind goes on journeys of its own. Possibly the polished marble panels which are such a feature of church decoration in many countries, and which some types of modern all-over paintings resemble so closely, were also placed there to serve a similar purpose.

169

101. *Dubuffet. Pierre de la vie (1952)*

Dubuffet, following on his metaphysical land-scapes, pursued a series of what he called 'stones'. These are pictures showing in high relief a more or less rectangular or ovoid form covered with textures and roughnesses stained and blotched with colour, very like the surface of a rough lichen-grown boulder. They are intended to induce the suspension of thought, a mood of contemplation and repose, and Dubuffet has given them names like *Stone of Life*, *Philosophical Stone*, *Stone of New Knowledge*, that suggest at most a general direction in which the contemplating mind can stroll according to its own inclinations.

The Dubuffet *Stones* are complicated, almost contorted, objects which might well be taken as examples of the previous tendency, the representation of the unconscious mind. The works in which the idea of the picture as an object of contemplation is most fully developed are canvases with a much greater simplicity of visual appearance. The most important painter of this kind is Mark Rothko. Others are Clyfford Still and Barnet Newman, with

Klein, Morris Louis and Kenneth Noland in the next painterly generation (which nowadays succeed one another every half-dozen years at most).

Rothko, like so many American painters, began with a Surrealist phase. He worked gradually from this towards greater simplification, even in some sense towards a geometricizing approach. His forms became predominantly rectangular or linear. He became of world stature as he attained to a mature style, which might be taken at first glance to have reached the simplicity of Mondrian at his heyday. The rectangular canvases present an even-coloured background on which are disposed, in a strictly horizontal arrangement, two or three rectangular expanses in one or two other colours. Yet the effect, even after a mere five minutes' inspection, and the intention, as far as one can divine it after a considerable period of thought, are fundamentally different from those which Mondrian achieved or sought in his arrangements of rectangles. Mondrian set out to create a 'pure reality' independent of, and wholly extrinsic to, man.

[48] *Rothko. Light band (1954)*

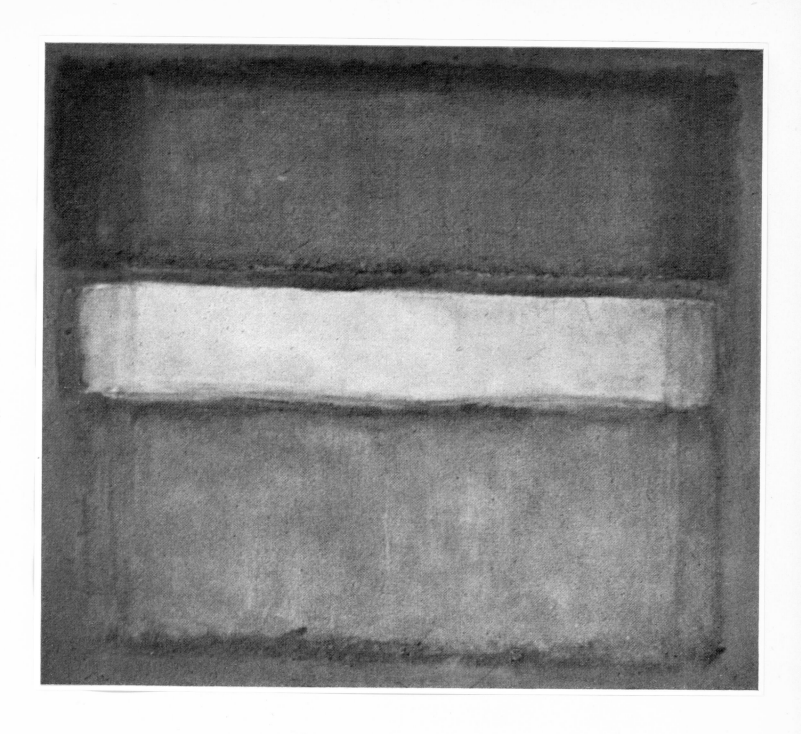

Rothko's aim is to set the observer free into an uncharted field of being, in which he can come to a realization – which involves the active creation – of his own intrinsic nature.

The technical differences of the two painters are at first sight relatively slight. Mondrian's forms were hard-edged – the lines were ruled as precisely as a steel straight-edge, the colours primary, the greater part of the area occupied by a blank opaque white. Rothko's rectangles have fuzzy edges. Colour has been applied – often sponged on – in a liquid state in which it sinks into and becomes incorporated in the canvas – in a sequence of layers giving rise to extremely subtle gradations and nuances within areas of colour which are, in the first place, not primary but involve blends of at least three or four regions of the spectrum. The nebulous consistency of the superimposed areas, with their soft edges, which may be emphasized by thin, as it were radiant, streaks of a bright contrasting colour, creates a remarkable impression of effulgent, internally generated light.

The straightforward visual experience which to me seems closest to the effect produced by a Rothko is this: when one is flying in a jet plane above a continuous cloud cover, just after the sun has sunk below the horizon, and there are some banks of high level cloud off towards the west, one looks in that direction into a diffused radiance, crossed by the dark horizontal bars of clouds which emphasize the infinite recession between them into the depths of space. I should like to quote an unfashionable author, Virginia Woolf.[35] 'Let me now raise my song of glory. Heaven be praised for solitude. Let me be alone. Let me cast and throw away this veil of being, this cloud that changes with the least breath, night and day, and all night and all day. While I sat here I have been changing. I have watched the sky change. I have seen clouds over the stars, then free the stars, then cover the stars again. Now I look at their changing no more. Now no one sees me and I change no more. Heaven be praised for solitude that has removed the pressure of the eye, the solicitation of the body, and all need of lies and phrases.'

The most revealing remark by Rothko himself is this[36]: 'I am for the simple expression of complex thoughts.' His pictures have something of the same quality as one of those almost vacuous-looking equations of fundamental physics: Einstein's $E + MC^2$, for instance; expressed in an algebraic vocabulary appropriate to a primer for nine-year-olds but enshrining a principle – the equivalence of matter and energy – which one can hardly think through in a lifetime.

Rothko has been classified by one of the more perceptive modern critics, Lawrence Alloway[37], as an exponent of the 'American Sublime'. He put into the same category with Rothko another American painter, Clyfford Still. His paintings are less visually transparent than Rothko's. The forms are not rectangular, the edges contain a certain quality of softness only from the fact that they are defined by ragged rather than straight lines. They look like great black curtains drawn across a stage, through the chinks of which one looks through into some indefinite lighted arena.

Both Rothko's and Still's paintings strike one as suitable murals for some chapel of contemplation. Their character is quite an insistent one. A few years ago Rothko accepted a commission to produce paintings for the walls of a large formal dining room in an elegant New York mansion. When they were completed, after a year's work, he decided, and one imagines his patrons agreed with him, that their character was too sombre and otherworldly to form a background for sophisticated social conversations.

7. Texture and material

Allied to, but not quite the same as, 'all-overness' is another pervasive characteristic of modern painting – an interest in material as such. This appears in two rather distinct forms: an interest in materials of all sorts and kinds, and an interest in the particular materials out of which the picture is made.

(a) *No class distinctions in the material world.* To the classical Beaux Arts tradition certain subjects seem particularly appropriate to painting: landscapes, mythological scenes, portraits, naked ladies, and so on. There have, of course, always been painters who have chosen their subject without so much regard for gracious living. For instance, Chardin, with his everyday household objects, or, more recently, van Gogh, who delighted to paint worn-out boots, decrepit bedroom chairs, and so on. In quite recent times one might mention Morandi, who developed a very individual, delicate art, the subjects of which were nearly always arrangements of bottles; or again William Scott, with a long series of semi-abstract works derived from the appearance of frying pans and other cooking utensils.

There is a strand in post-war painting which goes much further than this in accepting, as suitable subjects for painting, materials in which no previous artists had seen anything worth dealing with. Some of Tobey's all-over pictures, for instance, have titles like *Harvest*, and are clearly derived from a close-up view of a field of ripe corn. Many of Dubuffet's are close-ups or even slightly magnified views of patches of soil, sand, or mud. Sometimes the picture suggests an 'interesting' piece of ground; for instance, a Mediterranean sea bottom embellished with sea urchins and starfish, but some of them depict nothing more extraordinary than a few square feet of garden soil. Dubuffet has written[38]: 'Personally I am little interested in the exceptional in any domain. Common things are my sustenance, the more banal a thing is the more I am concerned with it. . . . Many

people have imagined that I am predisposed to disparage, that I get pleasure from showing wretched things. What a misunderstanding! It was my intention to reveal to them that it is exactly those things they thought ugly, those things which they forget to look at, which are in fact very marvellous.' This is almost exactly the same feeling as that expressed by Paolozzi (p. 77) and which he applied to his collage constructions, whose basis is an assemblage of bits and pieces of worn-out material and machinery.

Another expression of the same attitude is by Avray Wilson,[39] who relates it more definitely to an influence of science. After discussing the modern revolution in physics and the supersession of the Newtonian world of billiard ball atoms, he goes on: 'Matter, so long looked upon as dead, is pregnant again with miracle, and since a sacred view of life can only come from a sacred view of matter and all the creatures and states that arise from it, there are the growing possibilities of a new definition of humanism, of man's place in the Universe, of the importance and dignity of the human presence.'

On a less exalted level, scientists are hardly likely to need reminding that some of the subjects they have found most rewarding for study are not a type which has much appeal at first sight to the classical humanist. Where would biology be without fruit flies, bread mould, pond-scum, and intestinal bacteria — better known to their friends as *Drosophila, Neurospora, Chlamydomonas,* and *Escherischia coli*?

(*b*) *The stuff of the picture.* Among the materials in which recent painters have shown great interest have been, understandably, in particular the material out of which the painting itself is made. The technical demands of their craft have, of course, always demanded that painters should concern themselves considerably with these materials. A few centuries ago painters had to prepare their own pigments by grinding the appropriate material and incorporating it into some viscous medium. A few meticulous craftsmen continued to do this even when commercially produced oil paints were readily available. Until relatively recently the main aim was to fabricate painting materials which could be used to produce the smooth, highly finished, brightly coloured surfaces characteristic of classical painting. The paints were in general regarded as means to an end rather than as substances of interest for their own sake. In the early modern period of the 1920s and 1930s, some artists, such as Moholy-Nagy and Gabo, explored the use of certain modern synthetic materials such as plastics, particularly in constructions that were halfway between pictures and sculpture. The American innovators of post-war painting have also made considerable use of modern science-based media, particularly various kinds of fast-drying paints or emulsified pigments. Their use of commercial wall paints, distempers, metallic

[49] *Dubuffet. Astravagale (1956)*

102. Dubuffet. L'arbre des fluides (Corps de Dames). (1950)

Dubuffet understands formally the physico-chemical processes involved, but it is certain that he has developed, by experiment and practice, an extraordinary technical expertise.

Alcopley, who spends the working week in a biological laboratory, has used painting techniques based on certain scientific procedures which involve the spreading of solutions through porous papers (chromatography and electrophoresis). It is rather surprising that no one seems yet to have explored the possibility of methods which would be designed to set in train a sequence of chemical and physical alterations in the materials of the work, so that the painting would gradually 'mature' over a period of months or years, and then either reach a state of finality or eventually degenerate, when it could be thrown away.

Dubuffet rarely, and then probably usually as the result of an experimental exercise, produces pictures in which the manipulation of the material is the sole interest. It is usually combined with some quite different appeal and, following his habit of bringing into the same picture two or more things of as sharply contrasting character as possible, he often employs these spontaneously generated refinements of texture with a strong figurative suggestion. One of his most famous and to some people most shocking series of pictures is a group of nudes entitled 'Corps de Dames'. Of these he writes[40]: 'It is as well not to take too literally the drawing, which is always exaggeratedly coarse and slovenly, in which the figure of the naked woman is delineated, and which taken at face value would imply abominably obese and deformed people. My intention was that this drawing would not confer on the figure one particular form or another, but would keep it in a state of immateriality as a general concept. It pleased me, and I believe that this inclination is probably almost constant in all my paintings, to juxtapose brutally in these female bodies the most general and the most particular, the most subjective and the most objective, the metaphysical and the trivial grotesque. From the same outlook are derived the confrontations, apparently illogical, which one finds in these nudes, of textures suggestive of human flesh (even to the point of perhaps sometimes violating a little the sentiment of decency, but that also seems to me efficacious) with other textures having nothing to do with the human, but suggesting rather the soil or all sorts of things such as bark, rocks, or mechanical or geographical materials.' He goes on to point out that these only partially controllable textures, together with various 'mistakes,' such as involuntary or clumsy marks which he makes, and leaves alone to appear on the finished canvas, 'establish a sort of two-way flow between the objects produced and the painter who produces them' and prevents the painter entirely dominating his production. This is the point of 'participation', which we discussed earlier.

paints, and so on was, to some extent, a protest against the conventionally accepted aristocracy of oil paint as the only material worthy of being used in high art. But in general American painters have not been very profoundly interested in varying the nature of their painting materials and have been, on the whole, content to explore the material qualities of more or less conventional media.

In Europe many people have made more far-reaching experiments. Some of these have involved playing about with rather sophisticated properties of the painting material. Dubuffet, for instance, has produced many pictures which derive much of their interest from the peculiar surface textures which can be obtained by combining materials with different properties; for instance, superposing layers, with various intervals of time between their application, of quick and slow-drying paints, a procedure which leads to a whole range of degrees of wrinkling and contraction of the various surfaces, or by combining oily and aqueous media, or materials which induce precipitates in one another. It is not clear how much

174

[50] *Dubuffet. Le prince charmant (1946)*

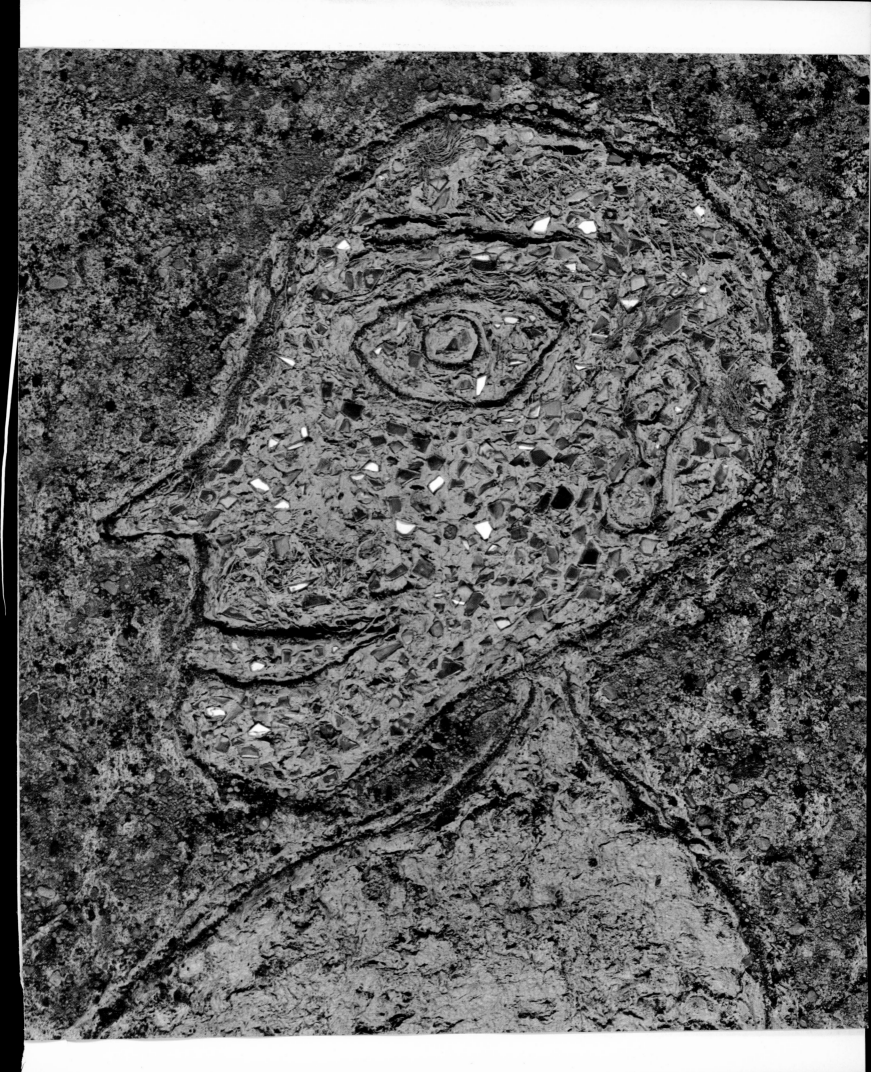

103. *Tapies. Dark grey (1958)*

Not all Dubuffet's elaborate textures depend on playing with the sophisticated products of the chemical industry. He also increases the variety of the material and surface qualities of his paint by such simple procedures as adding to it sand, ashes, coal-dust, or a variety of natural substances. It seems to have been mainly in the Mediterranean countries — perhaps because they are still more rural? — that the interest in these almost primitive materials has been most fully developed. There is a school of young Spanish painters, of whom the best known is Tapies, who have worked very largely in what one might call a 'mud pie' medium. Tapies produces enchanting surfaces of stained, faded, cracked, or streaky mud. He usually combines these with a design, a disposition of forms, which are often gouged into the surface or built up as lumps and knobs on it, which has an almost shockingly unexpected character — asymmetrically jabbing in from one side, leaving the centre blank, suggesting and then denying a balance of the kind

the eye has been trained to accept. They are works which very forcefully express the violence and the melancholy of the Spanish temperament.

In Italy Fontana has used rather similar technical means, but to produce much more gay, sophisticated, and elegant results. When he attaches lumps of stone to the surface of the painting these are likely to be particles of semi-precious stones, jagged lumps of brightly coloured glass, or even shining fragments of black coal, and they are arranged in taut whimsical patterns. Another Italian working with primitive raw materials is Burri. He was originally a doctor and practised medicine until captured by the Americans during the war. His best-known productions, which he started doing while in a prisoner-of-war camp in Texas, are 'paintings' made mainly by attaching to the canvas areas of coarse sacking, often torn, sometimes scorched, sometimes sewn together with long stitches of coarse string. Through the gaps in the canvas, or sometimes applied to the

176

[51] *Fontana. Painting*

canvas itself, there are patches of pigment. In many of his works the basic design is actually a series of more or less rectangular areas with roughly straight lines; not far away, in underlying anatomy, from a Mondrian. This gives them a basic strength which greatly enforces the charm of his materials, which might otherwise tend towards the chi-chi or the conscientiously rustic or antiquarian, like exaggeratedly homespun tweeds or the worn leather binding of a book disinterred from a country gentleman's forgotten library.

It is one of the perils of the whole enterprise of laying great stress on the materials of the picture that there are so many potential substances, any

of which can be as interesting as any other. Tapies and Burri can make us look at mud and sacking and burnt planks, but they are intrinsically no more exciting than the chromatography paper used by Alcopley, and do not offer such varied possibilities as the artificial materials used by Dubuffet. Their appeal is probably much less 'pure' and abstract than it seems at first sight, and depends more on deeply laid associations — Freudian or at a less deep level — than on their purely plastic quality.

8. Urbanism

An important ingredient in recent painting, though not in that which we have just been discussing, is

104. Burri. Composition 8 (1953)

that it has been carried out by people living in an urban and often in a megalopolitan environment. Nearly all the painters who made and followed up the American breakthrough were profoundly influenced by the character of great American cities, particularly Manhattan. They were used to the aerial views from the upper windows of sky-scrapers, the multiple reflections and refractions one sees when surrounded by sheets of glass set at angles to one another, the multiple circles of road and subway, the swiftly moving car head-lamps, that trace out lines which are trajectories rather than outlines, in the 'concrete jungle' of the big cities. The conventional romantic or artistic properties — trees, flowers, grass, rocks, streams, and so on — are no longer everyday homely parts of

ordinary life. Almost the only item of the old-fashioned furniture of living that survives in the city is the sky.

In general the effect of these conditions has been rather to arouse a mistrust of conventional nature than an attempt to represent, either directly or even in any overtly symbolic way, the forms and patterns of the urban environment. Painters were working in and for, but not from, their urban surroundings.

9. The cult of violence?

It may be thought that some modern painters, par-ticularly Americans, have made almost a cult of violence, an uninhibited torrential outpouring of force. Certainly Hoffman and de Kooning seemed, when they first appeared, something phenomenal

178

in the way they threw the paint around; and compare Kline with Soulages. Here is the reaction of someone who was himself an innovator, in the iconoclastic days of Dada, Huelsenbeck[41]: 'The law of chance is really in comparison with action painting a kind of comfortable quiet stroll through the country, while action painting has this wild, a little bit hysterical, note which is so – so characteristic for the American way of doing things.'

Energy is certainly one of the things which recent painters have attempted to embody on their canvas, and many painters have expressed the idea that clear-cut, precise forms are antagonistic to this. Barnet Newman, a painter in the Rothko-'American Sublime' vein, writes[42]: 'It is precisely this death image, the grip of geometry, that has to be confronted.'

The striving after a symbolization of energy is certainly a real factor in much modern painting. But if it did indeed go far enough to be justifiably called a cult of violence, that was certainly no more than a very minor component of modern painting, even among Americans; and the impression that it ever did go so far is perhaps mistaken. When they first appeared, Jackson Pollock's painting gave an impression of an uncontrolled outburst of daemonic violence. We see now that this reaction was as superficial as that to analytical cubism in its day. Pollock's vocabulary was one of flow and gyration, the lines continually returning towards their starting point. Perhaps one can take them as alluding to destructive cataclysms like the well-known later drawings of Leonardo; but from another point of view Pollock was not far off being a cubist, with all that that implies of reference to an eternal space-time continuum, in which aggression becomes a meaningless term.

10. Art Brut

As America might perhaps be accused of a Cult of the Tough, Europe may be open to the counter charge of a Cult of the Loony. The grounds for it would be that several artists, such as Dubuffet and Michaux among others, have shown a considerable interest not only in the art of children – from which Piaget has drawn such important conclusions for our whole understanding of epistemology and symbolism, and which Freud has shown is not so simply innocent as our grandparents liked to think – but also in that of psychopaths, neurotics and drug addicts, and in such embodiments of the public unconscious as the graffiti on lavatory walls. Brassaï was photographing these graffiti and exhibiting them in *Minotaure*[43] in the early 1930s, but it was not till Dubuffet in the late 1940s that any important artist allowed his style to be influenced strongly by such graphical methods.

Dubuffet, who is usually so much to the point about his own intentions and methods, seems to me to carry less conviction about this one.[44] 'My idea – which I have already expounded elsewhere – is not exactly that art does not require any practise (for every artist faces the task of getting his techniques up to the mark) – but that it requires no instruction coming from outside, no study of what other artists do or what they have done in the past. . . . It is only necessary that he (the painter) discovers the means of expression which are suitable for him, which allow him to exteriorize his feelings without falsifying or losing anything of them; that's what's difficult! It's that which requires, most of the time, a long and patient work of experiments and researches.' So far, so good. But in another place he writes[44]: 'What I want to recapture in my pictures are things as seen by a completely average and ordinary man, and to add nothing to the simple means the hand of an ordinary man would use. The elementary techniques of the uninitiated, I want no others, they seem to me to be sufficient. . . . It is to the mind, of course, that art is directed and not to the eyes. Too many people think that art is only something for the eyes. This is to make but poor use of it.'

But the scratched and scribbled lines, incised into the soft paste of the pigment surface, that Dubuffet actually produces according to this programme – maybe the ordinary man uses them when he half-shamefacedly embellishes the walls of a pub gents with a pornographic sketch, but they are surely very far from a straightforward expression of the character of a 'completely average and ordinary man.' They carry in them a strong flavour of the *homme moyen sensuel* being naughty, just as the allied art of the neurotic or psychopath obviously represents something more extraordinary than simple basic uncontaminated human nature. Dubuffet's instinct may have led him, along some circuitous course, to adopt this type of graphic expression, but the reasons cannot have been that it is particularly 'natural'.

11. Doctrinaires and amateurs

The newer types of abstract painting are, as we have seen, underlain by some at first sight strange motivations and are influenced by a number of definite though unconventional theories. Further, in their practice they do not usually at all obviously call on any resources of craftsmanship and trained painterly skill. These characteristics have made them a tempting target on the one hand for doctrinaires (and/or crackpots) and on the other for amateurs, or finally for simple jokesters. The last category are of no particular importance. Ever since the cubist or even the impressionist or fauve repudiation of conventional art school expertise, it has been a fairly easy joke of diminishing humorousness to spread paint on canvas in a manner intended to guy one or other of the modern manners. At their best, which is very rarely attained, such works may have some of the bite of good verse parody. Usually, however, they give no more, if as much, as would a parody of Wordsworth or

105. *Dubuffet, two drawings (1960, 1949)*

Milton which succeeded only in copying the rhyming pattern of their sonnet forms. Even to achieve this, of course, may be something of a task, and a few of those who start out to make fun of the appearance of modern pictures may discover that in doing so they begin to find what the real nature of these pictures is; and what began as a joke may turn into a fairly serious amateur effort.

The doctrinaires are a somewhat, but not much, more important element in the situation than the jokesters. I refer to people who accept one or a few of the basic theories of modern painting, but who proceed to drive them along one line until they run into a dead end. In a sense it was doctrinaires who gradually, between 1920 and 1940, narrowed down the cubist initiative into the two confined schools of the intellectual geometricizers and the Surrealists.

This was a comparatively mild degree of the disease. Malevitch had got it much more badly: it took him only a few years to go from the idea of geometrical abstraction to the production of a white square on an almost indistinguishable white background. In the post-war period there have been a number of painters who have driven some of the modern tendencies almost equally hard. Tinguely, for instance, has taken the two themes of stochastic processes and worn-out scrap machinery, and combining these two has come up with a completely mechanized randomization of the drawing process. A set of bent, broken or otherwise defective levers, cranks, and cogwheels are loosely assembled, all bearings being highly irregular and badly fitting, in such a way that when the mechanism is activated — perhaps by an electric or clockwork motor into which a coin can be inserted — a brush attached to one of the levers moves in an indeterminate and scarcely controllable manner over the drawing surface. The resulting works could perfectly well be produced while the 'artist' was in the next room. They provide, perhaps, a demonstration of Leonardo's point that chance blots and stains are visual phenomena in which

[52] Dubuffet. Mouchon berloque (1963)

the observing eye and mind can roam about with some freedom. But, surrounded as we are by such demonstrations on all sides, on walls, pavements, fading leaves, twigs against the sky, the result seems hardly worth the effort expended on it, let alone the publicity with which it is promoted.

Again, there have been painters like Klein who have reduced their pictures to an unmarked or modulated canvas, stained evenly all over in one particular shade. The kindest comment is that he is going one better than Rothko, but in fact these artefacts are scarcely more than one could buy by the yard from a wholesaler and tack to a frame without touching it. He pursued the existentialist doctrine that the picture is a mere record of the act of producing, and that the act is identical with the intention. He therefore held an exhibition in which there were no canvases on the walls, but only the presence of the pure intentions undefiled by the imperfections of action. He is said even to have made some sales! Whether this is to be regarded as a seriously intended, though exaggeratedly doctrinaire, development of one of the strands of modern philosophical thought[45], or whether it was a rather funny highbrow joke, is perhaps not quite clear.

The intrusion of the amateur into modern painting is much more important than the activities of jokesters or of those who get on to a monorail and do not know how to stop. The new painting does not demand, though it may use the manipulative skill that requires years of practice. We are entering a period when the automation of productive processes is going to make it necessary for industrial man to reconsider very radically how he shall spend his time. In the older civilizations based on the individual craftsman and agricultural labourer the working week was long, perhaps about sixty hours or more, spent in considerable independence of the clock and devoted mainly to labour which had in it some element, often very considerable, of creative activity and manual skill. The industrial world passed into a machine age in which the factor of creativity was usually reduced almost to vanishing point, while even skill is more and more dispensed with. Working hours were at first long but have been gradually shortening, liberating time to be spent on things other than work. Some of this spare time has been devoted to craft activities, such as gardening, fishing, or various constructive hobbies, and much of it to spectator activities — watching organized games played by others, or the cinema or telly.

With the coming of automation the amount of non-worktime available will increase to a point where it seems likely that these rather second-best solutions — unnecessary exercises in simple craft skills, or participation only as a spectator — will no longer seem a satisfactory way of spending what will be perhaps the greater part of one's time. Creative activities of various sorts seem to be one of the most likely outlets for the surplus energies which will have to find something satisfactory on which to expend themselves. There is therefore good reason to expect an ever-increasing number of non-professional painters. In these circumstances it is favourable that the modern manner does not necessarily demand a long apprenticeship.

This subject has been discussed in a very perceptive article by Margaret Mead.[46] She makes the comment, however, that 'the most casual visit to our campuses where "modern art" is produced by the yard would suggest that the gap (between artist and common man) is really widening while it might seem superficially to be closing.' She convincingly diagnoses the trouble. 'It is undoubtedly a good thing that many people . . . should be given the chance to "create", to stand before an easel and wrestle with an attempt to make the world anew. But what is happening today is that in these thousands of studio situations the painter does no such wrestling; it is not individual vision but the ability to replicate a strange commodity — individuality — which is being practised.' For in reality the modern style of painting, which seems so technically undemanding, actually faces even the amateur with quite deep and profound personal problems of integrity and participation. The surrealists in the 1930s used to claim that their movement was a particularly democratic one, since they had shown how, for instance by the use of automatic techniques, anybody could produce paintings. The modern movement goes one better, in that its methods are inherently no more difficult, but its problems have a broader implication for the personality as a whole than the mere appeal to unconscious imagery with which the surrealists were primarily concerned. As John Cage has said[47]: 'It may be objected that from this point of view anything goes. Actually, anything does go, but only when nothing is taken as the basis. The thing to do is to keep the head alert but empty.' It is taking nothing as a basis that is the difficulty for the amateur; and it is this challenge which makes the endeavour worth while.

The whole modern movement whose development we have been tracing does, perhaps, have a character which leaves it open to exploitation by exponents of the phoney, the gimmick, and self-salesmanship. But in its essential nature it is an art of exceptional honesty, integrity, and wholeness of being.

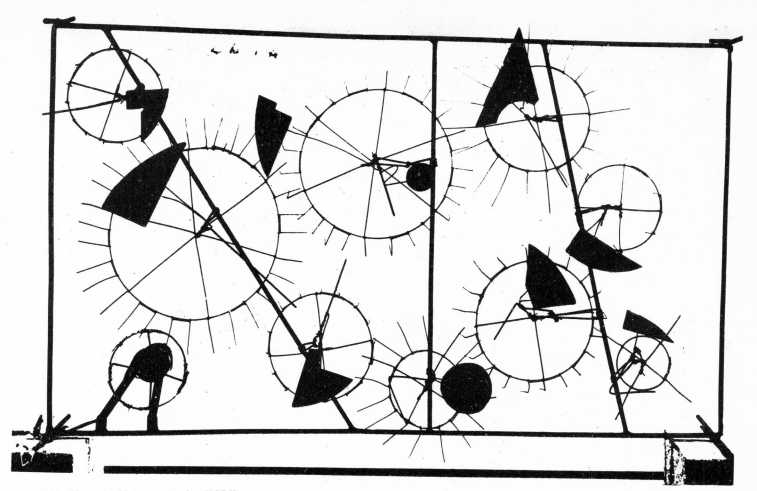

106. *Tinguely. Meta-mechanics (1954)*

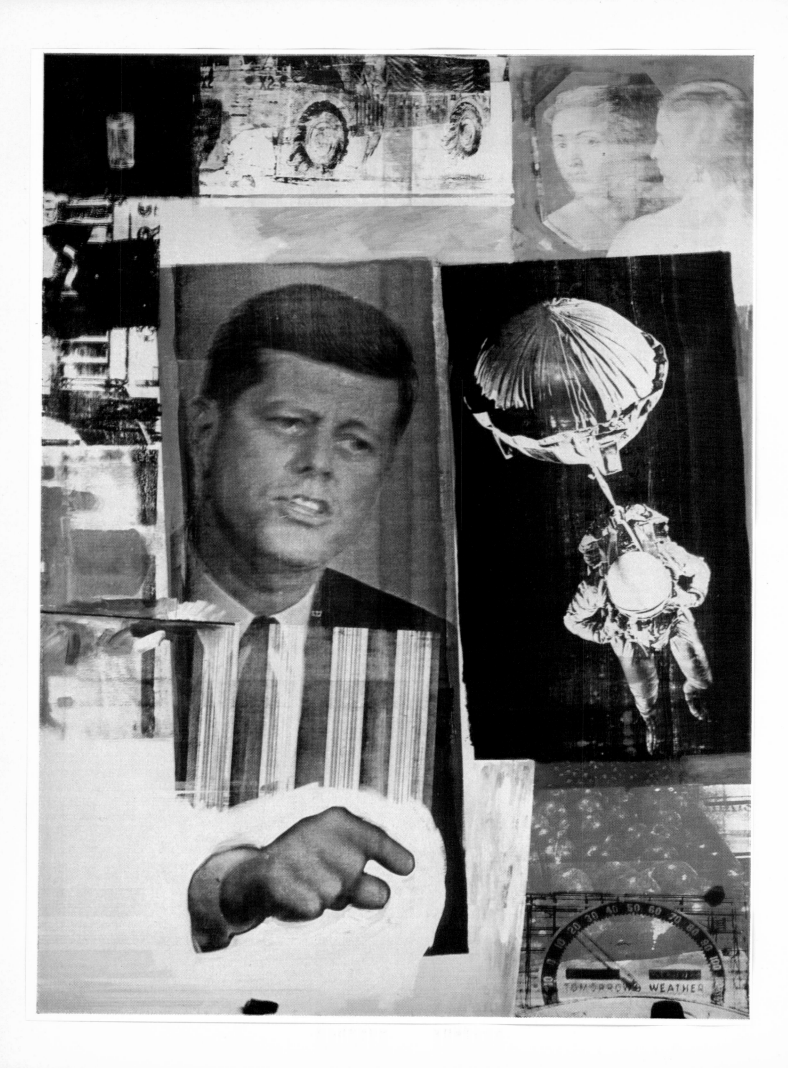

6

Reactions and Continuations

The first wave of the New Painting produced an extraordinary diversity of efforts. It had reached a peak of efflorescence by about 1955, and the following decade saw a large number of even more diverse reactions to its various aspects, a number of apparent or alleged new starts, and, of course, many continuations and developments of the older permanent themes of modern painting. This period is particularly difficult to discuss in a reasonably concise manner. For one thing, the movements have not yet become consolidated enough to be sorted into neat categories with accepted labels. Some of the first American reactions against the dominance of the New York School were originally referred to as 'Assemblage', but this movement soon became a part of a wider current, for which the name Pop has been widely used — although actually the current is so broad, and contains so many separate streams and eddies, that it is probably a mistake to try to find one name to cover the whole thing; and it is certainly quite difficult to find an artist who will readily accept this label for himself. In particular, there are very considerable and important differences between the 'post-New York' development in America and in Great Britain, which latter has, once again, made one of its rather rare original contributions to painting at a level of world significance. But Pop, we are often told, is already on the way out, to be replaced by Op — a type of art specializing in peculiar optical effects — and there is already a sizeable quantity of post-Op.

This super-rapid succession of dominant schools is a symptom of one of the other circumstances that makes it so difficult to form sensible opinions about the most modern painting. The publicity machines of large operators concerned with the sale of works of art have moved into the scene with a vengeance. The artist is no longer left in comparative obscurity and poverty to go through his initial studies as a young man, as he did even as late as the time of Jackson Pollock and de Kooning. If he is 'lucky', someone may spot him as saleable when he is still quite young, and his line will be ballyhooed into an appearance of profound importance, and, especially, of absolute up-to-dateness. The best artists, of course, resist these pressures — quite largely by paying no attention to the publicity on behalf of other lines of work, which insulates them against a lot of disturbance, but also tends to cut them off from the stimulating influences of other painters. It is not so easy for the critical onlooker, who does not have a single creative line into which to become absorbed, to pick his way through the babel of high-powered sales talk. Fortunately, in this book, I am concentrating on one theme, which provides something of a lifeline through these stormy seas. As we shall see, although a good deal of the recent painting has a science-like look — using strictly geometrical shapes such as concentric circles, or the forms of

industrial products like automobiles and other mass-produced items, or even exploiting some of the sight-testing diagrams one might find in a laboratory investigating visual perception – this impression is rather superficial. There are few of these artists who are much concerned with our deepening understanding of the nature of the non-human world; their interests are much more in the professionalism of painting and in the character of the man-made industrially produced environment; and these are fields into which we shall not attempt to follow them very far.

There are some other types of painting, besides Pop and Op, which are relevant and require discussion. One of the realistic painters of today, Giacommetti, is particularly important in relation to the scientific way of regarding external objects. There have also been important new developments in geometrical painting; some as continuations of the old constructivist tradition, and some with a rather different lineage, counting painters such as Rothko amongst their nearer forebears. Finally there are forms of artistic production involving the introduction of motion into the work. These are perhaps closer to sculpture than to painting, but in spite of the self-denying ordinance which has led to the exclusion of sculpture from most of this discussion, many of these newer works are so closely connected with science that it would not be sensible to exclude them altogether.

Pop art

The first stirrings of the movement which eventually gave rise to the heterogeneous collection of art styles nowadays referred to as Pop Art* took place about the middle of the 1950s. Two different and, for some time, rather distinct currents were involved, an American and an English. In the United States the most powerful influences were Jasper Johns and Robert Rauschenberg. In England there were no talents of quite such dominating power, but probably the most important early influences were Richard Hamilton and Eduardo Paolozzi. Since Johns and Rauschenberg provide a firmer link with the discussion of the last chapter, it will be as well to consider them first.

By the mid-fifties the New York style painting had in most cases – though a few painters such as de Kooning resisted the trend – lost all traces of explicit reference to external objects. The paintings were more 'all over alike', and more completely abstract, than any of the works of analytical Cubism – the previous version of partially all-over and partially abstract paintings. And the New York style was still further removed from external reality by its insistence on the value of the subjective

mood and gesture of the artist. Artists do not seem to be able or content to maintain such a high level of remoteness for long. Picasso and Braque only remained at the peak of analytical Cubism for a year or two before introducing some aspects of simple visual appearances into their paintings again. Johns and Rauschenberg can be regarded as facing problems very like those which worried the Cubists in about 1911 or 1912, and they dealt with them in ways which are surprisingly similar; that is to say, the introduction into essentially all-over abstract works of items which are either photographically realistic representations (imitation grained wood, etc., for the Cubists, actual photos in Rauschenberg), or the definite but banal forms of everyday symbols such as letters or numbers. The Cubists in their day rapidly went beyond this, and fixed things such as nails or hanks of string to their paintings, and since those early times we have seen the production of all kinds of assembled art objects brought to a high pitch by the Dadaists just after the First World War, and continued by artists, such as Miro, working in the surrealist tradition.

Rauschenberg's 'pictures', to call them that, are made up of some paint and a great deal of a variety of objects – photographs, reproductions of paintings, dried specimens of insects, keys, clocks, scraps of paper, neckties; in fact, practically anything you like to think of. In one of the best known a stuffed eagle with spread wings was suspended a foot or two in front of, and slightly below, the main area of the picture. In another, the main picture plane lies horizontally, and in the centre of it stands a stuffed Mouflon mountain sheep, its belly braced by an electric armature. At first sight they seem to be no more than a continuation of the tradition of Dada collages; in fact, with their softly modulated colouring they often come very near the sheer prettiness of Schwitters' *Merzbilde*. But apparently the resemblance is not actually the result of historical deviation. American culture specializes in approaching everything as though no one had ever thought about it before. So you get these extraordinary (to European eyes) grass-roots geniuses – mute Miltons from the deep Mid-West who insist on a beginning in the head-lines, often announcing a few self-discovered versions of insights definitively formulated by Aristotle, Einstein, or Mendel, and – this is the point not to forget – from time to time unexpectedly opening up a totally fresh vision never before glimpsed by anyone. Buckminster Fuller is perhaps the type specimen in the architecture-sociology field; in poetry, e. e. cummings, or even Walt Whitman.

It is as a character of this sort that we are asked to take Rauschenberg. Questioned about his affinities with Dada, he replied[1]: 'I have not seen those others. . . . I only know that in books it seems to me that the spirit of it was completely different.

* Note that 'Pop' is being used here in a very broad sense; many people would not stretch it to cover Johns, Rauschenberg, or related artists such as Larry Rivers.

186

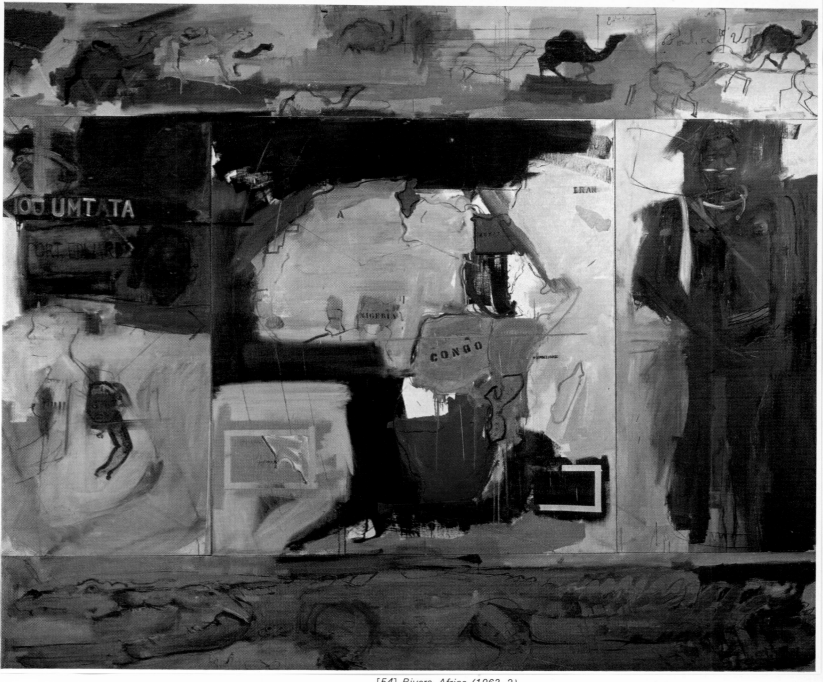

[54] *Rivers. Africa (1962–3)*

For Dada it was a matter of exclusion. It was a censure against the past, its effacement. Today for us, it's a matter of including the movement, of introducing the past into the present, totality into the moment. There is in that the whole difference between exclusion and inclusion.' A similar point is made by Alan R. Solomon in the introduction to the catalogue of the American exhibit which won the main prize at the Venice *Biennale* in 1964[2]: 'Rauschenberg, like all of the American artists discussed here, operates from a positive and constructive view of the world.' But one may, I think,

wonder whether this is any more than a charmingly naïve expression of the American myth about themselves as a bunch of simple frontiersmen and pioneers. Rauschenberg was born in Texas; but he had studied under a sophisticated refugee from the Bauhaus, and travelled in France and Italy, besides living in New York for several years, before he did his first significant paintings; it is difficult to regard him as a quite untutored genius. Moreover, the Dada works which had been produced in Europe a third of a century earlier are not actually by any means so exclusively negative and destructive.

187

107. *Rauschenberg. Urban, lithograph (1962)*

The still earlier futurist collages were in fact only too positive: artists such as Carra used the technique to issue rousing manifestos on behalf of the Italian war effort, full of patriotic fervour and military enthusiasm. The Dadaists' attitude would certainly have been regarded as pretty un-American by the late Senator McCarthy. But patriotic salesmen with a line of talk on the he-man virtues of the current American stable might be well advised to cast an eye at the salient points of the Dada competition. 'La pudeur se cache derrière notre sexe', remarks Picabia.[3] And even the more Existentialist utterances — 'Il n'y a pas d'inconnus excepte pour moi'; and 'Je n'ai pas besoin de savoir qui je suis puisque vous le savez tous'; would not be difficult to translate into the idiom of Dallas, Tex., and might even seem positively brash in Black Mountain, So. Carolina, or Big Sur, Calif. The Dadaists were out to criticize the orthodox world of conventional 'beauty', but in the main they did this by exactly the same means as those used by Rauschenberg — that is to say, by demonstrating that a lot of rubbish and discarded junk can be assembled into objects which have an undeniable beauty. Theirs is a parentage that nobody,

not even a yea-saying American, need be ashamed to accept.

There is, however, something which Rauschenberg does which is absent, or nearly so, from the earlier Dada collagists such as Schwitters, Arp and Miro. Rauschenberg is often concerned to create a pictorial space, which is three-dimensional, with various incidents taking place, some nearer, some further away, but which is not organized — size does not correspond to distance, there is no definite focus, no distinction between what you're looking at with high-resolution foveal vision and what is swanning around on the periphery of the visual field. There are a number of phenomena occurring, disconnectedly scattered haphazard throughout an ill-defined volume of space, and you can take your pick, or stray around from one to another. This is carrying the 'assemblage' method — throw a lot of miscellaneous stuff together and see that happens — definitely a step further. Whereas Schwitters, Arp and the others gummed up mostly two-dimensional items — bus tickets, labels of cigarette packs and what have you — usually respecting the picture plane, or at most adventuring into a shallow showcase of

188

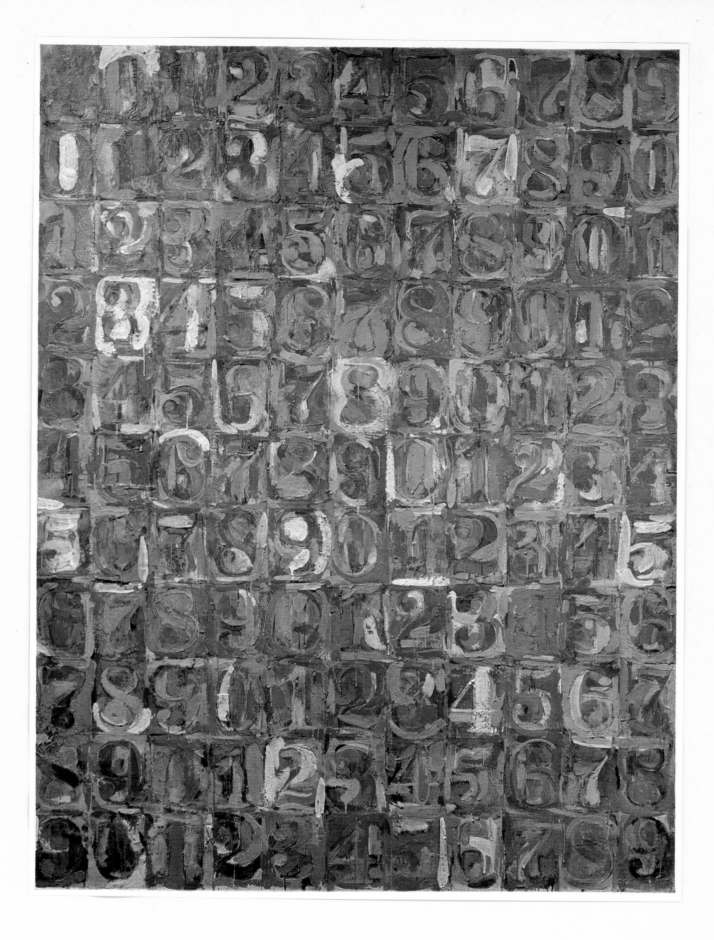

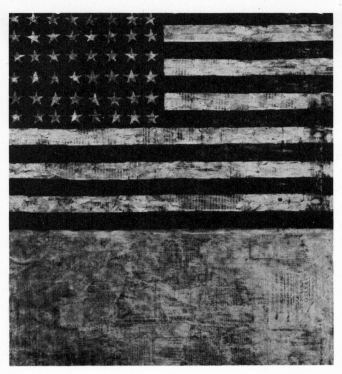

108. Johns. Flag above white (1955)

space, as when Miro plays with a stuffed bird and a hank of rope, Rauschenberg strews a heap of incidents, often described in photographic detail, through the depth of a much deeper chasm.

This is an explicitly, even outrageously, empirical attitude: taking things as they come, and whether they come. It expresses one of the aspects of science, one in which it differs, for instance, from rationalism, either of the secular eighteenth-century, or the theological thirteenth-century, varieties. Science begins with the Phenomena. The world divides into facts, if only one could find out what the facts are; and sometimes Rauschenberg hangs in front of us some ill-defined but undeniable event occurring some place out there, in a jumble of other things happening elsewhere in the general neighbourhood. This is the raw material of science; neither the clockwork meshing of neatly fitting gears envisaged by *a priori* rationalism, nor the featureless, muddy, all-pervasive paste in which some Existentialist writers suggest we are embedded.

Jasper Johns has also often used the assemblage method, though mainly in rather later work. His earliest paintings were somewhat in the direction of the Cubist works which incorporated letters and numerals into their design. However, Johns carried this tendency very much further, and made it a more powerful influence on his work than the Cubists had dreamt of doing. Many of his earliest pictures produced an insistent first impression of some conventional form, such as a target made of concentric circles. The first response of many

spectators was to suppose that the main importance of these pictures is to raise problems about the relations between existence, representation and symbolization. When Johns exhibits canvases painted with the precisely copied design of the American flag, he seems to be laying before us the problem: is this a picture, or a flag, or a symbol of the United States? He himself did not pursue the theme very far. Even in his first, most realistic paintings, a closer look shows that the paint surface is not at all uniform, but is closely worked into subtle and interesting textures. In his more recent works, such 'images' as there are in the picture are still of simple conventional clear-cut forms, such as flags, targets, letters, numerals, etc.; but they are not represented realistically, on the contrary they often scarcely emerge from a surface which is modulated and diversified by layer after layer of splashes and strokes of paint. These works are not far from the central modern American style, reminding one at times of de Kooning, at times of Tobey. Their interests for our theme are in the various implications of 'all-overness' which were discussed earlier. Their main distinction is in the extreme beauty and refinement of the surfaces which Johns can create. One's final impression is that it is this immediate sensuous quality of the act of perception which is the main inspiration of Johns' work; the conventional rational images, such as letters or numerals, can be interpreted according to taste, either as suggesting that there is an underlying logical structure, as yet not fully grasped, or as traces of an understood rationale which is becoming submerged by the sheer attractiveness of the superficial appearances.

This is perhaps to read more into them from the point of view of a scientist than they were intended by the artist to convey, but one should never be afraid of seeing more in a painting than the painter consciously knew was there — in Whitehead's philosophy an event contains everything you can find in it and a great deal more than you have yet learnt how to find. Jasper Johns' intention may have been, as some critics have suggested, to make his painting around an image of such boring banality that it served only to force the spectator to look for something else; in particular, the quality of the painterly performance. But even if this was what he thought he was doing — about which I am not sure — there is no reason why we should accept this as excluding any other responses.

One of Johns' early works, *Moulded Bronze*, looks exactly like two cans of Ballantines beer — but one of them is empty, and much lighter than a can of beer should be, and the other filled with lead and much heavier. Many painters, particularly in America, have started from the point which Jasper Johns made and hammered it home — sometimes to the extent of causing the irreverent to allow thoughts of sledgehammers and nuts to drift through their minds. Wesselmann paints

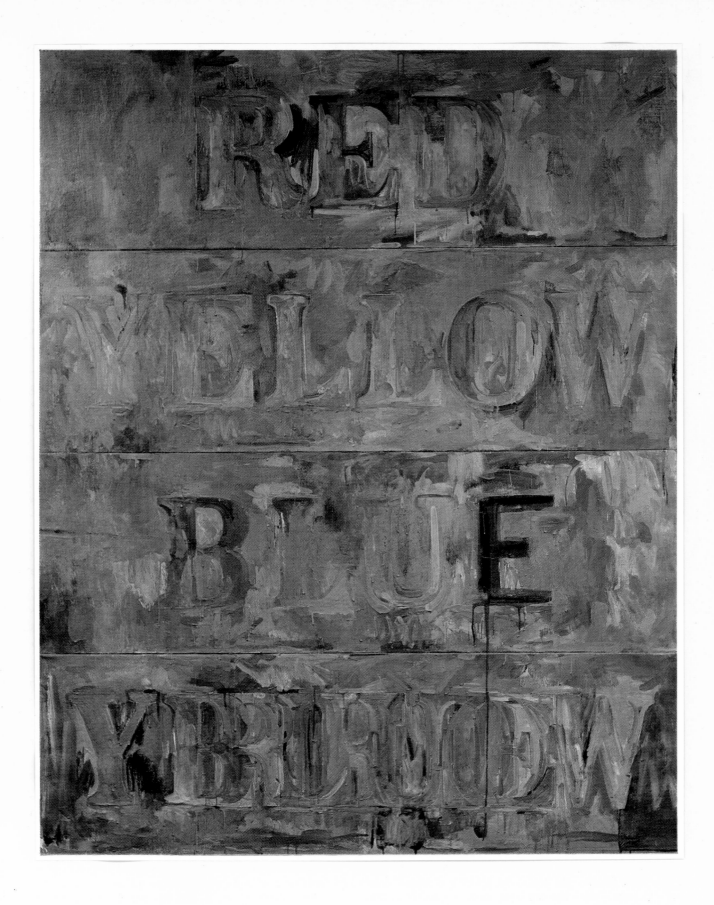

nudes, the forms simplified and the colour areas rendered uniform in a poster-like technique, but with some completely realistic items, such as an ice-cream sundae on a table (or, to pep it up a bit, real pubic hair), and the total work, as mounted for exhibition, may include not only the painted surface on the wall but a stretch of carpet on the floor in front of it. By the time the movement had got to the point of making accurate copies of packaged goods with no goods inside, or *trompe l'œil* wax models of steaks, allowing themselves possibly no more deviation from the model than a change of scale, it had attained a *reductio ad absurdum*. But the original problem, as posed by a sensitive painter like Johns, is an interesting and important one, which will certainly continue to be worked over by painters for many years. It is perhaps more closely connected with modern philosophical thought than with natural science. It is not for nothing that Paolozzi christened one group of his works *The Wittgenstein Series*, and gave individual items names which are quotations from the *Tractatus Logico-Philosophicus* (see pages 109 and 110). The intellectual (as opposed to the visual) problems with which this kind of art is concerned are not far removed from the questions of the nature of language, and what we mean by saying a word 'refers to' something; these were central problems for the linguistic philosophers.

It is interesting to consider the relation between Jasper Johns' realism and that of Giacometti. Both insist that there are, in our surroundings, quite undeniable *things* which are definitely outside of and other than ourselves. Johns, in his *Beercans*, for instance, handles these as though they were made of old-fashioned 'solid matter', but contrives to imply that the matter, even if solid, is anything but outspoken, forthright or unequivocal – things are things, all right, standing pat just where they are, but not necessarily what they seem. Giacometti is perhaps closer to the scientific view. His things are not so simply located at a definite place; they are not such ordinary solid impenetrable masses, but rather each is the focus of a flux of energy (of 'violence', even) which radiates from, rather than has its habitation at, a certain region, not at a certain ascertainable space-time co-ordinate. But both artists move on the other side of the coin to those for whom the picture surface is an area on which to act out the impulses which arise within their own personalities.

Among the progenitors of Pop in England, Paolozzi, a sculptor, had worked for a number of years with methods closely allied to those of the Dadaists. He has been quoted in this connection already (p. 77); but problems concerning the nature of representation and reality, similar to those which seemed to be posed by Johns' early work, are among the many facets of his recent sculptures. These are constructions, usually of cast and

109. Paolozzi. Akopotik rose (1965)

welded metal, which imply many machine-like elements which build up to form the image of some sort of vaguely personal presence – not necessarily human or even living in any ordinary sense, but still an active operator in some realm, of another plant or of outer space. The mechanical elements do not appear, as they did in Paolozzi's earlier works in the Dada-Merzbild tradition, as a disordered welter of scrapped and discarded refuse. Often the individual parts of the constructions have an appearance of excessive ordinariness; they are like the balusters of an undistinguished Victorian staircase, or cylinders and pistons from a garage. They are not, by a long way, so wholly dictated by conventions as Johns' flags, letters and numerals; and the total intention of the works is, as always with Paolozzi, not at all simple but very decidedly multi-evocative; nevertheless he, like Johns, is raising questions about the relation to reality of the conventional furniture of our minds as well as of our homes.

The last of my progenitors of Pop is the English artist Richard Hamilton. It is too early to pronounce definitively on the art history of such recent times, but it is probably not outrageously unfair to take him, if not as the originator, at least as an outstanding representative of the first generation of painters who made use of images taken from commercial 'art work', employing them not merely as bare visual items, but exploiting them precisely as unavoidably recognisable things taken out of this world, and inescapably carrying with them the atmosphere and reek of that milieu, however one

110. Paolozzi. Diana as an engine (1963/66)

193

111. *Richard Hamilton. Homage to Chrysler Corp. (version for line reproduction, 1958)*

may wish to interpret it. By doing this he launched the phase of what one might call Pure Pop — the Pop Art that will be listed under this heading in art histories written fifty years from now.

This exploiting of commercial admass imagery, for the sake of the fact that it *is* admass imagery, is not entirely new. A modern Pop artist, Larry Rivers, made something very pretty to look at out of the Camel cigarette pack in 1962; but Stuart Davis made something quite amusing out of the Lucky Strike pack in 1921; and Peter Blake's *Love Wall*, embellished with saucy postcards — back view of a man on a motorbike with a callipygian girl on the carrier, 'He has such fun with Her Behind' — arouses a poignant nostalgia for the time when *Minotaure* Nos. 3 and 4 came through the post in 1933, with Paul Eluard's abundantly illustrated article on 'Les Plus Belles Cartes Postales', and S(alvator) D(ali)'s note on 'Le Phenomène de l'Extase', illustrated by, I think, forty-five photos of facial expressions at the moment of orgasm, sixteen being details of the ear.

The new movement played itself in with at least as much verve and self-confidence as the old, and made greater claims than did the Surrealists that its sources in mass-produced imagery should be taken seriously in their own right. The Surrealists used them as a side issue, while their real interest was in the ways in which the conceptualizing intellect actually gets to work. Richard Hamilton's first major picture, in 1956, has the socially provocative title *Just what is it that makes today's homes so different, so appealing?* It shows the living room of an elegant split-level apartment designed for gracious living, with pictures on the walls of a mid-Victorian father figure, and considerably larger, a blown-up cover of a pulp magazine, *Young Romance,* inhabited by a muscleman out of a physical culture magazine and a posturing striptease nude wearing nothing more than a coolie hat and sequinned suction caps over her nipples. There is a faint whiff of late Surrealism — Magritte, Delvaux, or Dorothea Tanning — about the whole production, and so there is in some of Hamilton's later works, such as — even the names give the flavour without seeing the pictures — *Homage to Chrysler Corp, Hers is a lush situation, Towards a definitive statement on the coming trends in men's wear and accessories;* but it is clear enough that the Surrealism is well in the background, and the foreground is some sort of comment on the modern urban environment as put across by commercial sales techniques. In our context it is not necessary to try to disentangle just what this subtle and equivocal comment is. It certainly involves a rather unappetizing snigger as a major element. But whatever else besides there may be, it has almost nothing to do, directly, with the kind of understanding of the non-human real world with which science is concerned.

We cannot, however, simply consign it wholly to our colleagues on the literary and 'humanities' side of the house to try to make sense of. Hamilton's work, and that of a few people associated with him, touched off a major current of modern painting which is relevant in two ways to our theme of the inter-relations of science and art. At a first, and more superficial level it set going another attempt — recurrent red-herrings — to utilize in painting the forms developed by science or science-based industry; and secondly, a very few of the painters who adopted these forms have actually succeeded in using them to comment on the nature of reality and of our symbolic pictures of it. For one example, at a fairly superficial level, look at the use which D'Arcangelo has made of the industrialized landscape of the motorway; this has some of the effect which Chirico expressed about forty years earlier, of the strangeness of the world man has made for himself, and his own isolation within it.

A more important artist, both on account of the visual effects he produces and for the social criticism he expresses, is Andy Warhol. He makes

112. Richard Hamilton. 'Just what is it that makes
today's homes so different, so appealing?', collage (1956)

113. D'Arcangelo. No. 80 (1964)

a quite original use of reiteration of images. Sometimes these are simple shapes which echo commercial graphic work; sometimes they are news photos or the like. The subjects usually convey a criticism of the Admass world, they may be of popular film stars, or even more ephemeral items, such as trading stamps, and the photos are likely to be of the less attractive features of modern life — race riots, auto crashes. The repetition of these images produces two dominant effects. It insists that the real world cannot be captured in a single instantaneous snapshot, but consists always of a process continuing throughout a duration of time. Warhol has found a new way of conveying this sense, which is basic to modern science. Secondly, the reiteration in effect universalizes the detailed or matter of fact image, much as an 'abstraction' of it would do. One is forced to see the Race Riot, not merely as something which lasts through a period of time, but as the essence of all race riots, not a specific scene from a particular one. These are very interesting and important effects.

But in general the imagery utilized by the Pop artists is even further removed from science itself than that which was exploited by Léger, or even by the Futurists or the Dada-Surrealist tradition of Picabia and Max Ernst. These employed shapes from science itself, or from science-based industries. The Pop artists draw their imagery from the publicity material produced by a substratum of commercial art workers, to illustrate these same forms, or to romanticize them in the guise of science fiction. There is something almost cannibalistic in all this. One group of people going through an art school training earn a relatively modest living by turning out art work for advertising agencies and magazines. Another group, having gone through the same art schools, make the grade as real Artists, and are exhibited in Bond Street and the East 50s, for playing sophisticated tricks with the works turned out by the first group. This is a far less simple and straightforward way of relating to the environment created by science-based industries than was the communist-peasantlike simplicity of Léger, or even the gaiety of Stuart Davis.

In America this type of Pop succumbed rather quickly to the urge to build everything up to at least one hundred and fifty per cent of size, which is one of the less amiable aspects of that, on the whole, endearing country. Witness, for one example, the following criticism[4]. 'The content of Wesselmann's *Still Life* [p. 198], like his later *Great American Nude* series, is heavily erotic without being at all sensual in a much less obvious manner than Lichtenstein's. The increase in subtlety, to the adult viewer, is probably due to the fact that we are more familiar with slick magazine ads filled with organic quasi-genital forms than we are with comic books. In fact, many appear to be so

196

114. Wesselmann. Still life

familiar that they miss the Madison Avenue sensuality entirely; incredible as it seems, Wesselmann does not offend. Even "the hidden persuader", a gurgling sound from a speaker concealed behind the works, drew only smiles.' This has got about as much to do with the spirit of science – even psychological science – as bacteriological warfare has to do with biology.

English Pop of this type, as might be expected, played it with a considerably straighter bat – unless, of course, like the gallery-goers of whom Barry Lord complains, I am just so unsophisticated that the underhand trickery fails to register. They generally use popular images with a good deal more immediate impact than a carton of Lipton's tea-bags – the Beatles, cine-star sex idols, girl wrestlers, and so on; and they treat them in ways, most of which call for the description of 'sweet and pretty'. Peter Blake, for instance, is unashamedly nostalgic, treating cardboard romantic personages (the Beatles and the girl wrestlers belong to him) in a technique halfway between the coloured supplements to Pear's *Christmas Annual* at the turn of the century and the blurry advertisements for a touring circus that you can still sometimes come across in old-fashioned pubs in out-of-the-way parts of what is left of rural Britain. It is prettiness, again, which is the most obvious characteristic of David Hockney, who is often acclaimed as one of the leading English Pop artists. He is a serious

artist notwithstanding, and uses a vocabulary derived from magazine illustrations and other aspects of admass art work to produce pictures whose affinities are much more with Art Nouveau and Matisse than with any Madison Avenue technological infra-psychology.

There is another aspect of Pop, primarily American, which has some relevance to our theme. Some Pop artists have felt that, following the all-over and nebulous character of the typical abstract expressionist paintings, they had become 'eye hungry'. They craved for an image with firm outlines and a smacking visual impact. Again, it is a feeling which affected the Cubists in their time. It was not many years after Cubists had been painting pictures, like that on page 14, that we find them producing works like the one on page 21, with its strong black outlines and areas filled with tone rendered in coarse dots or lines. At least one Pop artist, Roy Lichtenstein, came to a surprisingly similar result, though he followed a very different course to reach it. He took his simplified outlines and textures from the graphic techniques that had been worked out to produce illustrations suitable for reproduction by the mass printing methods used for newspapers and similar ephemera. The basis of his vocabulary is essentially mechanical, whereas that of the Cubists was to a very large extent hand-made, although they included some mechanically reproduced materials

198

115. Lichtenstein. Seascape with clouds (1965)

in their collages, for example pieces of newspaper and so on.

It is clearly the mechanized — that is, ultimately science-based — character of these printed textures and lines that provides one of the main stimuli to Lichtenstein's work. He always emphasizes this character by enlarging the scale so that an area of circular 'half-tone' dots, intended to fuse into a uniform grey, is changed in his pictures into an area in which the regularly spaced dots are insistently visible. This is another version of the exploitation of machine-produced shapes, but Lichtenstein uses these to comment, not on the external world which is studied by natural science, but on existing pictorial works which have been made by other artists reacting to the natural world. One of his pictures, for instance, is derived from a printed reproduction of a Picasso painting. More

usually and. characteristically, the representational element is taken from a level even further removed from natural objects — from the conventions of commercial art work, which themselves are simplifications of pictorial methods invented by a still further stratum of artists who may actually have looked at nature. He uses, for instance, drawings taken from comic strips, or conventional clichés for everyday articles like a hot dog. The intellectual content of such paintings is subtle and complex. It certainly expresses some kind of a love-hate relationship. He seeks (according to the anonymous author of the catalogue of the recent Gulbenkian exhibition at the Tate) 'an involvement with what I think to be the most brazen and threatening characteristics of our culture . . . things we *hate*'. He plays it very cool, and he has said[5] that he was trying to illustrate 'passion, fear, violence

199

116. Lichtenstein. Girl with mirror (1964)

in an impersonal, removed, and mechanical manner'. It would be outside the scope of this book to try to particularize his emotional and intellectual outlook any further; it remains too completely within the art world, in which one painter is reacting to what other artists have done, with the final far-removed anchor in reality in the form of a reference to an emotion rather than to a natural object.

This exploration of the relation of symbol to symbol, with an emotional response in the background, is also the field of work of another recent Pop, or near-Pop artist, Robert Indiana. His paintings consist of severely formal arrangements of highly simplified letters, usually painted in strong and aggressively contrasting colours; and the letters spell highly loaded words or phrases, such as EAT, DIE; LOVE; YIELD, BROTHER. The content of these huge pictures, which have been compared to highway signboards, however intriguing, is not a part of our theme. The main importance in our context of Lichtenstein, Indiana, and other similar painters is their purely visual quality. They have been some of the most important influences in bringing back to painting the powerful visual impact of simplified forms and unified areas of colour. This is a great contrast to the soft-edged, all-over messiness characteristic of the painters of the

200

[58] Lichtenstein. 'This must be the place'

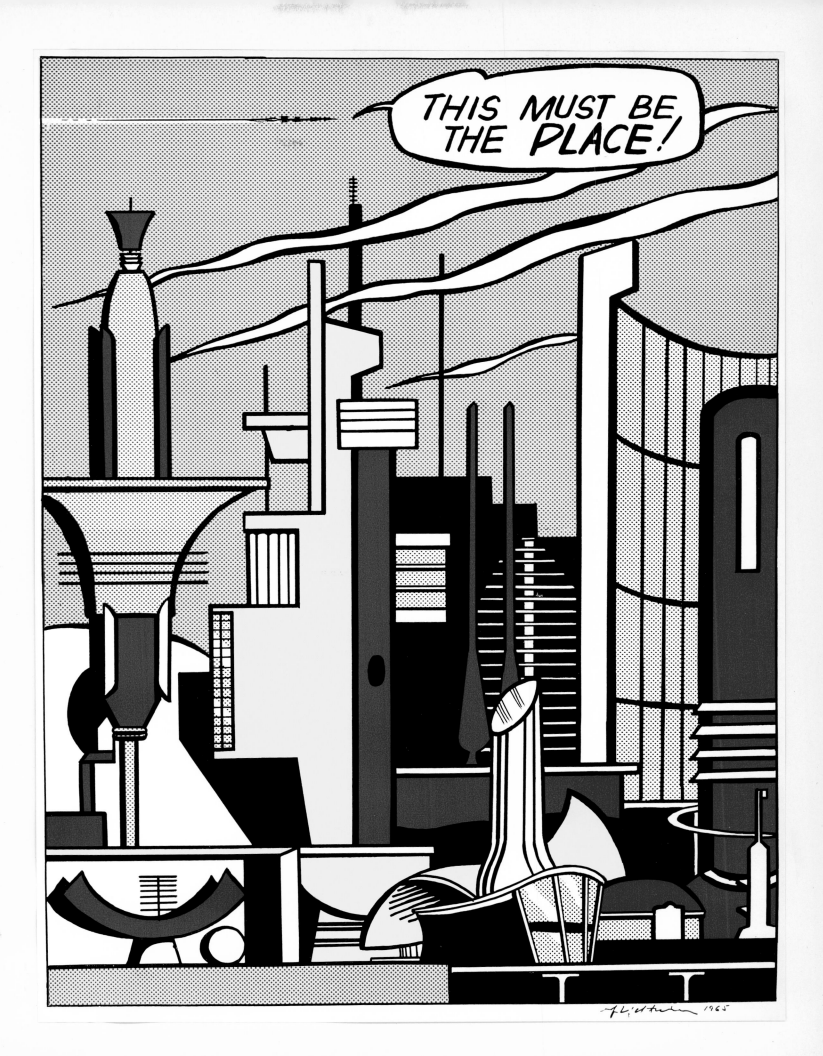

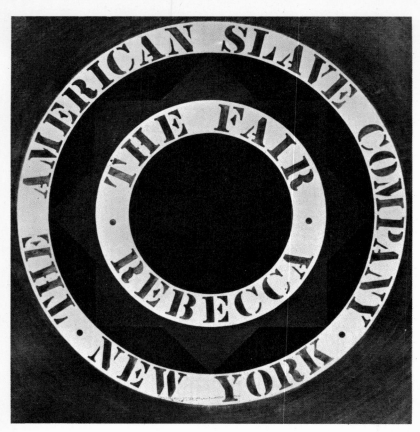

117. *Indiana. The Fair Rebecca*

immediately preceding generation. In general, as I have argued, modern science deals with 'soft edge' concepts, but it has also an aspect, which painters like Mondrian seized on, in which it attempts to operate with precisely defined concepts related to one another by clear logical processes. It certainly produces results – Men are Descended from Monkeys – Most of a Solid Object is Empty Space – which produce an immediate impact, and which look simple enough and hard-edged enough until one examines them in detail. The inhabitants of the world of scientific culture are likely to feel the need for a proportion of bold simple forms in the paintings they keep in their surroundings.

The challenge of the Pop movement lies in the apparent magnificence – but I will return to this – of the ideals it sets out to realize and the profundity of the questions of social-artistic philosophy which it raises. Its aim is nothing less than to create an art which is enjoyed by everybody. A leading writer on art and technology[6] gave an adult education course on 'the principles of basic design' in Norfolk, and everyone had enormous fun looking at pictures and doing abstracts; 'and, at the end, one of the girls in the class said to me: "It's been very very interesting, Mr Banham, but I still like Giles [cartoons] better".' And what Pop sets out to do – as Léger did before – is to be as Popular as Giles, and Art into the bargain. It uses raw materials which have been accepted as universally enjoyable. *Everyone* is expected to get a kick out of

at least eighty per cent of the last ten Playmates of the Month in *Playboy* or the current month's Top Ten discs; and no one is supposed to be afraid of any of them, unless he has been indoctrinated out of the common body of humanity by some form of orthodox academic 'education'. Pop is the latest phase of that persistent and appealing attempt which Paolozzi expressed, in a phrase I have already quoted, as 'the golden ability of the artist to achieve a metamorphosis of quite ordinary things into something wonderful and extraordinary that is neither nonsensical nor morally edifying'.

It faces us again with the question whether this endeavour is really as 'appealing' as our sound democratic principles would lead us to think, at first sight. One question that arises is a sociological one. Is it the case that in our society — and perhaps necessarily in any complex multi-levelled society? — there is an ineluctable opposition between the popular and the artistic; so that Pop Art (both words capitalized) is a contradiction in terms? Pop means Popular, enjoyable immediately, without any glance over the shoulder, but Art is a part of Culture; and to Culture most people react, not so brutally as Goering, who reached for his gun, but rather like the character in Lewis Carroll who silently faded away. Is it possible that the whole of this notion, of an entire civilization permeated by a Culture which is an organic unity, from its roots in the common man in the street to its freshest blossom in a Bond Street gallery, is nothing more than a myth put over on us by romantics who daydream about an imaginary Golden Age in the past? Scarcely anyone today has the face to pretend that the Greeks had a Popular culture; after all, it was the *citizens* who condemned Socrates to death and banished Pericles and Alcibiades — heaven knows what the masses, the slaves, would have done. It is, mainly, the Middle Ages that are held up as an example to demonstrate that a total integration of individual sensibility throughout the whole range of a civilization is a possible ideal to aim at. The message has been dinned into us by a whole series of writers, from Ruskin and Henry Adams, through a variety of interested Catholic parties, to D. H. Lawrence. But can one really believe that any arbitrarily selected thirteenth-century clodhopping peasant was as good a man at building Chartres Cathedral as any other; or even knew what it was about, when built?

I am not sufficient of a social historian, or social anthropologist, to answer this question with any confidence. But my slender experience suggests some scepticism about the belief that when a culture achieves a general diffusion within it of artistically valuable objects, this success is founded on a development of what the masses of the people would choose if left to themselves. I was recently, for instance, in the Oaxaca valley of Mexico, where the people were until the last few years living in an essentially medieval state of civilization. The

household pots and crockery of this now rapidly vanishing culture attained the high general level of beauty and artistic worth that we are so often told characterizes these vanished Golden Ages. But they were not Popular products within the meaning of our recent manifestos. They were made, not by the people at large, but by highly trained specialists; for instance, a particularly attractive type of jet black ware, inscribed with rather Picasso-ish drawings in dull gray tones, is produced only at the village of Coyotepec, where practically every household is engaged in their manufacture, and has been so engaged since pre-Aztec times, at least a thousand or more years; they are not less specialists than a painter issuing from the Royal College of Art, they are in many ways much more so. Perhaps these integrated societies – in so far as they genuinely are integrated – approach this romantic ideal more because the ordinary man is willing to go along with the various kinds of specialists than because the outstanding creators bother to find out what the ordinary man thought he wanted before he knew any better?

There is another question which the Pop movement raises which goes even deeper. Suppose we grant that our society at this time is organized in a way which tends to isolate the masses of the common man from the creative artists, and allow, for purposes of argument, that other forms of society might not erect such barriers between them. Even so, to what extent is it reasonable for the artists to look to the taste of the man in the street as a basis on which to build? Conventional democratic principles suggest that he should. But professional scientists would never dream of doing so. They may, of course be bullied and pressured into producing what society demands of them – an atom bomb or a moon probe – just as workers in art find themselves forced into designing the 1968 Cadillac or Guinness poster. But this is not science run by scientists, or art run by artists. When scientists have the opportunity to do what they want to do, they certainly do not turn to the general public as a source of ideas. A plain-man do-it-yourself quick-return theoretical physics or molecular biology hasn't much to be said for it. It has something. An appeal to the ordinary man might, and should, evoke the response 'Are you sure that it is more important to understand the interior of the atomic nucleus than to find how to manage the synthesis of beef without all this unaesthetic and inefficient business about cows?' The value his comments might have to scientists would be in such general directives, not in providing detailed items for inclusion in scientific theories.

May not the same be true in art? Is not the working up of strip cartoons into pictures for the Gulbenkian Exhibition at the Tate Gallery rather like trying to incorporate the Astrology column from the *News of the World* in a just-developing theory of cosmology? Pop art looks to be in danger of falling into the great Democratic Fallacy: because any man is as valuable as any other in the sight of God, he must therefore be considered just as good as any of his fellows for carrying out the particular job that we happen to be interested in just at this moment. Scientists, as a professional group, have little truck with this *non-sequitur*. They accept, on the whole, that some of their colleagues are worth a Nobel Prize, others not; and do not always feel, even secretly, that they themselves are among those worthy.

It is a sign of the vitality of the Pop movement that it raises questions of such a fundamental nature; but it still remains, I think, pretty doubtful whether it can provide any new and enlightening answers.

Some formally simple painting styles

Many people are still tempted to think that any painting which employs simple, more or less geometrical forms must *ipso facto* have something to do with science. In a very remote way this may be true, since it was a reaction to science in the times of the first Cubists that made it acceptable to put forward a painting containing nothing but geometrical shapes. However, this is now very ancient history, and there are many painters today who employ such shapes but who have only very slight interest in the state that the dialogue between science and painting has reached at the present time. People who approach paintings from the profession of the arts will know this very well, but it may be advisable to mention some of the better known of these developments to sound a note of warning to gallery-going scientists.

There are a number of artists – Morris Louis and Kenneth Noland being the best-known Americans; Dorazio, a European working somewhat later in a related manner – who use brightly coloured areas or stripes of a geometrical or near-geometrical form. The colour is often applied by soaking liquid pigment into absorbent canvas rather than by the application of solid paint. With Noland in particular the forms may be almost strictly geometrical: for instance, a series of concentric circles. This geometrical image is used for quite different purposes either from those which it would have had in a late Kandinsky or in one of the series of *Targets* by Jasper Johns. Noland's intention is primarily to produce a lyrical feeling by the manipulation of colour, and he is deeply concerned with such matters as after-images, induced colours, contrasts between hard clean edges for the coloured areas and softer boundaries, and the like. A concern with the niceties of colour vision has also, as we shall see, engaged the attention of artists working in the geometrical constructivist

tradition, such as Max Bill (p. 206), but for Louis, Noland, and the artists we are considering here, the colour interest is primary, and the apparently geometrical quality of their forms has little to do with their real objectives. They can perhaps be regarded as the progeny of Rothko and Still, and before them of Delaunay and Kupka, much more than as a late development of the tradition founded by Mondrian.

There is another type of recent geometrical painting, often referred to as 'Hard Edge'. This is much closer to the old geometricizing tradition, but even so most of it seems to me to have little to do with the scientific picture of the world, although it may be developing – particularly perhaps in sculpture – in directions which will make it very relevant to the subject we have been discussing here.

The mere chronological facts make it clear enough that recent Hard Edge is one of the phases of reaction against the 'soft edge' of the New York style abstract expressionist school. Before considering the reaction, it is worth glancing at where this tradition had got to, ten or fifteen years after it began. It is not, I think, mere chauvinism to argue that its real creative vitality had migrated across the Atlantic to London – and perhaps across the Pacific to Japan – at any rate into countries which were not so affluent that an artist was pressurized into thinking more about his sales rating than about his canvases. A good example is Patrick Heron – I have chosen a picture representing a rather early phase of his abstract work to illustrate the continuity with his forerunners. It has not the immediate shocking impact of Pollock, de Kooning, or Kline; it is more on the level of Brooks or Guston. And Heron has developed subtleties of reverberations between not too dissimilar colours, rather than the vociferous confrontations between hues and tones which the initiators of the school employed. But his paintings still imply that things – represented on canvas as shapes – vibrate out into their surroundings and impinge on other things around them. Each form is – in the Whiteheadian vocabulary – a concrescence of all the others which it prehends into itself. Heron, like Guston, expresses this in colour, not in line as Pollock or Tobey might do; but he is still operating in terms of an everywhere-dense continuum, with the regions which are a bit more dense than others related to each other by intergradations, and by resonances and antiphonies of colour.

It was against this that the Hard Edge school asserted that, after all, things have outlines – an essentially reactionary statement, because at a fundamental level, for science, that is, for our real understanding of the material world, things do *not* have precisely defined boundaries. Some of the apparently 'hard-edged' painters of today implicity acknowledge this, either by juxtaposing

along a line two areas of colour of such contrast that they excite sensations of induced colour which dissolve the sharpness of the boundary (e.g. Max Bill, p. 211), or by exploiting an ambiguity in which a colour changes from being used as a line to limit something else to becoming an area which is itself confined by some other line (e.g. Robyn Denny, p. 215).

One of the features of Hard Edge is that, usually, any given canvas contains only a part of a complete geometrical form. One may, for instance, have a rectangular canvas which is divided into two areas by the arc of a circle whose radius is very much greater than the longest dimension of the picture and whose centre lies well outside it, either above or below, or to the sides. Even when the forms are not geometrically regular, they often imply some general shape which would need to be completed outside the limits of the canvas (for instance in the Ellsworth Kelly on p. 206). These paintings therefore do not operate in the usual manner of most geometrical art, where one is concerned with the relation between geometrical forms which are fully delineated and are placed in particular relations to one another within the area of the canvas.

A second characteristic of most of the paintings of this type is their enormous size. They are literally as big as the wall of a room, and they were intended to be exhibited in places where it is impossible to get far enough away from them to take in the whole thing within a single field of critically sharp vision. One of the intentions of the painters was that they should be not so much an item in a visual environment but should rather constitute a total visual environment, filling up the field of sight to the very edges of peripheral vision. The method was used in the early forties by Barnet Newman, who usually employed shapes of the most extreme purity – often no more than a few thin precise vertical strips. The more recent painters we have just mentioned are also mainly concerned to provide a total visual environment, but the shapes they use endow this with a quality of dynamic forcefulness and vigour. This is, on the one hand, not unlike the muscular slashing energy so well conveyed in a less neat and tidy idiom by Kline; but on the other hand, the pictures also carry a hint – just because of their clean, hard outlines – of the presence of unseen fields of force, of the kinds with which physics deals and which are invoked by the magnetic sculpture of Takis (p. 228).

It seems likely in fact that it will be sculptors who will develop this scientific theme from its so far tentative expressions within Hard Edge painting. These sculptural developments, quite largely based in Britain, are going in a number of directions. Some sculptors, such as Anthony Caro, share with the Hard Edge painters the desire to create a total environment rather than a mere isolatable item within a larger living space – some of

[59] *Heron. Blue painting – Venetian*
Disc and Black Column (1960)

his sculptures are spread out over a considerable area and the spectator is intended to get inside and walk around. Others, such as Philip King and Richard Smith, still produce objects which are circumscribed in space, but colour their sculptures in ways which are clearly related to the recent types of Hard Edge paintings. It is I think too early yet to know just how far and in what directions this movement will develop, but it is one which the scientist interested in the arts should follow with interest.

New developments in the geometricizing tradition

Geometrical painting, of the classical kind which goes in for hard-edged rectilinear shapes, has continued right through the post-war period to the present day; but, as was pointed out earlier, at the cost of restricting its range so as to become merely one narrow specialization. There have, however, been several other and fresher developments within the general field of art originally opened up by the Geometricizers and Constructivists. Many of these have been in sculpture, but there have also been movements in painting which are closely related to science.

Max Bill, and his followers in Germany and Switzerland, derive rather directly from the Bauhaus. Bill, who was a student there for several years, is in fact one of the very few Bauhaus offspring who are still actively creating. Possibly this is because he reacted intensely to several of the many strands of thought and feeling which gave so much richness to that astonishing place. He made a profound study of the painterly technicalities which Klee and Kandinsky expounded in their lectures, and his own works are still quite largely concerned with such matters as the organization of the visual-aesthetic movement of forms

205

[60]. *Kelly. Blue Green Red I (1965)*

within the picture surface, how to place and colour lines so that they appear both to leave the picture-plane and at the same time not to break it up, how to exploit the fleeting after-images and induced colours which result from juxtapositions of hues.

These professional niceties are explored by the use of forms which are often unequivocally derived from mathematics; a picture may have a title like *Construction on the formula* $a^2 + b^2 = c^2$. Whereas the earlier artists who worked in this direction have, by their use of simple geometry, given their work a generally mathematical flavour, they have, in fact, not used mathematics, and indeed many of them,

such as Gabo, have gone out of their way to emphasize that they are not operating by mathematical principles. On the other hand, Bill writes[7]: 'I am convinced of the possibility of developing art wherein the mathematical approach is fundamental. Such a concept will immediately arouse strong objections. It is often held that art has nothing to do with mathematics and that the latter is a "dry" inartistic matter; a subject only for thought, and as such incompatible with Art.'

In arguing his case he first of all points out that the art of Mondrian, who attempted to be so pure and objective, is actually a highly subjective

206

[61] *Richard Smith. Painting*

118. Max Bill. Variation 15 (1938)

design on a surface, mark approximately the same stage in the search for new means of artistic expression as did the discovery by the Cubists of the African sculptures. . . .'

In its simpler forms, this mathematics-based painting found such expressions as the use of defined simple systems of proportion to determine the layout of pictures in the central highway of the geometricizing tradition. The illustrations on the last and next few pages show such principles were used, in the so-called *Cold Art*, to produce pictures that tried to combine the authoritative purity of Mondrian with a structure which could be intellectually grasped and enjoyed. They were not wholly unsuccessful, and these are some of the modern works in which scientists can most simply recognize a mental climate very closely allied to their own professional methods of thought. But perhaps the recognition comes too easily. Spatial ratios arranged in arithmetical or geometrical progression, and similar logical structures, belong to the comparative infancy of mathematics.

This is, perhaps, the place for an interlude on the by-no-means-negligible aesthetic impact of the translation of an artistic statement into the most overtly non-artistic scientific vocabulary. Max Ernst, many years ago, could 'artistify' drawings from scientific textbooks into such images as Figure 48, and Max Bill turn physical diagrams into paintings like that opposite.

Reciprocally, one can 'scientificate' statements which were initially made in an artistic or literary idiom. Take the opening lines of Eliot's BURNT NORTON:

> Time present and time past
> Are both perhaps present in time future,
> And time future contained in time past.
> If all time is eternally present
> All time is unredeemable.

and put this into scientific idiom:

If the set t_i includes the sets t_j ($j < i$, and $j > i$), then

$$t_i = \bigcup_{j=i}^{\infty} t_j$$

and so $\qquad t_i = t_j \ (\forall i, j)$.

It follows that no action taken at time i can modify the effects which action taken at time j ($j < i$) will produce on the end state of the system at time ∞.

(Not perhaps a very convincing theorem)

And this 'scientification' has actually been used as an artistic medium, for instance in Themerson's translation of the opening words of a Russian ballad[8], which begins

> Haida Troika
> The snow's downy
> The bells are ringing . . .

which he turns into what he calls 'semantic poetry':

performance which expresses Mondrian's own personal character. 'It is not merely incidental that his last paintings are titled *Broadway Boogie Woogie* and *Victory Boogie Woogie*, showing their affinity with jazz rhythms. The horizontal-vertical construction in his work is utterly subjective, despite the severity of the means of expression employed.' But Bill's main point is that mathematics is a form of conceptual thought and that conceptual thought is an aspect of the whole human personality, not something foreign to it, and that it is therefore capable of being, and he claims should be, incorporated into an artistic expression:

'It must always be emphasized that rational thought is one of the chief intrinsic characteristics of man. It is by means of rational thinking that we are able to arrange the sensorial values in such a way as to produce works of art. . . . Thus, even as mathematics is one of the essential forms of primary thought . . . it is also intrinsically a science of the relationship of object to object, group to group, and movement to movement. And since this science encompasses all these phenomena and gives them a meaningful arrangement, it is natural that these relationships themselves should also be captured and given form. Such mathematical representations have long been known to us. They emanate undeniable aesthetic appeal, such as goes out from mathematical space-models. . . . Such limiting instances, in which mathematics assumes plastic form or appears as colour and

Haida three large powerful solid-hoofed domesticated mammals with long coarse flowing mane and tail
all their 3 × 4 feet in the air together
all their 3 × 4 feet in the invisible elastic gaseous substance which surrounds the earth
all their 3 × 4 feet having no foundation in any substance capable of resisting penetration by other substances
— at one stage of each stride
and at another stage of each stride
all their 3 × 4 solid hoofed feet
no more in the air
but in the multishaped crystals

formed by slow freezing of water vapour.

I think that many scientists whose daily work is normally carried out in a medium of lab. jargon will recognize with pleasure the poetic contribution it makes to the flavour of these hybrid expressions.

But this remains at a fairly superficial level. Max Bill, at quite an early stage in his development, realized the need to look deeper.

[63] *Max Bill. 1–8 (1955)*
A development of a favourite theme of Max Bill, based on the fact that 1+2+3+4+5+6+7+8=36=6². In this case the depth of tone diminishes as the number of elements in the group increase. The groups with 2 and 3 elements are arranged linearly, the former vertically, the latter horizontally; the larger even groups form hollow figures, the uneven groups face-centred figures. The drawing on p. 208 is another development of the same arithmetical relationship, this time developed first into a series of non-face-centred polygons and then further elaborated.

5	7	4	2	5	7
6	8	6	8	6	8
4	7	5	7	4	7
3	8	3	1	3	8
5	7	4	2	5	7
6	8	6	8	6	8

119. Max Bill. Cool partitions

'The process of mathematical thinking in contemporary art is not mathematics in itself, and hardly makes use of what is known as exact mathematics. It is primarily a representation of rhythms and relationships, of laws that have their own specific origin, even as mathematics had its mainspring in the original thinking of pioneer mathematicians. Euclidean geometry, which the scientist today considers as possessing only relative validity, is now also relative for the artist. The

120. Max Bill, drawing

concept of finite infinity, an indispensable postulate in mathematical and physical thinking, is likewise of vital importance in the realm of artistic creation. It is in this sense that art today creates new symbols, which, although their fundamentals of perception may be traced back to antiquity, are more successful than any other media of expression in fulfilling the subjective world of our era. The mystery of mathematical problems, the inexplicableness of space, the nearness of distance of the infinite, the surprise afforded by a space beginning on one side and ending in a different form on another side, congruent with the first; limitations without fixed boundary lines; the manifold which is none the less unity; uniformity which is changed by the presence of a single stress; a Field of Force; parallels that meet in the infinite and that turns back upon itself as presence; and then again the square in all its stability, the straight line untouched by relativity, and the curve, each point of which forms a straight line – all these things that do not seem to have any bearing on our daily needs are nevertheless of the greatest significance. These forces with which we are in contact are the elemental forces underlying all human order and are present in all forms of order which we recognize. These measurements therefore supply contemporary art with a new content; they are not formalism, for which they are often mistaken; they are not form signifying beauty, but thought, idea, cognition transmuted into form.'[7]

This is probably the clearest statement that any modern artist has given of his intention to take a scientific aesthetic – in Bill's case the aesthetics of mathematics, not of one of the more experimental sciences – as one of the main elements in his work. Of course it is not the only element. When I visited his studio, Bill was in a mood when he was tending to play down the importance of science in his work considerably more than he did in the essay quoted, which was written about 1949. He told me that one of the first experiences which influenced his artistic development was reading Jeans' book on mathematics and music. He stated that his main aim still is to produce visual works which have qualities of internal balance and self-sufficiency comparable to those of good music – an aim very like that of Kupka at the very beginning of the geometricizing tendency (see p. 22). His mathematics, he argued, did no more than provide formally defined and related units, out of which compositions can be made as music is composed in terms of a defined scale of notes. But in other of his works science has certainly been something more, as he claims for it in his essays. Sometimes mathematics has contributed one of the themes of the 'music' his painting creates, and not merely the units of which it is composed. The quiet and almost concealed richness of Bill's best work, which makes it more lastingly satisfying than it may look at first sight, derives from the multiplicity

of approaches, aesthetic and painterly as well as scientific, which contribute to it; but to acknowledge this does not make it necessary to overlook the importance of the scientific element.

I have quoted Max Bill at considerable length, not only because he has explicitly discussed his views on the relations of science and art, but because he is a central figure in one of the widespread movements in recent painting. 'Cool Painting' has become one of the dominant modes of the day, along with Op and Pop. There are of course many varieties of it, but they can mostly be regarded as developments of either or both the mathematical-geometrical tendency, and the almost intellectual interest in colour relationships and contrasts with which Bill was concerned. Tess Jaray's systematically linear networks are an example of the former, and she adds a new subtlety to the geometry by planning that the areas defined by the lines will look even more intricately, but still formally, transformed when the picture is viewed not frontally but from one side or from below. Robyn Denny and Peter Sedgley are among the many who are exploring new types of colour juxtapositions. Denny, for instance, is particularly concerned with the reverberations between somewhat muted colours which differ little in tone, the hues and colour intensities teetering from side to side on a tonal tightrope; but simultaneously his pictures have clear, often bilaterally symmetrical, but not entirely simple forms; they also exploit the 'Figure and Ground' ambiguity, with which Gestalt psychologists have been so concerned — any one of the colours in his picture reproduced here is in some places an area surrounded by lines of another colour, but in other places becomes metamorphosed into a boundary line. Many of his pictures express, not emphatically but very thoroughly, a sense of tight-knit organization of interpenetrating systems of equal importance — a very 'biological' concept conveyed through forms which, being rectilinear, are very far from those which biologists usually encounter.

Bill is perhaps even more a sculptor than a painter. There has in fact always been a strong movement towards sculpture among geometricizers, beginning with the early works of the Dutch and Russian pioneers. The early Dutch works were characteristically in a severe rectilinear style, while the Russians, such as Gabo and Pevsner, allowed themselves greater freedom to handle curved lines and planes, often defined in a way which left them transparent, for instance by modelling them in suitable plastics or by defining them by sets of stretched strings. In one of their first Manifestos,[9] in 1920, they proclaimed: 'We deny volume as an expression of space. . . . We reject solid mass as an element of plasticity. . . . We announce that the elements of art have their basis in a dynamic rhythm.' And their works have in fact more of the

121. Vassarely, drawing

213

quality of dynamism than the rectangular-plane constructions; there is space flowing through and around objects which themselves have an organized structure, usually involving several axes of more or less complex symmetry. They approach the 'resolved complexity' of the forms of living things; but they do not, by a long way, achieve it. And ultimately they too, like all the rest of the classical geometrical art, come to seem just one particular species of artistic expression, not the general paradigm for aesthetic creation which had been hoped for in the early days of enthusiasm.

Max Bill had added a very definite new factor to such constructions. He has brought to them not merely the kind of shapes that issue from three-dimensional algebra, but those of topology also. He was for some years fascinated by the Moebius strip — a length of ribbon-like form which is twisted once before its ends are joined together, when it makes a shape which, although pierced so that

one can pass through it, yet has only one surface. He has made a number of very satisfying sculptures on this theme, and also on that of another structure well known in topology, the Klein bottle. The quality of intellectual paradox inherent in these structures lends an added zest to his constructions, which, however, rely for their main effectiveness, as all good sculpture must, on the organization of the total mass.

Op art

The element of intellectual, and still more of visual, paradox, is a powerful influence in one of the most recent types of painting — Op Art, which can be regarded as a late derivative of this tradition. Like most widely practised types of painting, it cannot be simply and clearly delimited by a generally applicable definition. It is rather a coming together

214

[64] Tess Jaray. Painting (1967)

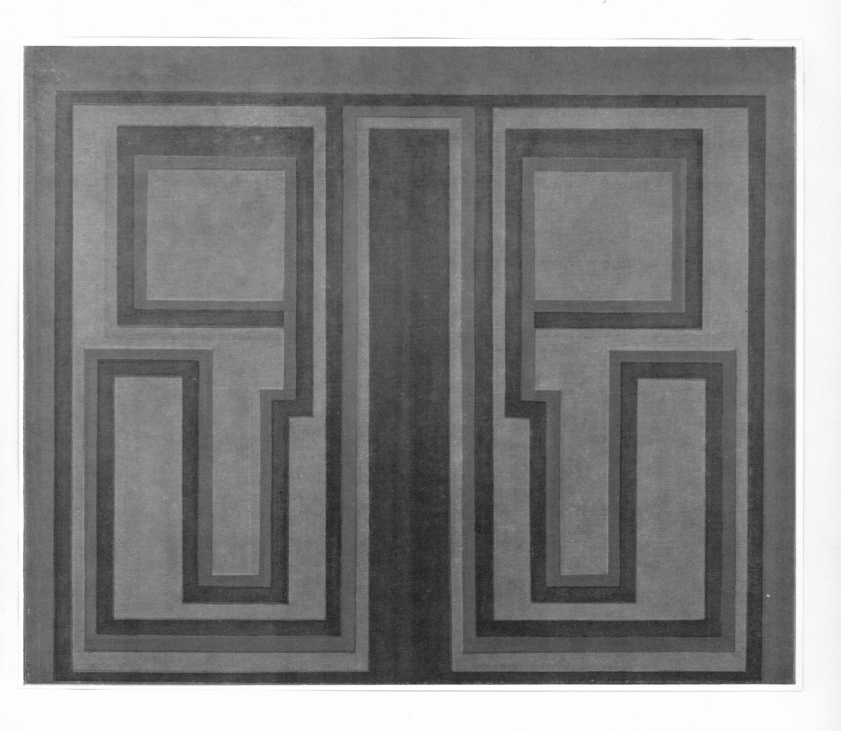

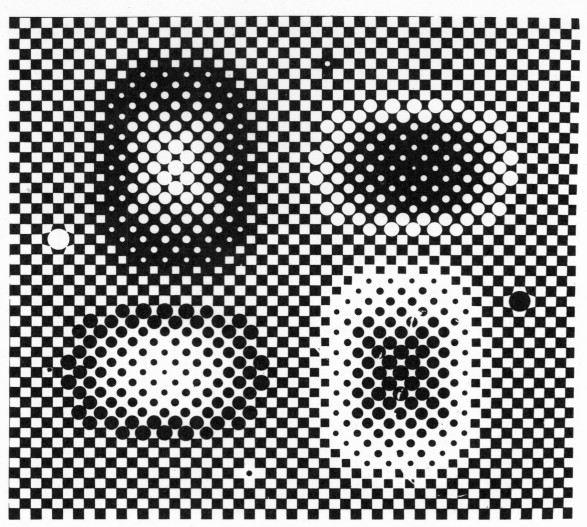

122. Vassarely. Metagalaxie (1964)

of several strands of interest, one or more of which may be absent from some works which would still fall into the general category. Perhaps its most general characteristic is some quality of visual paradox or ambiguity of perception. Such comparatively early works as the drawings by Albers on p. 49 illustrate one form that this can take. More usually, an Op work has a more all-over appearance, the whole canvas being covered by the repetition, with minor variations, of one or a few simple forms. There is often a good deal of logical formalism in the manner in which the repetitions and variations are carried out, and this provides a link with the mathematically planned design of the Cold Art pictures. A simple example is the drawing by Vassarely on p. 213, in which the arrangement of the white oval shapes is obviously by no means arbitrary, although the actual rules used are not immediately recognizable.

Some type of systematic planning is also clearly involved in the larger, more all-over designs by Vassarely and Bridget Riley (above and opposite). But these bring into very clear expression the

fascination of the Op artists with some of the more unusual phenomena of visual perception, of a kind that have often been studied by psychologists and neuro-physiologists interested in perception. As we saw, Max Bill passed on from the simple geometrical basis of Cold Art to devote himself to exploring less straightforward visual experiences, such as after-images and induced colour. The Op artists have so far been much more hesitant in the exploitation of colour contrasts, and have concerned themselves mainly with after-images, optical illusions, confusions between figure and ground, spatial ambiguities of far and near, and similar effects which can be produced in black and white paintings. Bridget Riley has told me that one of her main preoccupations – and the same is probably true for most of the painters in this style – is to make the picture surface alive instead of static and 'merely there'. She wants it to quiver in depth, and also to have apparent movement within it, from top to bottom or across. This is a new expression of one of the basic technical endeavours of recent painters – not to destroy the picture plane,

123. Bridget Riley, painting (1966)

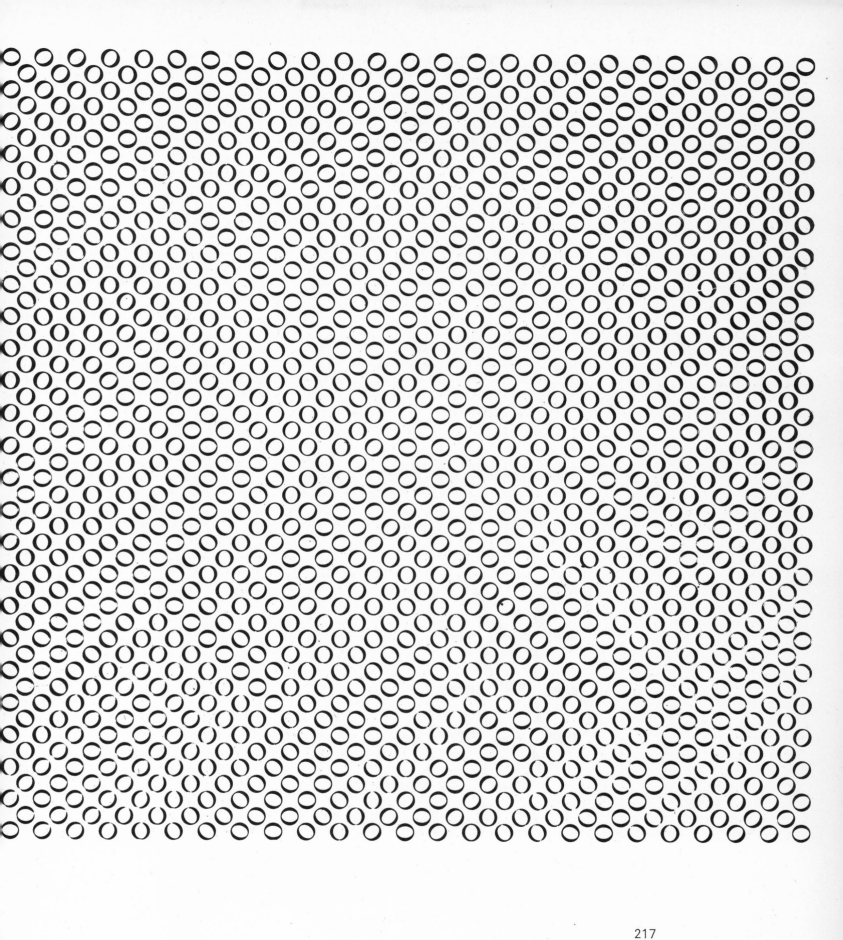

217

as a classical perspective painting did, but at the same time to 'quicken' it. Earlier, and quite different, approaches to a similar end were the theories of Hoffman about 'push and pull', and the experiments described by Kandinsky in his *Punkt und Linie zu Fläche*, and Klee in *Das Bildnerische Denken*. But these artists used more informal styles. Bridget Riley wishes to retain some of the austerity of the geometricizing tradition.[10]

She makes her designs by the arrangement of elements which are themselves relatively simple and clear-cut in shape – long lines with regular sinusoidal curves of various periods, black circles containing white ovals, and the like. These are modified across the canvas in some systematic manner, according to what, in science, might be formulated as 'field laws'. For instance, in the painting on p. 217 the alterations of the basic unit are made according to the scheme shown in the working sketch below; the axis of the inner white oval is moved systematically from vertically upright (north–south) through the horizontal (east–west) direction to the south–north orientation; the transition may be carried out slowly, boxing the compass in four steps per quarter (N, NNW, NW, WNW, W), or in two (N, NW, W), or in one (N, W). The units are arranged in sequences, along the diagonal lines; and within a line the sequences may all go at the same rate, or may begin fast and become slow after the first quarter-turn, and so on; and further, some vertical lines may operate as reflecting surfaces, at which the sequence running down from top left towards the bottom right is turned back to run on towards the bottom left. Her intention, as I understand it, was both to create an

impression of more or less rapid movements within and across the picture plane, and also, by exploiting the peculiar visual effects of repetitive patterns, to make this plane appear alive, jiggling, sparkling, ambiguous. This she often succeeds in doing. But sometimes a systematically applied field rule of gradual modification of a unit may result in an illusion of three-dimensional modelling which was not within the original intention. For instance, some of Riley's paintings in which circles are altered in a regular fashion into narrower and narrower ovals can only too easily be interpreted as representations of bent sheets of perforated metal. There is, of course, nothing wrong with a painter finding that he has produced something more than he had consciously set out to create; but in some of the Op paintings the inadvertent results may be so powerful as to tend to obliterate the original intention – they may be a bonus, but the proverb about not looking gift horses in the mouth is not universally applicable.

There are many other varieties of Op Art, many of them verging towards sculpture, employing three-dimensional constructions built so that the movement of the spectator creates an illusion of movement – or, indeed, employing moving elements in a way which gives rise to anomalous effects. For instance, geometrical forms can be repeated over two transparent surfaces placed one behind the other, so that moiré figures are produced and change as the point of view alters. An example of the use of actual movement: Soto has explored the effects produced by a linear shape, such as a piece of wire, placed some distance in front of a background ruled in black and white

124. Bridget Riley, working drawing

218

125. Bridget Riley. Fall (1963)

126. Soto. Vibration structure (1964)

lines of similar dimensions; even if the foreground wire is not mobile, the parallax resulting from movement of the point of view gives rise to peculiar effects, allied to moiré figures, and, if this wire is mobile, similar results are produced even to a stationary viewer.

Some of the Op artists, and also some of the 'kinetic' artists discussed in the next section, have expressed a conscious intention that their works shall exhibit what they take to be the basic qualities of the real world. One of the most explicit statements is by Agam. He has worked in a number of styles, nearly all of which involve some departure from the strict two-dimensionality of pure painting, but usually not departing so far from this as to qualify as sculpture. His work has always been concerned with ambiguity, or perhaps, one should rather say, with the concrescence of two or more things into one unity. He has usually employed some form of actual movement to bring about the change from the separation of the elements to their fusion. In one set of works, small forms are attached to the picture plane in such a way that the spectator can rotate them or move them from one position to another, bringing into being a number of different aspects of the work — aspects in which clearly there is participation of the spectator, and the distinction between the perceiver and perceived becomes blurred (see Chapter 4).

The works for which he is best known are painted on surfaces which are not flat but bear a series of narrow parallel corrugations, which may be flat-sided ridges, triangular in section, or thin blades set perpendicular to the surface. When such a structure is viewed from one side, only that aspect of a ridge or blade which faces in that direction can be seen; so by painting different forms on the various aspects of the corrugations, Agam can arrange so that the shapes and colours presented to the spectator change as he moves from one side of the work to the other. The elements in such a painting which are visible from the left side may be quite different from those seen from the right, and when the viewpoint is central the two different aspects fuse.

Agam has expounded the philosophical basis of his work in relation to Jewish religious thought. He has written[11]:

'The driving force and the source from which I draw my inspiration stem from my desire to give plastic and artistic expression to the ancient Hebrew concept of reality, which differs in its essence from that of all other civilizations, and which, to my mind, has never found true artistic expression.

'The basic principle of Judaism derives from the concept of one God. "One Being, yet unique in unity", until the very word "one" has no justification, for it is everything together which is the wholeness of the "form", and there is no end to form except in the complete form.

'The concept of Time in Judaism differs in essence from that of other civilizations, and constitutes, like the concept of God, one reality of its fundamentals. Other civilizations freeze Time and believe in things that exist despite Time (eternity). Such are the pyramid and the practice of embalming and the very fact of plastic expression which is conveyed by the freezing of Time and by the perpetuation of the ephemeral. As opposed to this the Jew finds himself in a world of reality which cannot be reconstructed. "For dust thou art and to dust returneth." All is transient.

'. . . My intention was to create a work of art which would transcend the visible, which cannot be perceived except in stages, with the understanding that it is a partial revelation and not the perpetuation of the existing. My aim is to show what can be seen within the limits of *possibility* which exists in the midst of coming into being. . . .'

Agam's points are perhaps not quite so specifically Jewish as he suggests, but belong to a kind of thought which is becoming more widely accepted within modern science. In the first quoted passage he insists that things do not exist in isolation from one another, so that there is no 'reality' except the complete reality in which everything is an ingredient. It may well be that it is only or primarily Judaism among religions which has stressed this, but it is also the basic outlook of an 'organic' philosophy, such as that of Whitehead. Again, Whitehead, and biologists in general along with him, would quite agree with Agam that time is an essential and not merely a contingent aspect of reality — the world is process, not things. Thus Agam is using these rather sophisticated techniques, allied to those of Op Art, to express characteristics of the world which are becoming

[66] *Agam. Transformable picture (c. 1961)*

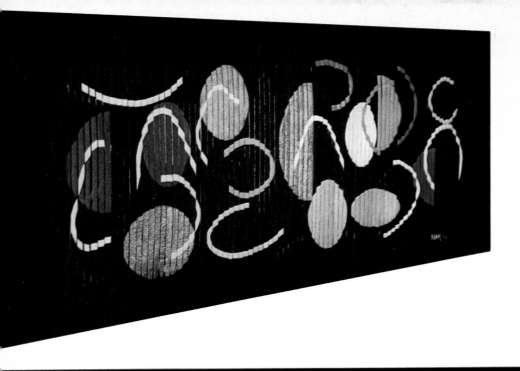

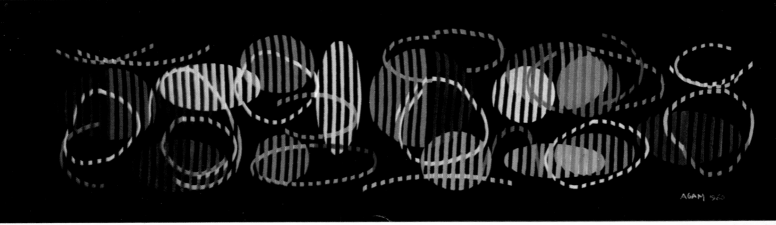

[68] *Agam. Two sideway views of 'Union' (c. 1963)*

of increasing importance within modern science. His own writings state that he derived these notions not directly from science, but from religion; but no previous Jewish painter seems to have felt that his religion impelled him to express this kind of view of reality, and it seems likely that we have here again an instance of parallel movements, more or less simultaneous within science and within other domains of human thought.

Most of the Op painters are not trying to express anything specific about science, or about the way in which scientific theory envisages the nature of the real world. They are basically concerned with matters which are of interest within the world of painting — movement of, and within, a surface, and the like. But they make use of technical means that are clearly related to diagrams and figures which are found elsewhere only in the context of scientific discussions. Many scientists are therefore likely to find their productions inviting, and in

some way 'up their own street'. Indeed, if one wants to be imaginative enough, one can feel, in the ambiguous, fluctuating space created by Op painters, where a figure comes and goes and changes into something else, some sort of embodiment of such scientific concepts as the modern picture of a molecule, in which all the distributions of electron density (diagrammed on p. 120) are superposed on one another. In my opinion, what the Op artists are trying to do is sufficiently interesting in its own right for an instinctive movement of sympathy on the part of scientists to be not inappropriate — particularly, perhaps, because of the threat to the artists' integrity of intention which arises from the commercial-publicity exploitation of the eye-catching impact of the Op idiom. Although the movement is still quite young, it has produced some artists, particularly Bridget Riley, who have shown that it can far transcend the merely decorative.

[67] *Bridget Riley. Deny (1966)*

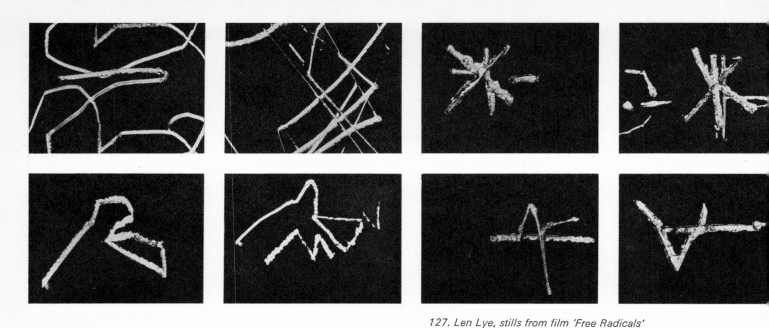

127. Len Lye, stills from film 'Free Radicals'

Movement and mobiles

No account of the place of geometricizing art in the world today could be adequate without at least a sketch of the use by recent artists of real, and not merely suggested, movement — although this is, for mechanical reasons, rather outside the field of painting, with which this book is mainly concerned, and more in that of sculpture, which is being touched on where unavoidable; but this is one of the contexts in which it cannot be omitted.

The most obvious method is of course the use of the cinema. Abstract films in which abstract shapes are moved around on the screen have been made since not long after the First World War. Léger was experimenting with at least semi-abstract films as early as 1923, but they did not come into full flower until the effective arrival of talkies, when the movements could be synchronized with music.

We get back nearer to our proper subject of painting in certain constructions in which the mobile elements are used to reflect or refract beams of light which then fall on a surface, the visual effect being primarily the movements of the light within this surface rather than the apparatus by which it is led there. There is a considerable group of artists, many of them from South America, whose work in this mode is winning a good deal of international recognition. For instance Le Parc has made some fascinating objects (pictures? devices?) in which some Calder-like flat shapes, suspended on threads which leave them free to rotate, reflect a light beam in patches and streaks on to a background textured plane; or a thin pencil of light is reflected backwards

and forwards between strips of flexible polished metal whose curvature is continuously changed by a motorized set of cams, finally becoming visible as lines of light moving across the back plane of the construction. Some of these works also incorporate 'eye-dazzling' effects similar to those used by Op painters; Soto, who is one of the South American group, has already been mentioned in this connection.[12]

One of the first artists to explore systematically the use of movement was Moholy-Nagy at the Bauhaus. But after a few experiments with moving parts of wire and metal, and with cinema films, he soon adopted as his main medium, not any material substance, but light itself— light projected, refracted, reflected, coloured, and varied in intensity. It is an enormously flexible medium and potentially very powerful. But it is a bother to handle, requiring a whole battery of apparatus and possibly a screen to project on to; a medium, most people seem to have thought, for a performance rather than for a work to be lived with.

A good deal of ingenuity has been devoted to producing colour-organs, that is, instruments in which a player has at his disposal a number of controls by which he can vary the colour, intensity, and direction of projected beams of light. One can, of course, programme such a machine to carry out some definite designed sequence, but the whole contraption is then becoming rather complicated. One of the artists who has explored these possibilities is Frank Molina[13].

A simpler scheme has been used by Hoenich. He is, like Agam, an Israeli, and lives in a place in which the sun can be relied upon to shine for much of the time. Hoenich arranges mirrors, lenses, sheets of colour or polarizing filters through which the sun's light is projected on a wall, such as that

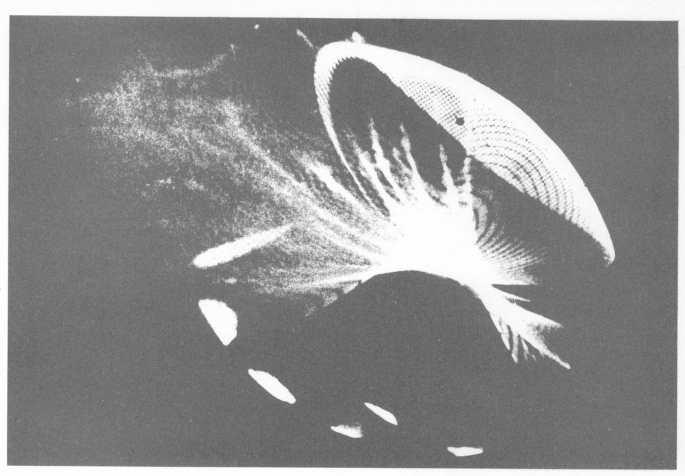

128. T. K. Hoenich, two projections of sun-rays, made
with one reflector at different times of day

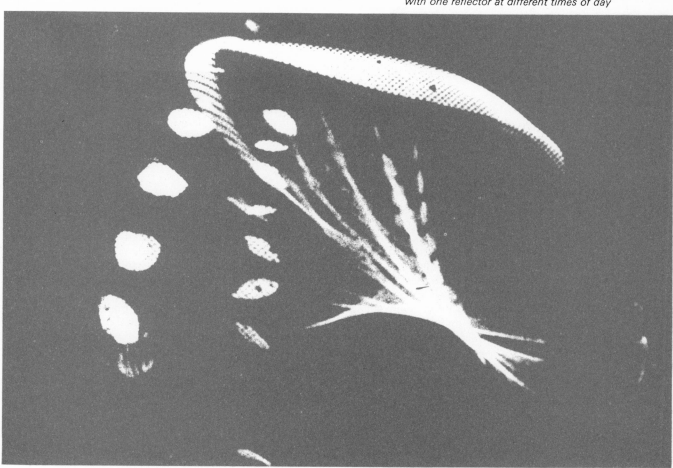

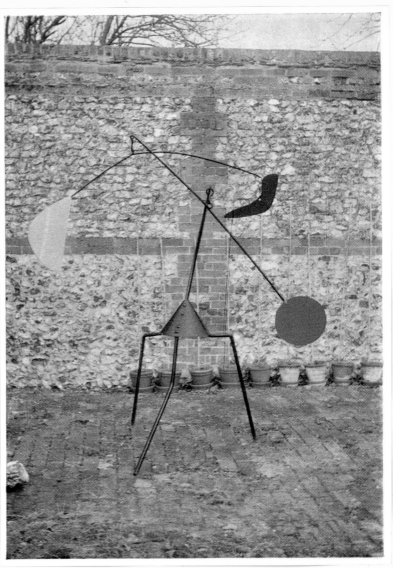

[69] *Calder. Mobile (1937)*

of a suitable building. The projected coloured images of course change as the sun revolves through the sky, and the sequence from day to day will alter more slowly with the seasons. This must be an interesting and demanding art-form to master, but I confess I have seen it only in photographs and never in reality.[14]

A somewhat more orthodox, and far more influential, step towards the introduction of motion was taken by the American sculptor Alexander Calder. The 'mobiles' which he began making in the early 1930s usually consisted of a number of forms, cut from thin sheet metal into shapes of a rounded oval or 'biomorphic' character, somewhat reminiscent of those used by Arp, which were suspended from thin metal pivoted arms in such a way that the whole contraption could rotate and oscillate up and down. They were of extreme grace and beauty, often seeming to combine some of the precision of bridge-building engineering with the

vivacity of young leaves sprouting on a bare tree in early spring. They are often discussed as though their main theme is the elegance and joy which they certainly radiate. But actually they seem to have had an origin much closer to geometricizing art, and to science and Calder's own education as an engineer. He himself thought of them largely in terms of astronomy. He is reported[15] as saying:

'My entrance into the field of abstract art came about as the result of a visit to the studio of Piet Mondrian in Paris in 1930.

'I was particularly impressed by some rectangles of colour he had tacked on his wall in a pattern after his nature.

'I told him I would like to make them oscillate — he objected. . . . I think at that time and practically ever since, the underlying sense of form in my work has been the system of the Universe, or part thereof. For that is rather a large model to work from.

'What I mean is that the idea of detached bodies

226

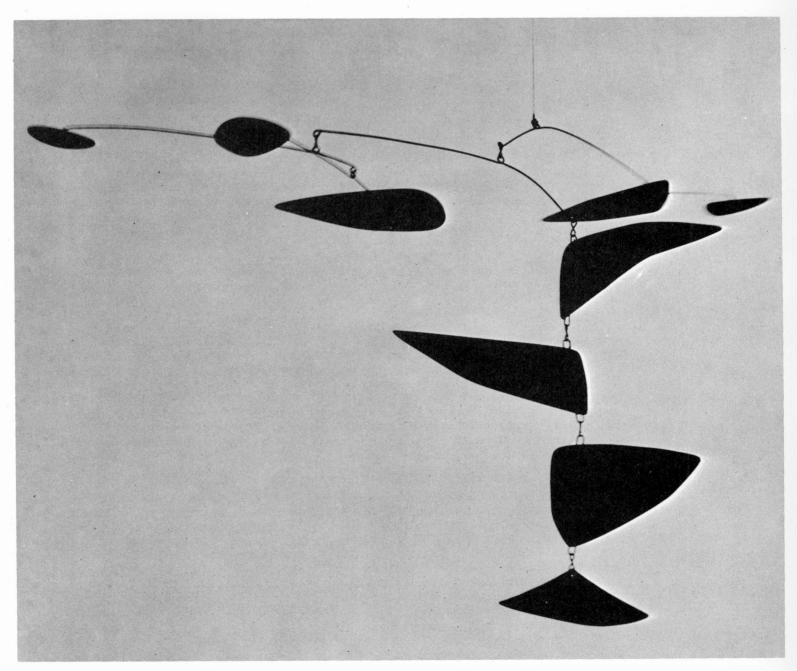

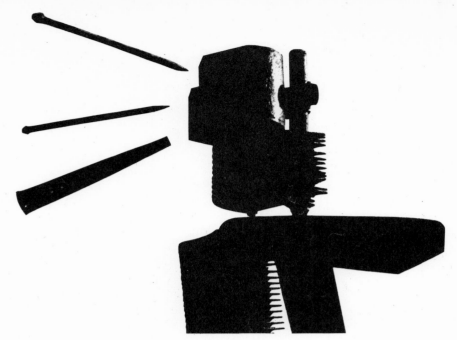

130. Takis. Telemagnetic sculpture (1964)

floating in space, of different sizes and densities, perhaps of different colours and temperatures, and surrounded and interlarded with wisps of gaseous condition, and some at rest, while others move in peculiar manners, seems to me the ideal source of form.'

We cannot here go into all the later ramifications of mobile sculpture, but there are some varieties which remain quite close to two-dimensional painting. Another obvious major factor to be introduced is motorization. Len Lye, who was one of the first makers of abstract films, has recently produced structures consisting of wands of spring steel, shaken at the base by electric motors so that they oscillate in the various wavelengths characteristic of their form, and so produce, under suitable lighting, a series of virtual volumes which can be controlled and sequenced by monitoring the motors. Or, as in others of his works, the structures can be designed to respond to such natural and random forces as the wind; in some of his metal fountains a bunch of thin steel rods, each carrying a heavyish ball at the tip, bend and sway in an unending dance responding to every breeze. Or, again, a motion can be built in which, though strictly determined, is so complex that only the most patient observer could deduce its laws.

Finally, the built-in motion can incorporate some stochastic element, such as loose bearings, ill-fitting gears, or a slipping transmission. One group, represented by Tinguely – an inheritor of Dada, but more of its politico-expressionist aspect than of its interest in the structure of the material world, with which we are primarily concerned – has invented machines, usually with a strongly stochastic element in their mechanisms, which perform

such evocative acts as destroying themselves, or spewing out interminable reams of the *cacoethes pintorum*. These are mechanized comments on the human situation rather than on the nature of the world at large; and not very profound ones at that.

An interesting recent development is the use, to hold the various parts of a sculpture in place, or to move them, of non-mechanical and indeed invisible forces, such as magnetic or electrical fields. Takis has exhibited a number of works in which large pieces of metal are poised in space, but are obviously not retained there – where they may vibrate slightly, but in general float more or less immobile – by any simple structural support. The effect on the spectator, particularly in those which tremble under the tension, is to make him vividly aware of the existence of unseen forces, which are, of course, far more in the centre of scientific interest than the old Archimedean Statics on which most sculpture is based.

All these moving devices are more or less fascinating to watch. In spite of the gimmickry to which they obviously lend themselves, the best of them, Calder's, Len Lye's, Le Parc's, use the new dimension of motion to make real additions to our aesthetic experience. It seems likely that this direction of advance, and the further exploration of the use of less obvious forces, as in Takis' magnetic sculpture, will finally be the most interesting of the offspring of the geometricizing tendency.

A new realism

There are today, as always, many types of realist painting. But there is one which it is important to

228

131. Len Lye. Rotating harmonic (1960)
A reciprocating movement is imparted to the lower end of a spring steel rod, which first goes into a standing harmonic wave-form, and then, as the energy increases, begins to rotate

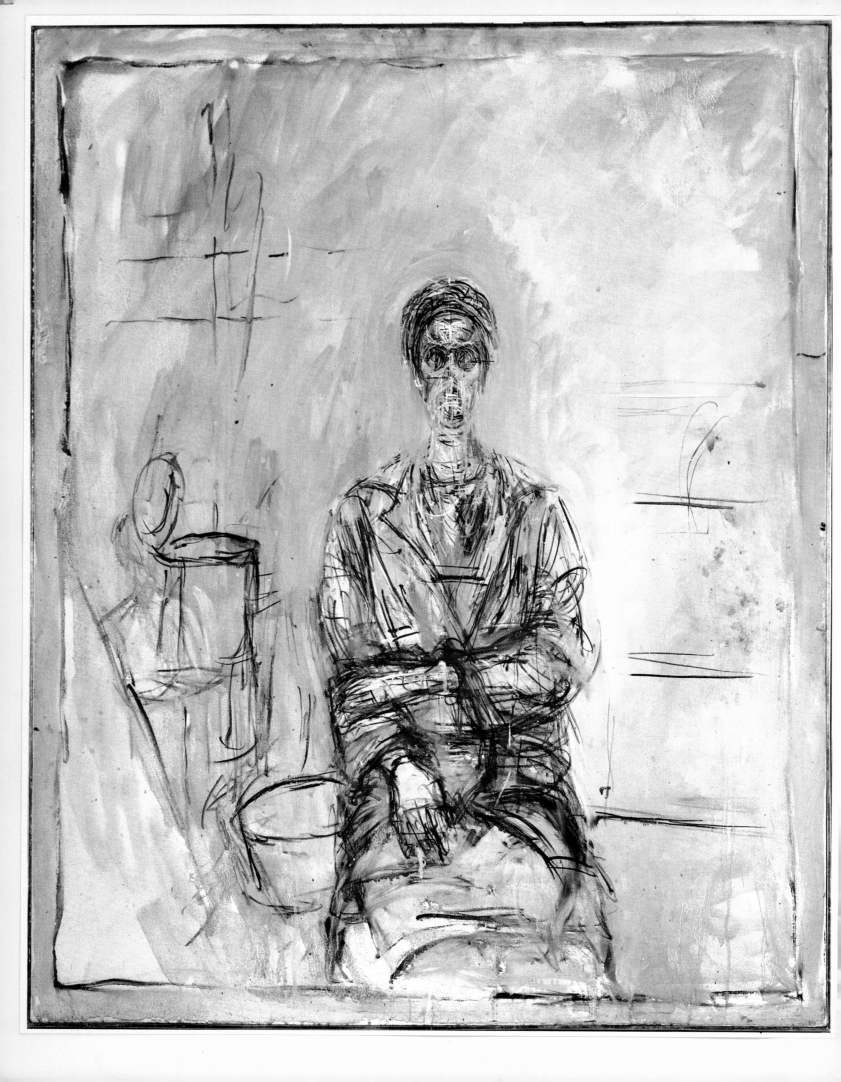

discuss in the context of this book — that associated with the name of Alberto Giacometti, who is not only perhaps the most profoundly original of all modern realists, but whose own explanations of what he is setting out to accomplish have been rather fully recorded. His early works were mostly sculptures, considerably influenced by surrealism. More recently he has devoted more energy to painting, though he remained, until his recent death, one of the most important of present-day sculptors.

Giacometti points out[16] that during the last few decades realist or representational painting has been very unfashionable: 'So, caught between the impossibility of competing with the photo, and the fear of making a picture which merely resembles all that one despises in former paintings — against which the abstract painters have quite sensibly revolted — painters no longer try to represent the external world. You could count on your fingers today the painters in Paris who really try to represent the external world.' But this is not really good enough; it is running away from a problem. And he pokes fun at the abstract painters who fetch a photo of their wife and family out of their pocket to show their friends. But, he claims, reality is not actually *like* the conventional realist paintings by which it is usually represented by orthodox Academy painters such as Bougereau; 'I have friends who say that they like Picasso because he doesn't make "resemblances". The same people claim that they see reality like Bougereau. And they try hard to make me say that it is the same for me. If that were true, I should prefer Bougereau to Picasso or Cézanne, because the thing that interests me in all paintings is resemblance, that is to say, what seems to me resemblance — what makes me discover a little about the external world.'

Giacometti is quite explicit that he does not see the external world in the way that our experience of conventional paintings has taught us. He describes an experience when he came to recognize this. 'Yes, as for myself I began to wish to represent what I see — basically — on the same day that there was for me for the first time a fundamental difference between my view of the world and the photographic or cinematographic view. That happened after the war, about 1945, I think. About that time I often went to the cinema. I came out of the cinema, I looked about the surroundings, I came out and I was in the road, in a café; nothing happened, absolutely nothing happened. That is to say, there was no distinction between my view of the external world and the view of that which went on on the screen. One was the continuation of the other. Up to a certain day when there was absolute distinction: instead of seeing some person on the screen I saw vague dark patches which moved about. I looked around at the people around and all of a sudden I saw them as I had never

seen them before. What was new was not what was going on on the screen: it was that which was happening beside me. On that particular day, I remember very precisely, coming out on the Boulevard du Montparnasse, having looked at the Boulevard in a way I had never seen it before. Everything was different, both the depth of space and the objects, the colours and the silence . . . because the silence counted, the film having been a talkie, you see. . . . Everything seemed different to me and absolutely new. . . . That day, reality became revalued for me, from top to bottom; it became the unknown, but at the same time a marvellous unknown.'

It is Giacometti's insistence on the impossibility of a complete knowledge of the external world, and the way in which he suggests we can approach it, which relates him to some aspects of recent scientific thought. He begins to describe his own outlook in some remarks about Cézanne: 'Cézanne's vision is, simultaneously, the most subjective and the most objective possible. Cézanne left totally out of account his emotional personality, or his desires — didn't he? Cézanne is almost like a scientist. If other people experience, subjectively, the sensation which he wishes to give them, and if several of them experience the same sensation, this sensation tends to become objective. There is something valuable for many people. The subjective becomes objective. . . . But in trying to render his vision of the world, exhibiting it by the force implicit in things, he could not see the Montagne Sainte-Victoire in the same way as it had been seen by the painters who preceded him. . . . It was necessary to create new means. He had to create new means just to the extent that he tried to express himself. Because it is in this way that he spoke of seeing reality in terms of cubes, cones, and spheres. It is obvious that these cubes, cones, and spheres were only means by which to get a little nearer to reality, and that the representation of the mountain or the apple was the essential. For him, the apple on the table was for ever, and by very far, beyond all possibility of complete presentation. He only approached it a little.'[16]

This is a statement which could be very simply transposed into an account of what most scientists think they are doing. They too are studying an 'external reality' — an apple on a table or a mountain, and these are Whiteheadian 'events', other than ourselves and impossible to comprehend in their totality. Science sees them, at any given time, with a particular vision — in terms of Daltonian atoms, or wave-mechanical quantum theories, or according to some other paradigm. And each paradigm is essentially something which was invented or created by man, perhaps in its beginnings by one man; but it becomes valuable when other people can use it also, and it then develops into a public property — the subjective, as Giacometti puts it, becomes objective. But no paradigm is

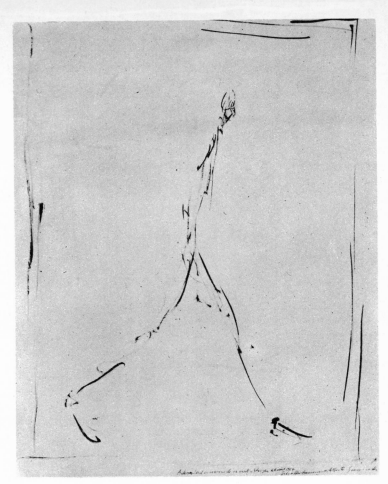

132. *Giacometti. Walking man (c. 1950)*

exhaustive; there remains always something more to be discovered about the apple, and sooner or later new methods, perhaps whole new branches of mathematics, will have to be elaborated to express something that the old paradigms had left out.

Giacometti is certainly one of those who has presented us with a new paradigm in which to see the world. It has, I think, two main characteristics: an insistence on the otherness of things, and the suggestion that what we know about them is not their own private essence – the Ding an Sich – but the influence they radiate on their surroundings. Both are essentially sympathetic to the modern scientific philosophy.

The first point is conveyed by the kind of space that Giacometti creates. His sculptured figures, for instance, always look as though they were far away, across the other side of some large open space. They have a peculiar and characteristic elongation, and Giacometti said somewhere that he tends to see people as though they stood out against the sinking sun, with their edges whittled away by the light refracted around them. In his paintings he draws, as it were, the space between him and the figure. 'Whatever I look at', he says,[17]

'everything gets beyond me and astonishes me, and I do not know exactly what I see. It is too complex. . . . It is as if reality is continually behind curtains which one tears away – and then there is another – always another. . . . And so one goes on, knowing that the nearer one comes to the "thing", the more it recedes. The distance between me and the model tends always to increase . . . it is a quest without end.'

It is more difficult to pin down exactly how he puts across the point that what we know about a thing is its *influence*. John Piper once made to me the illuminating comment that Giacometti is concerned to make, about reality, a statement that is not a description. And what is the statement about? In his conversation with George Charbonnier, Giacometti said[18] that the sculptures which most moved him had 'forms under tension', and a 'contained violence'; using the French word *violence*, which should perhaps in this context better be translated 'energy'. Charbonnier asked him if he saw this contained violence also in the real world, and Giacometti replied: 'I think so, yes. In everything. And further. It is really this that astonishes me; even in the most insignificant head, the least violent, in the head of the most delicate soft and

232

[71] *Giacometti. Personnage dans l'atelier (1949)*

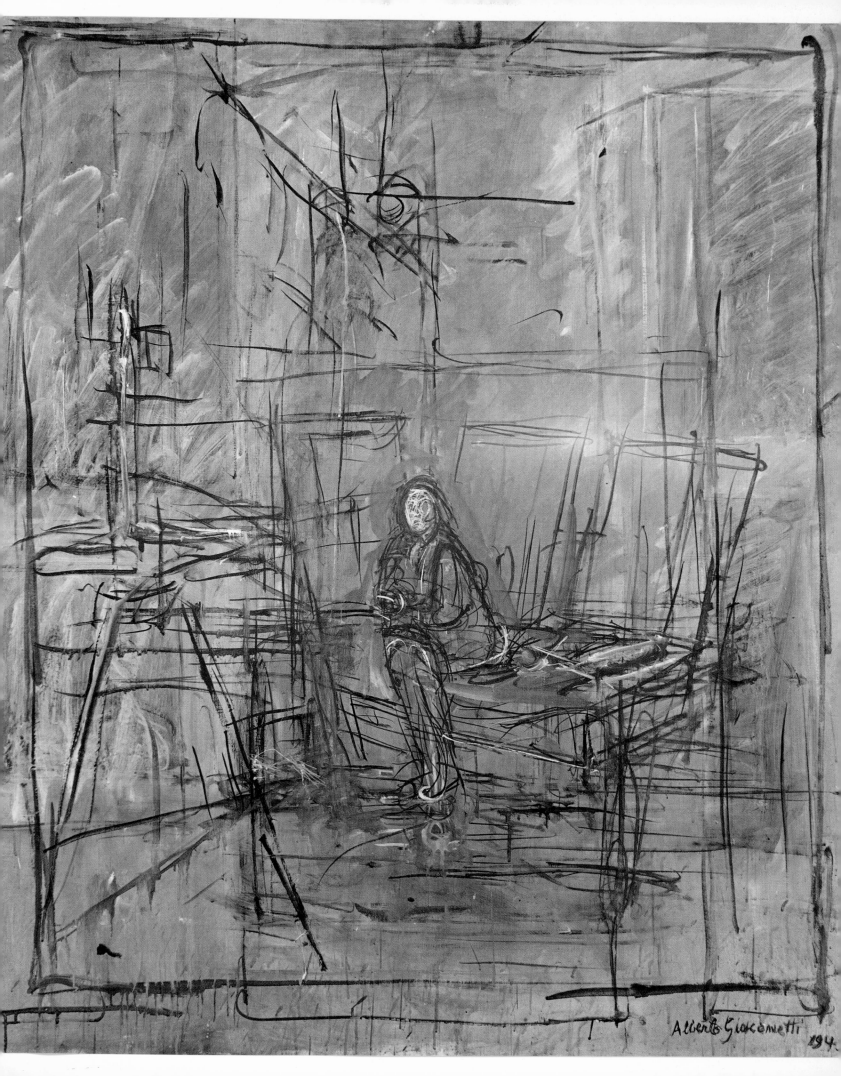

deficient person, if I begin to wish to draw that head, or paint it, or above all sculpt it, it all transforms into a form under tension, and, it always seems to me, to a violence powerfully held in, as if the form of the person always extends beyond what the person actually is. But it is also this; it is above all a sort of nucleus of violence. It is probably something besides. It seems quite plausible to me that it is like this because of the very fact that it is capable of existing — the fact that it does exist, that it is not crushed, scrubbed out, it seems to me that it is necessary that there is a force which maintains it.'

A little later in the same discussion he makes it clear that this force is, as he sees it, not simply an internal energy; it does not merely sustain a Presence, but is outgoing and has an impact on its surroundings. The passage is difficult to translate. Giacometti uses the French word *regard* in a sense which is more active than 'look', more weighty than 'glance', and is nearest perhaps to what is referred to in the slang phrase 'I gave her the eye'. To convey his meaning I have had to paraphrase a good deal: 'One day, when I wanted to draw a girl, something struck me, and that was that, all of a sudden, I saw that the only thing that remained living was the Regard. One has the desire to sculpt a living being, but in the living, there is no doubt, the thing that makes it living is the Regard. It was then that I came to the sculp-

tures of the New Hebrides and of Egypt. The sculptures of the New Hebrides are true, and more than true, since they have the Regard. It is not an imitation of an eye, it's well and truly a Regard. . . . In the Egyptian sculpture, which has always greatly affected and attracted me, there is the figure of the Scribe, in which the eyes are represented in glass or stone. The eye itself has been imitated as exactly as possible. But the Scribe sends to you no Regard. It's just an eye in glass, isn't it? That worries me, in spite of the admiration I have for the Scribe. That certainly worries me. The Egyptian who made the Scribe is, obviously, infinitely stronger, knew far more things, mastered far more things, than the person who made the New Hebrides sculptures. Still the latter succeeded in creating a Regard, without imitating the eye. And it is only the Regard which matters. The New Hebrides sculptor is much nearer to reality, to what artistic creation is all about.'

This makes clear enough that Giacometti sees the real world as consisting of entities which are unknowable in their totality, but which we can be aware of as centres of active energy that stretch out to affect other things, including ourselves. This is a view very far removed from the old idea of the world as being solid, inert matter, but it is coming very close to the world-picture of modern physics, and indeed of modern science as a whole.

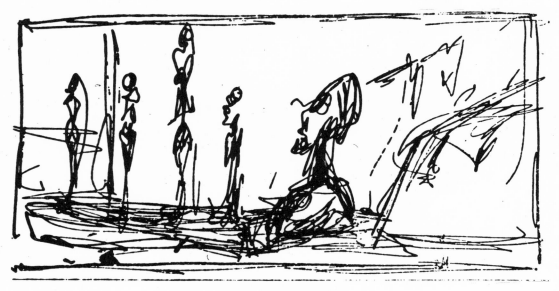

133. Giacometti, drawing

Part 3 Sucklings of Diana of the Ephesians

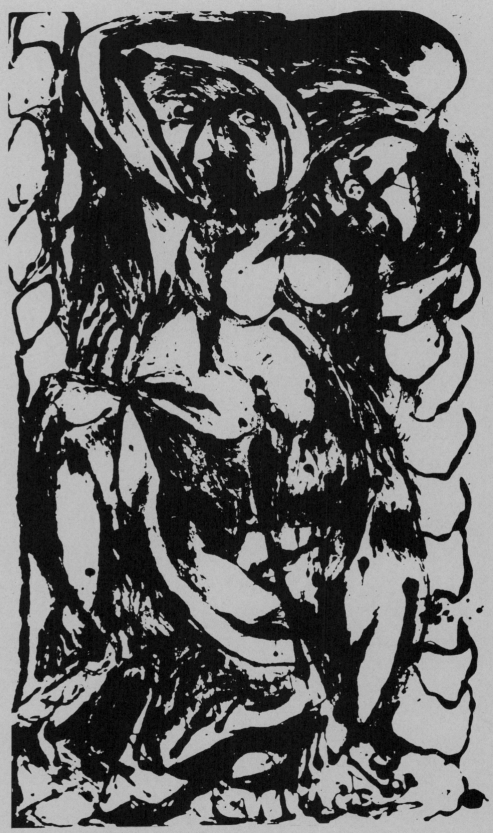

134. *Pollock. Black and white (1952)*

7

The Profits
of Plurality

Against unity

The story of painting during the last half-century, which has been summarized in the previous chapters, is, clearly enough, a very complex one, and far too rich and diverse for there to be any single simple relation between painting and science which we can put our finger on. There was the early outburst of the Cubists and Futurists, both in their different ways influenced by science or science-based technology, if only as something which inspired them to be radical and revolutionary; the attempts of Mondrian and the Constructivists to create a 'New Reality' as pure and self-sufficient as they thought the real world of science to be; the Romantic-Dada-Kandinsky reaction against a particular notion of science and the science-dominated world, which became mixed up with developing ideas of psychology to produce the Surrealist thesis about the nature of our perception of the world; then a new wave of innovations, along a great number of different paths, from New York style to Dubuffet, Rothko to calligraphy, with Giacometti's new realism, Bill's developments of constructivism, Pop Art, Op Art, and a whole range of other varieties. As I hope to have shown, most of these different kinds of painting have some ascertainable connection with science, either with its basic ideas or with the kind of world which the application of science has produced for man to live in. In such circumstances it is hopeless to expect our discussion to arrive at some clearly formulated firm conclusion: that the nature of science is so-and-so, that recent painting has been thus-and-thus, and that the relations between them are as follows.

There are other reasons why it could never have been expected that any such conclusion was even on the cards. For one thing, both painting and science are, to use a valuable American expression, on-going activities. Man will never reach finality in his scientific attempts to express his understanding of the natural world, or even in his efforts to formulate exactly what sort of relation his scientific theories have with the subject matter they are concerned with. Neither will painters cease to explore new ways of creating aesthetically valuable visual objects; and in pursuing this, their primary aim, they will inevitably continue to reflect, in some degree or other, the ways in which the nature of the physical world enters their intelligence and feelings. We shall see, in the future, fresh emphases in scientific natural philosophy, and also new types of relatedness between the marks made by painters on canvas.

It seems probable that in the near future the notion of organization will come to play a larger part in general scientific theory, deriving its strength from our now rapidly advancing understanding of biology, but also being reinforced by

currents of thought from sub-atomic physics and from such branches of engineering as the design of computers and automated or error-correcting machines. If it does so, one may hazard the guess that painters will find themselves showing forth some character of organization in their work. This will, presumably, not appear as any simple tightly 'composed' arrangement of related forms, or as the revival of any of the past types of painting which we are already used to recognizing as being organized. It will, if it is to be a valid and valuable correlate of a newly developed natural philosophy, embody this in some quite fresh way which we cannot as yet visualize.

This leads to the second reason why we cannot reach a single statement which defines the relations between painting and science; one which has still more important implications than the points just discussed. The fact that organization is an important factor in the natural world has the result that there must be many different sciences; and there are certainly many different types of painting. The subject matter of this book has turned out not to be the relations between two things – painting and science – each of which is a unity. We have been dealing with the relations between two groups of topics, each group having a considerable internal diversity. I have argued that this is inevitable, and we should accept and even welcome it. But to do so calls for a radical reconsideration of our concept of a satisfactorily unified culture.

In the past, discussions of culture have usually been based on an implicit assumption that a healthy civilization is a close-knit unity focused on some single central doctrine or philosophy. The principle of organization which, it was implied, a culture should possess was a hierarchical one. Thirteenth-century Europe had a healthy cultural life because everything rotated around the dogmas of the Universal Church; sixteenth-century Italy, because it was dominated by the humanistic ideals of the Renaissance. We took it for granted that our own times demanded some equally commanding philosophy. I have myself previously discussed modern art and science in terms which carried this implication. In a small book written about a quarter of a century ago I wrote [1]: 'All the cultural activities of our epoch have failed in their main function. Neither painting nor literature has been able to arrive at a point of view which was positive and definite enough to be even worth considering as a basis for a new society.' I believe now that, in looking for a single basis for a new society, I was asking for the wrong thing – and so was everyone else at that time and for most of the time since. Our trouble has been, not that the great dominating systems offered to us – Marxism, Free Enterprise Capitalism, Fascism, and so on – have proved inadequate. It is rather that we have failed to realize that cultural life in the present day needs to be organized as an Egalitarian Democracy of ideas and activities, instead of as a Hierarchical System.

There are almost innumerable different sciences – polymer chemistry, quantitative genetics, neurophysiology, ecology, particle physics, and so on and on. Why not? We need them all. Again there is, even within the section of modern painting I have dealt with, an enormously greater range of diverse types than any previous age could show; in what previous couple of decades of Western civilization could one find artists as unlike one another as Pollock, Rothko, Bill, Rauschenberg, and, Giacometti, to name only a very few? But again, we should rejoice in the richness of what our contemporaries offer us rather than lament that they have so many different voices. Our societies, as assemblages of people, are organized as democracies in which each man is expected to be himself and to interact with his fellows; he is no longer thought of as having a definite place in a unified hierarchical social structure. Our culture, as an assemblage of ideas and activities, does in fact present us with a parallel type of organization. But we have hardly yet realized this. The result of this misapprehension is a rather profitless argument: whether we have One Culture, or Two, or possibly Three; whereas the really important task is to facilitate and encourage lively interchanges, controversies, and co-operations between the many, many sub-cultures in which the life of man now finds expression.

It is a task of this sort that this book has attempted, in one area. Approaching the subject from the background of a professional scientist, I have tried to show, by considering in some detail the various schools and types of painting of the last half-century, that the visual arts and natural philosophy are related parts of man's exploration of the world around him. As I have repeatedly emphasized, the field I have explored is itself only a fragment of the total human experience of our time; I have been concerned with only one aspect of painting and of science – the way they reflect our knowledge of the structure of material things – and have not attempted to include the much greater, and probably much more important phases which deal with our understanding of man and society. But in these times our intellectual-emotional life has been so fragmented and divided into separate compartments, and these so often classified as mutually exclusive, that it is rather rare that any attempt is made to examine in detail the connections that actually exist between the different pigeonholes, although voices are sometimes raised to point out, in general terms, that relations are, or ought to be, there. I have preferred to discuss a restricted area more thoroughly, rather than the whole of culture without the bedrock of particular instances.

Duet for twice N hands

What then emerges about the character of the relationship which, as I hope I have shown, exists between these two human activities? Let us begin by a step in the scientific style of procedure, and try to clear out of the way some of the surrounding circumstances with which we are not primarily concerned but which could easily lead to misunderstandings or confusions — a step rather like purifying one's chemicals and setting up screens against extraneous radiation before starting the experiment proper. So let it be stated that natural science and painting, although related in some ways, are quite different in their essential aims. I still know of no better short description of science than one I gave myself many years ago[2]: it is the organized attempt of mankind to discover how things work as causal systems. The crux of this, in our present context, is that the essential test of a piece of science is: does it show how to arrange a part of the external world in such a way that it 'works' to produce a previously determined end result? There is no need here to labour the point with full semantic rigour: the basis of science is to tell us what will be the result of a previously untried experiment; and this result will usually be a particular material event, though it could, in certain fields of science, equally well be the production of a certain emotional or aesthetic feeling in some person who formed part of the experimental set-up.

In contrast, the main characteristic of artistic creation has nothing whatever to do with foretelling the results of experiments. The aim of a piece of art is not to show *how* to produce an effect, but actually to produce it. And it is concerned, of course, primarily with effects of a certain kind; not material events, but human responses of the kind we call aesthetic. In so far as there is any understanding of how to produce such effects, as science teaches us how to produce experimental results, this belongs to the theory of aesthetics — a rather backward aspect of knowledge — not to painting itself. It is difficult even to define what is an aesthetic response and distinguish it from what is not. But, without going into the recent theories, from authors such as Herbert Read, Gombrich, Suzanne Langer, Adrian Stokes, and many others, we can recognize that artists judge the basic importance of their work by applying a criterion which is totally different from that which is used by scientists in judging a contribution to science. In so far as this goes, art and science *are* in two different pigeonholes.

But that is not the whole story. Man can never live, even momentarily, on only one definite level of being. He is, as has been pointed out by a succession of authors, from Sir Thomas Browne[3] in the seventeenth century through Joseph Need-ham[4] in the 1930s to Aldous Huxley[5] the other year, 'that great and true Amphibium, whose nature is disposed to live, not only like other creatures in diverse elements, but in divided and distinguished worlds'. But neither the Elizabethan doctor nor the Californian seer go quite far enough. Man does not only haunt many various worlds; he lives simultaneously, at one and the same time, in worlds which are distinguishable, but not truly divided. He cannot produce anything which has solely an aesthetic impact and no conceptual meaning; nor anything which is purely scientific without providing any basis from which aesthetic creation is possible.

In her recent Terry Lectures, Margaret Mead[6] has discussed in detail the importance, in the transmission of human culture, of modes of communication which are less clear-cut and on-the-surface than expository words or representational painting. Man can, she reminds us, learn by empathy, imitation, and identification; and he can transmit many types of meaning and feeling by incorporating them in something he has made, an artefact, as well as by attempting to formulate them explicitly. She is particularly concerned to document the effectiveness of such processes in the transmission and evolution in the simpler forms to which it has been developed by more primitive peoples. But she is at pains to point out that 'all forms of transmission of previous experience are to be found in the highest forms of human civilization today. Evolutionary advances in communication (e.g. symbolic language, records on film, videotape, etc.) have not eliminated any one of the earlier forms'.

It is in fact by means of communication systems of this 'primitive' kind that the most important parts of the dialogue between art and science in this century have taken place. When artists have tried to learn direct lessons from science, copying the visual phenomena turned up by scientific research or technically-based industry, not much of value or profundity has been produced. The notions which have been more fructifying are those which have been absorbed by empathy, through the pores, as it were. And they have been expressed again by the artists not so much in any explicit exposition or diagramming of scientific ideas, but rather by living a life of implicit incorporation into a work of art — an artefact — from which the spectator again absorbs them by in-feeling more than by analysis. It is at the deep levels of the human psyche, where these kinds of communication operate, that there is the closest unity between science and art.

For purposes of discussion it has been necessary to try to put into words some of these connections between the two types of activity. As we have seen, during the whole period from the beginnings of Cubism till the outbreak of the Second World War there was a considerable and

continuing attempt by painters to adopt explicitly thought-out attitudes towards the world of science and technology. This intellectualizing led to the two dominant avant-garde schools, the Geometricizers and the Surrealists. Today we can respect their seriousness of purpose, sympathize with some of their intentions, and grant that there is some logical force in many of their arguments. But the main impression left, both by their writings and by their paintings, is of the thinness and inadequacy of the artists' response, in so far as it attempted to come to grips with our rapidly advancing understanding and control of the natural world. Of course, to be fair we should have to point out that the complementary efforts which might have been demanded from the scientific side — efforts to develop a comprehensive theory of man's relation to nature, in which artistic modes of apprehension were seen as having a place alongside the methods of scientific analysis — were at least equally if not more deficient. Such contacts as were made between the two types of human creativity occurred, except in very few instances, on too superficial and intellectual a level to lead to anything more lasting than two kinds of doctrinaire fashion.

In the last twenty years avant-garde painters have written less about science, but there are signs, in their productions, of an assimilation of it at a deeper level. The dominant theme in 'modern-modern' painting has been the insistence on looking at the whole of the world in which the painter is now living with newly opened eyes, unprotected by either blinkers or filters. Artists have looked at their world — an urban, wave-mechanical, stochastic, everywhere-dense continuum of events, of which he himself is more intimately a part as a contributor than the skin diver is of his marine environment — and have seen it from a number of viewpoints. I have listed between a dozen and a score; one could have distinguished others. Not all of these have much connection with scientific insights into the nature of the material world man inhabits and has to deal with, but many — and perhaps, of those likely to be significant for the future development of human culture, most — have a rather close connection. One can list them summarily:

(a) The epistemological foundation. The observer does not wholly make what he observes, but his intrinsic character colours it. There is no strict objective-subjective dichotomy. The painter is *in* his painting, the scientist is *in* his science.

(b) Chance plays a role amongst the fundamental mechanisms.

(c) Everything 'has a feeling for' (prehends) everything else; things have fuzzy edges.

(d) On a more down-to-earth level: we live in surroundings and conditions that we ourselves make, not in any state of nature that we have to accept in its entirety.

The crunch

In the last resort the question arises, do painters give expression to the really basic contributions of science to civilization? Or do they merely live in the same world as some of the contemporary forms that science takes at this particular point in history? One cannot even discuss this until one has some idea what is the basic contribution of science to culture. We are used to being told that we live in a scientific culture; that science does contribute to culture; but we are very rarely told explicitly just what it contributes. Clearly the contribution is not just an assemblage of particular facts that happen to be known at this time. The essential contribution of science to the way man lives his life is something altogether more basic — if you like, altogether more brutal — than any collection of detailed information. To put it with the crudity which its importance demands, the scientific contribution to human civilization is its insistence that some things are true and others not.

Now of course it is very difficult to express precisely what you mean by 'true' and still more difficult and laborious to find out which things qualify for this category; but the essential point of the scientific endeavour is to insist that, whatever philosophical subtleties we may introduce in trying to express the meaning of 'truth', and however imperfect our information about actual situations may be, nevertheless the world has a structure of effective interactions between its constituent elements. The structure is by no means obvious at first sight. It is in fact difficult to discover and even more difficult to describe. We can attempt to capture it in verbal butterfly nets of various kinds — Christian theology, Newtonian physics, Zen Buddhism, symbolic logic, the Vedanta, quantum mechanics, and so on — but science insists that there is an existing structure in the universe that cannot be talked out of existence by any type of language or system of philosophy.

There has of course always been one fact of existence which mankind — extremely reluctantly and trying to avoid the issue whenever possible — has had in the last resort to accept as a brute fact — death. Invent what theories you will about afterlives, reincarnation, higher planes of existence, Nirvana, and so on, it remains inescapable that any particular person — be he one of God's Anointed, a Peculiar Person, or an Enlightened One — will not be eating his pasta, fried herring, or bowl of rice, as the case may be, a century hence. The fundamental contribution of science to human civilization is to insist that there are a great many more brute facts than this one.

Science goes further, in giving a recipe — perhaps one should say a category of recipes — for finding out what these brute facts are. Again, the recipe is so brutally basic that it is better expressed

by a coarse colloquialism than by any highfalutin jargon about hypothetico-deductive systems and the like. The recipe is simply 'Suck it and see' – the classical answer to the little boy who asked whether the orange was sweet. To follow this recipe demands both courage and humility, neither of them qualities of which mankind has much surplus. In so far as a civilization is influenced by science, it would demand of its members an acceptance that the world has an undeniable structure, and a readiness to apply a general method of discovering what this structure is and to abide by the consequences.

These are demands that most men in most parts of the world in most ages of history have been by no means ready to accept. Even the post-Renaissance scientific culture of western Europe in the last few centuries has given them much more lip-service than actual thoroughgoing acceptance. But when one gets down to it, what the scientist wants to ask of the contemporary artist is, does he give expression to this basic challenge which science issues to the older, more self-confidently self-sufficient systems of intellectual thought?

In the last half-century the obvious emphasis has been on expressing the fact that the elements of the real world are not mere lumps of impenetrable matter, existing in isolation, just for themselves in vacuous actuality, as Whitehead put it, in a clearly defined framework of space, to which time was an inessential complication. There was a major task to do, to bring the modes of visual art to express the inter-relatedness of 'things', both to each other and to the observer, and to convey the Heraclitean view that reality is not 'things' but process, extended in time. Can it really be claimed that artists have succeeded in going beyond this primary task, to assert that there is an underlying causal structure which cannot be circumvented?

Of the Surrealists, certainly not: they were too much concerned with the involvement of the percipient in what might come to his conscious recognition. Mondrian and his followers focused their attention on structure, logical or visual, leaving out of their theory or practice the relation of one structured entity with another or with the percipient. The American school of the 1940s and early 1950s, and the related Europeans such as Dubuffet, brought together into some sort of synthesis the infinitely complex inter-relationships between real entities, and between them and people observing them, and even hinted that the entities are processes rather than things; but there is little suggestion of a 'truth-function' – that some processes happen and others do not. Perhaps there is a certain expression of this in some of the quite recent paintings. Agam's works have the ambiguity of a world of mutual involvement in that they look different from different viewpoints; but the ambiguity is strictly limited to one or other

of a few definite alternatives – or, of course, combinations of these. In many of Jasper Johns' paintings, the way the paint is laid on the canvas conveys a sense of a network of mutual relationships, of which the painter or spectator is a part – but back of it all, the picture is ineluctably of the numeral 5, or the American Flag, or something similarly inescapable.

In the last century atomic theory envisaged the basic elements of reality as being like arthropods or insects – supported by a hard layer on the surface, an 'exo-skeleton' which is more or less impenetrable and may conceal who knows what unreachable software within it. With the cracking of the atom, and all the other scientific developments of a similar tendency, we have had to start considering the world as made of things much more like vertebrates – soft on the outside, but with a solid skeletal structure within. The challenge one might throw out to painters is, how far can they express the underlying hard skeletal structure without sacrificing the great advances they have made in exhibiting the softness of the immediately apparent outside of the fundamental elements of our experience? Because for science both are equally essential.

The gifts from art to science

But it would be a mistake to see the traffic between art and science as a one-way affair. Science, of course, cannot expect to learn scientific truths from the production of artists, any more than the latter can get much profit from merely taking over superficial appearances or intellectual concepts from science. But science is something more than a collection of conceptual or practical results. It is also an activity; and its practice involves, as a very important part, the exercise of the faculties of insightful perception of natural phenomena and of the imaginative creation of new concepts. These are not processes which proceed exclusively, or even mainly, on the verbal plane. Aldous Huxley has pointed out[7] the narrowing effect of the usual reliance on book-learning. 'Training in the sciences is largely on the symbolic [he means verbal] level; training in the liberal arts is wholly and all the time on that level. When courses in the humanities are used as the only antidote to too much science and technology, excessive specialization in one kind of symbolic education is being tempered by excessive specialization in another kind of symbolic education.'

Some aspects of scientific work are almost as demanding as painting on the twin processes which Kubie[8] has described as '*Cogito* – shaking things up, to roll the bones of one's ideas, memories, and feelings, to make a great melting pot of experience; plus the superimposed process of *intelligo*, i.e. consciously, self-critically, but

241

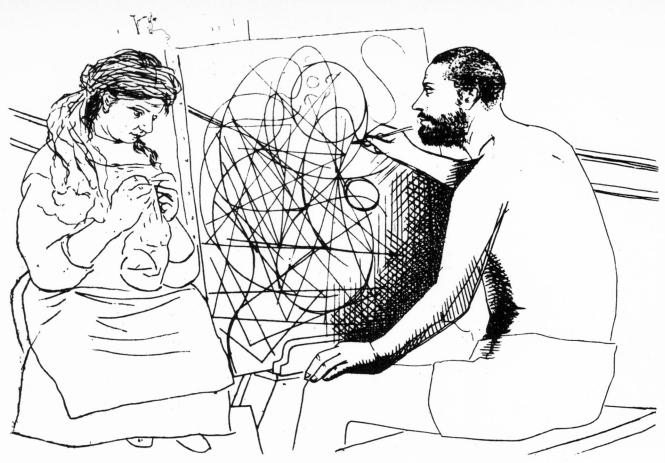

136. *Picasso. Artist and model*

retrospectively to go through an after-the-act process of choosing from among un-anticipated combinations those patterns which have new significance'. Under the pressure to produce 'results', by taking the next short step along a path which is obviously stretching ahead, or beguiled by the fascinating manipulative play that the actual conduct of an experiment so often provides, scientists find it easy to forget what kind of mental processes are required for the most important advances. Looking at paintings, or experiencing other kinds of art, especially kinds which are not too immediately transparent but which demand some attempt by the spectator to enter into the experience of the artist's creative process, is one of the best ways for a scientist to loosen the joints of his psyche, to 'roll the bones' of his ideas, and give himself a chance to dredge up from the obscure internal depths something, which will probably have not the slightest obvious connection with the work of art he has been contemplating — but which may be fresh enough to be worth while.

At the level at which, I am claiming, art and science are in true communication, the level of creativity — the connections do not stop short at the boundaries I have set to the discussion. The meanings incorporated into the artefacts of painters are not all concerned with the character of the natural world; they involve, often much

more, implications about the nature of man and society. And science is not only natural science, but also social science, which shades off through gradual transitions into moral philosophy. It is only for purposes of convenience, because one cannot in practice discuss everything all at once, that it is legitimate to isolate some small part of man's whole being for particular treatment. The directions in which our arguments have led us have pointed up the essential artificiality of such fragmentation. It appeared that bringing biological considerations into the purview of the natural philosophy of science leads inevitably to some type of 'organicist' view, which emphasizes the unity and reciprocal interaction between man and nature, and between the various aspects of human existence; while one of the salient characteristics of recent painting has been its insistence on the involvement of the whole man in depth in the act of creation. Jackson Pollock's paintings, I have claimed, have some connection with modern physical theories about the nature of matter; but they certainly also are related to the political and social circumstances of their time. They do not yield anything like their full load of meaning when looked at through scientific eyes; and this is true even though science is not a Cyclops, and can see, to some extent, in the round. These are still further important angles of vision, points of view which

242

are from outside science altogether, although not totally disconnected with it, since nothing human can be quite isolated from anything else. We have been led, by a consideration of one apparent discontinuity in human experience, that between painting and natural science, to recognize that there is continuity between them after all, and that this continuity extends out into wider fields. It not only connects the painters we have discussed with others, such as Henry Moore, Matisse, and Francis Bacon, who are mainly concerned with the human situation, and little if at all with the nature of the physical world, and through them with philosophers of man's situation, such as Sartre and Heidegger, but on the other side reaches out to social scientists such as Mead or Mumford. Starting from the argument that science is not, after all, merely a one-eyed Cyclops, the conclusion we have come to is that man is Argus with innumerable eyes, all yielding their overlapping insights to his one being, that struggles to accept them in all their variety and richness.

REFERENCES

Preface

1 *The Autobiography of Charles Darwin*
ed. N. Barlow, p.138 (London: Collins
1958).

2 Herbert Read *The Concise History of
Modern Painting* (London: Faber 1959);
Modern Painting (Geneva: Skira,
several editions), and *Contemporary
Trends* (Geneva: Skira 1960).

Chapter 1. The Image of our Surroundings

1 F. B. Blanshard *The Retreat from Likeness
in the Theory of Painting.* (New York:
Columbia University Press, 2nd ed. 1949).

2 T. C. Kuhn *The Structure of Scientific
Revolutions,* (Chicago: University of
Chicago Press 1962).

3 M. C. Goodall *Science and the Politician*
(Cambridge, Mass.: Schenkman 1965).

Chapter 2. The Geometricizers

1 Among the innumerable books about
Picasso, probably the best in conveying
the atmosphere in which Cubism was
born are: the charming *Picasso and His
Friends* by his girl-friend of that time,
Fernande Olivier, English translation
(London: Heinemann 1964); and Roland
Penrose *Picasso, his Life and Work*
(London: Gollancz 1958); and the essay
on Apollinaire in Roger Shattuck *The
Banquet Years* (New York: Harcourt,
Brace 1958). A systematic discussion is
in John Golding *Cubism* (London:
Faber and Faber 1959).

2 A. S. Eddington *The Nature of the
Physical World* (Cambridge: Cambridge
University Press 1928).

3 Eddington, op. cit., p.35.

4 A. Lhote 'La naissance du Cubisme',
In *Histoire de l'art contemporaine* ed.
Rene Huyghe (Paris: Alcan 1935).

5 cf. C. Gray *Cubist Aesthetic Theories*
(Baltimore: Johns Hopkins Press 1953).
The quotations from Apollinaire are
taken from this book, where full
references to the original sources can be
found.

6 D. H. Kahnweiler *Juan Gris, his Life and
Work,* p.145 (New York: Valentine
1947).

7 G. Severini. In *XXme. Siecle,* Second
Series, no. 2 (1952) 69.

8 John Golding *Cubism,* p.81 (London:
Faber and Faber 1959).

9 John Berger *Success & Future of
Picasso* (Penguin Books 1965).

10 For a perhaps excessively 'square'
analysis of Cézanne's procedures, with
photographs of his subjects confronting
his paintings, see Erle Levan *Cézanne's
Composition* (Berkeley and Los Angeles:
University of California Press 1959).

11 F. Kupka. From the *New York Times*
19 October 1913, quoted by Guy
Habasque in an article on Kupka in
Connaissance des arts (Paris, July 1960).

12 *Futurist Manifesto.* A convenient source
of an English translation is J. C. Taylor
Futurism (New York: Museum of Modern
Art 1961).

13 Marcel Duchamp. In *Eleven Europeans
in America. Museum of Modern Art
Bulletin,* vol. 13, nos. 4–5 (New York
1948).

14 Duchamp, op. cit.

15 Conversation published in Edouard
Roditi *Dialogues on Art,* p.47 (London:
Secker and Warburg 1960).

16 M. Duchamp *From the Green Box,*
English translation (New Haven:
Readymade Press 1957) no folios.

17 Quoted in Sam Hunter *Modern American
Painting and Sculpture,* p.58 (Dell,
Laurel Edition, 1959).

18 The best general account of his work is
D. Cooper *Fernand Léger* (London and
Paris: Lund Humphries and Trois Collines
1959). For the latest work, see
P. Descargues *Fernand Léger* (Paris:
Cercle d'Art Contemporain 1955).

19 From an essay first published in English
in *The Painter's Object* ed. Myfanwy
Evans, pp.18, 19 (London: Gerard Howe
1937).

20 For reproductions of some of his paintings
on scientific themes, see F. C. Thiessing
Erni, Elemente zu einer kunftigen Malerei
(Zurich: Meyer and Thiessing Verlag
1948).

21 Most Mondrian quotations are taken
from the English translation of his
writings, published as *Plastic Art and
Pure Plastic Art* (New York: Wittenborn
1945). This is p.10.

22 Mondrian, op. cit., p.14–15.

23 Mondrian, op. cit., p.10.

24 Mondrian. In *Eleven Europeans in America. Museum of Modern Art Bulletin*, vol. 13, nos. 4–15 (New York 1946) 33.

25 Duchamp. In *Eleven Europeans in America*, p. 20.

26 Max Ernst, in a conversation with Georges Charbonnier on the French radio. In *Le monologue du peintre*, p. 33 (Paris: Julliard 1959).

27 Mondrian. In *Eleven Europeans in America*, p. 36.

28 *Plastic Art and Pure Plastic Art*, p. 41.

29 *Realistic Manifesto*. English translation in *Gabo* ed. Herbert Read and Leslie Martin, p. 151 (Cambridge, Mass.: Harvard University Press 1957).

30 N. Gabo 'Art and Science'. In *The New Landscape* ed. G. Kepes, p. 61 (Chicago: Theobold 1956).

31 K. Malevitch *Die Gegenstandlose Welt* (Munich: Bauhausbucher 1927; English translation, Chicago: University of Chicago Press 1960).

32 Quoted in C. Gray *The Great Experiment: Russian Art* 1863–1922, p. 226 (London: Thames and Hudson 1962).

33 See *Bauhaus* 1919–1928, Herbert Bayer, Walter and Ise Gropius (London: Allen and Unwin 1939).

34 English translation as: *The Thinking Eye* (New York and London: Wittenborn and Lund Humphries 1961).

35 Special number of *Telehor* (Brno: Kalivada 1936) 30.

36 Essay on Moholy-Nagy, published as foreword to a catalogue of exhibitions at Institute of Design, Chicago, and Kleemann Galleries, New York, 1957.

37 L. Moholy-Nagy *Vision in Motion* (Chicago: Theobold 1946); *The New Vision* (New York: Brewer, Warren & Putnam 1930; New York: Norton, 1938); G. Kepes *The Language of Vision* (Chicago: Theobold 1949); *The New Landscape* (Chicago: Theobold 1956).

38 A. Ozenfant and P. Jeanneret *La peinture moderne*, p. 66 (Paris: Cres 1927) (quoted in English translation from Blanshard *Retreat from Likeness*, p. 105).

39 *Circle*, Martin, Nicholson and Gabo (London: Faber 1937); *Axis* ed. Myfanwy Evans, nos. 1–8, 1937. See catalogue of exhibition in Marlborough Galleries, London, New York and Rome, 1965, entitled *Art in Britain* 1930–40.

40 de Kooning. In *What Abstract Art means to Me. Museum of Modern Art Bulletin*, vol. 18, Spring (New York 1951) 7.

Chapter 3. The Magicians

1 See note 26, p. 40.

2 G. Apollinaire. Quoted in Anna Balakian *Surrealism, the Road to the Absolute*, pp. 57 and 53 (New York: Noonday 1959).

3 A. Ozenfant, in Preface to American edition of *Foundations of Modern Art* (New York: Dover 1952).

4 G. de Chirico. Quoted in J. T. Sobey *G. de Chirico*, p. 79 (New York: Museum of Modern Art 1955).

5 Quoted in Sobey, op. cit., p. 109.

6 Quoted in Sobey, op. cit., p. 74.

7 *The Times*, 28 November 1963.

8 F. B. Blanshard *Retreat from Likeness in the theory of painting*, p. 129 (New York: Columbia University Press 1949). Quoted in *In Memory of Wassily Kandinsky* ed. H. Rebay, p. 55 (New York: Guggenheim Foundation 1945).

9 W. Worringer *Abstraction and Empathy* (London: Routledge and Kegan Paul 1953).

10 Worringer, op. cit., p. 134.

11 Worringer, op. cit., pp. 5, 135.

12 A. C. Haddon *Evolution in Art* (London: Scott 1895).

13 F. Boaz *Proceedings U. S. National Museum*, vol. 34 (1908) pp. 321–44.

14 W. Kandinsky, from the English translation of the *Autobiography* (*Text Artista*) originally published in Russian in 1918, included in the Guggenheim Foundation volume of 1955.

15 Kandinsky *Autobiography*.

16 Kandinsky *Autobiography*.

17 W. Kandinsky *Concerning the Spiritual in Art*, English translation (New York: Wittenborn 1947) p. 47.

18 Kandinsky, op. cit., p. 52.

19 Kandinsky, op. cit., pp. 31–2.

20 Kandinsky, op. cit., p. 33.

21 S. W. Hayter 'The Language of Kandinsky'. In Kandinsky *Concerning the Spiritual in Art*, p. 16.

22 W. de Kooning. In *What Abstract Art means to me. Museum of Modern Art Bulletin*, vol. 18, Spring (New York 1951) 6.

23 A more conventional account by Huelsenbeck, with much other material, is in *The Dada Painters and Poets* ed. Robert Motherwell (New York: Wittenborn 1951). For other personal accounts by original Dadaists, see G. Hughnet *L'aventure Dada* (Paris: Gallerie de l'Institut 1957); and W. Mehring *Berlin Dada* (Zurich: Arche 1959).

24 Gabrielle Buffet-Picabia *The Dada Painters and Poets* ed. Motherwell, p. 259.

25 For simple accounts see C.H.Waddington *Principles of Development and Differentiation* (New York: Macmillan Co. 1965); or J.P.Changeaux 'The Control of Biochemical Reactions', *Scientific American* (April 1965) 36, for allosteric compounds; and W.B.Fowler and N.P. Samios 'The Omega-minus Experiment' *Scientific American* (October 1965) 36 for the bootstrap physics.

26 Tristan Tzara, from the magazine *Dada* 111, quoted by Marcel Jean in *History of Surrealist Painting*, p.69 (London: Weidenfeld and Nicholson 1960).

27 H.Arp 'Notes from a Diary' *Transition*, no. 21 (March 1932) 191.

28 H. or J.Arp *On my Way*, p.48 (New York: Wittenborn 1948) 2nd quotation from page 28; 3rd quotation, *Notes from a Diary* as above.

29 H.Arp *Notes from a Diary*.

30 H.Arp *Notes from a Diary*.

31 M.Duchamp *From the Green Box* (New Haven: Readymade Press 1957).

32 H.Arp *On my Way*, p.40.

33 H.Arp *On my Way*, p.46.

34 Huelsenbeck. In the BBC talk cited on p.72.

35 E.Paolozzi. In Edouard Roditi *Dialogues on Art*, pp.155, 156 (London: Secker and Warburg 1960).

36 Roger Shattuck *Au seuil de pataphysique*, Collège de Pataphysique.

37 Max Ernst *Beyond Painting*, p.14 (New York: Wittenborn 1948).

38 Anna Balakian *Surrealism*, chap. 2 (New York: Noonday 1959).

39 Max Ernst. In *The Painter's Object* ed. Myfanwy Evans, p.77 (London: Gerald Howe 1937).

40 Quoted in Balakian, op. cit., p.120.

41 Marcel Jean *History of Surrealist Painting* p.126 (London: Weidenfeld and Nicholson 1960).

42 Max Ernst *The Painter's Object*, pp.74, 77; and a slightly different version in Marcel Jean, op. cit., p.127.

43 Max Ernst. In *Le monologue du peintre* ed. G.Charbonnier, p.35 (Paris: Julliard 1959).

44 Max Ernst *Histoire naturelle* (Paris: Berggruen, drawings of 1925).

45 M.Eagle, D.L.Wolitsky and G.S.Klein 'Imagery; effect of a concealed figure in a stimulus' *Science* 151 (1966) 837.

46 A.Masson. In *Le monologue du peintre* ed. G.Charbonnier, pp.188, 191 (Paris: Julliard 1959).

47 C.Madge *Times Lit. Supp.*, 25 October 1963.

48 Andre Breton *Nadja*, pp.59, 60, English translation (New York and London: Grove Press and Evergreen Books 1960).

Chapter 4. The Scientists

1 A.S.Eddington *The Nature of the Physical World*, p.251 (Cambridge: Cambridge University Press 1928).

2 S.A.Barnett. In *Lessons from Animal Behaviour for the Clinician* (Little Club Clinic in Developmental Medicine 1962).

3 J.Hadamard *The Psychology of Invention in the Mathematical Field* (New Jersey: Princeton University Press 1945; New York: Dover Publications 1954).

4 Hadamard, op. cit., p.12.

5 Hadamard, op. cit., p.25.

6 Hadamard, op. cit., p.142.

7 W.Barrett *Irrational Man: A Study in Existentialist Philosophy*, p.34 (London Heinemann 1961).

8 W.Heisenberg *The Physicist's Conception of Nature*, pp.15, 17, 24 (London: Hutchinson 1958).

9 E.Schrödinger *Nature and the Greeks*, p.15 (Cambridge: Cambridge University Press 1954).

10 E.Schrödinger *Mind and Matter*, p.89 (Cambridge: Cambridge University Press 1958).

11 L.Wittgenstein *Tractatus Logico-Philosophicus* (Cambridge: Cambridge University Press 1922).

12 Marcel Jean *History of Surrealist Painting*, p.155; Wittgenstein *Tractatus*, 4.21, 4.22.

13 N.Gabo *On Divers Arts*, p.57 (New York: Random House 1962).

14 R.Motherwell. In *What Abstract Art Means to Me. Museum of Modern Art Bulletin*, vol.1, No.18 (New York 1951) 12.

15 N.Gabo *On Divers Arts*, p.61.

16 R.Motherwell *Catalogue of Exhibition at Smith College* (Northampton, Mass, 1963).

17 W.Baziotes. In *Problems of Contemporary Art*, 4 (New York: Wittenborn 1947–8); J.Brooks *The New Decade*, Exhibition Catalogue (New York: Whitney Museum 1955); P.Guston. Quoted in *Die neue Amerikanische Malerei*, Exhibition Catalogue (Basel: Kunsthall 1958).

18 J.Cage *Silence*, p.46 (Connecticut: Wesleyan University Press 1961). Typography normalised.

19 J.Cage, op. cit., pp.175, 187.

20 C.H.Waddington *The Ethical Animal*, ch. 9 (London: Allen and Unwin 1960).

21 *Kunst und Naturform* (Form in Art and Nature) ed. G.Schmidt and R.Schenk (Basel: Basileus Presse, c, 1959).

22 See p.52.

Chapter 5. The New Start

1 A. Masson. In G. Charbonnier *Le mono-logue du peintre* (Paris: Julliard 1959).

2 See H. Hoffman *Search for the Real* (Andover, Mass.: Addison Gallery 1948).

3 W. de Kooning. In *What Abstract Art means to Me. Museum of Modern Art Bulletin,* vol. 18, Spring (New York 1951) 7.

4 James Joyce *Anna Livia Plurabelle. Criterion Miscellany,* no. 15 (London: Faber and Faber *c.* 1939). Also in *Finnegan's Wake.*

5 H. Rosenberg *The Tradition of the New,* p. 30 (New York: Horizon Press 1959).

6 Lawrence Alloway. *The Listener,* 23 October 1958.

7 W. de Kooning. In *What Abstract Art means to Me. Museum of Modern Art Bulletin,* vol. 18, Spring (New York 1951).

8 See, for instance, Michel Tapié *Manifeste indirecte dans un temps autre* (Turino: Fratelli Pozzo Edition 1954).

9 Jackson Pollock *Possibilities.* In *Problems of Contemporary Art,* no. 4 (New York: Wittenborn 1947−8).

10 Robert Motherwell. In *The Creative Artist and his Audience. Press fictions,* no. 9, Autumn 1954.

11 Frank Avray Wilson *Art as Understanding,* p. 85 (London: Routledge and Kegan Paul 1963).

12 G. H. Hardy *A Mathematician's Apology,* pp. 65 and 79 (Cambridge: Cambridge University Press 1940).

13 Jack Tworkov, in a discussion at the Philadelphia Museum. In *It Is,* no. 5 (Spring 1960) 37.

14 Avray Wilson, op. cit., p. 78.

15 See William C. Seitz *Tobey,* p. 50 (New York: Museum of Modern Art 1962). There are many comments by Tobey on in his own work in the catalogue published by Gallerie Beyeler, Basel for their Tobey exhibition, Spring 1966.

16 Seitz, op. cit., p. 10.

17 Georges Mathieu *From the Absract to the Possible,* p. 20 (Paris, Zurich, Bruxelles: Cercle d'Art Contemporain 1960).

18 Alcopley *A Reflection on Position* (London: Drian Gallery 1959).

19 Alcopley *Listening to Heidegger and Hisamatsu,* p. 87 (Kyoto: Bokubi Press 1963).

20 G. Charbonnier *Le monologue du peintre,* p. 67 (Paris: Julliard 1959).

21 Elaine de Kooning. In *Twelve Americans. Museum of Modern Art Bulletin* (New York 1956).

22 W. H. Auden 'In Memory of W. B. Yeats'. *Collected Shorter Poems,* 1930−44 (London: Faber and Faber 1953).

23 See the collected edition of Picabia's review *391,* ed. M. Sanouillet (Paris: Le Terrain Vague 1960).

24 M. C. Goodall *Science and the Politician,* p. 17 (Cambridge, Mass.: Schenkman Publishing Co. 1963).

25 Seitz, op. cit., p. 23.

26 Avray Wilson, op. cit., p. 152.

27 Georges Mathieu 'D'Aristote à l'abstraction lyrique'. *L'Oeil* (April 1959); and Alain Mosquet *Cent questions poseés à Georges Mathieu.* In *Ring des Arts* (Paris, Zurich, Bruxelles: Cercle d'Art Contemporain 1960); see also p. 153.

28 Michel Tapié, op. cit., see note 8.

29 Often quoted in several different versions; this from Kenneth Clark *Leonardo da Vinci,* p. 83 (Cambridge: Cambridge University Press 1939).

30 Herbert Read 'An Art of Internal Necessity'. *Quandrum,* no. 1 (1956) 7.

31 Quoted in catalogue *Die neue Amerikanische Malerei* (Basel: Kunsthall May 1958).

32 Read, op. cit.

33 In G. Limbour *L'art brut de Jean Dubuffet,* p. 95 (Paris: Drouin 1953).

34 Limbour, op. cit., p. 96.

35 Virginia Woolf *The Waves.*

36 Joint statement with another painter, Gothlieb, in a letter to *New York Times,* 1943. See Rothko Catalogue (New York: Museum of Modern Art 1961).

37 Lawrence Alloway 'The American Sublime'. In *Living Arts,* no. 2 (1963) 11.

38 In Limbour, op. cit., p. 96.

39 Avray Wilson *Art as Understanding,* p. 20.

40 In Limbour, op. cit.

41 B B C talk, cited on p. 72.

42 In catalogue *Die neue Amerikanische Malerei* (Basel: Kunsthall 1958).

43 Brassai 'Du mur des cavernes au mur d'usine'. *Minotaur,* nos. 3−4 (1934).

44 In Limbour, op. cit., p. 92.

45 G. Mathieu *From the Abstract to the Possible,* p. 21.

46 Margaret Mead 'Work, Leisure and Creativity'. *Daedalus, The Visual Arts Today,* Winter (1960).

47 John Cage *Silence* (Connecticut: Wesleyan University Press 1961).

Chapter 6. Reactions and Continuations

1 Interview with André Parinaud, *Arts,* 10 May (1961); also catalogue, Ileana Sonnabend Gallery (1963).

2 Alan R. Solomon *Catalogue of US artists.* 23rd International Biennale (Venice 1964).

3 In *391,* no. 13 (July 1920); cf. collected edition, ed. M. Sanouillet (Paris: Le Terrain Vague 1960).

4 J. Barry Lord 'Pop Art in Canada'. *Artforum*, vol. 2, March (1964).

5 Quoted by Robert Melville. *Architectural Review*, February (1965) 145.

6 Rayner Banham. *Living Arts*, no. 3 (1964) 94.

7 Max Bill 'The mathematical approach in contemporary art', originally published in German in *Werk*, no. 3, Winterthur 1949; this English translation from Thomas Maldonado *Max Bill* (Buenos Aires: Editorial Nueva Vision 1955).

8 Stefan Themerson *Bayamus*, p. 62 (London: Poetry Editions 1949).

9 *The Realistic Manifesto* 1920 (in Russian); for translations see *Gabo* (Cambridge, Mass.: Harvard University Press and Lund Humphries 1957), or C. Gray *The Great Experiment: Russian Art 1863–1922* (London: Thames and Hudson 1962).

10 For a recent statement by this artist, see *Studio International*, March 1967.

11 Jasia Reichardt *Yaacov Agam* (London: Methuen 1966).

12 Interviews with many of these artists, and photographs of their work, are published in *Signals* (Signals London Gallery, Wigmore St, London W1).

13 See *Four Essays on Kinetic Art* by Stephon Bann, Reg Gadney, Frank Popper and Philip Steadman (St Albans: Motion Books 1966).

14 T. K. Hoenich *Robot Art* and *Design with Sunrays* (Haifa: Israel Institute of Technology, January and July 1965).

15 *Museum of Modern Art Bulletin* (New York 1951).

16 All the Giacometti quotations on page 231 are from Georges Charbonnier *Le monologue du peintre*, pp. 178, 172, 179, 175 (Paris: Julliard 1959).

17 From exhibition catalogue (Basel: Gallerie Beyeler 1963), opposite item no. 60.

18 Charbonnier, op. cit., p. 164.

Chapter 7. The Profits of Plurality

1 C. H. Waddington *The Scientific Attitude*, p. 54 (Penguin Books 1941).

2 Waddington, op. cit., Foreword.

3 Sir Thomas Browne *Religio Medici*, 1, section 42.

4 Joseph Needham *The Great Amphibium* (Student Christian Movement Press 1931).

5 Aldous Huxley *The Humanist Frame*, p. 419 (London: Allen and Unwin 1961).

6 Margaret Mead *Continuities in Cultural Evolution*, p. 137 (New Haven: Yale University Press 1964).

7 Aldous Huxley 'Education on the Non-verbal level'. *Daedalus*, Spring (1962) 279.

8 Lawrence S. Kubie *Neurotic Distortion of the Creative Process* (University of Kansas Press 1958).

SOURCES AND ACKNOWLEDGEMENTS

I am well aware that, to the professionals in the field of modern art history, some of these sources may seem unduly 'secondary.' I can only plead the difficulties which face the professional scientist, working without frequent contact with a well-organised art library, in identifying the correct primary sources without the expenditure of more time than he can make available.

I am deeply grateful to a number of journal editors, gallery directors, and individual artists and owners, who have all helped in the collection of suitable illustrative material for this book. In the first place, I must mention M. G. di San Lazzaro, editor of *Vingtième Siècle*, and Mr Peter Townsend, editor of *Studio International*, who have so generously allowed me to dip into their rich stores of material. Between them, they have provided the majority of colour plates. For black-and-white illustrations, I am particularly grateful to the Museum of Modern Art, New York, who allowed me to browse through their extensive collection of negatives.

Publisher's Note. Every effort has been made to trace the copyright ownership of the illustrations used in this book. In some cases this has proved difficult and we would welcome the opportunity to make corrections and additions in future editions.

COLOUR

Vingtième Siècle. Galleries and private owners of the following pictures can be verified by reference to the appropriate issues of *Vingtième Siècle:* pls. 5, 7, 8, 10, 13, 24, 36, 37, 39, 66 (no. 17) ; pl. 70 (no. 18) ; pls. 3, 14, 22, 33, 50 (no. 19) ; pls. 9, 25, 46 (no. 20) ; pls. 1, 6 (no. 21) ; pls. 28, 29, 30, 68 (no. 22) ; pls. 43, 44, 71 (no. 23) ; pl. 52 (no. 24) ; pl. 27 (no. 25) ; pl. 4 (no. 26) ; pls. 21, 23 (no. 27) ; pl. 42 (no. 28) ; pl. 26 (no. 30).

Studio International. Pl. 45, Galerie Beyeler, Basel ; pl. 41, Mr and Mrs Walter B. Braiss, Munich ; pl. 12, Downtown Gallery, New York ; pl. 54, Gerson Gallery, New York ; pl. 47, Mr Charles Gimpel ; pl. 61, Grosvenor Gallery, London ; pl. 59, Calouste Gulbenkian Foundation (Patrick Heron and the British Council) ; pl. 51, Landau Collection, Paris ; pls. 32, 38, Marlborough Fine Art Ltd, London ; pl. 49, Pierre Matisse Gallery, New York ; pl. 11, Museum of Modern Art, New York ; pl. 67, Rowan Gallery, London ; pl. 53, Galerie Ileana Sonnabend, Paris. Also pls. 15, 17, and 40.

Other Sources. Pls. 62, 63, Max Bill ; pl. 65, British Council ; pls. 55, 56, Leo Castelli Gallery, New York ; pls. 31, 48, Contemporary Slides ; pl. 60, Hansom Books Ltd, London ; pl. 64, Tess Jaray and the Hamilton Gallery, London ; pl. 69, John Piper ; pl. 19, Mr James Soby and the Museum of Modern Art, New York ; pls. 57, 58, Galerie Ileana Sonnabend, Paris ; pl. 20, Gianni Mattioli, Milan ; pl. 18, C. H. Waddington ; pls. 16, 34, 35, Whitney Museum of American Art.

BLACK AND WHITE

p.xii Paul Eluard *À Pablo Picasso*. Genève-Paris : Trois Collines 1944.

1 Herbert W. Franke *Wohin keine Auge reicht*. Wiesbaden : Brockhaus 1959.

2 Stanley W. Angrist 'Fluid control devices.' *Scientific American*, December 1964.

3 As Figure 1.

4 Stanislav Ulam, Los Alamos Scientific Laboratories, USA.

5 *Uppercase*. Whitefriars Press 1958.

6 As p.xii.

7 *Scientific American*, May 1964.

8 Maurice Raynal *Picasso*. Paris : Cres 1932.

9 Left, as Figure 8 ; right *Picasso, an American Tribute*. New York : Public Educational Association and Chanticleer Press 1962.

10 Offentliche Kunstsammlung, Basel.

11 *Cahiers d'Arts, c.* 1936

12 J. Casson and D. Fedit *Kupka*. London : Thames and Hudson 1965.

13 J. C. Taylor *Futurism*. New York : Museum of Modern Art 1962.

14 Museum of Modern Art, New York.

15 M. Jardot *Léger, Dessins*. Paris : Deux Mondes 1953.

16 As Figure 15.

17 Douglas Cooper *Fernand Léger*. London and Paris : Lund Humphries and Trois Collines 1959.

18 As Figure 15.

19 Original.

20 *A, B, C, D*. M. Seuphor *Mondrian*. London : Thames and Hudson, n.d.

21 *De Stijl*, catalogue. Amsterdam : Stedelijk Museum 1951.

22 Museum of Modern Art, New York.

23 *Gabo*. London and Cambridge, Mass.: Lund Humphries and Harvard University Press.

24 Museum of Modern Art, New York.
25 Joseph Albers *Poems and Drawings*. New Haven, Conn.: Readymade Press 1958.
26 G. di San Lazzaro *Klee*. New York: Praeger Paperback 1957.
27 Hans Hildebrandt *Oscar Schlemmer*. Stuttgarter Verlag KG 1949.
28 S. Giedion *Moholy*, catalogue. Chicago: Institute of Design, n.d.
29 *Moholy-Nagy*. Special number of Telehor. Brno: Kalivada 1936.
30 Original photomontage, from record sleeve of Lotte Lenya and title-page of Die gegenstandlose Welt, Bauhausbücher 11.
31 *Ben Nicholson*. London: Lund Humphries 1955.
32 Print in author's possession. British Ministry of Information *c*. 1942.
33 Museum of Modern Art, New York.
34 Will Grohmann *Kandinsky*. Köln: Schauberg 1958.
35 As Figure 34.
36 *391*, collected edition, ed. M. Sanouillet. Paris: Le Terrain Vague 1960.
37 C. Giedion-Welcker *Jean Arp*. Stuttgart and New York: Verlag Gerd Hatje and Abrams.
38 As Figure 37.
39 As Figure 37.
40 *XXme* Siècle, no. 4, 1954.
41 Museum of Modern Art, New York.
42 *Uppercase*. Whitefriars Press 1958.
43 As Figure 36.
44 Max Ernst *Histoire naturelle*. Paris: Berggruen, n.d.
45 Bruxelles: Henriquez.
46 Raymond Borde and André Breton *Pierre Molinier*. Paris: Le Terrain Vague 1964.
47 Salvador Dali *La conquète de l'irrationel*. Paris: Éditions Surréalistes 1935.
48 Max Ernst *La semaine de bonté*. Paris: Jeanne Boucher 1934.
49 Eagle, Wolitsky and Klein. *Science*, **151** (1966) 837.
50 *André Masson et son univers*. Paris: Limbour and Leiris 1947.
51 Museum of Modern Art, New York.
52 *Minotaure*. Paris: Skira 1933; Man Ray *Portraits*. Gütersloh: Prisma 1963.
53 André Masson *Nocturnal Notebook*. New York: Curt Valentin 1944.
54 Max Ernst *Paramythes*, from French edition, Paris: Le Point Cardinal 1967; original edition, Beverley Hills: Copley Gallery 1949.
55 *Minotaure*. Paris: Skira 1934.
56 Paul Eluard and Man Ray *Facile*. Paris: Edition GLM 1935.
57 As Figure 48.
58 Picasso *Vollard Suite*. New York: Abrams.

59 Feugelmann *et al.*, *Nature*, **175** (1955) 834.
60 *Scientific American*, October 1963.
61 Professor H. Lipson, Manchester College of Arts and Technology.
62 Eduardo Paolozzi and the Alecto Gallery, London.
63 Electronics Department, Ferranti Ltd.
64 Josef Galun 'Screw dislocations in crystals.' *Information*, **51**, Karl Zeiss Ltd.
65 As Figure 1.
66 Anthony Kelly 'Fiber-reinforced metals.' *Scientific American*, February 1965.
67 As Figure 1.
68 Arnold C. Wahl 'Molecular orbital densities – pictorial studies.' *Science*, **151** (1966) 961.
69 Dr John Kendrew, M R C Molecular Biology Laboratories, Cambridge.
70 As Figure 69.
71 As Figure 69.
72 *Scientific American*, September 1964.
73 Dr F. H. Harlow, Los Alamos Scientific Laboratories, U S A.
74 Professor W. H. Thorpe, Zoological Laboratory, Cambridge.
75 Bell Telephone Laboratory, New York.
76 Dr Max Birnstiel, Department of Animal Genetics, Edinburgh.
77 Original.
78 Original.
79 Drs Emmett N. Leith and Juris Upatniecks, University of Michigan.
80 As Figure 79.
81 As Figure 69.
82 *Jackson Pollock*, catalogue. Marlborough Gallery, London.
83 Marcel Jean *The History of Surrealist Painting*. London and Paris: Weidenfeld and Nicholson, and Editions du Seuil 1959.
84 Patrick Waldberg *Max Ernst*. Paris: J. J. Pauvert 1958.
85 Bryan Robertson *Jackson Pollock*. London: Thames and Hudson 1960.
86 *Erste Internationale der Zeichnung*, catalogue. Darmstadt, 1964.
87 Thomas B. Hess *Willem de Kooning*. New York: Braziller 1959.
88 As Figure 85.
89 As Figure 85.
90 *Cashiers du musée de poche*, no. 1. Paris: Éditions Georges Fall 1959.
91 Ring des Arts. Zürich 1960.
92 (*a*) Alcopley *You Don't Say*. Reykavik: Ditter Rot.
 (*b*) Gift from artist.
 (*c*) Will Grohmann *Alcopley, Voies et Traces*. Wuppertal: Galerie Parnass 1961.
93 Dorothy C. Miller *Twelve Americans*. New York: Museum of Modern Art 1956.
94 As Figure 93.

95 *Henri Michaux,* catalogue, Hanover
 Gallery, London.
96 *XXme Siècle,* no. 14, 1960. Jean Dubuffet
 Secretariat, Paris.
97 Giampiero Giani *Spazialismo.* Milan :
 Conchiglia 1957.
98 Jean Dubuffet Secretariat, Paris.
99 As Figure 98.
100 As Figure 98.
101 As Figure 98.
102 As Figure 98.
103 Michel Tapié *Antonio Tapies.* Barcelona :
 Editorial R M 1959.
104 Museum of Modern Art, New York.
105 As Figure 98.
106 *XXme Siècle,* no. 25, 1965.
107 Museum of Modern Art, New York.
108 Catalogue, Whitechapel Gallery, London.
109 Robert Fraser Gallery, London.
110 Hanover Gallery, London.
111 Richard Hamilton and Robert Fraser
 Gallery, London.
112 As Figure 111.
113 Galerie Ileana Sonnabend, Paris.
114 Artforum, Los Angeles.
115 As Figure 113.
116 As Figure 113.
117 Rolf Nelson Gallery, Los Angeles.
118 *XXme Siècle,* 1938.
119 T. Maldonada *Max Bill.* Buenos Aires :
 Editorial Nueva Vision 1953.
120 Catalogue, Galerie Hilt, Basel 1962.
121 *Quandrum,* no. 3, 1957.
122 Catalogue, Pace Gallery, New York.
123 Gift from artist.
124 Gift from artist.
125 Catalogue, Gallery One, London.
126 *Signals.* London, November–December
 1965.
127 Gift from artist.
128 T. K. Hoenich *Design with Sunrays.* Haifa :
 Technion 1965.
129 *Calder: an autobiography with pictures.*
 London : Allen Lane and Penguin Books
 1967.
130 *Signals.* London, October–November 1964.
131 Gift from artist (*New York Times* photo).
132 Peter Selz *Alberto Giacometti.* New York :
 Museum of Modern Art 1965.
133 Ernst Scheidegger *Alberto Giacometti.*
 Zürich : Verlag Arche 1958.
134 As Figure 85.
135 As Figure 108.
136 *Cahiers d'Arts, c.* 1932.

Text set in 9 point Monotype Univers Light and printed on
Culter Mills Smooth Litho at Kynoch Press, Birmingham.
Colour plates printed by W. and J. Mackay Ltd, Chatham,
and Arti Grafichi Amilcare Pizzi, Milan.
Bound by W. and J. Mackay Ltd.

Date Due

Demco 38-297